# CHINA THROUGH THE LOOKING GLASS

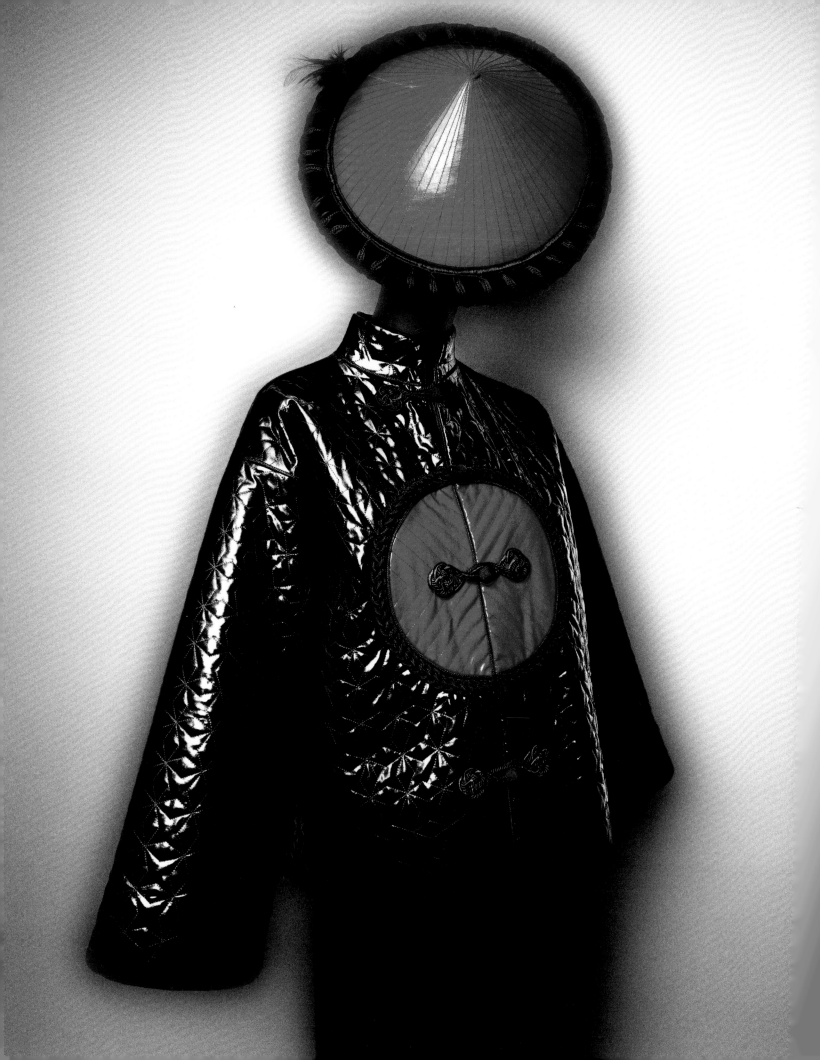

# CHINA THROUGH THE LOOKING GLASS

Andrew Bolton with John Galliano, Adam Geczy, Maxwell K. Hearn,
Homay King, Harold Koda, Mei Mei Rado, and Wong Kar Wai
Photography by Platon

THE METROPOLITAN
MUSEUM OF ART
NEW YORK

DISTRIBUTED BY
YALE UNIVERSITY PRESS
NEW HAVEN AND LONDON

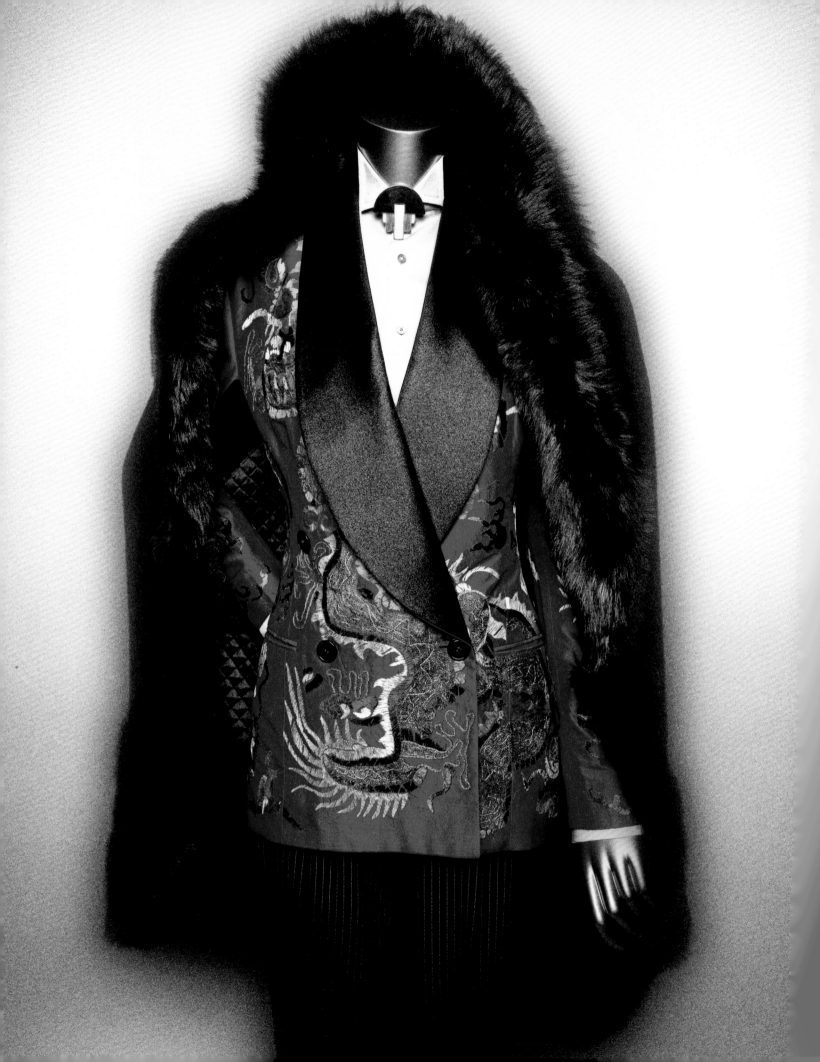

# SPONSOR'S STATEMENT

Yahoo is honored to sponsor "China: Through the Looking Glass," The Costume Institute's spring 2015 exhibition at The Metropolitan Museum of Art. This exquisite exhibition juxtaposes high fashion with historic Chinese costumes, film, and art to explore Western designers' enduring fascination with Chinese imagery.

Exploring the world of fashion is a beloved pastime. The Met's Costume Institute is renowned for providing new perspectives on both celebrated and emerging designers of great talent and artistic merit. Yahoo likewise brings a sophisticated, fresh take on fashion to our global audience through our digital magazine *Yahoo Style*. Its in-depth coverage is for everyone from fashion enthusiasts to those who love it from the sidelines. As its editor in chief, Joe Zee, says, "Fashion is storytelling, and *Yahoo Style* is meant to be a must-land destination for great and stylish storytelling."

At Yahoo we are dedicated to inspiring and delighting our users, creating content every day in the subjects that matter to them most, including news, beauty, travel, and entertainment, as well as fashion. We could not be more thrilled to sponsor this iconic exhibition and to amplify the efforts of the talented designers showcased here.

*Marissa A Mayer*

Marissa Mayer
President and Chief Executive Officer
Yahoo

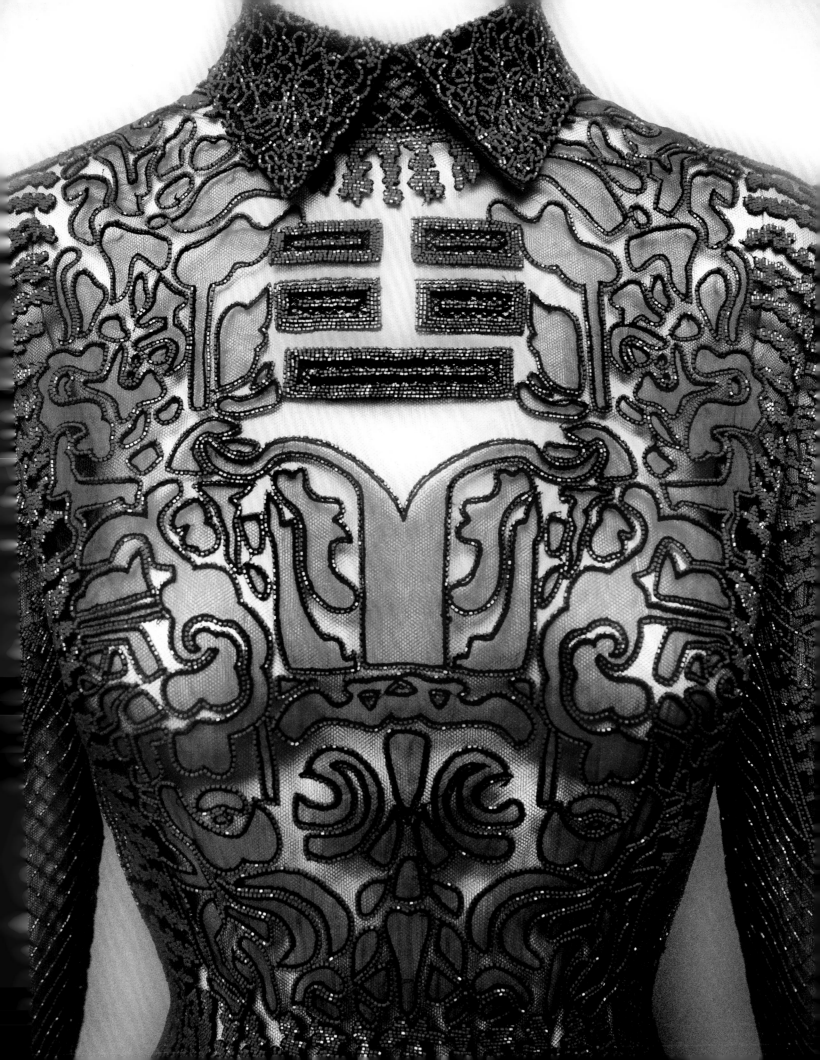

# DIRECTOR'S FOREWORD

"China: Through the Looking Glass" brings together two of The Metropolitan Museum of Art's most innovative departments. Costume Institute Curator Andrew Bolton, with the support of Maxwell K. Hearn, Douglas Dillon Chairman of the Department of Asian Art, presents an exhibition that extends from the Lizzie and Jonathan Tisch Gallery and the Carl and Iris Barrel Apfel Gallery in the Anna Wintour Costume Center through the Museum's galleries for Chinese art. Ambitious in both scale and subject matter, the result is a stunning, cinematic journey in which magnificent examples of the haute couture and avant-garde ready-to-wear are presented alongside masterworks of Chinese art, ranging in materials from jade and bronze to lacquer and porcelain.

This epic exhibition, which could only have been realized at the Met, highlights the unparalleled strengths of the Museum's collections and scholarship in both Asian art and costume. While the show relies primarily upon the Museum's encyclopedic collections of Western fashion and Chinese art, it has been augmented by important loans from the leading fashion houses in Europe as well as from the foremost museums in China, including the Palace Museum, the China National Silk Museum, and the Hong Kong Museum of History. It is a unique and truly cross-cultural collaboration.

We are thrilled to have had the acclaimed filmmaker Wong Kar Wai working with Andrew Bolton as the exhibition's artistic director, and the equally celebrated production designer Nathan Crowley as its artistic designer. The amazing photographer Platon created the extraordinary, poetic images of costumes and objects that fill the pages of this volume.

The exhibition and this publication would not have been possible without the commitment of our sponsor, Yahoo, and its CEO, Marissa Mayer, who championed this partnership. Our thanks also go to Condé Nast for its additional support of the project and continued dedication to the work of The Costume Institute. We likewise extend our appreciation to Wendi Murdoch, Veronica Chou, and several Chinese donors who have demonstrated exceptional generosity toward this endeavor. And finally, I would like to express my gratitude to Museum Trustee Anna Wintour for her ongoing guidance and commitment. Anna's devotion to The Costume Institute is felt year after year in her continued enthusiasm for these exhibitions, and we remain indebted to her vision and support.

*Thomas P. Campbell*

Thomas P. Campbell
Director
The Metropolitan Museum of Art

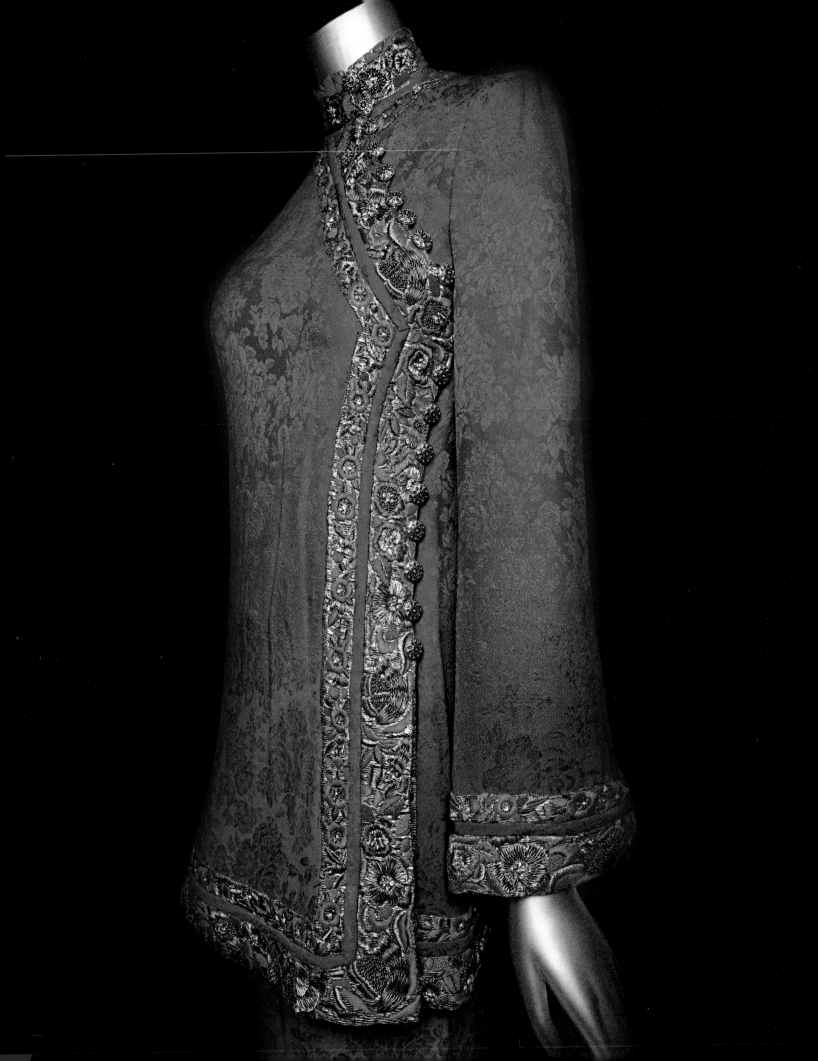

# A Note on Film and Fashion

## Wong Kar Wai

I am honored to have been asked by The Metropolitan Museum of Art to serve as artistic director of the exhibition "China: Through the Looking Glass." As a filmmaker, I have been delighted to discover that some of my films and those of my peers have provided inspiration for many of the fashions displayed in the exhibition and in this related catalogue. The film clips in the galleries and the film stills in this book reveal the impact that cinematic representations of China have had on Western designers' imaginations.

"Mirror Flower Water Moon," the Chinese title of the exhibition, includes recurring symbols in Chinese art and literature and represents projection, reflection, and fascination. As the Tang dynasty poet Pei Xiu wrote in the ninth century: "Like moon in the water, image on a mirror / It comes and goes, with no inherent reality." The couplet suggests the subtle nuances that separate cultures—as when the bright moon of the East finds its reflection on Western waters. What appears does not correlate with reality. The aesthetic experience might also be at variance.

Nevertheless, a remark once uttered by Gabrielle "Coco" Chanel suggests to me how similar Eastern and Western philosophical impressions can be: "Fashion is not something that exists in dresses only. Fashion is in the sky, in the street, fashion has to do with ideas, the way we live, what is happening." When we look into a mirror, we only see ourselves, but when this mirror turns into a window, we see the world around us. Together with the curator Andrew Bolton, I hope that the art, film, and fashions in "China: Through the Looking Glass" will serve as windows, providing visitors to the exhibition and readers of this book with a closer view of Chinese aesthetic and cultural traditions.

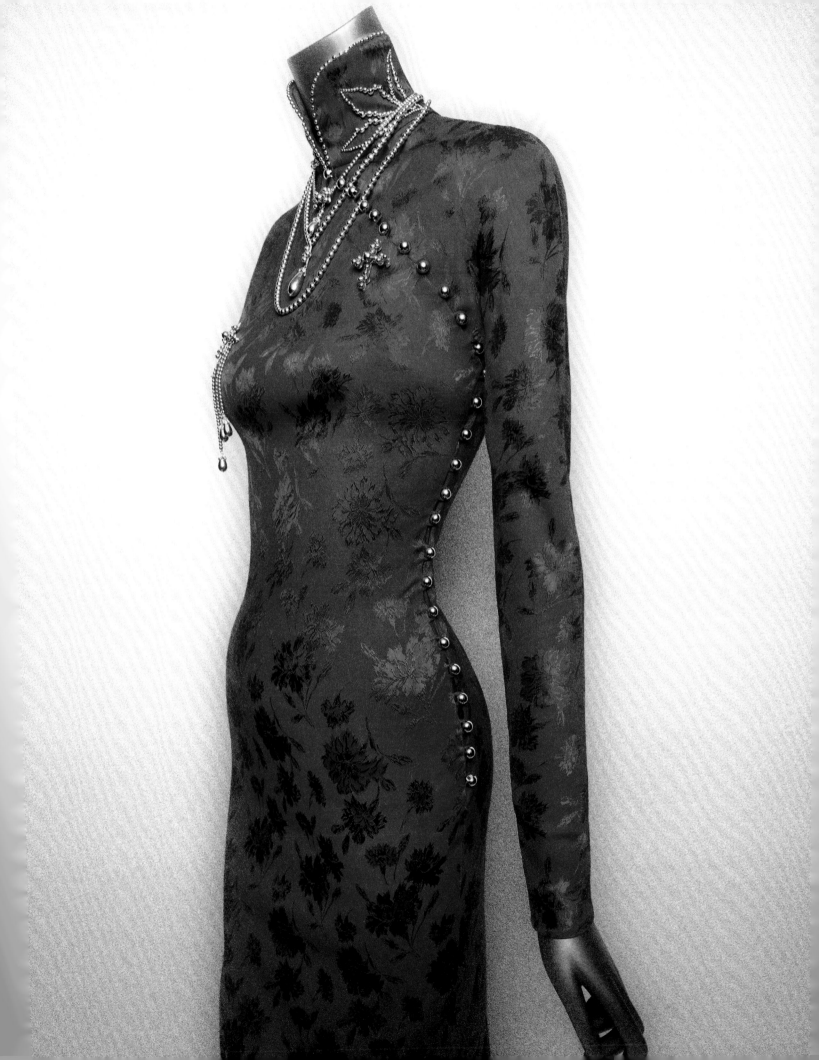

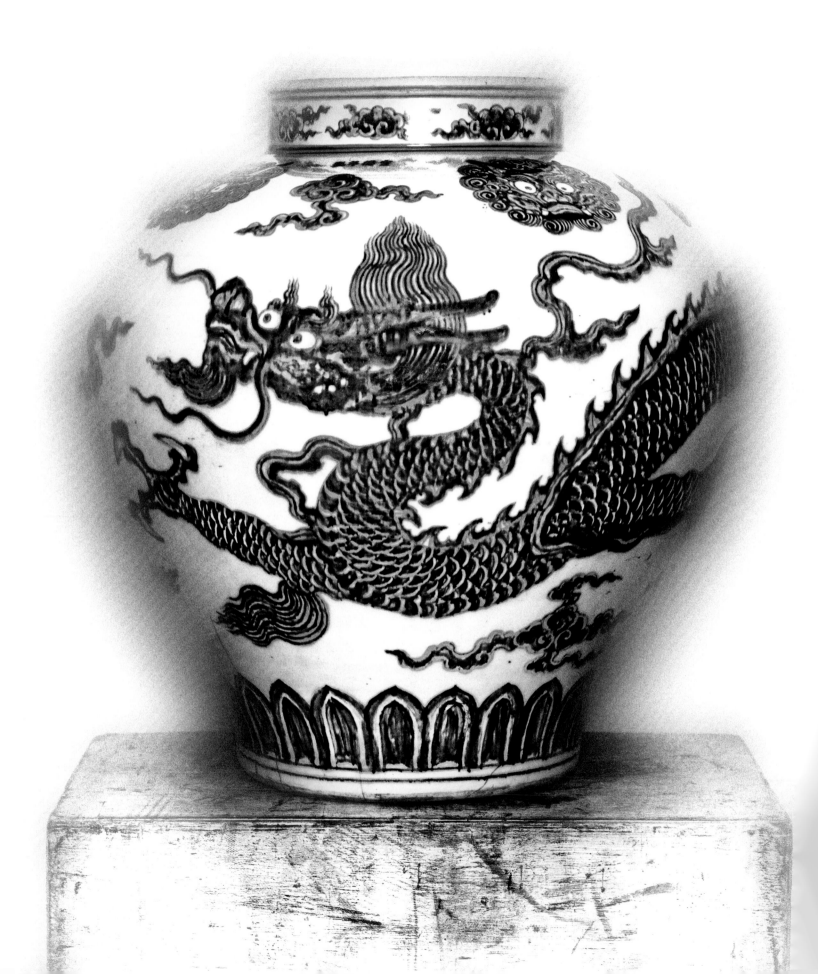

# A Dialogue between East and West

Maxwell K. Hearn

*China: Through the Looking Glass* and the exhibition it accompanies take full advantage of The Metropolitan Museum of Art's encyclopedic collections to explore the long history of interaction between China and the West. Juxtaposing haute couture with Chinese art, both within these pages and within our galleries, vividly reveals how some of the most creative minds in the world of Western fashion design have been inspired by Chinese imagery and aesthetics.

Ever since the silk trade flourished between Asia and the Roman Empire, China has been a source of fashion inspiration for the West. The fabric was so wildly popular that the Roman Senate even issued prohibitions against wearing silk—apparently to little avail. Not only did silk's importation cause a serious outflow of gold, but garments made of it were regarded as immoral: "While they cover a woman, at the same moment [they] reveal her naked charms," Pliny the Elder (A.D. 23–79) remarked in *The Natural History* (book 11, chapter 26).

Another wave of interest in China crested in the early Renaissance, when fabulous stories of the Orient recounted by Marco Polo (1254–1324) and others fired the European imagination. Later, sea trade exponentially increased Chinese exports, notably of spices, tea, textiles, and ceramics, giving rise in the seventeenth century to what would be a lasting taste in Europe for chinoiserie (Chinese-themed imagery).

China continues to speak resonantly to the West; its past artistic achievements—from ancient artifacts of pottery, jade, and bronze to Qing dynasty porcelains, as well as paintings, calligraphies, and early Buddhist sculpture—still shape artistic expression in the present, as *China: Through the Looking Glass* lavishly demonstrates. Hosting Western fashions in all the Museum's galleries devoted to traditional Chinese art (as well as in the Anna Wintour Costume Center) emphasizes not only the sources of their inspiration but also how different the modern visions are from those sources.

A similar tactic was employed in the Museum's first exhibition of modern Chinese art, in 2013. "Ink Art: Past as Present in Contemporary China" introduced works by contemporary Chinese artists into the

permanent galleries of traditional Chinese art—often directly adjacent to early pieces—to underscore how some currents of modern Chinese art have found inspiration in earlier models and forms of expression.

In like manner, the encounter between Western fashion and Chinese culture is here presented as a series of conversations between haute couture creations and iconic Chinese objects drawn from the Met's resources as well as key loans from the Palace Museum, Beijing. In this way, a richly embroidered dragon robe, cinnabar screen, blue-and-white porcelain vase, or supple jade ornament may suggest the genesis of the design viewed side by side with it. The connection may be through material, pattern, or color that in some way is reflected in costume.

In addition to particular works of art, the performing arts have provided a rich and important source of imagery through the powerfully heightened reality of theater and film. The inclusion here of cinematic imagery and theatrical sets suggests how our perceptions of China have often relied less on primary sources than on romanticized notions of the exotic East.

Regardless of where their inspiration originates, the garments on display each narrate a story and convey a persona: dragon lady, lotus flower, moon goddess, or Little Red Guard. The clarity of their narratives depends upon the viewer's ability to decode the motifs and stylistic references that have inspired the designers. That is where the Metropolitan's collection of Chinese fine and decorative arts can expand our appreciation for what is new as well as what is old in the designs. Matching fashions to objects has been the particular genius of the exhibition's curator, Andrew Bolton, and his vision has been critical to eliciting their illuminating dialogues. The juxtapositions of art objects, cinematic imagery, and fashion designs demonstrate how the creative process is inherently transformative, boldly reducing a complex matrix of meanings into graphic signs that say "China"—not as literal copies but as allusions to a prototype.

The work of two well-known Western artists who have drawn upon Chinese sources further illustrates this process. David Hockney (born 1937) has often escaped the spatial limitations of one-point perspective by adopting his own version of the Chinese handscroll's so-called moving perspective in his landscapes. Brice Marden (born 1938) has been inspired by calligraphy in his quest to create linear forms that are nonfigurative. Neither artist intended to master Chinese painting or calligraphy to achieve his goals. Rather, each creatively appropriated those aspects of his Chinese sources that solved a particular challenge and realized his artistic vision.

The fashions presented here similarly display a clear debt to Chinese imagery without slavishly reproducing it. In fact, the original function or significance of a motif or form may have been misunderstood or otherwise lost in its translation, but a literal copy of the model was never the objective, and labeling something as a "misunderstanding" misses the point. Rather, the Chinese originals are points of departure for excitingly creative reinterpretations, demonstrating how easily art crosses boundaries of time, space, and cultural language to serve its own purposes.

All the works presented here also reveal an underlying truth: that China's immensely long and varied cultural traditions continue to serve as a rich source of invention and renewal for artists in China and beyond. Indeed, art provides a looking glass through which we are able to reflect on our common heritage and envision new creative possibilities.

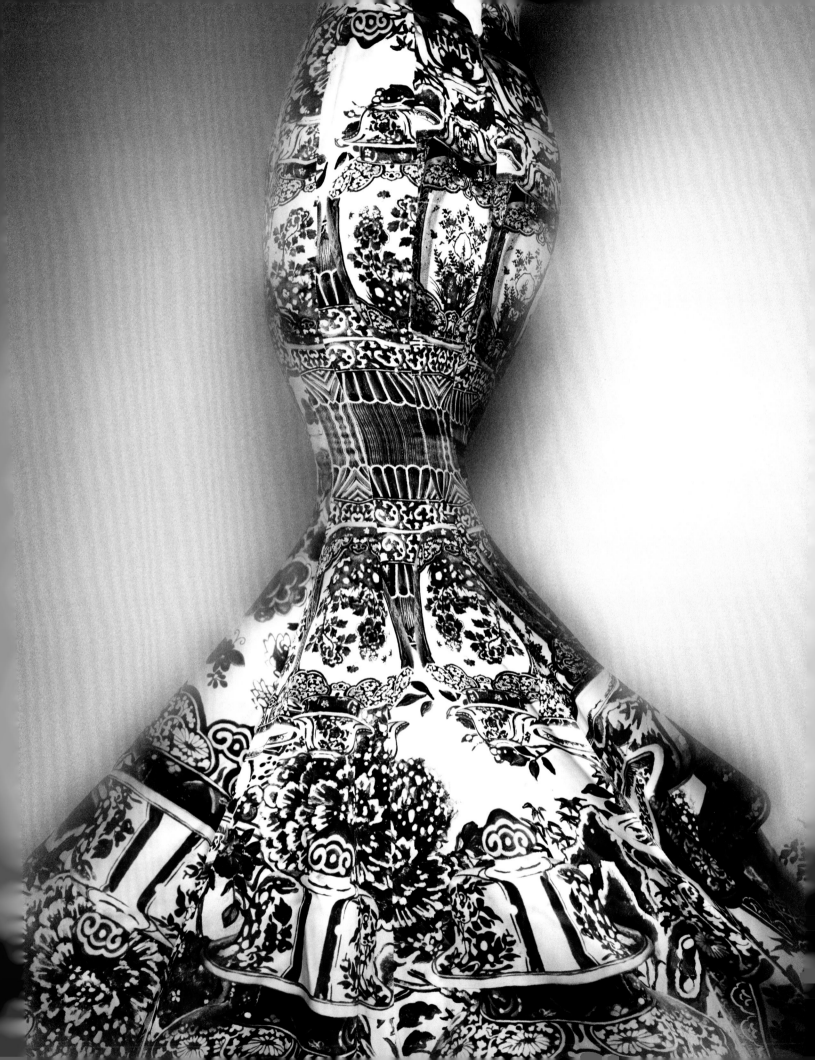

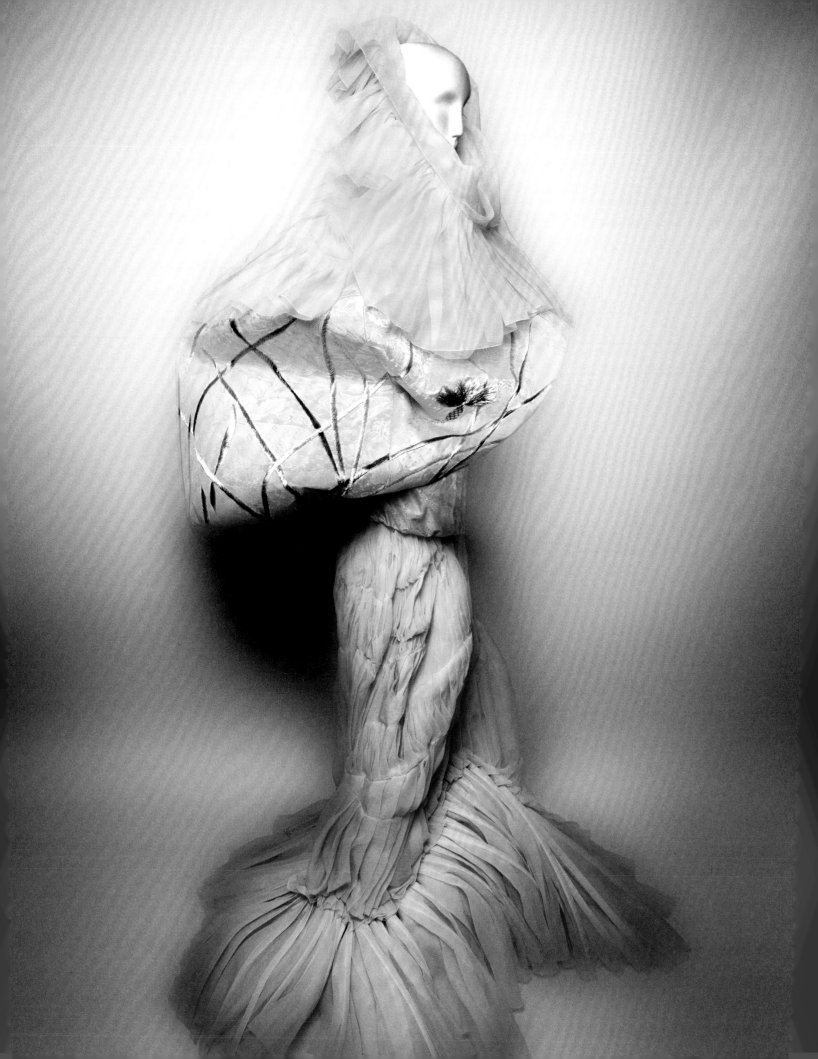

# Toward an Aesthetic of Surfaces

Andrew Bolton

In Lewis Carroll's *Through the Looking-Glass, and What Alice Found There* (1871), the heroine enters an imaginary, alternative universe by climbing through a mirror in her house. In this world, a reflected version of her home, everything is topsy-turvy and back-to-front. The basic rules and codes of conduct of her real existence are reversed. Cakes are served before being cut, individuals think better while standing on their heads, and destinations are reached by walking in the opposite direction. Alice understandably finds these inverse systems both disarming and disorienting. They destabilize her sense of time, space, and, ultimately, self.

Like Alice's make-believe world, the China reflected in the examples of haute couture and avant-garde ready-to-wear fashions in this catalogue and related exhibition is a fictional, fabulous invention, offering an alternate reality with a dream-like illogic. Its fanciful imagery, which combines Eastern and Western stylistic elements, belongs to the tradition and practice of chinoiserie, a style that emerged in the late seventeenth century and reached its pinnacle in the mid-eighteenth century. Within the conventions and trajectory of chinoiserie, China is a site on which historically changing fears and desires are projected. As a style, it belongs to the broader tradition and practice of Orientalism, which since the publication of Edward Said's seminal treatise on the subject in 1978 has taken on negative connotations of Western supremacy and segregation. At its core, Said interprets Orientalism as the Eurocentric predilection to essentialize Eastern peoples and cultures as a monolithic other.

While neither discounting nor discrediting the issue of the representation of "subordinated otherness" outlined by Said, *China: Through the Looking Glass* attempts to propose a less politicized and more positivistic examination of Orientalism as a locus of infinite and unbridled creativity. Through careful juxtapositions of Western fashions and Chinese costumes and decorative arts, this catalogue presents a rethinking of Orientalism as an appreciative cultural response by the West to its encounters with the East. As these comparisons

demonstrate, China has proved a source of continual inspiration and reinvigoration for Western fashion. Far from being dismissive or disrespectful of its peoples and customs, Western designers have invariably looked to China with honorable intentions, to learn from both its artistic and cultural traditions. Instead of relating Orientalism to modes of power and knowledge, this catalogue relates it to concepts of cultural exchange and mutual understanding.

There is a tonic effect in the placement of Western fashions alongside Chinese costumes and decorative arts. Mutually enlivening and mutually enlightening, the resulting visual or aesthetic dialogues encourage new mimetic and referential readings that are based on subjective rather than objective assessments. As observers and active participants, we are forced to exercise our imaginative capacities, for the China that unfolds before our eyes is a China "through the looking glass," one that is culturally and historically decontextualized. Freed from settings, past and present, the objects in this catalogue and in the exhibition galleries begin to speak for and between themselves. A narrative space opens up that is constantly being reorganized by free associations. Meanings are endlessly negotiated and renegotiated. As if by magic, the psychological distance between East and West, spanning worldviews that are often perceived as monolithic and diametrically opposed, diminishes. So too does the association of the East with the natural and the authentic, and the West with the cultural and the simulacrum. As these binaries dissolve and disintegrate, the notion of Orientalism is disentangled from its connotations of Western domination and discrimination. Instead of silencing the other, Orientalism becomes an active, dynamic two-way conversation, a liberating force of cross-cultural communication and representation.

Cinema often serves as a conduit for this reciprocal exchange between East and West. Frequently, film is the principal—and certainly the most compelling and seductive—lens through which contemporary designers encounter Chinese

imagery, and this volume explores the impact of movies in shaping their fantasies. The China of cinema is, of course, a phantasmagoria of make-believe stories and characters located in an elsewhere of endless possibility. Even films that are based on real-life people and events reflect the personal perspectives (and prejudices) of their creators. This invented, imaginary China is not the exclusive preserve of Hollywood. Chinese directors, especially those belonging to the so-called Fifth Generation, such as Chen Kaige and Zhang Yimou, depict the nation as both illusory and indistinct. Indeed, their films, aimed at an international audience, can be interpreted as an extension of eighteenth- and nineteenth-century Chinese export art in their negotiation of internal/introverted views of China (romanticized national history) and external/extroverted views (exoticized national history). Thus, the China portrayed in the haute couture and ready-to-wear fashions in this publication are doubly removed from reality and actuality.

Mediated by such cinematic representations, the conversations in *China: Through the Looking Glass* attempt to reimagine the relationship between East and West not as one-sided mimicry or appropriation, but rather as a layered series of enfolded exchanges. Broadly speaking, the dialogues are divided into two categories. The first is titled "From Emperor to Citizen," taken from the 1964 autobiography of Aisin-Gioro Pu Yi, the last emperor of China, who ruled as Emperor Xuantong. Pu Yi's memoir formed the basis of the screenplay for Bernardo Bertolucci's 1987 biopic *The Last Emperor*, in which Chinese history assumes an overtly aesthetic and emotional dimension. Perhaps because of this reason, the movie has had an enormous and continuing influence on the Western fashionable imagination. Like the movie, this series of conversations spans three periods of Chinese history: the Qing dynasty (1644–1911), the Republic of China (1912–49), and the People's Republic of China (1949–present). When designers are inspired

by China's long and rich history, they invariably gravitate toward these three epochs or, more specifically, the fashions that prevailed during those times: the Manchu robe, the modern *qipao*, and the Zhongshan suit (after Sun Yat-sen, but more commonly known in the West as the Mao suit, after Mao Zedong). These three garments, in turn, tell the story of the gradual introduction and increasing implementation of Western tailoring techniques within Chinese dressmaking traditions, underscoring the circuitous character of cross-cultural interaction.

For Western designers, the attraction of these garments lies in their cultural specificity and historical determinacy. They serve as a kind of sartorial shorthand for China and the shifting social and political identities of its peoples, no matter how diverse and heterogeneous. In the case of the Manchu robe, designers typically gravitate toward the imperial dragon robe in all of its imagistic splendor and richness. Clouds, ocean waves, mountain peaks, and, in particular, dragons are presented as meditations on the spectacle of imperial authority. The *qipao* is a special favorite of designers, not least because of its mutability and malleability. A garment that emerged in the post-dynastic republican era, it is situated not only in the interstices between Old China and New China, between traditionalism and cosmopolitanism, but also between the 1920s chemise dress and the 1930s bias-cut gown in terms of its formal and symbolic properties. While the appeal of the close-fitting *qipao* lies in its allure and glamour (and perhaps in its decadent sensuality), that of the Mao suit rests in its principled practicality. Its uniformity implies an idealism and utopianism reflected in its seemingly liberating obfuscation of class and gender distinctions.

All three garments function as sartorial symbols that allow Western designers to contemplate, if only hypothetically, the idea of a drastically different society from their own. By integrating references to the Manchu robe, *qipao*, and Mao suit

in their fashions, designers engage in a romantic Orientalism that emphasizes the ludic role of dress as a performative act–a means of self-staging through cultural plurality. By embracing the other, their clothes, like those depicted in eighteenth- and nineteenth-century Orientalist paintings, fabricate an alternative identity through a process of self-displacement. Postcolonial discourse perceives an implicit power imbalance in such Orientalist dress up, but designers' intentions often lie outside such rationalist cognition. They are driven less by the logic of politics than by that of fashion, which typically pursues an aesthetic of surfaces rather than an essence governed by cultural contextualization.

This aesthetic of surfaces forms the basis of the second category of conversations, titled "Empire of Signs" after Roland Barthes's *Empire des signes*, a 1970 treatise on semiotics inspired by a trip to Japan. Written as a volume of fragments, his brief work describes the author's meditations on a variety of signifying practices within that unique culture. Barthes finds the signs within Japan so beguiling and so satisfying that he does not feel compelled to understand their meanings. This rupture between signified and signifier forms the basis of the conversations in "Empire of Signs," which are grouped under the headings "Enigmatic Bodies," "Enigmatic Spaces," and "Enigmatic Objects." Like Barthes, the designers who engage in dialogues with these enigmatic signifiers do not feel the need to go beyond their surfaces. As Japan was for Barthes, China for them is a country of free-floating signs (signs, after all, assume a life of their own once they are released into the world). In the world of fashion, China is a land in which postmodernity finds its natural expression.

Several artifacts featured in "Enigmatic Objects" reflect multiple meanderings of Orientalist influence between East and West. Perhaps the most compelling are the examples of blue-and-white porcelain. Developed in Jingdezhen, China, during the Yuan dynasty (1271-1368), blue-and-white porcelain was exported to Europe as early as the

sixteenth century. As its popularity increased in the seventeenth and eighteenth centuries in tandem with a growing taste for chinoiserie, potters in the Netherlands (Delft), Germany (Meissen), and England (Worcester) began to produce their own imitations. One of the most familiar examples is the Willow pattern, which typically depicts a landscape centered on a willow tree flanked by a large pagoda and a small bridge with three figures carrying various accoutrements. Made famous by the English potter Thomas Minton, founder of Thomas Minton & Sons in Stoke-on-Trent, Stafford-shire, it was eventually mass-produced in Europe using the process of transfer printing. With the popularity of Willow pattern porcelain, Chinese craftsmen began to produce their own hand-painted versions for export overseas. Thus, a design that came to be seen as typically Chinese was actually the product of various cultural exchanges between the East and West.

At the start of *Empire of Signs*, Barthes cautions his readers that the country he has written about is not the "real" or "actual" Japan, but rather a fictive nation of his own devising (possibly the reason why the word "Japan" does not appear in the title). In this sense, his book belongs to the same genre as Jonathan Swift's *Gulliver's Travels* (1726), Voltaire's *Candide, ou l'Optimisme* (1759), and, as Barthes himself indicates, Henri Michaux's *Voyage en Grande Garabagne* (1936). Indeed, at no point during his travels does Barthes relinquish his status as a tourist—he remains a foreigner, in every sense of the word. Likewise, the designers featured in this catalogue are travelers to another country, reflecting on its artistic and cultural traditions as an exoticized extension of their own. Their China is one of their own making: mythical, fictional, and fantastical, it exists only in their minds. Whether quoting Chinese artifacts or costumes, these designers are not seeking to reproduce them as literal copies or accurate facsimiles. Rather, they aim to trans-form and reinterpret them through seemingly para-doxical postmodern constructions. Their China

combines and conflates incongruent stylistic allusions—made all the more potent by the fact that each reference is recognizable rather than blurred through synthesis—into an incredible and wondrous pastiche. This polyglot bazaar of anachronistic juxtapositions is melded together with an almost hallucinatory logic.

*China: Through the Looking Glass* is not about China per se but about a China that exists as a collective fantasy. It is about cultural interaction, the circuits of exchange through which certain im-ages and objects have migrated across geographic boundaries. This publication points to the aesthetic importance of exploring all the products of our cultural fantasies. Rather than censor or disregard depictions of cultural others that are not wholly accurate, it advocates studying these representa-tions on their own terms, appreciating them from the outset as having been infused with imagination and discovering in this complex dialogue of elided or transfigured meanings, a unified language of shared signs.

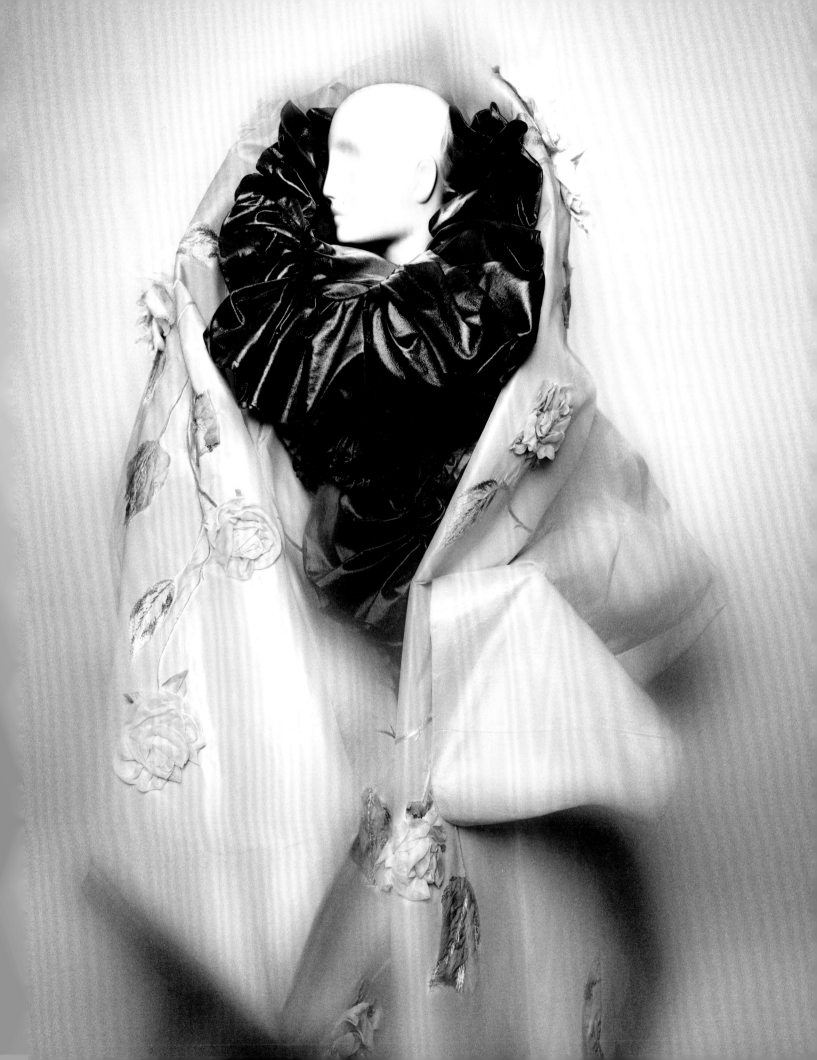

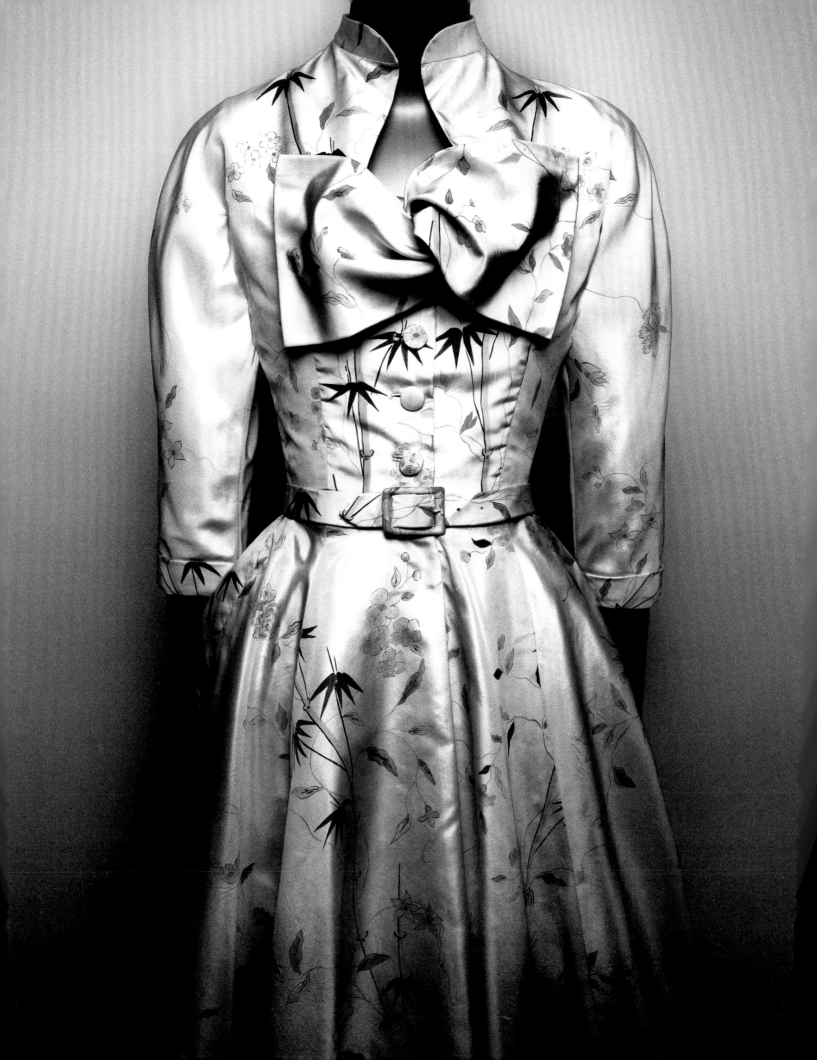

# A Chamber of Whispers

Adam Geczy

The jewelled steps are already
quite white with dew,
It is so late that the dew soaks
my gauze stockings,
And I let down the crystal curtain
And watch the moon through
the clear autumn.

—Rihaku, "The Jewel Stairs' Grievance,"
translated by Ezra Pound

玉階怨 李白

玉階生白露
夜久侵羅襪
却下水晶簾
玲瓏望秋月

Perhaps the most fitting way to illustrate the innumerable convolutions and evolutions of the role of Chinese aesthetic and cultural influence on the West is with an anomaly. When Ezra Pound released his booklet of translations of Chinese poems, *Cathay*, in 1915, its critical reception was decidedly positive. T. S. Eliot, William Carlos Williams, and a number of other eminences were warm if not effusive in their admiration. But Pound was not a Sinologist, and when he had started on his adventure in Chinese poetry a little while earlier, he had known not a word of Chinese. Critics and linguists, then and now, agree that it was Pound's own intuitive genius coupled with this very ignorance that under-scored the poems' success.

    Pound's choice of title was also wisely reflexive of the blending of ambition and shortcoming, since Cathay had come to mean a Western vision of China. Cathay, a term originating from around the tenth century, had been modernized to China, so its invocation was deliberately evocative and figurative, preempting how the poems mix sug-gestion and interpolation with fact. Hence, too, Pound's caveat in the subtitle on the cover: "For the most part from the Chinese of Rihaku, from the notes of the late Ernest Fenollosa, and the decipherings of the Professors Mori and Ariga."[1] This is quite an intellectual itinerary, beginning

---

1. Pound's translations are, in fact, doubly removed from their source, based as they are on the work of Japanese, rather than Chinese, scholars. "Rihaku" is a romani-zation of the Japanese pronunciation of Li Bai, the eighth-century Chinese poet.

with the doubt-inducing "for the most part." The genesis of these poems was therefore from a multiple remove, since the notes from Fenollosa, which Pound relied on heavily, were already at one remove, mediated from the Japanese, and at many points inaccurate. In one instance ("River Song") Pound conflated two poems into one.[2] Examples such as these are conveniently omitted in the more indignant critical analyses of Orientalism as something exploitatively molded by Western eyes. To be sure, Pound's was one of countless examples of enthrallment to exoticism, but the results are salutary, and salutary by dint of infidelity and invention. And it is the very notion of invention that is operative here. Mendacity, when used to creative purpose, has the tendency to afford new images and insights, qualities that the Orient was and still is apt to plunder. To address the multiple meanderings of Orientalist influence, where there is more than one thread and the threads are seldom straight, I have coined the term "transorientalism."[3] It is a more serviceable term that, while admitting of ethical aspects of cultural appropriation, also supports the undeniable circumstances of exchange, retranslation, and re-envisioning embedded in the Orientalist idea, and a dynamic that still today shows no signs of abating.

Since the publication of Edward W. Said's now-classic work *Orientalism* (1978), the term "Orientalism" would henceforth carry the shadow of the worst aspects of Western imperialism. Said's observations were forceful and gave pause: Orientalism was not only a reflection of Western domination but an important dimension of the very means of domination, instilling a mind-set that was debilitating to the countries it set out to stereotype. To be sure, the Orient was and still is a highly mobile, nebulous concept, signifying the people, geography, and culture of North Africa, the Middle East, and the rest of Asia, including Southeast Asia and Polynesia. The sheer breadth of cultures that it encompasses suggests that an overarching idea is highly moot or, alternatively, that the idea is more of a rubric for a tendency of relegation to the realm of the generic

other. Said's thesis occurred on the wave of other forms of political-theoretical revisionism, including feminism. It was a necessary corrective but, as successive scholars have argued, altogether too limiting, beginning with the fact that its evidence is drawn almost entirely from travelogues of prominent nineteenth-century French authors such as Gérard de Nerval and Gustave Flaubert. Said would temper slightly his critique in *Culture and Imperialism* (1993) but would maintain that Orientalism was a jaundiced by-product of Western imperialism, ensuring that the "imperial burden" of civilization was a legitimate and still presiding issue. While causing the West to consider itself in a more skeptical and self-critical light, the short-term effect of Said's theories was one of paralysis, contributing as it did to the pall of postcolonial guilt. Take for instance the expression "Chinese whispers," the British term for the game of telephone, which would subsequently be seen as tainted and therefore deleted from the speech of the earnest and politically correct. But while an expression as arguably innocuous as this continues to be haunted by reservation, others more noxious, such as "Indian giver," have come to be more widely expunged, and thankfully so.

Said, with his Palestinian background, did not spare much space for China. Retrospectively speaking, this is perhaps a bigger oversight than it was taken for. Furthermore, as Said was a literary theorist, his main touchstones were not the decorative arts or clothing. But had he been in the position to do so, he might have destabilized what appeared at first to be a fairly watertight theoretical edifice.

---

2. For his "Jewel Stairs" translation and subtitle, see Ezra Pound, *Poems and Translations*, edited by Richard Sieburth ([New York]: The Library of America, 2003), pp. 252, 247. For "River Song" see Ming Xie, "Pound as Translator," in *The Cambridge Companion to Ezra Pound*, edited by Ira B. Nadel (Cambridge and New York: Cambridge University Press, 1999), pp. 209–10.

3. Adam Geczy, *Fashion and Orientalism: Dress, Textiles and Culture from the 17th to the 21st Century* (London and New York: Bloomsbury Academic, 2013).

Indeed, it is one of the goals of this exhibition and accompanying volume to show that appropriation, especially when it comes to China, was seldom a one-sided affair. Hugh Honour, in his 1961 book, *Chinoiserie: The Vision of Cathay*, was the first to sketch out the legacy of centuries of chinoiserie for the modern era. The suffix "-erie" in French is similar to the English "-izing," as in "medievalizing," a stylistic bent, taste, or look with an accepted retinue of signifiers that has become unmoored from any point of origin. Crucially, chinoiserie was related to China but far from limited to it, much as how, today, many foreign souvenirs signifying national specificity are made there. Although full of surprises, Honour was writing before the period of cultural theory that Said helped to shape, and his book does reveal the extent to which chinoiserie in its heyday of the late seventeenth to eighteenth century was a site for fantasy. For China, or Cathay, was in truth the sine qua non of Orientalism: a dramatic mixture of facts and fantasies that was actively grasped and exploited by the Chinese themselves. Nor can the Europe of the sixteenth to seventeenth century—at the dawn of its imperialist march, and when chinoiserie first appeared—be seen to occupy any position of domination, manipulation, or cultural condescension. Rather, chinoiserie was born of the fascination and knowledge that there was a culture out there that was not "primitive" but had systems, languages, rules, and images markedly foreign to Europe. In the sixteenth century this realization was analogous to our contemporary science fiction conceits about life on Mars.

An important episode in the genesis of the popularity of chinoiserie helps to illustrate this point. In 1686 the French king Louis XIV received a delegation of ambassadors from Siam, now Thailand. France at the time was experiencing considerable isolation from the rest of Europe and was looking farther afield for new allegiances and affiliations. While to some extent *la siamoise*, a light striped cotton or linen garment, thereafter became a short-lived fashion in France, the longer-term effect was to entrench chinoiserie more deeply into the French cultural imagination. But in this case it was not China that had done this but the smaller state of Siam. What is more, in order to celebrate the occasion of the ambassadors' visit, the king had himself dressed up in costume that was "half Persian, half Chinese" (*moitié à la persienne, moitié à la chinoise*). One culture was not enough, and here we have an aesthetic staging of three. The event was the first of a continuing series of sumptuous balls *à la chinoise* involving numerous players, including the king and his princes.[4]

Chinoiserie undoubtedly offered the aesthetic opportunity to play. Yet it is also worth remembering that, against all the accusations of inauthenticity (borrowing, bowdlerizing, stealing, and modifying), dressing up furnished a means for expression that allowed one to do things that would have been difficult to justify in everyday life—through such voluntary deceits one could become more of oneself. The association with play and the expressive potential of the exotic that permeated chinoiserie gave birth to all kinds of objects, from furniture to smaller objects that could be worn as souvenirs, talismans, or trophies, in such magnitude that it became harder and harder to tell whether they originated in China or in Europe. This stylistic thirst for chinoiserie, the cult of Cathay in France, was given the new name of *lachinage*—literally, "Chinese-ing" or "Chinese-ifying" (*la Chîne-age*). It was a tendency in fashion and the decorative arts whose equivalent had already come into place in music. Just as Bach riffed on Vivaldi or as Mozart would later riff on Turkish themes, the decorative arts of the late seventeenth and early eighteenth centuries riffed heavily on "China."

---

4. See Hugh Honour, *Chinoiserie: The Vision of Cathay* (London: John Murray, 1961), pp. 62–63, and Dawn Jacobson, *Chinoiserie* (London: Phaidon Press, 1993), p. 31.

The example of Louis's many chinoiserie masques and balls also serves to introduce the much-overlooked connection of chinoiserie with the Mannerist invention of role-play in the commedia dell'arte, which first emerged in mid-sixteenth-century Italy. Since antiquity people have dressed up for both ritual and play, and the commedia marks a significant nodal point in the way in which certain generic types were used and observed as a theatrical language, in which each character type became the site for a specific but still variable form of expression. Early modernity, and hence the period of chinoiserie's evolution and explosion, was preoccupied with matters of personality and, with that, otherness. (There are several instances of plays from the late seventeenth century that feature harlequins in Oriental dress, including one as "a Chinese doctor."[5]) One of the tools of self-reflection was to explore new mechanisms of expression, which also meant new cultures. The latter had the salutary potential of affording a parallax view of the world and offering surprising alternative insights. Chinoiserie was therefore an important lens for such insights, irrespective of whether it was manufactured locally or abroad. While generic (like the characters of the commedia), its decorative armature allowed for endless new forms. Indeed, it was the very presence of something that was not seen to be directly inherited, and which seemed to be owned by no one in particular, that permitted so much scope and potential.

It is precisely the recognition of these complexities that has allowed cultural theorists to reclaim the term "Orientalism," accepting that it is a far more nuanced notion with more than one level of complicity, especially in the sense that the East (used here simply as a term of convenience to denote that which is not the West) was an avid consumer of its own cultural values, from customs to fashions to food, many of which had undergone several degrees of modification. "Exchange" has come to replace "domination" in contemporary discourse, as it more accurately reflects the manner of retranslation that occurred, and that the movement of East to West or vice versa was not bilateral but rather one of irregular but constant oscillation. Tell a Hungarian that the national culinary ingredient paprika came from Mexico, or someone Dutch that tulips came from China, or a denizen of Provence or Italy that tomatoes derive from the Andes of South America and you may be met with surprise or even indignation. While the saffron in paella does not come from Granada, the Indian food in Western restaurants is an adaptation funneled from Indian migrants to Britain. But these examples serve as more than good table talk, for if we stop to ponder them, we learn that they are tangible examples of the multilayered ways in which cultural identity is constructed.

Fashion and dress are arguably the best locus for approaching this notion. "Fashion" is used here as an umbrella term that encompasses all elements of bodily appearance, including accoutrements such as jewelry, tattoos, and hairstyles. Critically, fashion is the means by which we convey identity and belonging (including nonbelonging). And fashion shows us the extent to which such belonging is as materially real as it is imaginary. A compelling example is the fate of the fez in Turkey. Also known as the *subara*, the fez originated in North Africa and was adopted, with some resistance, as standard military headdress in 1828. In subsequent decades (1839–76), Turkey underwent reforms known as the Tanzimat, or "reorganization," that were devoted to lifting society and the economy to a level on par with the more prosperous Western Europe. The fez's sartorial culmination was in the Kemalist reforms that followed in the early twentieth century, whereupon in 1924 it was summarily outlawed. Introduced some hundred years earlier, its lawful suppression met with highly emotive resistance, to the extent that

5. See Geczy, *Fashion and Orientalism*, p. 38.

many male Turks expressed a kind of national emasculation. In less than a century, the fez had gone from an imposition to a borderline national prosthesis. Hence something of highly symbolic worth that was seen as an extension of geographic, cultural, and historical fealty was actually something with a rather short history.

Four decades after the fez officially landed on the heads of Turkish troops and civilians, the Japanese opened their doors to the world. The Meiji era (1868–1912) was also one of dramatic cultural reform. It redressed what was perceived to be the stagnant Edo period (1615–1868), which had seen Japan left behind by the West's industrial onward march. The West enjoyed a foretaste of Japanese art and culture when a few pieces were exhibited in the Chinese pavilion at Prince Albert's Crystal Palace Exhibition in London in 1851, garnering the lion's share of attention. One of the cultural hallmarks of this transition was the kimono, seen by many as the quintessential item of Japanese dress. Yet like the Scottish kilt, it is a nineteenth-century conception that nonetheless, to quote Anne Hollander, "invokes remote times."[6] Pre-Meiji dress had been fairly consistent for centuries, comprising several neutrally colored outer garments concealing a motley silk inner garment that accented the collar area. Whereas clothing had long been relatively gender neutral, the colored inner garment became used on its own and worn by women, while men came to wear suits of Western manner and taste. In what can be called a cultural marketing campaign strategy, Japan had re-Orientalized itself from within by accenting what was most discernible while ensuring that those who consorted with those outside themselves were attired in a way that guaranteed their mobility. Japan thereby customized its cultural aesthetic for Western consumption. But today it has internalized this change such that, if you visit historic sites such as those in Yokohama or Kyoto, you might witness casually clad Japanese photographing themselves next to fully dolled-up geishas.[7]

These are two examples of cultural implementation; then there is cultural imbrication, or folding, exemplified by the Tree of Life pattern, which became popular in the mid-seventeenth century. In Tudor England (1485–1603) came the invention of "China fashion," which came to mean all manner of floral textile patterns. These designs, which were indelibly associated with chintz, began in England but were printed in India and were subsequently modified by Indian textile craftsmen by dint of their own inherited visual vocabulary. Working from the demands of the English, one more Indian visual idiom with widespread popularity was the Tree of Life, which later became popular with the Chinese, who in the eighteenth century began producing versions of their own. To recapitulate: "Chinese" designs invented in England were then reformulated in India to be taken up later by the Chinese. Amusing but true, this case is a more accurate illustration of how Orientalism is "made up," in both senses of the phrase. To search for an origin is to find a room of mirrors—or, perhaps better, a room of whispers, since the indeterminacy of the sound allows for further invention, much as Indian textile designers have done with designs developed out of the Scottish town of Paisley, themselves plunderers of the *buta*, the lesser-known word for the famous motif.

This dynamic of mirrors and whispers—a continual process of intervention involving appropriation, reclaiming, and reshaping—is fundamental to understanding transorientalism. The notion has three facets or tiers. The first is the ways in which the East has engaged in its own Orientalizing and re-Orientalizing. At the simplest level this can relate to the organization of its economy for the sake of

---

6. Anne Hollander, "Kimono," in *Feeding the Eye: Essays* (New York: Farrar, Straus and Giroux, 1999), p. 129.

7. For visual examples of this, see Geczy, *Fashion and Orientalism*, p. 129.

Western trade. Chinese fans, which rose in popularity in the seventeenth century, were produced following models developed in Europe, both in the choice and style of chinoiserie ornament and in the kind of fan itself. The *brisé*, or folding, fan that is now so intimately associated with China is, in fact, an import, introduced from Japan in the twelfth century and competing for popularity with the indigenous flat variety. Another example is the way in which contemporary Chinese fashions have revived the cheongsam, the narrow silk dress, into something carrying national substance, although its origin can be localized to 1920s Shanghai. Given the nature of global markets, the need to assert difference, as well as the industry of tourism, these examples are far from anathema; on the contrary, they are entirely understandable, much as Romania has turned Bran Castle into a Dracula theme park, despite Vlad the Impaler, on whom Dracula is based, having spent only a short time there. The assertion of cultural authenticity is therefore as much in the interests of market share as it is an expression of belief in one's own cultural authenticity. Yet we have already seen that this authenticity is built on many foundations, most of which are constructed, imagined, and stitched together. What begins as fiction and illusion transmutes magically into substance, thanks to a combination of conviction and expediency.

The second aspect of transorientalism is the bleakly sobering working conditions in various parts of the former Orient. From Bangladeshis working in dangerous sweatshops to laborers manufacturing electronics who are made to sign contracts that they will not commit suicide, from the armies of workers in Chinese provinces kept from documentary view to immigrants in Dubai living in what is effectively enforced slavery, these are the unspoken millions for whom Orientalism or any of its offshoots is not of much interest. There is no narrative for such people, no space for pause to worry about the correct political claims of a word, a motif, a style, or an image. But if we step away from this vantage point it is hard not to see that all Orientalist roads begin and end in China. In the seventeenth century China was a figural construct for that which was not Europe, a curious and barely reachable place on the outskirts of a known reality. Today, with textiles one of the bulwarks of its colossal economy, China is again feared, not only for its economy but also once more for the implacability of its government.

The final component of transorientalism is the freewheeling nature of Orientalist styling, found predominantly in fashion. This category applies to the intentional organization of Orientalist signs around a garment or collection, the first instance of which was probably Paul Poiret's 1911 collection, staged around a "Thousand and Second Night" party at which he himself dressed up as the Ottoman sultan Süleyman the Magnificent. Poiret's collection was eventful for several reasons. The first was the way in which it exemplified what the fashion industry today euphemistically calls "inspiration": his hooped skirts and harem pants evinced no interest or need in replication; rather, they were variations on a theme, an emulation of a style. Put differently, they were inventions based on something imagined. Their connection to "fact" was important, but just as important was the looseness of this connection. By contrast, Orientalist styling in the nineteenth century had been as either tropes or accents—wearing a Turkish sword or a chinoiserie-style gilet (vest)— or were vaunted for their authenticity (and by now the reader will observe the liberal and relative use of this word), as in the cashmere shawl. In effect, Poiret had taken the extravagance of chinoiserie styling and brought it to an ensemble, only this time with an Ottoman flavor. For with chinoiserie, as the Metropolitan's exhibition amply demonstrates, ideology was left at the door; there was no truth to form, only the space for experimentation and visual conceit. And as numerous textiles and artifacts show us, the Chinese for their part were happy to take up where their Western counterparts left off, visibly flattered and enthused by the level of interest. Today, as any inhabitant of Hong Kong will tell you, China is the biggest consumer of Western fashion—most

of which is made in China—with visitors from the mainland queuing in vast numbers outside the stores of name houses such as Armani and Miu Miu to get their latest chic fix.

Is this mode of transorientalism insulated from critique? To begin with, we have to admit that wearing a shirt or dress covered in paisley (probably made in China) is not going to incite criticism over cultural insensitivities. Unlike art, in which cultural proprieties are still to some degree extant, in fashion they are next to absent. Quarrels and anxieties over the burqa and hijab do not apply here, for the reason that, in Islam, they are not styles of dress but seamless with belief, essential to one's religious being, and it is because they do not share this religious conviction that non-Muslims see it as trespassing on their own ways of life. In their essay for the catalogue to "China Chic," a 1999 exhibition inspired by Britain's relinquishing control of Hong Kong to China in 1997, Valerie Steele and John S. Major openly acknowledge that cultural purloining is not without its ethical risks and pitfalls, but they also warn against assuming a clash between anthropology and politics on the one hand and fashion on the other, because, quite plainly, fashion designers are neither theorists in the conventional sense nor anthropologists.[8] The history of fashion and dress is a history of all imaginable forms of borrowing and reshaping. With globalization's pressure to normalize, standardize, and unify, the need to reimagine cultural identity is as exigent as ever.

In a recent book, the philosopher and cultural theorist Slavoj Žižek explains how national revivals in various countries that have been subject to colonial oppression (and China, while never fully colonized, was subject to it by more than just Europe) have nothing to do with the actual past. His own point of reference is India:

> Of course there was something before the loss—in the case of India, a vast and complex tradition—but this lost tradition was a heterogeneous mess that has nothing to do with that to which the later national revival wants to return. This holds for all "return to origins": when, from the nineteenth century onwards, new nation states were popping up in Central and Eastern Europe, their return to "old ethnic roots" generated these very same roots, producing what the Marxist historian Eric Hobsbawm calls "invented traditions."[9]

This is not to say that these traditions, including re-Orientalizing revivals, are to be ridiculed. For although these Orientalisms might be invented, they are not counterfeit. Rather, they persist in order to secure anchorage in place and society. What chinoiserie demonstrates is the extent to which cultural identity is made up and, further, that what is made up can have a more lasting resonance and a more fitting bearing on the sustenance of a secure existence than a series of brute and perhaps lackluster truths.

This brings us full circle or, should we say, full tangle to Pound as a translator of Chinese. His are still commonly counted among the most visionary translations of Chinese poetry into English, owing to the high level of license that Pound gave himself. Unbridled by dogma, he allowed himself to invent. But it is thanks to these ingenious and audacious inventions that the door of some unspoken Chinese essence is left ajar to Anglophone readers, who are able to experience something deliciously outside themselves, as something whispered from afar.

---

8. Valerie Steele and John S. Major, *China Chic, East Meets West* (New Haven and London: Yale University Press, 1999), p. 70.

9. Slavoj Žižek, *Event: A Philosophical Journey through a Concept* (Brooklyn and London: Melville House, 2014), p. 44.

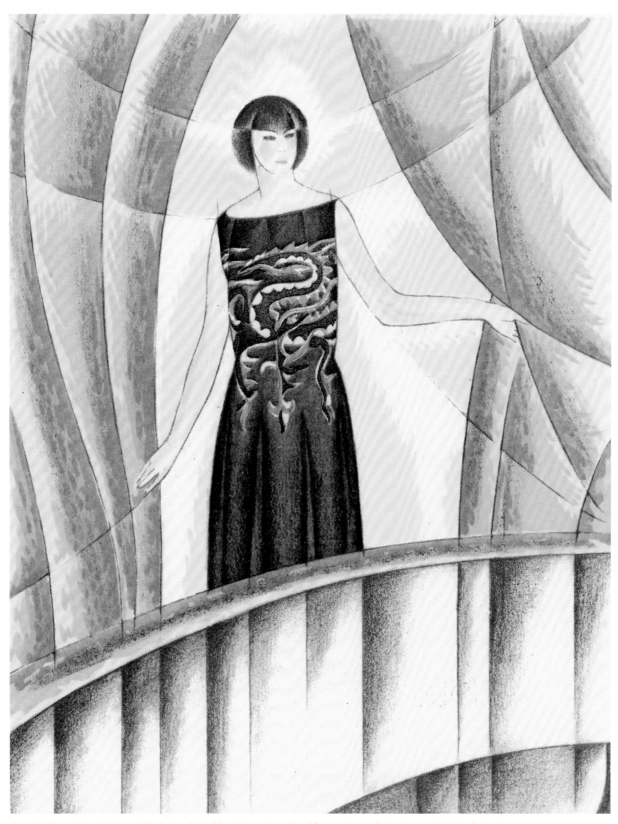

Thayaht (Italian, 1893–1959). *Une Robe du Soir, de Madeleine Vionnet.* Reproduced from *La Gazette du Bon Ton*, no. 1 (1923), pl. 47. The Irene Lewisohn Costume Reference Library, The Costume Institute, The Metropolitan Museum of Art

# Fashioning China

## Harold Koda

Samuel Taylor Coleridge's 1797 poem "Kublai Khan"—said to have been inspired by an opiate-induced dream Coleridge had after reading Samuel Purchas's description of Xanadu in *Purchas his Pilgrimes* (1625)—conjures aspects of China ostensibly based on the testimony of visitors who had penetrated its metaphorical wall. But the eyewitness accounts of the "real" China upon which Coleridge and others relied were as riddled with myths and inaccuracies as if the reporters had set out to tell stories or fables, so freighted were they by cultural bias. Purchas's account of China, like that of Marco Polo before him, infused facts and half-truths with rich and fantastical embellishment. In the West, the perception of China for centuries was—and perhaps still is—wrapped in imagination and invention. China itself has perpetuated some of that misty misperception, as exemplified by the insinuation of Western tastes (and Chinese assumptions about those tastes) into Chinese products made for export. The relationship between source and consumer is complex and nuanced, with the manufacturer determining for the export market a body of imagery often simplified, sometimes to the level of intracultural inauthenticity, but invariably retaining a salable exoticism and Chinese-ness.

Throughout the history of Sino-European trade, China's elusiveness—its physical remove and the empire's deliberate isolation—contributed to the potency in the West of its symbols and signs. When the Ming court of the Jiajing emperor (reigned 1521–67) reestablished trade agreements with the Portuguese in Macau in the mid-sixteenth century, porcelains and silk, among other exports, began to flow with vigor. The rarity of the goods, combined with the fragmented information about the country that produced them, contributed to the image of China as a land of riches enveloped in mystery and fantasy.

A boy's cape of Chinese velvet from that period survives in the collections of The Costume Institute (06.941). Scholars have suggested that it might have been worn by a page in the court of the French king Henry III (reigned 1574-89). The velvet—a burnt orange silk pile on a supporting ground of gold-wrapped red-orange silk threads (typical of Chinese textiles)—has been deployed, as are many textiles of exceptional value, in a garment that required only the most minimal cutting and shaping. It would have been sufficiently rare to befit a child of noble, even royal, birth; when the Museum acquired it, the piece was thought to have belonged to the young Louis XIV, almost a century later. It is The Costume Institute's

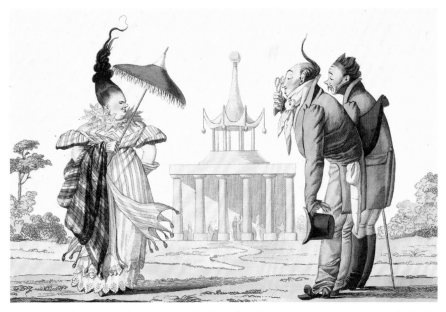

Fig. 1. *Le Goût du Jour ou Des Chinois du Boulevard Coblentz*, from *Caricatures Parisiennes*, ca. 1815. Hand-colored etching, 6 ⅛ x 9 ⅜ in. (15.5 x 23.7 cm). The Metropolitan Museum of Art, The Elisha Whittelsey Collection, The Elisha Whittelsey Fund, 1971 (1971.564.121)

earliest example of the incorporation of a Chinese textile into Western dress.

The use of costly imported textiles in Western attire continued to serve as chinoiserie's aesthetic point of entry for almost two hundred years, as can be seen in a British at-home gown from the 1850s (see page 205). Large pagoda sleeves, a fitted bodice, and a huge bell-shaped skirt form a dress of remarkable simplicity. The only ornament is in the subtle woven patterning of large roundels depicting writhing dragons on a sumptuous maroon silk satin ground. As with the sixteenth-century cape, the splendor of the gown resides exclusively in the silk and the clearly asserted signs of its distant origins in China. In these two examples, the textile types and patterns are not very different from what might have appealed to the native Chinese market, but applied to Western dress they transmit global reach and imperial, if not colonial, power.

A more complicated give-and-take between China and its Western markets can be seen in The Costume Institute's eighteenth-century gowns of hand-painted silk. Some of the silks are done in patterns expressly appealing to the export market; one example is in a stripe and sprig pattern that deliberately emulates a French style (C.I.54.70 a, b). Here is a design that originated in France, was copied in China, and was then exported back to France with the added luster of its status as a rarefied import. Also, because such silks were of such great expense, they were reproduced in the West, much as Scottish and French mills replicated Indian shawls in the nineteenth century. One Costume Institute example that was once believed to be of Chinese manufacture is indistinguishable from the Chinese textile designs it mimics; only recent technical analysis has revealed its European origins (see page 165).

The West began rapidly assimilating Chinese imagery in the eighteenth century–but, as in Coleridge's poem, the images were of questionable authenticity. Sometimes the designs and patterns were developed by the Chinese with modifications

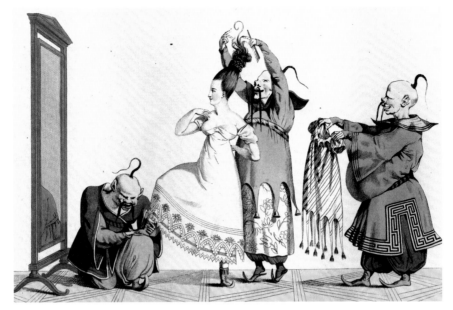

Fig. 2. *La Toilette Chinoise*, from *Le Bon Genre*, December 1813, pl. 63. Hand-colored etching, 8 x 10 ¾ in. (20.2 x 27.1 cm). The British Museum, 1866

for European tastes, as was the case with the painted silks. In other instances, European manufacturers incorporated symbols, sometimes garbled, from inaccurate or completely fictive images and descriptions of China. An elaborately brocaded court gown, a *robe à la française*, conforms to the most lavish standards of eighteenth-century dress; its exoticizing motif, a small, fragmented landscape of palm tree and pagoda, cites the contemporary taste for chinoiserie in the decorative arts, thereby establishing the wearer's refinement and modishness (see page 217). But the motif arguably conflates the Middle East with the Far East.

While costly trade goods with fantastical imagery continued to make their way to European and American markets in the early nineteenth century, the embrace of Neoclassicism, with its references to Greco-Roman antiquities, suppressed much of the exoticism that had characterized eighteenth-century taste. But even at the height of classical "naturalism," the seductive otherness of Chinese effects persisted

in small decorative details and accessories. No longer was chinoiserie restricted to an imported textile or a pattern; allusions to China were now incorporated into the garments' very design. The pointed, inverted scallop of a hem and parasols with the swoop of pagoda rooflines were considered charming manifestations of Chinese aesthetics—and were sufficiently faddish to have been the subject of satirical prints of the day (figs. 1, 2).

Prior to the nineteenth century, China and, to almost equal extent, the Ottoman Empire had been the leading sources for Orientalizing effects. By the mid-nineteenth century, the establishment of trade between Japan and the West eroded China's primacy as a repository of Far Eastern symbols and imagery. Fashion scholars have even argued that the Japanese kimono was crucial to the evolution of late nineteenth-century corseted silhouettes into the softly draped columnar forms of the early twentieth century. But while the novelty of things Japanese may have dimmed chinoiserie's allure, images from both cultures were

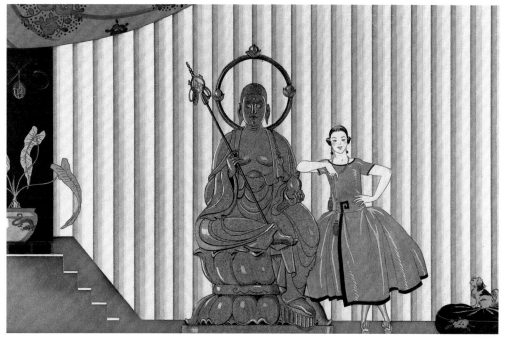

Fig. 3. George Barbier (French, 1882–1932). *Mademoiselle Spinelly chez elle*, from *Le Bonheur du jour; ou, Les graces à la mode*, 1924. Pochoir, 12 ⅝ × 17 ¾ in. (32 × 45 cm). The Metropolitan Museum of Art, The Irene Lewisohn Costume Reference Library, Special Collections, Purchase, Paul D. Schurgot Foundation Fund, 2002 (2002.10o)

often combined and juxtaposed in architecture and the decorative arts; the distinctions were further blurred by Japanese exports, especially porcelains and embroidered textiles, that mimicked Chinese prototypes.

Chinoiserie enjoyed a resurgence after 1900, a fad excited in part by well-publicized archaeological excavations of the Mogao Caves in Dunhuang. The renewed interest, which followed the suppression of Chinese nationalist initiatives and the assertion of power by allied Japanese and European states during the Boxer Uprising, may be understood in the context of an increasing imbalance of political might. While China had been a powerful, if imprecise, fantasy to the West in the seventeenth and eighteenth centuries, its cultural status had since waned; the Industrial Revolution had accelerated an economic, social, and cultural progressiveness that appeared to bypass it. China was increasingly subjected to pejorative stereo-

types and pernicious condescension, although fashion continued to incorporate Chinese sartorial signs in the most modish designs.

Nevertheless, in 1903 the designer Paul Poiret, then at the venerable but conservative couturier House of Worth, lost his job after introducing a dramatic, Chinese-inflected design: his "Confucius" coat, which had a capacious, silhouette-obliterating kimono cut. Poiret, with his pioneering interest in the exotic, would refer to Chinese decorative imagery throughout his career. A later permutation of the coat is embellished with embroidered Chinese shou symbols and incorporates in its tiny collar a piece of authentic kesi cloth from a Manchu robe (see vellum facing page 156). Poiret's 1920s day dresses with mandarin-collared, asymmetrically closing tunics over narrowly pleated skirts were explicitly *à la chinoise*. The designs not only recalled formal Manchu court attire but also referred to the fashions

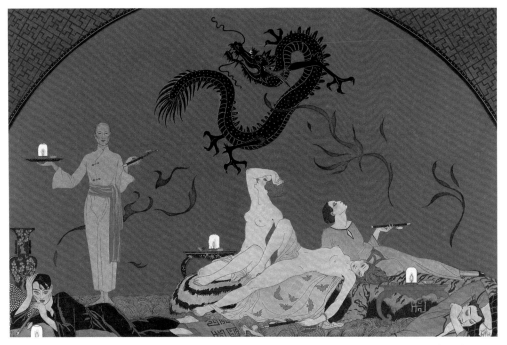

Fig. 4.  George Barbier (French, 1882–1932). *Chez la Marchande de Pavots*, from *Le Bonheur du jour; ou, Les graces à la mode*, 1924. Pochoir, 12 ⅝ × 17 ¾ in. (32 × 45 cm). The Metropolitan Museum of Art, The Irene Lewisohn Costume Reference Library, Special Collections, Purchase, Paul D. Schurgot Foundation Fund, 2002 (2002.10l)

then current in China, where women's jackets had become streamlined and less body obscuring and were paired with trousers or cropped skirts, sometimes worn over trousers. Poiret was significant in creating designs that truly assimilated Chinese ideas, including structure and cut, while infusing the garments with a decisive Parisian inflection.

Still, his fascination with China was based on an imaginative, somewhat reductive system of signs. Poiret was the first couturier to create his own collection of fragrances, a number of which were inspired by China. But his packaging and flacons for the fragrances applied an explicit, if facile, citation of Chinese exoticism, quoting imagery directly from Chinese sources; by contrast, his clothing designs tended to digest and interpret technical and structural principles from their Chinese models.

In the 1910s and 1920s, fashion illustrations by George Barbier situated contemporary gowns not necessarily of Chinese style against backdrops of lacquered tables and screens, incense burners, and Buddhist statues (fig. 3). By the 1920s, he was creating images of pure fantasy for fashion publications and limited-edition folios for the beau monde. In these tableaux, languorous opium users recline naked or dressed in pajamas (fig. 4). Barbier's androgynous decadents introduced the use of silk pant ensembles as loungewear and beach cover-ups, just as a Manchu jacket or Japanese kimono might previously have been purposed for intimate and at-home apparel. Western dress has often appropriated the costume of a perceived "other" to informal dress, exploiting the untailored fit characteristic of much regional attire for its aura of ostensibly liberating social practices. Even North African and Middle Eastern coats, with fitted bodices but expansive, flared skirts, suggested to the Western wearer a dressing gown or robe rather than a frock coat.

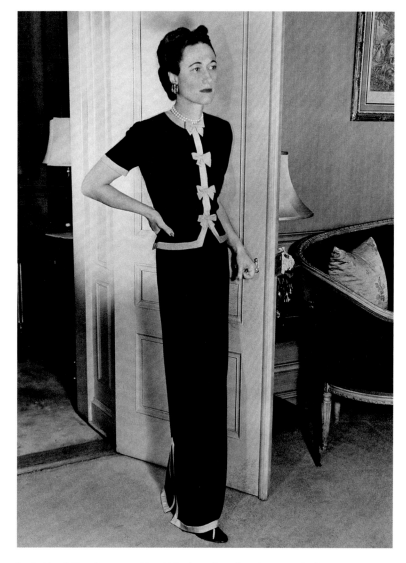

Fig. 5.  Horst P. Horst (American, 1906–1999). The Duchess of Windsor in Mainbocher, 1943. *Vogue*, July 15, 1943, p. 26

The Art Deco movement of the 1920s integrated symbols evocative of China into its aesthetic, seen especially in small accessories and the decorative arts. Calligraphy—authentic or invented—foo dogs, peonies and lotus blossoms, Buddha statues, and Guanyin figures adorned minaudières, cigarette cases, and fine jewelry. The taste for Chinese styles in the period's fashion can be seen in the designs of a number of couture houses, notably Callots Soeurs and Jeanne Lanvin. The Callots produced a series of luxuriously embroidered silk evening dresses with the scalloped patterning of Chinese cloud collars. At times the embroidery directly referenced the birds, butterflies, and floral motifs seen in Chinese export shawls, but the Callots modified the aesthetic with their vividly tinted palette of pale chartreuse, ice blue, and

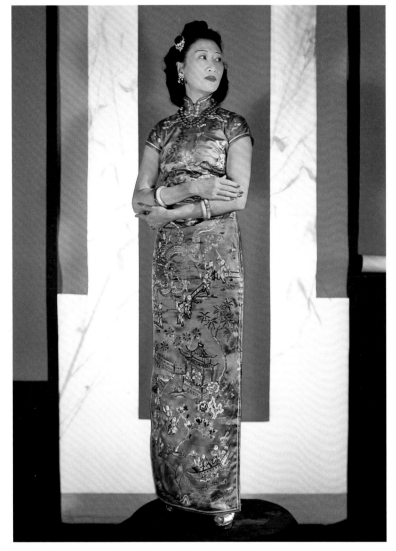

Fig. 6.   Horst P. Horst (American, 1906–1999). Mme. Wellington Koo. *Vogue*, January 1, 1943, p. 31

powder pink (see pages 84–85). Lanvin infused motifs borrowed from Chinese rank badges with a particularly French sensibility by rendering them with the couture's artisanal embroidery techniques (see pages 202–3). Lanvin continued to plumb the imagery of Chinese garments, including armor, in the following decade. Even Gabrielle "Coco" Chanel, Edward H. Molyneux, and Jean Patou, designers

known for a streamlined and unadorned modernism, were susceptible to the ornamental possibilities of Chinese graphics. They frequently incorporated reinterpretations of motifs derived from Chinese textiles into prints, appliqués, and embroideries, as did Premet, Drecoll, Worth, and other design houses.

In the mid-1930s, the American couturier Mainbocher began dressing Wallis Simpson, later the

Duchess of Windsor, who was then on the cusp of notoriety. When the society photographer Cecil Beaton first met Mrs. Simpson, he found her "brawny and raw-boned," but a year later noted in his diaries (*The Wandering Years*, published in 1961) that she had "improved in looks and chic . . . immaculate, soignée," with "hair so sleek she might have been Chinese"—an allusion not simply to her lacquered appearance but to her time spent in China, a sojourn that conjured lurid speculation that she had been schooled in the seductive mysteries of lovemaking in the East. In a number of photographs Mrs. Simpson is shown in Chinese attire, and in one notable portrait by Horst she wears a Mainbocher *qipao* in black silk crepe (fig. 5). Edging the dress in coral banding with a pale jade-green binding, the designer introduced details that evoke the Chinese style but supplanted the *qipao*'s frog closings with small French bow knots. With his deliberate synthesis of cultural and historical references, the designer transcends simple appropriation.

The *qipao* had become a sartorial signifier for China in the 1920s. As a form of postdynastic dress, it occupied the intersection of China's tradition-bound dress and a progressive embrace of international styles. Over time its silhouette evolved, referencing Western, specifically Parisian, fashion aesthetics: its columnar, body-skimming shape of the 1920s, a narrower expression of the flapper's chemise, became a contour-cleaving fit in the 1930s, similar to the haute couture's bias-cut gowns. An aristocratic version of what was considered a form of national dress was promoted in this period between the two world wars by images of Madame Chiang Kai-shek and the much-photographed style icon Huilan Koo, the wife of the influential Chinese diplomat Wellington Koo. Madame Koo, residing in London and Paris during her husband's ambassadorships, was a client of the couture, but she is most memorably depicted, whether in a Horst photograph or an Olive Pell portrait, in one of her beautifully embroidered *qipaos* (fig. 6; see vellum facing page 110).

The cinematic versions of the *qipao* took on a more vampish quality, as Hollywood traded on racially charged stereotypes of the femme fatale, personified by roles played by Anna May Wong, its first Chinese American star. Paradoxically, the trope of the dragon lady, a sexually knowing, emotionally removed, and ruthlessly ambitious woman, coexisted with an alternate fantasy of the Oriental woman's exaggerated femininity, extreme modesty, and pliant acquiescence.

The allure of Orientalist fantasy was so powerful that even Mainbocher, a designer known for such discreet elegance that his work seemed to repudiate the vulgarity of fashion trends, quietly embraced the richness of Indian saris and Chinese silks. Still, when the designer in the 1950s repurposed Manchu skirts purchased in China by Winston Guest for his wife, C.Z., he modified them into a deflated New Look silhouette, eliminating all fullness, and balanced their ornamental richness with a bodice of North Shore Establishment simplicity (see pages 106–7).

Similarly, stylistic allusions to China worked their way in the 1940s and 1950s into the sportswear of American designers known primarily for their pragmatic modernism. Carolyn Schnurer, Claire McCardell, and Bonnie Cashin began incorporating Chinese textiles, band (or mandarin) collars, frog closures instead of buttons, asymmetrical necklines, and even components derived from the prosaic work clothing of Chinese laborers. Following mainland China's Communist Revolution in 1949, the portals for the textiles and imagery were Hong Kong and Taiwan. Inexpensive *qipaos* in heavy satins and silk brocades from Hong Kong enjoyed a vogue in the West, suggestive of the stemlike, body-delineating sheaths that had emerged as an alternative to the voluminous skirts of Christian Dior's New Look.

By the 1960s, the primary trajectory of high style was toward a space-age sleekness, only to be displaced at the end of the decade by a nostalgic pastoralism and cult of the artisanal. The anti-industrial impulse and rejection of the fantasy of a

technological utopia were reflected in the vogue for a cultural collage of Indian gauze shirts, Afghan goatskin vests, Moroccan jewelry, and other components of non-Western dress. Simultaneously, military uniforms, notably surplus fatigues, were repurposed specifically for a countercultural, antiestablishment effect. Mainland China, which had attempted to erase status and hierarchy with an androgynous uniform, presented a new paradigm of Chinese dress, popularly called a Mao suit in the West. It was embraced, especially in Europe, by the left-leaning intelligentsia at a time of international political and cultural upheaval.

Although China's potency as a source of inspiration for Western fashion designers never completely faded, its most ostentatious expression was not until 1977 and Yves Saint Laurent's lavish fall/winter haute couture presentation. In a theatrical mélange of Chinese decorative elements, Saint Laurent reanimated the fantasy of the Chinese empire's sartorial splendor. As with the Russian-inspired collection he had done the year before, the designs were a fever dream of authentic, allusive, and imaginary elements. Quilted scallop patterns, pagoda shoulders, frog and tassel closures, cropped pants, and conical hats combined with cinnabar and jade jewelry to convey a sumptuous, seductive impression of Chinese style as glamorous as Barbier's 1920s fantasies (see pages 150–55). The collection coincided with the launch of Saint Laurent's fragrance "Opium," a name controversial even in the hedonistic 1970s. Its provocative engagement of racist stereotypes and social taboos illustrated contemporary fashion's marketing strategy of flirting with transgression.

Saint Laurent's Russian- and Chinese-themed collections were a turning point in the haute couture. Postmodern *avant la lettre*, fashion has always embraced narrative-laden forms. But by the 1980s, the magpie sampling of historical and cultural sartorial codes had become the creative strategy of a number of influential design houses; the practice would spread in the following decades. The earliest, most basic form of chinoiserie—incorporating Chinese textiles into Western garments—reappeared. Ornamental patterns derived from Chinese embroidered and brocaded silks, often of motifs associated with the Manchu court, were again copied directly or manipulated subtly and transposed onto printed fabrics. Export shawls, with their bold floral embroideries, deep fringes, and varied palette, inspired gowns in both the haute couture and avant-garde ready-to-wear. Designers as diverse as Raf Simons and Martin Margiela adapted elements of traditional Chinese dress much as Mainbocher had recut Manchu skirts (see page 256). References to the decorative arts, especially blue-and-white porcelains, cloisonné, and cinnabar and other lacquerware, were seen not only in the haute couture houses, notably Chanel and Valentino, but also in ready-to-wear collections. Citations of the *qipao*, Anna May Wong's film costumes, and the Mao suit expanded the familiar repertoire of codified allusions to China.

The invention of exuberant new silhouettes and ahistorical draping constructions with Chinese iconography—as seen in the work of John Galliano, Craig Green, and Alexander McQueen—suggests the creative liberty unleashed by an imprecisely known "other." The China expressed in the designs of the late twentieth century was as ever a response to ideas aggregated over centuries through trade and diplomatic exchange, mythmaking and illusion. More recently, however, citations of the imperial dynastic past have appeared in the collections of contemporary Chinese designers. The use of the same exported and codified motifs and styles by fashion houses in both China and the West suggests the evolution of a postmodern chinoiserie without borders. Paradoxically, chinoiserie's prescribed and relatively limited aesthetic vocabulary, whether exploited by the Chinese or the non-Chinese, is directly related to its communicative power. It is because of the omissions and elisions in its system of reductive signs that fashion so compellingly conveys China's unwieldy and complex reality.

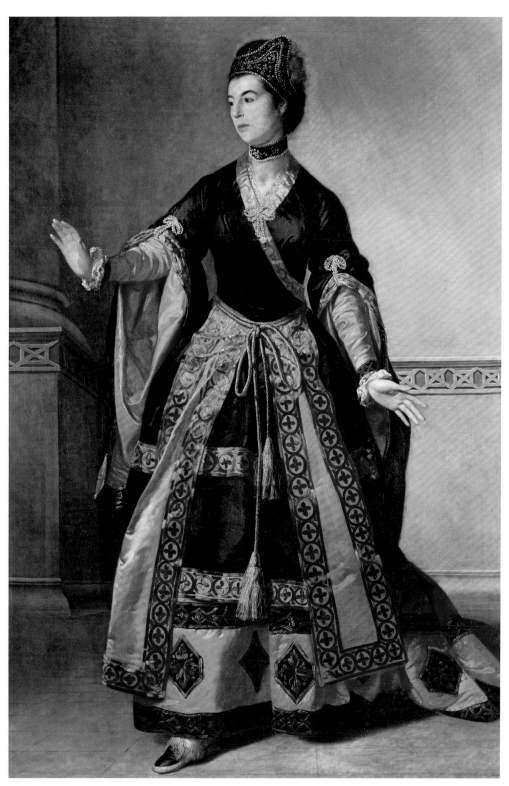

Tilly Kettle (British, ca. 1735–1786). *Mrs Yates as Mandane in "The Orphan of China,"* ca. 1765. Oil on canvas, 75¾ x 51 in. (192.4 x 129.5 cm). Tate Britain, London, Purchased with assistance from the Friends of the Tate Gallery 1982

# Imagery of Chinese Dress

## Mei Mei Rado

Conjuring mysterious lands and bygone eras, the notion of traditional Chinese dress has long ignited the imagination in the West and enchanted modern China. Yet the designation "Chinese" and the styles of clothing that tend to bear this label are ambiguous, outstripping the constraints of time and space. As a visual and material symbol, Chinese dress has been infused with shifting narratives and meanings, as can be seen in its depictions in art over the centuries and across cultures.

Before the mid-nineteenth century, European representations in art of Chinese dress generally fell into two categories: images of Westerners, whose clothes associated them with an idea of China, often imbued with exoticism; and depictions of Chinese people, frequently inflected by serious ethnographic and cultural interest, that sought to portray the lifestyles and customs of a different country, even though they tended to blend historical details with imaginary elements.

Johannes Nieuhof's (1618–1672) illustrated account of the first Dutch mission to China, first published in 1665, is one of the earliest and most influential works of the second type. The plates in his *An Embassy from the East-India Company* established a new visual vocabulary for depicting Chinese people in European art. Nieuhof's images,

presented as firsthand observations, are fraught with exaggerated or outright fictional details. In one illustration, for example, a "begging priest" sitting cross-legged on the ground wears a curious outfit in striped patterns with wide sleeves and tight leggings (fig. 1). His shoes have impishly upturned toes, while his preposterous hat is adorned with wing-length feathers, purportedly for "defend[ing] . . . against sun and rain." The accompanying text highlights his dress as "the most strange garb."[1] Such comical representations may have inspired the grotesque chinoiserie figurines popular in the eighteenth century.

Although Antoine Watteau (1684–1721) never traveled to China, he painted a series of vignettes representing Chinese people in different occupations and from various regions to decorate the Château de la Muette, on the outskirts of Paris.[2] Synthesizing

---

1. Johannes Nieuhof, *An Embassy from the East-India Company of the United Provinces, to the Grand Tartar Cham, Emperor of China* (London: John Ogilby, 1673), p. 190.

2. Watteau's paintings were engraved by Edme Jeaurat, François Boucher, and Michel Aubert and published as *Diverses figures chinoises et tartares, peintes par Watteau, peintre du Roy, en son Academie Royalle de Peinture et Sculpture tirée du cabinet de sa Majesté* (Paris: Chéreau et Caillou, 1731). The original paintings were made ca. 1708–15. For a discussion of this series, see Martin Eidelberg and Seth A. Gopin, "Watteau's Chinoiseries at la Muette," *Gazette des Beaux-Arts* 130 (July–August 1997), pp. 19–46.

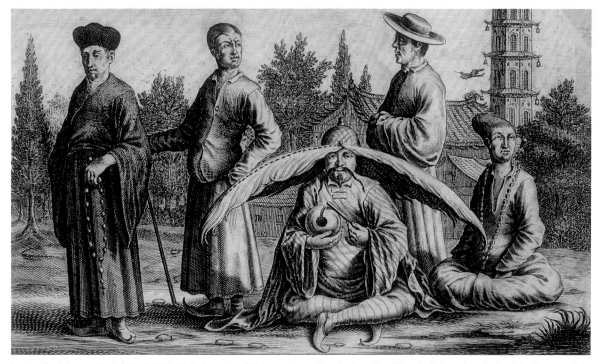

Fig. 1. After Johannes Nieuhof (Dutch, 1618–1672). Engraving of Chinese priests and monks. Reproduced from *An Embassy from the East-India Company of the United Provinces, to the Grand Tartar Cham, Emperor of China* (London: John Ogilby, 1673), p. 190

multiple sources, including travel books on China and Asian export goods, Watteau displays in his vision of China and Chinese people a body of knowledge enriched by romantic fantasies. The painstakingly transcribed Chinese words and re-created ethnographic details combine with an idyllic playfulness typical of Watteau's fêtes galantes (his paintings of costumed figures frolicking in arcadian settings). A series of thirty prints after Watteau's paintings was published in 1731. In one of the images, a goddess rises from a Chinese scholar's rock in a fantastical billowing form, balancing herself like an acrobat with a fan and a furry scepter (fig. 2). Her ersatz Chinese dress consists of a wrapped blouse with V-shaped décolletage and bouffant trousers inspired by Ottoman garments. The kneeling figure on her left, wearing conical Thai headgear, resembles

one of the Siamese envoys in the print *The Audience Given to the Ambassadors of the King of Siam on 1st September, 1686 at the Château of Versailles.*[3]

The most inventive and eclectic evocations of Chinese dress in European art can be found in costume designs for masquerade, opera, theater, and ballet. The "Chinese-ness" would be suggested by fragmentary details signifying China or a generic "Orient," which were superimposed onto a sartorial surface made to conform to both theatrical role types and the mores of contemporary fashion. In a fantastic masquerade costume, "habit d'un Mandarin chinois," designed by Jean Berain (1640–1711) for the

3. See Bibliothèque Nationale de France, Département des Estampes et de la Photographie,

Fig. 2. After Antoine Watteau (French, 1684–1721). *La Déesse Thvo Chvu dans l'Isle d'Hainane* (*The Goddess Thvo Chvu in the Isle of Hainane*), ca. 1731. Etching, 12¾ x 16¼ in. (32.2 x 41.2 cm). The British Museum, 1838

duc de Bourgogne in 1700, the bold checkered patterns on the jacket recall the buffoonish outfit of Arlecchino in the commedia dell'arte. The dangling bells attached to his hat, a motif taken from Nieuhof's image of Nanjing's porcelain pagoda, represented China, whereas the Islamic crescent and the stripes—a universal symbol of the exotic—heightened the ensemble's Oriental aura.

   In 1759 Arthur Murphy's tragedy *The Orphan of China* premiered at David Garrick's Theatre Royal in London and became an instant hit. Based on Voltaire's *L'Orphelin de la Chine* (1755), the play is an adaptation of a Yuan dynasty (1271–1368) drama, a morality tale suffused with themes of political intrigue, patriotism, and maternal love. With elaborate chinoiserie sets and costumes, the spectacular production made a star of the actress Mary Ann Yates (1728–1787), who played the character of the mother,

Mandane. Her stage dress immediately went on to influence fashion, as "the greatest part of the female audience seemed to envy her successful appearance, and entirely attribute it to her ornamental habit."[4] Yates's lifesize portrait in character, painted in about 1765, offers a glimpse of what her sensational Chinese-style dress might have looked like (see page 40). Its silhouette accorded with contemporary fashion, while its narrower cut stood as a novel alternative. A "Chinese" aura exuded through the crossed neckline, the wide-open pagoda sleeves, the tasseled strings around her waist, and even the bold hues of black and pink, reminiscent of Chinese lacquer. At the inter-

4.  *An Account of the New Tragedy "An Orphan of China" and Its Representation* (London: J. Coote, 1759), p. 12.

Fig. 3. Workshop of Peter Paul Rubens (Flemish, 1577–1640). *Portrait of Nicolas Trigault*, ca. 1616. Oil on canvas, 86⅝ x 53⅜ in. (220 x 136 cm). Musée de la Chartreuse, Douai, France

section of theater and fashion, Yates's dress forever fused her identity with the role of Mandane.

Representations of actual Chinese garments, albeit rare before the mid-nineteenth century, were not absent in European art. In most cases they appear in portraits of European expatriates—missionaries, merchants, or officials—whose active engagement with China anchored them in reality rather than exotic fantasy. The Chinese garments in their portraits were often the daily wear adopted by sitters in China or souvenirs from the subjects' travels, but in a new context for a new audience, such dress evoked the Orient as an idealized dreamland.

In a portrait of Father Nicolas Trigault (1557–1628) painted by Peter Paul Rubens's workshop in about 1616, the Flemish Jesuit missionary to China poses in a majestic Chinese scholar's robe and square hat (fig. 3). European missionaries in China adopted such attire as a strategy to gain access to Chinese elite society, critical to successful proselytization.[5] As documented in his portrait, Trigault

---

5. Stephanie Schrader, "Implicit Understanding: Rubens and the Representation of the Jesuit Missions in Asia," in *Looking East: Rubens's Encounter with Asia*, edited by Stephanie Schrader, exh. cat. (Los Angeles: The J. Paul Getty Museum, 2013), p. 40.

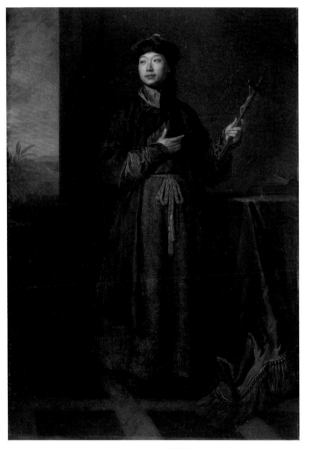

Fig. 4. Sir Godfrey Kneller (German, 1646–1723). *Michael Alphonsus Shen Fu-Tsung (d. 1691), "The Chinese Convert,"* 1687. Oil on canvas, 83⅜ x 58⅛ in. (212.2 x 147.6 cm). Royal Collection Trust, United Kingdom

also wore this outfit during his celebrated European tour in 1613–18 to recruit missionaries and raise funds. His opulent but solemn Chinese garment exemplified the sophisticated civilization of Old Cathay, showcased his religious devotion, and propagandized the Jesuits' achievements in China.[6] In both China and Europe, his Chinese outfit mediated between the two cultures, serving as the gateway for each to approach the other.

Very few Chinese traveled to Europe before the mid-nineteenth century, and fewer still were seen and represented in their indigenous dress. One exception was the young Chinese Jesuit Shen Fuzong (died 1691) from Nanjing, who traveled with the Belgian Jesuit Father Philippe Couplet (1623–1693) in several European countries in the 1680s and attracted a great deal of interest at royal courts. Upon his visit to Louis XIV at Versailles in September 1684, the French gazette *Mercure Galant* remarked: "[He had] an ample jacket with gold embroideries on blue ground, with dragon figures and an atrocious visage at the top of each sleeve.

6. Ibid., pp. 44–46.

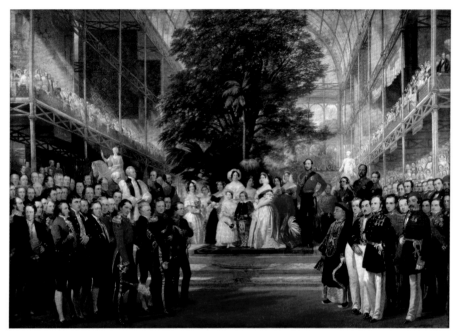

Fig. 5. Henry Courtney Selous (British, 1803–1890). *The Opening of the Great Exhibition by Queen Victoria on 1 May 1851*, 1851–52. Oil on canvas, 66¾ x 95¼ in. (169.5 x 241.9 cm). The Victoria and Albert Museum, London, Given by Warren W. de la Rue

Beneath he wore a type of tunic made of green silk."[7] *Mercure Galant* also recorded that Louis XIV's brother, Monsieur le duc (Philippe d'Orléans), examined Shen's outfit with curiosity; Shen took the liberty to offer him his dress, but the duke refused and in turn presented Shen with a magnificent French court habit.[8] The duke's reaction exposes an inherent tension between a fascination with exotic garments and a fear of actually donning them at the expense of one's own ethnic and cultural identity. A safer way to possess the exotic was by domesticating and collecting it. In 1687 the English king James II commissioned the royal portraitist Sir Godfrey Kneller (1646–1723) to paint Shen's likeness in his Chinese Jesuit attire holding a cross (fig. 4). As Shen's religious gesture and the painting's title, *The Chinese Convert*, suggest, he was celebrated as a successful result of the European mission in China. His dress asserted that there were no geographic or cultural barriers to the universal power of Christianity. Hung

in James II's Presence Chamber, Shen's portrait symbolized the king's own ambition "to reconcile his lost kingdom within a Roman Catholic imperium."[9]

While Shen in his Chinese dress encountered only a few European monarchs and elite courtiers, nearly two hundred years later another Chinese man unexpectedly appeared to the general public at the opening ceremony of London's 1851 Great Exhibition, arousing intense curiosity and ushering in an era when Chinese clothing was increasingly seen and worn in the West. Although unknown to

7.  *Mercure Galant* (September 1684), pp. 149–50.

8.  *Mercure Galant* (October 1684), pp. 127–28.

9.  Glenn Timmermans, "Michael Shen Fuzong's Journey to the West: A Chinese Christian Painted at the Court of James II," in *Culture, Art, Religion: Wu Li (1632–1718) and His Inner Journey: International Symposium Organised by the Macau Ricci Institute, Macao, November 27th–29th 2003* (Macao: Macau Ricci Institute, 2006), pp. 192–93.

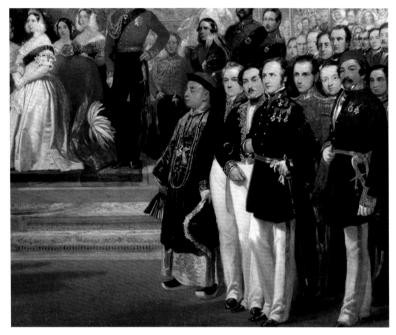

Fig. 6. *The Opening of the Great Exhibition by Queen Victoria on 1 May 1851* (detail)

the event's organizers, this mysterious man, Hee Sing, took on a central role. As Lyon Playfair (1818–1898), a member of the Exhibition Executive Committee, recollected, "a Chinaman dressed in magnificent robes, suddenly emerged from the crowd and prostrated himself before the throne. Who he was nobody knew. He might possibly be the Emperor of China himself who had come secretly to the ceremony."[10] Deceived by Hee Sing's dress and regarding him as someone significant, the organizers stood him between the archbishop of Canterbury and the Duke of Wellington. "In this dignified position he marched through the building, to the delight and amazement of all beholders."[11] Hee Sing was faithfully depicted in a large-scale scene painting by Henry Courtney Selous (1803–1890) commemorating the event, after which many prints were made and circulated (figs. 5, 6). The painting features the royal family in the center, flanked by important guests, including the arch-

bishop of Canterbury, ministers, foreign dignitaries, and commissioners. But no one stands out like Hee Sing, who is distinguished from the somber-suited Victorians by his incongruous dress—a Chinese official's formal coat with a rank badge and a mandarin's hat with red silk fringes and feather tail.

It turned out that Hee Sing was the keeper of a Chinese junk that had recently arrived at the River Thames and that he had attended the occasion purely by chance.[12] Although he dressed up in a mandarin's court robe, he held no official rank and by no means represented the Chinese delegation. The theatrical dynamics of this amusing incident—the chance

---

10. Lyon Playfair and T. Wemyss Reid, *Memoirs and Correspondence of Lyon Playfair: First Lord Playfair of St. Andrews* (New York and London: Harper and Brothers, 1899), p. 120.

11. Ibid.

12. Ibid.

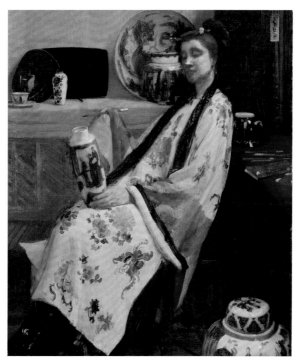

Fig. 7. James McNeill Whistler (American, 1834–1903). *Purple and Rose: The Lange Leizen of the Six Marks* (detail), 1864. Oil on canvas, 36¾ x 24⅛ in. (93.3 x 61.3 cm) overall. Philadelphia Museum of Art, John G. Johnson Collection, 1917

encounter, the dressing up for make-believe, mystification, and "delight and amazement"—in some ways characterize the reception and appropriation of Chinese clothing in Europe beginning at about that time.

From the mid-nineteenth century onward, Chinese garments reached Europe, and later America, in great quantity. Following China's successive defeats in the two Opium Wars (1839–42, 1856–60), sixteen coastal and inland Chinese cities were established as treaty ports. Western merchants and travelers could move more freely in China and had unprecedented opportunities to acquire Chinese garments—generally Qing dynasty (1644-1911) robes made of rich silk satin with exquisite embroidery—as commodities or souvenirs. As Verity Wilson points out, Chinese officials' formal robes with python-dragon motifs and overcoats with rank badges were not provided by the court but were instead procured by the officials themselves. Many such robes were available in the marketplace, and even foreigners could buy them without restriction.[13] Qing imperial dress also figured prominently among the looted trophies brought back to the West after the English and French armies sacked the Qing imperial Summer Palace in 1860 and again after the Battle of Peking (1900), in which Britain led a multinational force against China. Universal expositions, tremendously popular in Europe and North America during the second half of the nineteenth century, provided another arena for seeing and acquiring Chinese goods, including garments. Exquisite Qing dresses

13. Verity Wilson, "Studio and Soirée: Chinese Textiles in Europe and America, 1850 to the Present," in *Unpacking Culture: Art and Commodity in Colonial and Postcolonial Worlds*, edited by Ruth B. Phillips and Christopher B. Steiner (Berkeley and Los Angeles: University of California Press, 1999), pp. 230–33.

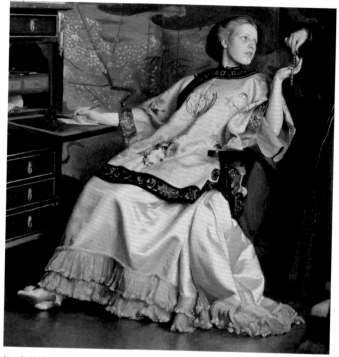

Fig. 8. William McGregor Paxton (American, 1869–1941). *The New Necklace* (detail), 1910. Oil on canvas, 36⅛ x 28¾ in. (91.8 x 73 cm) overall. Museum of Fine Arts, Boston, Zoe Oliver Sherman Collection, 1922

were presented to European royalty and aristocrats, were distributed among soldiers' and voyagers' families and friends, and found their ways into public auctions, curio shops, and department stores. As Chinese robes became accessible to a wide range of people—from the nobility to the bourgeoisie, and from intellectuals and artists to actresses and courtesans—new modes of representing Chinese dress in art emerged. In experimental paintings and the nascent art form of photography, Chinese robes became a versatile visual device and malleable symbol, appropriated for creating new pictorial styles, reformist aesthetic ideas, or idiosyncratic narratives.

James McNeill Whistler's (1834–1903) *Purple and Rose: The Lange Leizen of the Six Marks* (1864) is one of the earliest paintings to explore a new artistic vision through Chinese imagery (fig. 7). The "lange leizen" (from a Dutch term for "lanky

figures") and "six marks" in the title allude to the motifs and the reign mark in the blue-and-white porcelain from the Kangxi period.[14] In the painting, an Irish model in a Chinese robe leans back in a chair while painting a porcelain jar with a brush. Her reclining body extends along the diagonal of the picture plane and positions her gown at the very center of the composition. With a blurry face and almost imperceptible body, the figure is like a mannequin, solely for displaying the drape of the dress, an informal cream satin robe with wide pink bands on the sleeves, elaborately embroidered in a palette of pink, green, and brown. Its fluid form and rich color scheme offered Whistler ample possibilities to har-

14. Linda Merrill, "Whistler and the 'Lange Lijzen,'" *The Burlington Magazine* 136, no. 1099 (October 1994), p. 683.

monize light, texture, and hue. Relatively hazy and broad brushstrokes–new to his work–abstract and simplify details, subjugating individual elements to an overall visual impression. The prominent aesthete Dante Gabriel Rossetti (1828-1882) regarded this painting as "the most delightful piece of colour" and lauded that "its harmonizing power of art is so entire."[15]

This painting coincided with a turning point in Whistler's artistic development, as he shifted away from Realism and became increasingly affiliated with the Aesthetic circle, pursuing in art an ideal beauty detached from subject and function.[16] This painting also marked the beginning of Whistler's assimilation of the principles of Far Eastern art and design, which would soon lead to a productive period of Japanism. At this inceptive stage, the Chinese dress with its unique materiality and visual form inspired his aesthetic idealism and helped nurture his new painterly techniques; for Whistler, the Chinese robe embodied the general principle of formal beauty for which he was searching.

From the mid-nineteenth to the early twentieth century, Qing garments figured among the favorite choices in the West for fancy costumes, tea gowns (semiformal, flowing dress for hostesses receiving guests), and lounging robes. Drawing upon the exotic, Chinese dress perfectly gratified a longing to express an innovative or artistic flair and was frequently modeled and captured in portraits and paintings of interior scenes.

Many works at the turn of the twentieth century, especially those by American artists of the Boston School, such as William McGregor Paxton (1869-1941) and Joseph Rodefer DeCamp (1858-1923), depict Caucasian ladies in Chinese gowns idling indoors, reading, embroidering, arranging flowers, looking into mirrors, or simply daydreaming (fig. 8). Chinese robes cast these women in languid attitude as aesthetic objects and symbolized bourgeois notions of genteel femininity and artistic domesticity. In these works Chinese gowns held out the promise of an "Oriental" life-style that was tranquil and unhurried, allowing the people they costumed and the interiors they decorated to softly resist the fast-paced industrial world.

The view of China as an antidote to modern times was widespread and long-lasting. In a 1929 issue of the British edition of *Vogue*, a photographic portrait of Mrs. Oliver Locker-Lampson (wife of a parliamentarian) in a Qing embroidered gown preceded an essay titled "Speed–The New Vice" by the French modernist writer Paul Morand (1888-1976). Fiercely criticizing the new cult of speed, Morand denounced it as "a curse" and a "greater illusion" through the voice of a fictional character, who "had tasted the more leisurely rhythm of Oriental life."[17] Posed in a highly stylized manner and resembling a Chinese monk with her legs crossed and her hands joined in front holding a flower, Mrs. Locker-Lampson seems to physically enact the "rhythm of Oriental life."

In other works, Chinese robes contributed to bolder and more complex fantasies of femininity, often charged with erotic or transgressive undertones. The Orient had long been linked in the Western imagination with sensuality, decadence, and looser moral constraints. The Countess de Castiglione (1837-1899), an Italian aristocrat and short-term mistress of French emperor Napoléon III, audaciously explored this theme in costumed portraits by the French photographer Pierre-Louis Pierson (1822-1913). In three photos from the 1860s, the countess poses in a Qing imperial consort's ceremonial overcoat. In the first two, she stands demurely, with her hands held and her feet striking a T-step, as if to imitate the restricted Chinese pose of her imagination, but in the third picture she assumes a provocative posture, reclining on the floor and revealing her legs beneath her robe (see pages 98-99). Looking straight into the camera, her gaze is cold and defiant, mixing seduction, boredom, and contempt–

---

15. William Michael Rossetti, *Fine Art, Chiefly Contemporary: Notices Re-printed, with Revisions* (London: Macmillan, 1867), p. 274.

16. Merrill, "Whistler and the 'Lange Lijzen,'" p. 683.

17. *Vogue* (British edition) (July 24, 1929), p. 37.

classic traits of the femme fatale. Her bare legs, iconography drawn from contemporary pornography,[18] foregrounded her self-fashioned image of dubious morality. Her floating gown casually sweeping on the floor and the crumpled drapery in the background recalled the familiar trope of *beau désordre* (beautiful disarray) in eighteenth-century paintings with licentious themes.

The countess seems also to have been drawn to the Chinese gown's gender ambiguity. While female and male robes were clearly differentiated in China, such distinctions were not always apparent to Western eyes, and when adopted in Europe, men's dragon robes and rank coats were often worn by women. Their loose and straight cuts created a flat silhouette, a sharp contrast to the contemporary Western ideal of an hourglass-shaped female body. Interestingly, the countess wrote "Chinois" under her pictures, using the masculine form of the French word. Her Chinese robe facilitated her fantasy of impersonating a Chinese man and afforded her the pleasure of transgressing both gender and racial boundaries.

Chinese robes also found their way into the wardrobes of Western men, offering a channel for expressing an alternative or private inner self. In the French novel *In Search of Lost Time*, Marcel Proust (1871-1922) stages a scene where the haughty dandy Baron de Charlus attempts to seduce the male narrator in a "robe de chambre chinoise" (Chinese dressing gown).[19] An important prop for the narrative, the dressing gown facilitates the revelation of Charlus's true self and hidden longing. It speaks the unspeakable and softens the transgression. Worn in a posture of abandon—"le cou nu, étendu sur un canapé" (with his throat bare, lying on a settee)—the baron's Chinese gown dramatically contrasts with a tall hat by his side—a stern masculine symbol of his public identity.[20]

A similar juxtaposition of private and public masculine identities appeared in Eugène Delacroix's (1798-1863) double portrait of Count Charles de Mornay and Count Anatole Demidoff from 1832, a rare early representation of a French nobleman in a Chinese dress.[21] Mornay's dressing gown, with water patterns on the bottom and dragon motifs, was altered from a Qing robe; modifying the original neckline and adding a belt rendered it consistent with contemporary European style. The painting was destroyed in 1914 and only poor-quality black-and-white reproductions exist, but, according to an 1873 inventory, the robe was in "pink color."[22] As pink was never used for Chinese menswear, Mornay's robe may have been adapted from a Chinese woman's gown or a theatrical costume. An alternative to the public male fashion exemplified by Demidoff's somber redingote and slim trousers, Mornay's ornate, brilliant robe alluded to the eighteenth-century trope of representing male intellectuals and artists in exotic dressing gowns, extolling his status as a man of letters and accentuating his cosmopolitan background as an ambassador to Morocco and Karlsruhe, Grand Duchy of Baden.

**Through the Kaleidoscope:
Chinese Dress after 1911**

The Qing dynasty fell in 1911. The Republican period that followed witnessed the rapid modernization (synonymous with Westernization) of Chinese dress and life-style. Qing-style garments with ample cut and ornate decorations quickly became outmoded.

---

18. See Abigail Solomon-Godeau, "The Legs of the Countess," *October* 39 (Winter 1986), pp. 65–108.

19. Marcel Proust, *À la recherche du temps perdu*, vol. 2, *Le Côté de Guermantes* (1920; Paris: Gallimard, Bibliothèque de la Pléiade, 1988), p. 842; Marcel Proust, *In Search of Lost Time*, vol. 3, *The Guermantes Way*, translated by C. K. Scott Moncrieff and Terence Kilmartin, revised by D. J. Enright (London: Chatto and Windus, 1992), p. 640.

20. Ibid.

21. For a discussion of this painting, see Jennifer W. Olmsted, "Public and Private Identities of Delacroix's Portrait of Charles de Mornay and Anatole Demidoff," in *Interior Portraiture and Masculine Identity in France, 1789–1914*, edited by Temma Balducci et al. (Farnham, Surrey: Ashgate, 2010), pp. 47–64.

22. Adolphe Moreau, *E. Delacroix et son oeuvre, avec des gravures en facsimilé des planches originales les plus rares* (Paris: Librairie des bibliophiles, 1873), p. 173.

Fig. 9. Portrait of Eileen Chang, 1944. Reproduced from *Dui zhao ji* [Looking at photos] (Taipei: Huang guan wen xue, 1994), p. 68

Everyday dress in China metamorphosed as swiftly as social and political structures, and an interest in fashion history burgeoned in both the intellectual and popular domains. Traditional garments became both a material trace and symbol of a lost history, which in turn aided in the contemporary reflections of the modern. The influential Chinese writer Eileen Chang (1920–1995) wrote an essay in the early 1940s tracing the evolution of Chinese dress from the Qing dynasty to modern times and wittily psychoanalyzing Chinese history through fashion: Qing garments had been trapped in an unchanging state for three hundred years, mirroring the perpetual "stability," "uniformity," and "extreme conventionality" of China under the Manchus, whereas the fast-changing Republican fashion, often lacking order and restraint, indexed the chaos and uncertainty of modern Chinese history.[23]

Old Chinese dress, however, still possessed a sentimental allure and allegorical potency for Chang. In wartime Shanghai she invented an eccentric personal style by mixing old dresses and textiles handed down from her family with cutting-edge fashions. A photographic portrait of Chang from the

23. Eileen Chang, "Chinese Life and Fashion," *XXth Century* (January 1943), pp. 54–61.

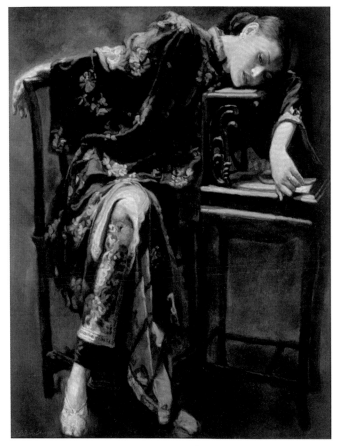

Fig. 10. Chen Yifei (Chinese, 1946–2005). *Peaceful Moment*, 1998. Oil on canvas.
Reproduced from *Chen Yifei* (Tianjin Shi: Tianjin yang liu qing hua she, 2008), p. 82

mid-1940s captures her most iconic outfit—a late Qing jacket with a wide cloud-shaped border worn over a contemporary *qipao* (fig. 9). Her sartorial embrace of the past emerged amid and resonates against the ruins of wartime Shanghai. She wrote: "In order to confirm our own existence, we need to take hold of something real, of something most fundamental, and to that end we seek the help of an ancient memory, the memory of a humanity that had lived through every era, a memory clearer and closer to our hearts than anything we might see gazing far into the future."[24]

This reassuring "ancient memory" was given substance by the texture, patterns, and fragrance of the old family dresses Chang adopted. They provided comfort and defense in a historical moment when life unfolded precariously between past and future. At the same time, the old garments were imbued with a tragic sense, simultaneously conveying the memories of Chang's ancestors—a once-prominent but now-fallen Qing elite family whose vicissitudes were interwoven with the fate of China—and the epoch's turbulence. For Chang, wearing those

24. Eileen Chang, "Ziji de wenzhang" [Writing of One's Own], in *Liuyan* [Written on Water], translated by Andrew F. Jones (1945; New York: Columbia University Press, 2004), pp. 17–18.

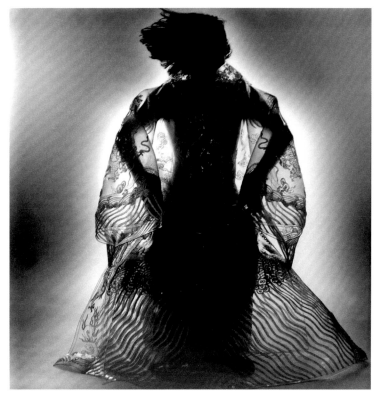

Fig. 11.   Wang Jin (Chinese, born 1962). *Dream of China No. 3*, 1998. Chromogenic color print, 46 x 46 in. (116.8 x 116.8 cm)

garments was not a nostalgic gesture but rather a conscious act of embodying fading history while salvaging some link to the present. Turning her own body into a kind of palimpsest, she wore a fable of time.

From the 1950s to the 1970s, the Communist era's cultural puritanism and radical rejection of almost everything from the past left no room for imagining and representing old Chinese dress. Only in the 1990s did such imagination make a powerful return, manifested as part of an intense nostalgic trend that gripped Chinese art, literature, cinema, and popular culture. The trauma of Communist cultural deprivation had not yet been relieved, while a new anxiety over cultural identity and loss of spiritual homeland intensified as China pursued aggressive capitalism and modernization. The

unsettled times gave rise to a collective longing for a bygone era that most people had never lived through and which to some degree they invented.

Much of this nostalgic fantasy centered on the Jiangnan region south of the lower Yangtze River, especially Shanghai, with its history of cultural refinement and decadent allure. Chen Yifei (1946–2005), one of the most commercially successful Chinese artists in the 1990s and a native Shanghainese, fabricated a popular dream of the old South through a series of oil paintings of graceful Southern ladies in exquisite late Qing and Republican dresses (fig. 10). Languid and delicate, melancholically gazing at a birdcage, holding a fan, or playing musical instruments, Chen's women recall the Western ladies in Chinese robes painted by the Boston School artists a century earlier. Gorgeous out-of-place clothing

depicted in realistic style gives material texture to an idealized otherworld. Here Chen created an Oriental myth that was equally exotic for Westerners and Chinese people; for the latter, it quenched a cultural desire to seize something beautiful, intact, and consoling. But this enchantment with an idealized past resembles the doomed romance in Chen's movie *Ren Yue Huanghun* (*Evening Liaisons*, 1995). Set in 1930s Shanghai, it recounts a love story between a journalist and an enigmatic female ghost who is clad in glamorous *qipaos* and aimlessly wanders the streets of old Shanghai. Like the specter who capriciously appears and vanishes, the nostalgia imparted only an illusion of love and hope, escaping any effort to grasp it.

Another Chinese artist, Wang Jin (born 1962), has also appropriated traditional Chinese dress but renders it with irony rather than Chen Yifei's tenderness. His series, Dream of China, made between 1997 and 2005, reproduces Qing imperial robes and Peking Opera costumes in monochrome, translucent plastic (PVC) embroidered with nylon fishing threads. The vague but evocative title lends itself to multiple interpretations. As Wu Hung discusses, it could refer to a capitalist dream of the commercialization of Chinese culture, which the robes parody; it could be a dream of old China through foreign eyes; and it could be some grand narrative that the costumes conjure when displayed in performance at historical monuments.[25] Wang wears such a costume in one of his performance photographs, his naked body visible through the plastic robe (fig. 11). The revelation carries an unsettling sense of inside-out inversion and demystification, as traditional silk robes conceal the wearer's contours and transform the body with colorful, auspicious symbols. Wang's robe, seemingly weightless and insubstantial, is actually heavy and suffocating; it confines the body like a petrified cocoon. Lit from the back, Wang appears statue-like in dark shadow, and his flying hair and kneeling gesture convey the impression of martyrdom. The industrial quality and deceptive materiality of Wang's robes seem to comment on

the predicament that characterizes contemporary Chinese culture and its dreams: the unbearable lightness that subjugates and manipulates gravity and dignity.

Creating another kind of dreamscape, the Chinese video artist Yang Fudong (born 1971) staged a surrealistic encounter between contemporary international fashion and historical Chinese dress in his short film *First Spring* for Prada's 2010 spring/summer collection. Shot in black-and-white, the film is composed of fragmented and suggestive mise-en-scènes about modern people attired in the latest Prada fashions haphazardly time-traveling. The setting, reminiscent of 1930s Shanghai, is inhabited by emperors, eunuchs, court ladies, and other dynastic figures from the second century B.C. to the twentieth century. Temporal barriers collapse as the ancients and moderns, dressed in vastly different garments, quietly observe each other, dine at the same table, and stroll on the same street, even though their lives seem to be governed by different logics and rhythms. Past and present unite in a wonderland rich with both Eastern and Western decors. At the end of the movie, an entourage of Han dynasty and Tang dynasty attendants chases the tram on which the modern couple is departing, as if history were trying to cling to fleeting contemporary fashion. Ironically, the period costumes in the film are not historically accurate. They are contrived versions, like the costumes in Chinese television series and epic movies. Similarly, the Shanghai streets shown here are not the real cityscape but an overfilmed back lot. Although contemporary fashion may last only a season, the Prada clothing and accessories are probably the only things in the film that can claim authenticity, whereas the Chinese dress and the Chinese city shimmer like kaleidoscopic reflections of an imagined past.

---

25. Wu Hung, "A Chinese Dream by Wang Jin," *Public Culture* 12, no. 1 (Winter 2000), pp. 75–92.

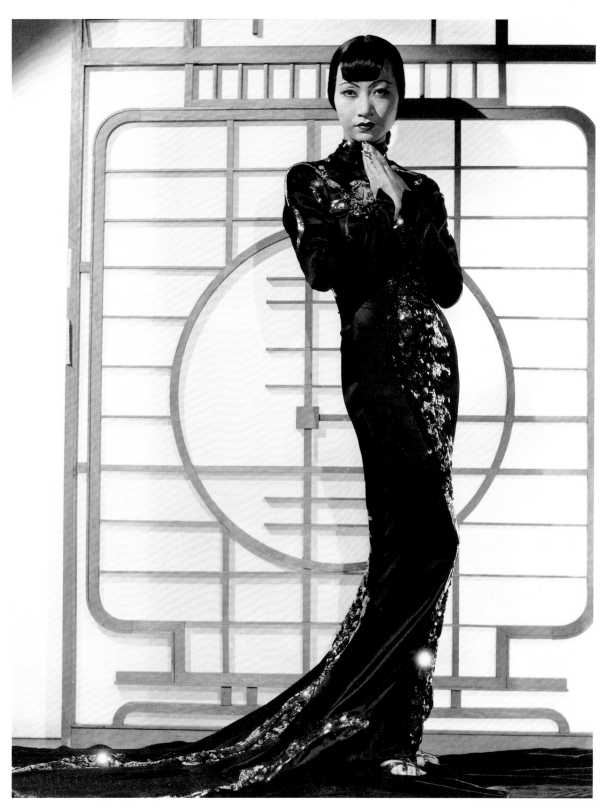

Anna May Wong in *Limehouse Blues*, 1934

# Cinema's Virtual Chinas

## Homay King

E. A. Dupont's 1929 silent film *Piccadilly* is set in London's cabaret underworld. Several scenes take place in the backstage offices of Valentine Wilmot, the proprietor of a popular nightclub. The decor is not particularly notable save for one small ornament on Wilmot's desk: a curious Chinese figurine with a bobbing head. The object appears several times in close-ups that last just slightly longer than warranted. This figurine has a somewhat cliché function in the plot; in an intertitle, Anna May Wong, playing a scullery maid who will later be promoted to cabaret star, calls it her "mascot" and says that it brings her luck. But the figurine resonates with additional significance. It evokes the Orient, in all the geographically indistinct and illusory senses of that term, and associates the club's British owner with a taint of foreignness.

### Enigmatic Signifiers

That figurine is an early example of what I have called an enigmatic signifier: an Asian decorative object that appears in Western narrative film seemingly for no other reason than to convey a sense of exotic mystery.[1] Such objects reflect the popular notion that something secret, unknown, and potentially dangerous lies hidden in things from the East. The trope is particularly visible in Hollywood films noirs of the 1940s, in which Eastern curios—jade necklaces, delicate snuff bottles, bits of calligraphy on rice paper—seem to appear only to invoke a vague inscrutability. Hollywood's Orientalist motifs and their loaded meanings emerged in tandem with the West's conflation of Chinese and Japanese aesthetics during World War II. And yet Western filmmakers lavished great care on Orientalist mise-en-scène and costuming, endowing Eastern details with a peculiarly seductive pull. Often such objects deflect attention from unresolved elements of the plot or are offered up as explanation for the inexplicable. More than just arbitrary set dressing, they are striking visual motifs that resist being deciphered and thereby become emblems of the unintelligible. Like Sphinxes bearing riddles without answers, these elements of decor are intricate and internally complex. They belong to elaborate fantasy worlds whose striking ornamentation merits closer scrutiny.

---

1. Homay King, *Lost in Translation: Orientalism, Cinema, and the Enigmatic Signifier* (Durham, N.C.: Duke University Press, 2010).

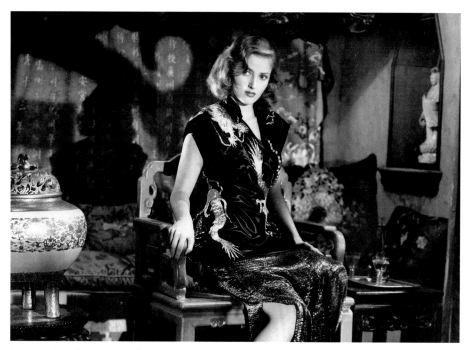

Fig. 1. Martha Vickers in *The Big Sleep*, 1946

Film, of course, is always at least one step removed from life: even the most judicious portrayals are the products of particular points of view and acts of selection. And like all lensed imagery, cinema is stamped with an especially persuasive imprint of reality: it can have the visceral impact and credibility of a live experience, with profound effects on viewers' perceptions of the world. Film is the first lens through which most of us encounter unknown places, and artists and designers who quote Chinese aesthetics are often citing cinema, not reality. Their visual motifs are thus already mediated by several degrees from the originals and sometimes are of a different order altogether: whole-cloth fictions that may be called "Shanghai" or "Chinatown" but that depict their namesake places no more accurately than Dorothy's dreamland of Oz depicts Kansas in the 1930s. Hollywood does not have a strong track record

when it comes to representing the world beyond its studio walls; historically, its invocations of China have tended to take the form of one-dimensional caricatures. Much more than the characters who inhabit them, though, these fictional worlds— their props, costumes, and artistic design—reveal fascinating chains of cultural and aesthetic contortions that are not merely gratuitous. With varying levels of awareness, artists, designers, and filmmakers have incorporated these fantasies into their work, sometimes reiterating a stereotypical view, sometimes refracting the images in ways that comment knowingly upon the ones that preceded them.

Howard Hawks's classic 1946 film noir *The Big Sleep* straddles the edge between these two modes. In one telling scene, detective Philip Marlowe, played by Humphrey Bogart, enters a suspect's Los Angeles home to find the interior decked out like an opium den, with smoky bowls

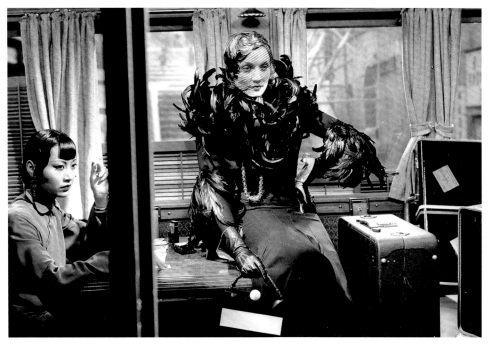

Fig. 2. Anna May Wong (left) and Marlene Dietrich in *Shanghai Express*, 1932

of incense, silk tapestries, and a suspiciously swinging beaded curtain. Carmen (Martha Vickers), the femme fatale he has been tailing, is clad in a cheongsam embroidered with metallic dragons and seated on a throne-like Chinese-style chair (fig. 1). Across from her, a serene wood Buddha opens to reveal a hidden camera, intimating voyeurism and vice. Confronted with these decorations, Marlowe scratches his head and pulls at his ear; quizzical music indicates his bewilderment. His deductive skills are being tested by a foreign visual code that he cannot crack. This notoriously convoluted film never reveals precisely who was behind all of the crimes Marlowe is investigating or why; reportedly even the original novel's author, Raymond Chandler, could not keep track of all his plot twists. What is clear, though, is that the decor is a red herring: the answer to the mystery lies not in China, but rather in the shady dealings of the family that has hired Marlowe.

In a psychoanalytic projection, the enigma is routed through China and its objects, and those objects become emblems of the unknown writ large.

The figure of the dragon lady is an Orientalized version of film noir's femme fatale that Hollywood also popularized in the 1930s and 1940s. An enigmatic signifier in her own right, she reflects a dense concatenation of Western fantasies and anxieties: she is fierce, quasi-matriarchal, and financially independent, and she tends to act out of vicious desire. She is identifiable by her almost reptilian dress: the fabrics of her long gowns, often embossed with twisting gold embroidery, cling to her body, both a sloughable armor and a scalelike tattoo. Sometimes she is lean and sleek, like Anna May Wong's character in Alexander Hall's 1934 *Limehouse Blues* (see page 56). In her more decadent, even kitsch versions, she sports large, garishly lacquered hairstyles that echo the intimidating,

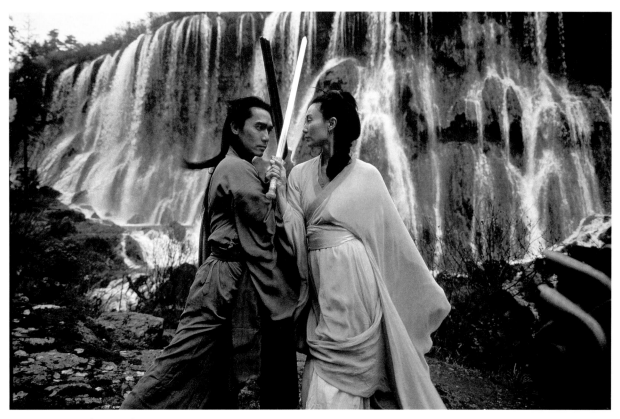

Fig. 3.  Tony Leung and Maggie Cheung in *Hero*, 2002

spiky swirls of the dragons on her clothing and makeup that masks the expressive capacities of the human face. Although no less predictable than the stock character of the submissive Chinese servant, the dragon lady lends herself to a feminist interpretation. Her inevitable downfall or death in films of the era reveals a fascination with and fear of seductive, mature female eroticism, which is safely kept at bay by association with distant lands–insulating the Western hero (and audience) from its dangers.

The dragon lady has a kinship with the characters that populate the baroquely exotic films of Josef von Sternberg. In *Shanghai Express* (1932), Marlene Dietrich plays the prostitute Shanghai Lily: it took more than one man, she drones, to give

her that name. She appears first in a closely fitted hat and veil trimmed with molded black feathers (fig. 2); later, she wears a silky robe featuring a pattern of flying cranes. An avian being, she is ethereal, heartbreakingly migratory–perhaps not of this world. Sternberg emphasizes that unearthliness by isolating her in wondrous close-ups that are lit differently from their neighboring shots; the nearly hagiographic lighting and soft focus make them look as if they had been inserted from another film. As in *The Big Sleep*, the plot hardly matters, so fascinated is the camera by the otherworldly atmosphere. The sultry quality of the light is enhanced by hanging sheets of sheer muslin: mosquito netting, perhaps, although the drapes are positioned in such a way that they couldn't possibly fulfill a practical

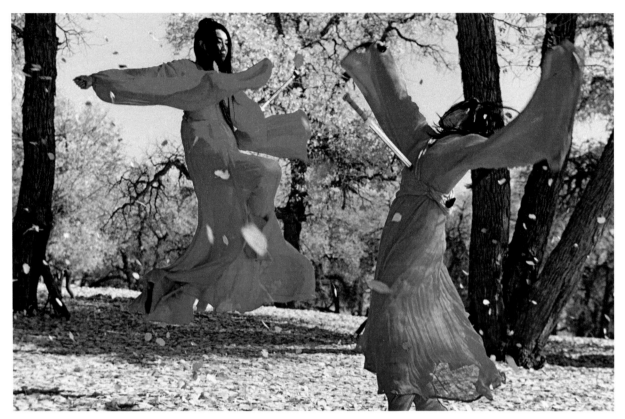

Fig. 4. Maggie Cheung (left) and Zhang Ziyi in *Hero*, 2002

function. The exotic costumes, airy textures, and gauzy illumination convey the artificiality of the environment. We are not in Shanghai anymore; indeed, we never were. The film flaunts its status as a product of the imagination, offering up a virtual world that does not map neatly onto any real place.

## Virtual Places, Virtual Times

Hovering between fantasy and reality, a film like *Shanghai Express* refers to historical Chinese aesthetics and motifs but crosses the line into pure fabrication. The result is a virtual China that combines anachronistic allusions to disparate times and places into a grand pastiche and, largely unwittingly, quotes centuries' worth of cross-cultural exchanges. The interchanges themselves have often been distorted by misinterpretation during the course of their journeys, with the original models lost in translation, if they ever existed at all. Like Western costumes and other artworks that evoke an imaginary East, these films speak to an ongoing fascination with inscrutable, enticing images from distant lands and epochs. While their makers often signal that they are veering into the realm of fairy tale, the works are no less revealing for being infused with fantasy, as are Homer's *Odyssey*, Xenophon's *Anabasis*, Marco Polo's *Travels*, and other epics of voyage and return.

Hollywood does not hold a monopoly when it comes to creating virtual Chinas. Among contemporary Chinese filmmakers who extrapolate away

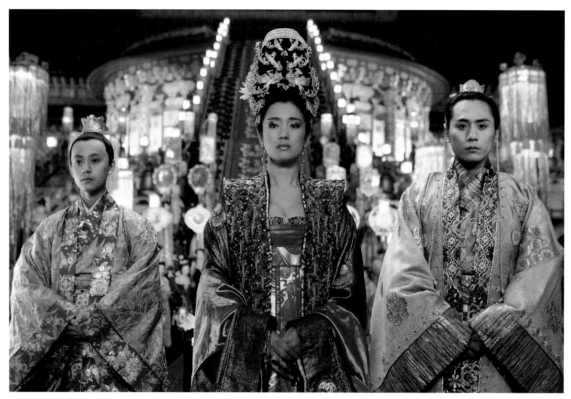

Fig. 5. Gong Li (center) in *Curse of the Golden Flower*, 2006

from the actual China and offer virtual re-creations in its place is acclaimed director Zhang Yimou. His extravagant cinematic exercises in legend include *wuxia* films, tales of ancient martial artistry, such as the 2002 *Hero* (figs. 3, 4). Like John Ford's westerns in Hollywood's golden age, his films do not represent a nation's past with documentary verisimilitude, but their landscapes are dramatically illuminating. Like British Regency romance novels, they may be set in a specific time and place but are more faithful to their genre's internal conventions and rhetoric than to historical reality. While the two works are not fully analogous, one could argue that the ancient past in *Hero*—a past that is largely unknowable—is as remote from its historical antecedents as Sternberg's virtual Shanghai is geographically remote from its namesake city.

That idea is borne out by *Curse of the Golden Flower* (Zhang, 2006). In the American version, a title card informs us that the story takes place in A.D. 928, during the Tang dynasty. But that dynasty had ended more than twenty years earlier, succeeded by the era of the Five Dynasties and Ten Kingdoms (907–960), a period of upheaval between the Tang and Song. Visually, the film, an epic of palace intrigue, does not conform to any single period of history. Costumes worn by the empress (Gong Li) display a mixture of styles: she wears the elaborate hairstyles and tinkling decorative pins associated with the Mandarin court of the Qing dynasty, but instead of the simply folded robes typical of that era, she wears dresses with snug, low bodices that very nearly suggest an Elizabethan costume drama (fig. 5). Her full lips are painted in red with

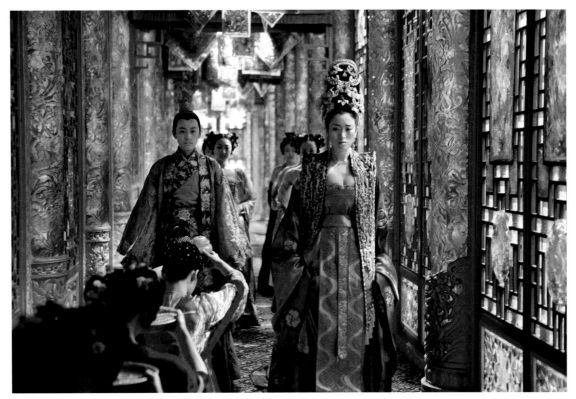

Fig. 6.  Gong Li in *Curse of the Golden Flower*, 2006

flecks of gold glitter, evoking not the 920s but the 1980s. Male characters sport gorgeous but fanciful suits of embossed gold and silver armor that would likely be of little use in battle. The imperial palace grounds are blanketed with acres of woven rugs and bright yellow chrysanthemums; the palace interior sparkles like a disco, with rainbow-colored, self-illuminating glass pillars (fig. 6). The decor overtly indicates that this world is a fantastical one, the setting for a flamboyant royal melodrama.

Similarly, *Raise the Red Lantern* (Zhang, 1991), while set in 1920 and offering a mise-en-scène richly stocked with art historical detail, unfolds in the manner of a parable rather than that of a historical chronicle; through his visual language Zhang makes clear that we are in a time of fables rather than facts. The plot concerns the competition among a rich man's four wives for his attention and the associated privileges. He indicates which wife he will spend the night with by having a lantern raised outside her quarters. The compound where the story is set, like the palace and grounds of the Forbidden City in *Curse of the Golden Flower*, is a closed world that obeys its own visual rubrics and rules of order. In this case, that world appears to be sealed off from time and immune to its effects. The consistent red and black color scheme, the dense orthogonality of the architecture, and Zhang's static framing and camerawork indicate the unchanging rules and rigid customs that govern this small universe (figs. 7, 8). The film's ceremonial aspects take on a theatrical quality; the nightly ritual lantern lighting and audible clinking of massage mallets create the sense that a stage is being set for a play.

Fig. 7. Gong Li in *Raise the Red Lantern*, 1991

## Modern Anna May

*Raise the Red Lantern* can be interpreted as an allegory about strictly prescribed social orders and the structures of power and kinship they serve to maintain, especially for women. Anna May Wong might have related to the tale: born in Los Angeles in 1905 as Huang Liushuang, Wong was fated to play characters that, as she would complain, tended to die by the end of the films; Hollywood could not conceive of a Chinese character living happily ever after. She cannily stretched the roles offered to her beyond their narrow parameters, and her performances are often marked by a sly wink at her character's lack of complexity. In Dupont's *Piccadilly*, Wong plays Shosho, a scullery maid turned nightclub sensation, and her insouciance at times nearly bursts the frame of the fiction.

*Piccadilly*'s techniques recall German Expressionism, with dance sequences filmed in kaleidoscopic process shots. Shosho's main dance sequence combines Jazz Age modernism with a Chinese "primitive" aesthetic, signaled by candles on pillars and a stringed instrumental accompaniment. She insists that her costume be purchased in a shop in Limehouse, London's Chinatown, but what she orders is far from a traditional Chinese dress: it invokes eclectic references to sculpture and architecture, almost postmodern in its amalgamations. Her helmetlike jeweled crown is the sartorial equivalent of a mixed metaphor, evoking both a Laotian deity's headdress and the spire of the Chrysler Building (fig. 9). The shape of her sleeves recalls the curved eaves of a pagoda. Her top resembles a medieval cuirass or a samurai's *dō*, and the whole ensemble has a vaguely industrial or automotive cast, in spite of its delicate proportions. It conflates

Fig. 8. Gong Li in *Raise the Red Lantern*, 1991

the ancient and modern, Eastern and Western, into a product that is ultimately none of these.

The photographer Edward J. Steichen (1879–1973) made a portrait of Wong that, though simple on first glance, captures her complexity more fully than did many of the film roles Wong was consigned to play (fig. 10). In this image, she kneels on a pedestal in a white silk gown with impossibly long sleeves. Her position on the pedestal renders her doll-like, yet the tilt of her head suggests the rebelliousness of a jazz baby with a 1920s New York accent. Her eyes are closed, suggesting a refusal to yield up her secrets, but were they open, she would be gazing defiantly at the viewer. She shimmers between two seemingly contrary aspects, one traditionally Chinese, the other an ultramodern image of Art Deco sleekness. (As scholar Anne Cheng notes, Wong's contemporary counterpart

Josephine Baker embodied similar contradictions.)[2] That combination suggests that high-modern style developed not in opposition to the so-called primitive and non-Western but by adopting some of their features as core elements of its aesthetic. Wong the cosmopolitan Jazz Age diva and Wong the second Chinese daughter of a Los Angeles laundry owner are, finally, one and the same.

Like Josephine Baker and others whose options in America were limited by race, economics, and social norms, Wong joined the expatriate community in Europe in the late 1920s and soon became part of an international avant-garde. In 1928 she met the

2.  Anne Anlin Cheng, *Second Skin: Josephine Baker and the Modern Surface* (2010; Oxford and New York: Oxford University Press, 2011).

Fig. 9.   Anna May Wong in *Piccadilly*, 1929

German philosopher Walter Benjamin, who wrote an essay in which he described her in a richly evocative sentence: "May Wong—the name sounds colorfully margined, packed like marrow-bone yet light like tiny sticks that unfold to become a moon-filled, fragranceless blossom in a cup of tea."[3] Patty Chang's *The Product Love* (2009) is a work of video art that imagines the meeting of Wong and Benjamin as an erotic encounter; the restaging is paired with footage of translators attempting to render Benjamin's German into English, with wildly diverging and absurd results. However untranslatable Benjamin's text may be, its form clearly references Marcel Proust, both in its choice of synesthetic metaphors and in its cumulative grammar. Notwithstanding the "Chinese" content of Benjamin's metaphor, with its moon, blossom, and tea, its Proustian form enfolds Wong in Western literary associations. Benjamin unearths dormant affinities between the two cultures, which Chang then burlesques in her video, exploring the creative infelicities that arise in the gaps between them.

---

3.  Walter Benjamin, "Gespräch mit Anne May Wong: Eine Chinoiserie aus dem alten Westen," *Die Literarische Welt* 4, no. 27 (July 7, 1928); reprinted in Walter Benjamin, *Gesammelte Schriften*, vol. 4, pt. 1 (Frankfurt am Main: Suhrkamp Verlag, 1972), pp. 523–27; translation by author.

Fig. 10. Edward J. Steichen (American, 1879–1973). Anna May Wong, 1930

## The Erotics of Restraint

Anna May Wong—and Steichen, who published photographs of her while he was editor at *Vogue* and *Vanity Fair* in the 1920s and 1930s—may take at least partial credit for popularizing the cheongsam, or *qipao*, as it is called in Mandarin. With few cuts and little fuss to its shape, the cheongsam lends itself to flights of imagination that belie its minimal construction. It can be rendered in nearly any fabric, texture, or print, conveying whatever desires and associations those might prompt. In the 1940s Madame Chiang Kai-shek paired one with a Western-style suit jacket; so chameleon-like is the garment that the combination looks unexpectedly natural. No one has made that fitted dress look as stunning on screen as the director Wong Kar Wai, particularly in *In the Mood for Love* (2000), a tale of restraint and yearning, as two neighbors (played by Maggie Cheung and Tony Leung) in 1960s Hong Kong develop a tentative bond after discovering their spouses are having an affair. The version of the dress that Wong's films favor has a slightly higher and stiffer collar than is customary, lending it the extra edge and tense fragility that characterize some of his protagonists. In *In the Mood for Love*, Cheung wears an array of cheongsams—"twenty to

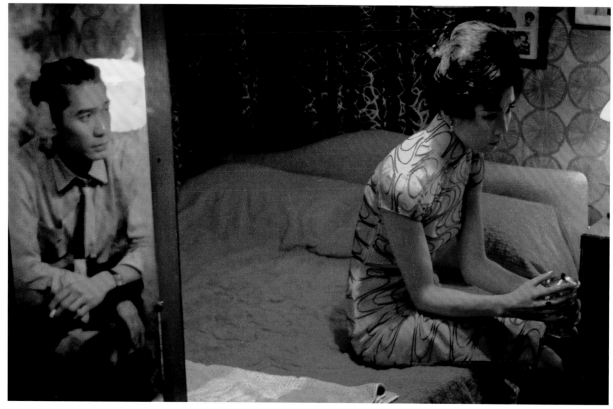

Fig. 11. Tony Leung and Maggie Cheung in *In the Mood for Love*, 2000

twenty-five . . . it becomes like a fashion show."[4] They include mod geometric prints, watery patterns in muted tones, an iridescent green brown, and a coral gingham check. Wildly promiscuous in texture and color but rigidly uniform in shape, the dresses express a florid longing that the character, stymied by her situation, can only allude to indirectly in her words and actions.

Giuliana Bruno has written that in *In the Mood for Love*, "all is pleated."[5] That description obviously does not apply to the cheongsam, but it fits other aspects of the film. Bruno notes that Cheung's dresses, thanks to William Chang's art direction, often match the decor in her rooms, the echoed patterns and colors creating a crease in the film's interior world (fig. 11). The story unfolds

not in a straight line but gradually, like an expanding accordion. The film doubles back on itself with repeated images of Cheung descending her apartment stairs to procure thermoses of soup from a nearby shop. Those scenes are exquisitely undercranked, a filming technique that produces a dreamy, slow-motion effect, wherein time feels slightly distended. Although it belongs to a more recent past than

4. Wong Kar Wai, interviewed by Anthony Kaufman, "The 'Mood' of Wong Kar-wai; the Asian Master Does It Again" (February 2, 2001), reprinted as "Decade: Wong-Kar-wai on 'In the Mood for Love,'" *Indiewire* (December 6, 2009); http://www.indiewire.com/article/decade_wong_kar-wai_on_in_the_mood_for_love.

5. Giuliana Bruno, *Surface: Matters of Aesthetics, Materiality, and Media* (Chicago: University of Chicago Press, 2014), p. 41.

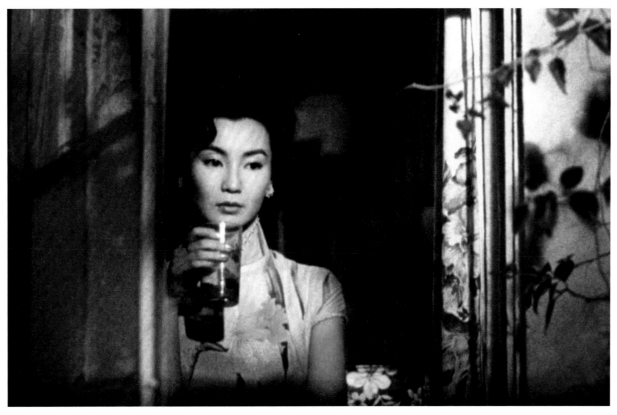

Fig. 12. Maggie Cheung in *In the Mood for Love*, 2000

Zhang's films, the Hong Kong of *In the Mood for Love* is a virtual China in its own way, an island haunted by the surrealistic temporal shifts that history imposed on it during its transitions from Chinese to British sovereignty and back again. Intertitles inscribed with poetry coat the film in the varnish of bittersweet nostalgia: "That era has passed—nothing that belonged to it exists anymore. . . . He remembers those vanished years as though looking through a dusty window-pane . . . everything he sees is blurred and indistinct."

Key images from this film are organized around windows, as though the characters were trapped behind glass, attempting to connect with one another through real and metaphorical walls. In one sequence, Cheung peers wistfully off-screen, framed by green vines and curtains of saturated turquoise and yellow, clothed in a cheongsam with a giant daffodil printed across her heart (fig. 12). The daffodil recalls the Chinese title of the film, which references the quickly expiring bloom of youth. The fading flower is not only youth; it is the characters' irrecoverable pasts and unrealized possibilities. It is also Hong Kong's past, and the futures that might have been for that island but will be no longer. Underscoring the elusiveness of the protagonists' connection, the camera tracks slowly down the exterior wall, bringing Cheung briefly in and out of view, before transitioning to a shot of Leung's character, who is also behind a window gazing off-screen. This time, in a movement that suggests what Ackbar Abbas calls "the erotics of

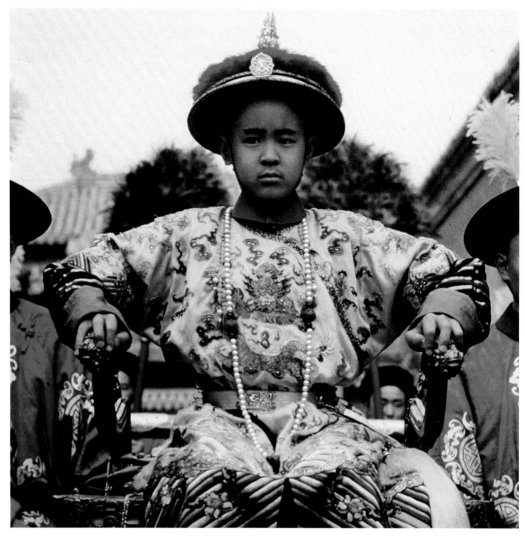

Fig. 13. Tijger Tsou in *The Last Emperor*, 1987

disappointment," the camera tracks from left to right, as if the two lovers isolated in their glass frames were sliding by without seeing each other.[6] Mere fractions of a second away in film time, and in exactly the same boat with regard to their marital situations, they are nevertheless separated by an unbridgeable psychic gulf. Accordingly, they are clothed in colors that vibrate together but that remain a hue shy of matching, as if they were just a degree out of phase.

## The Foreign within the Familiar

In contrast to both the epic time of Zhang's films and the halting, nonlinear time of Wong's, there is Bernardo Bertolucci's *The Last Emperor* (1987), which presents itself as a decade-by-decade chronicle of twentieth-century Chinese history, in the form of a biopic of Emperor Pu Yi. The film spans three eras in flashback: the close of the Qing

dynasty, with scenes filmed in the Forbidden City; the Nationalist era, set in the imperial court that under Japanese rule was relocated to the puppet state of Manchuria; and the Communist Revolution, the present tense of the film, during which Pu Yi is interned in a reeducation camp. The three locations, as producer Jeremy Thomas notes, are simultaneously theaters and prisons that Pu Yi could not escape;[7] the emperor, who succeeded to the throne as a two-year-old, was forced to play a series of roles and was powerless to shape his own fate, much less his nation's. The early scenes feature meticulous replicas of imperial garb, including *changshans* (the "long shirts" that are the male equivalent of cheongsams), with Pu Yi appearing in the yellow coronation version that is hemmed with surprisingly contemporary-looking diagonal stripes (fig. 13).

The film is studded with references to its own theatricality and to the imagistic aspects of national identity. In her grand chamber, Empress Dowager Cixi wears her hair folded over massive, heavy-looking hair combs trimmed with tassels and beads. Women of the court, also with gravity-defying coiffures, go boating on a lotus pond within the palace walls. A large mirror sits at the back of their boat, and one of the women peers through opera glasses. The framing and art direction here indicate how enmeshed these characters are in the potent dynamics of seeing and being seen. The film draws further attention to the pageantry of the court with references to Pu Yi's poor eyesight: although it wouldn't look right for the emperor to wear glasses, he cannot see without them. Like Bertolucci's *The Conformist* (1970), the film at times adheres closely to history, particularly in costume and setting, but it is equally a meditation on the theatricality of power and the power of visual spectacle.

Bertolucci once said that imperial yellow, the distinctive color worn only by the Chinese emperor, reminded him of the golden yellow buildings in his hometown of Parma, Italy.[8] Another Italian filmmaker, Michelangelo Antonioni, likewise discovered the familiar on foreign shores. For his 1972

documentary *Chung Quo–Cina*, Antonioni visited the city of Suzhou, in eastern China, and filmed its canals and bridges. In voice-over, he notes that they remind him of Venice. During a scene shot in a restaurant with fettuccini-style noodles, the director says, "It isn't easy to accept that the Chinese invented it all." Like Bertolucci, Antonioni is struck not merely by the similarities between the two cultures but by the revelation that touchstones from home—all internalized as core elements of cultural identity and the self—might have originated elsewhere. Just as there are traces of the pagoda in the Art Deco skyscraper, there are traces of the Forbidden City in Parma and of Suzhou in Venice.

The Western fascination with "the Orient," in such instances, might not be merely the result of a fetishistic curiosity or xenophobic projection, although those attitudes can be detected in certain texts and films. Rather, it might stem from the uncanny realization that one's own culture is a mosaic of fragments that arrived, once upon a time, from elsewhere. Where did they all come from—the curious ceramic figurines, the silks and metallic brocades, the smoky metaphors of tea and blossoms that we see scattered throughout cinema's visual worlds? They came from a virtual place that is somewhere between East and West and is both and neither at the same time—a place that film is particularly well suited to invent and animate, and where cinema finds itself at home.

6. Ackbar Abbas, "The Erotics of Disappointment," in *Wong Kar-wai*, edited by Jean-Marc Lalanne (Paris: Editions Dis Voir, 1997), pp. 39–81.

7. Commentary track, *The Last Emperor*, directed by Bernardo Bertolucci (1987; New York: Criterion Collection, 2008), DVD.

8. James Greenberg, "Bernardo Bertolucci: The Emperor's New Clothes," *DGA Quarterly* (Spring 2008); http://www.dga.org/Craft/DGAQ/All-Articles/0801-Spring-2008/Shot-to-Remember-The-Last-Emperor.aspx.

# EMPEROR
# TO
# CITIZEN

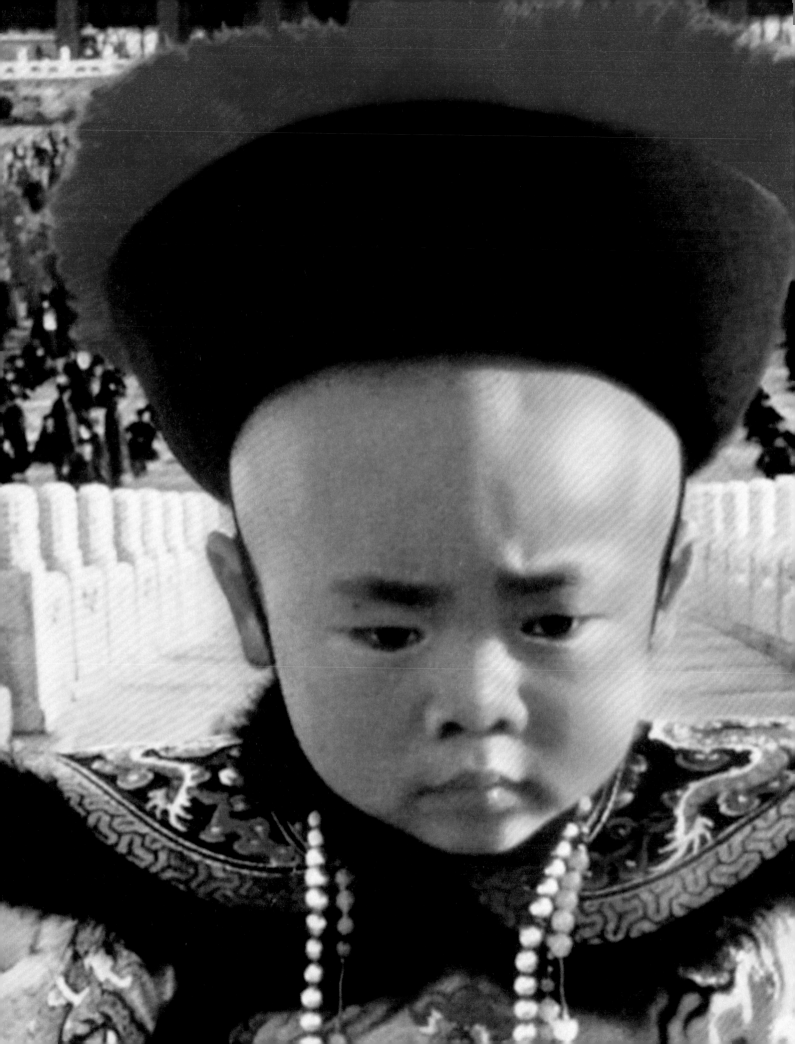

IMPERIAL
CHINA

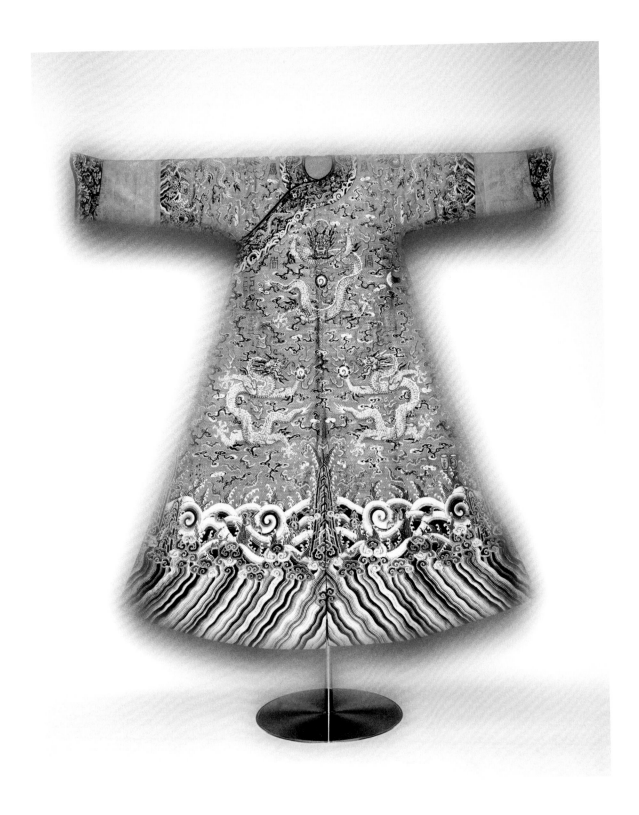

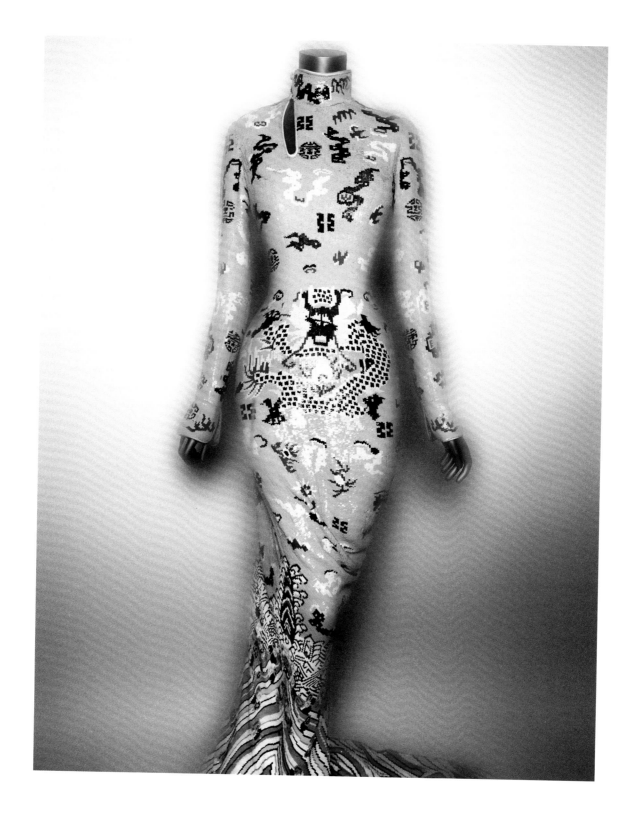

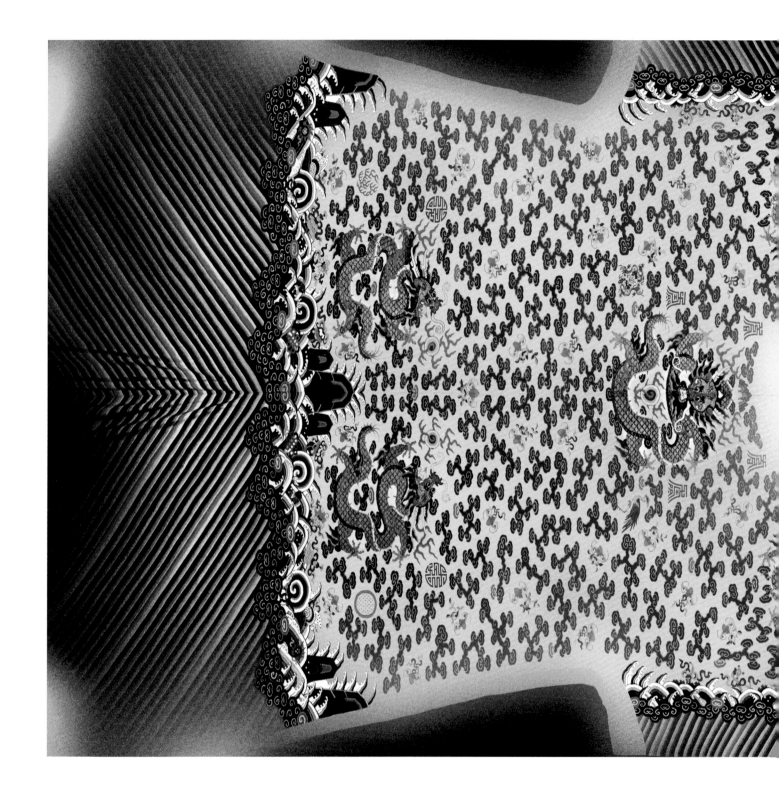

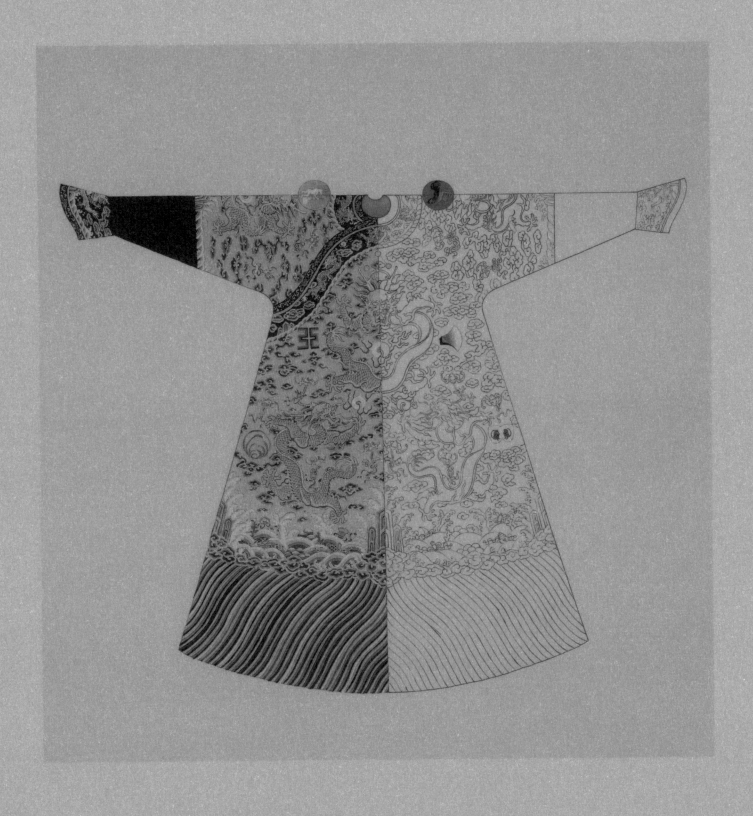

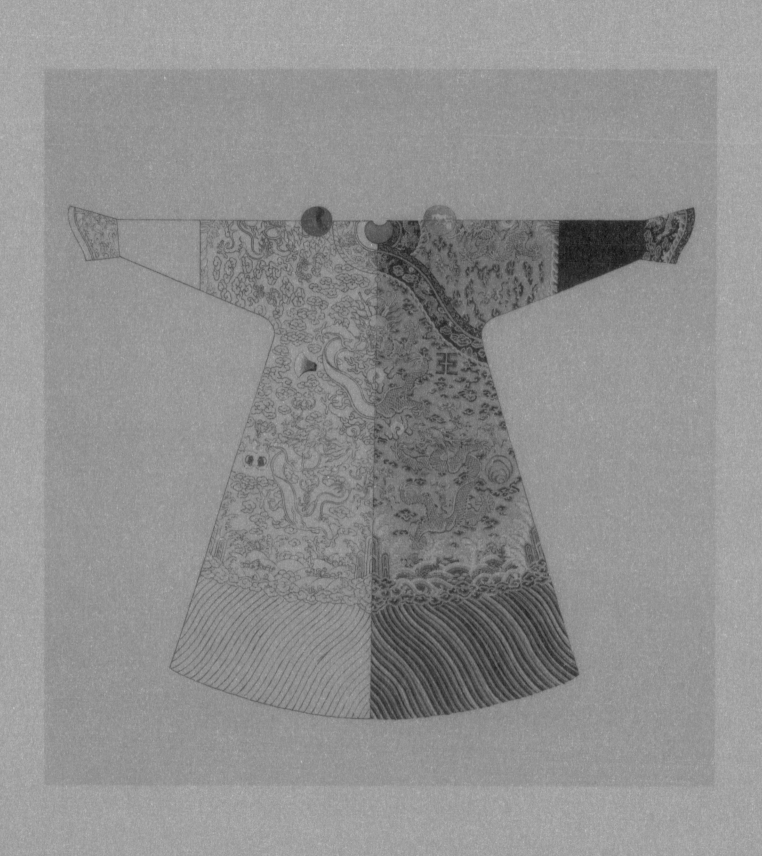

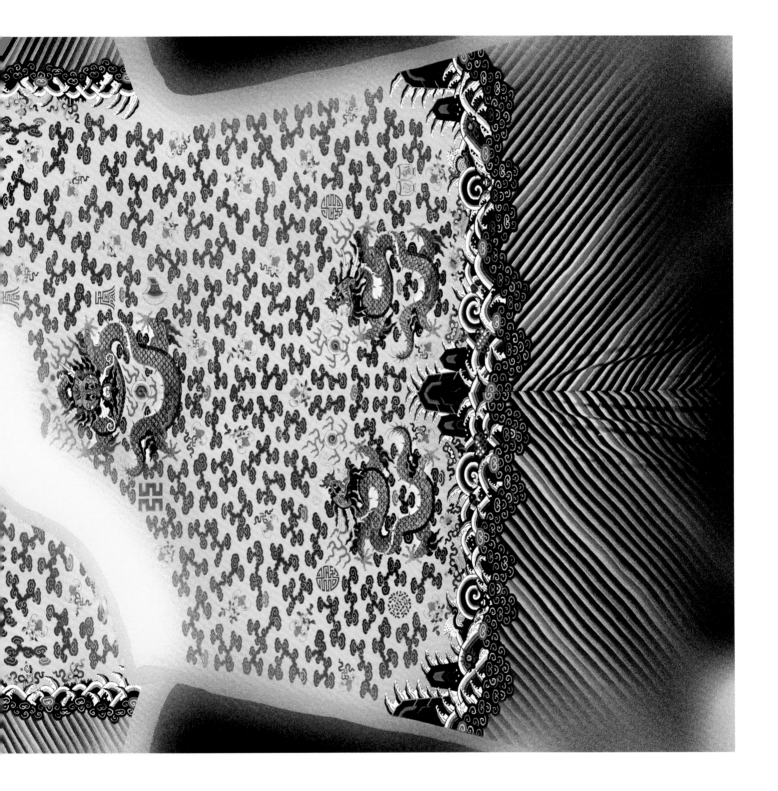

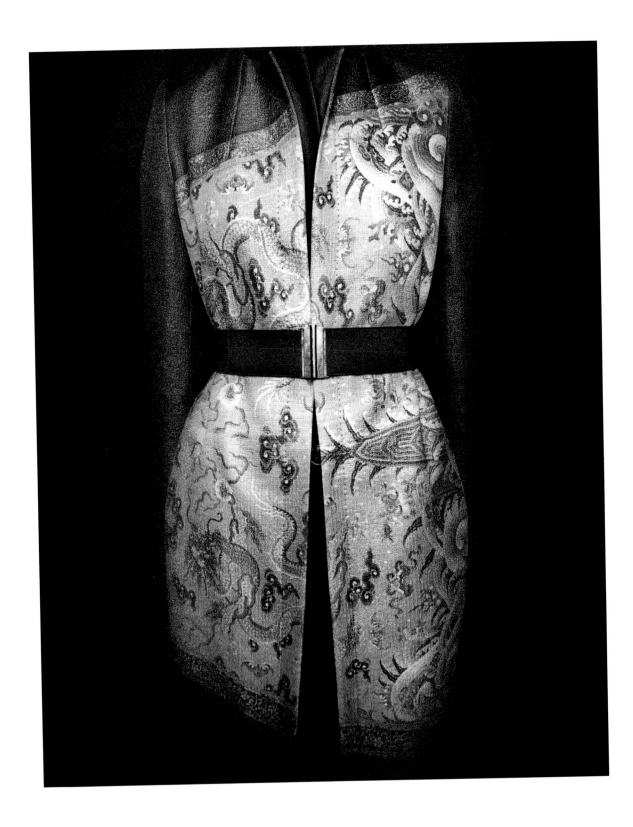

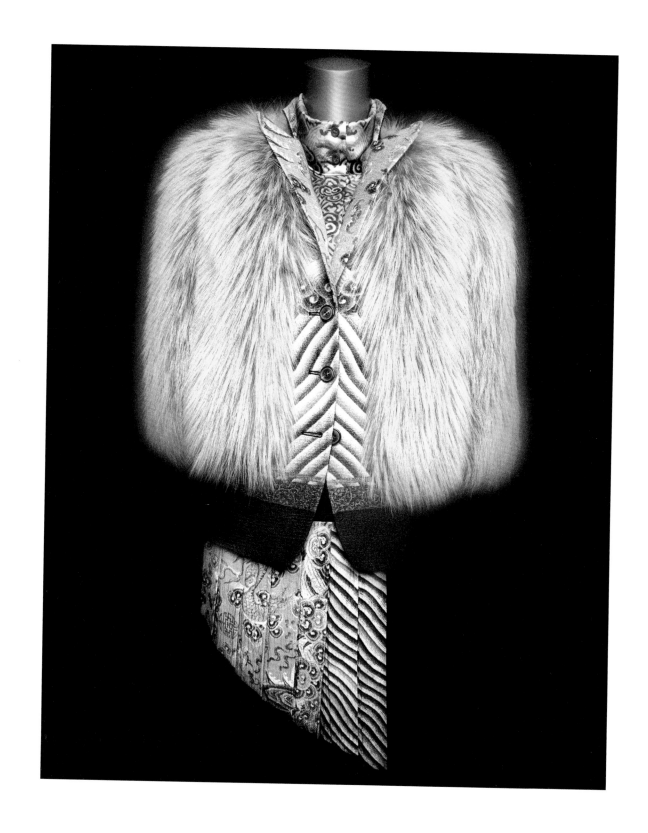

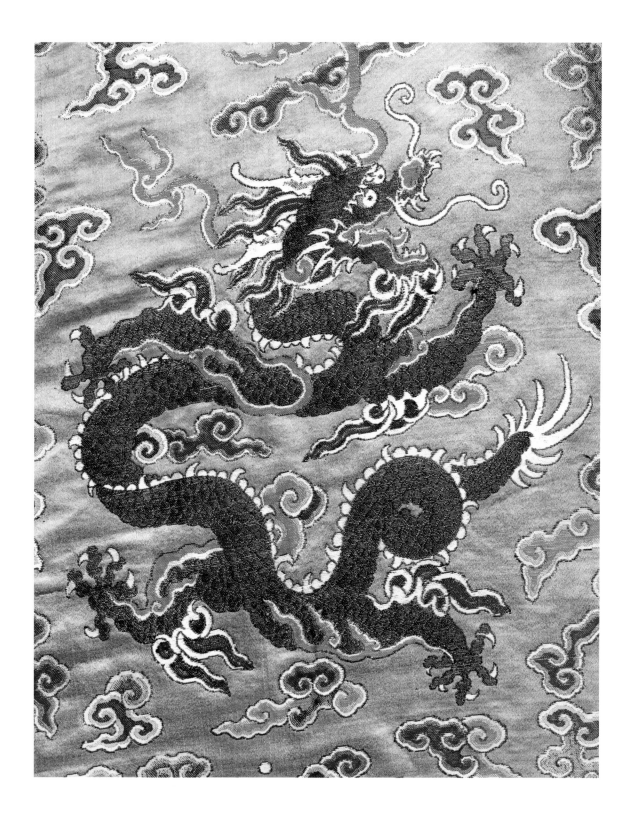

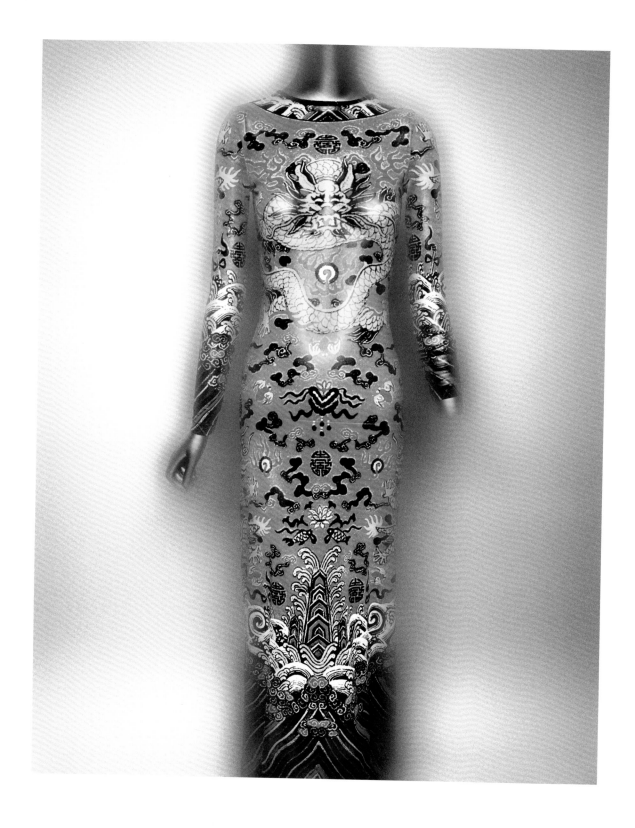

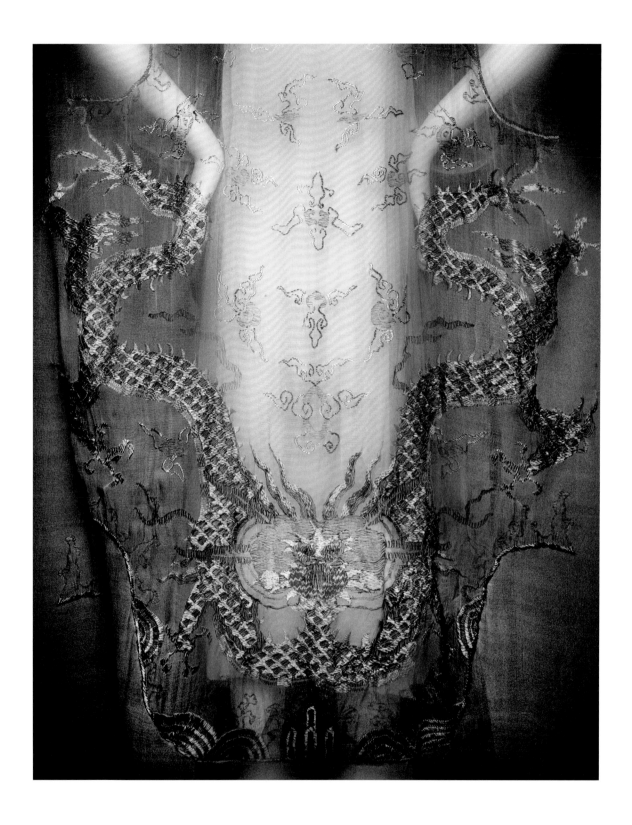

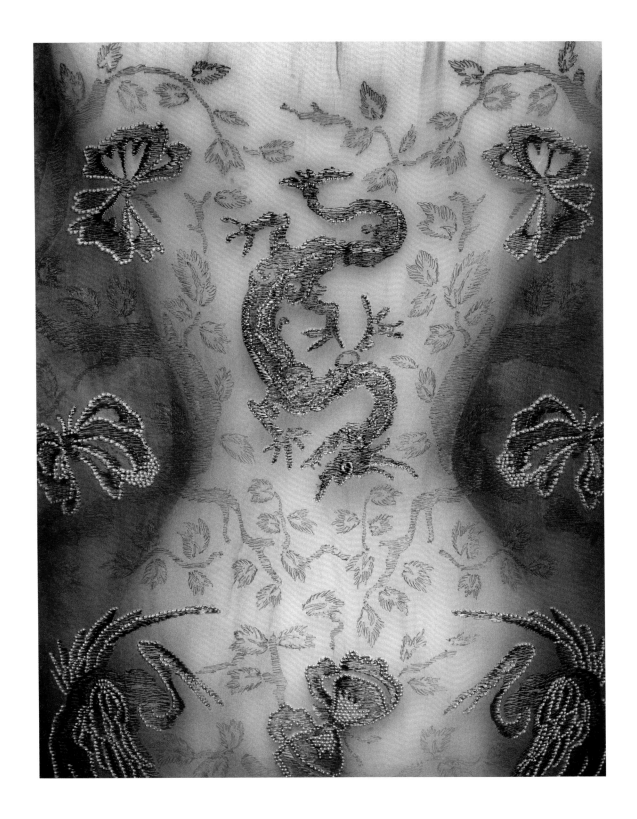

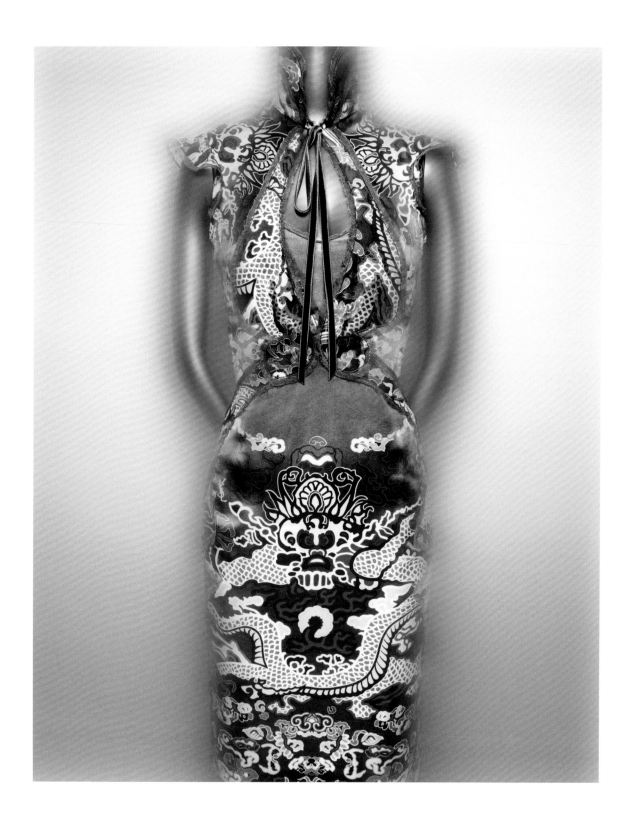

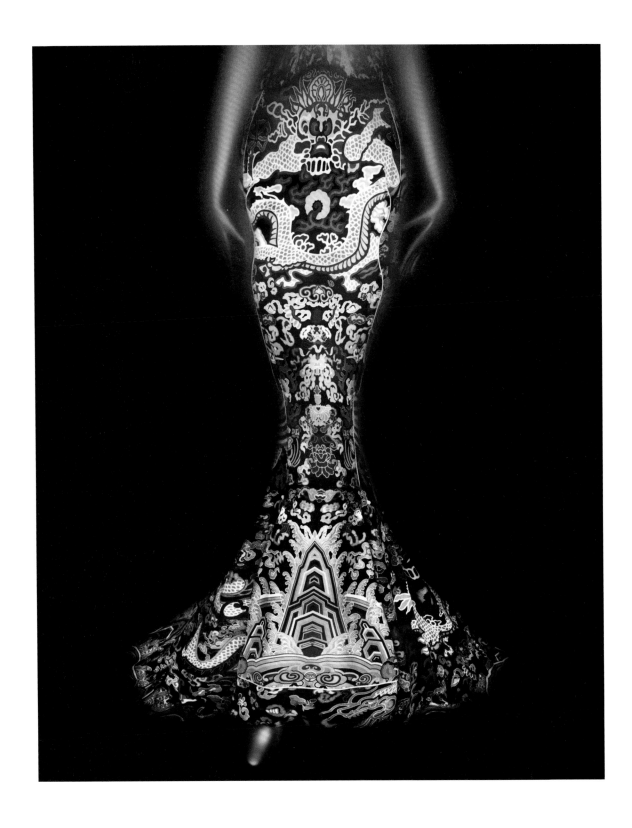

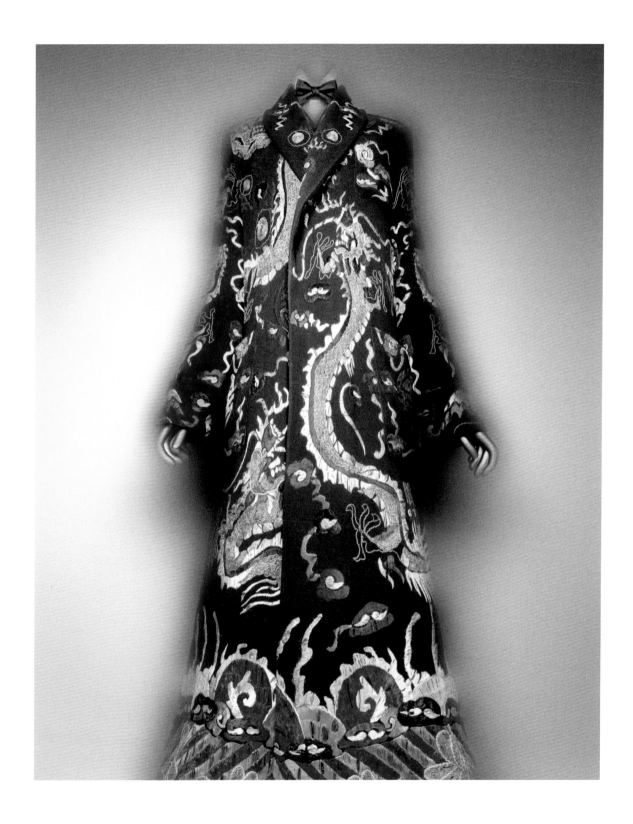

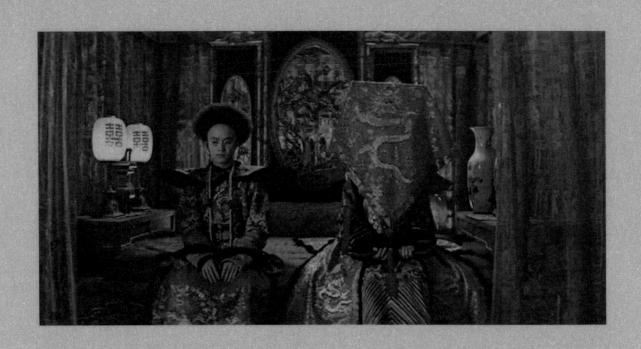

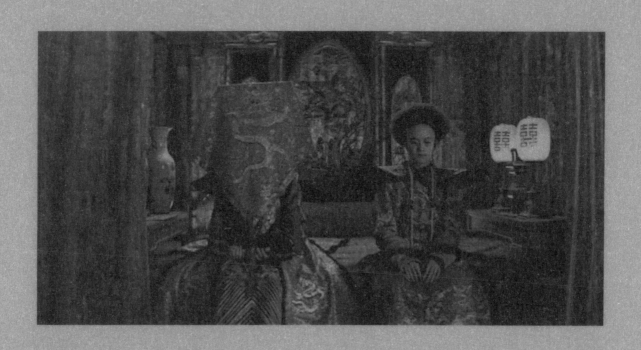

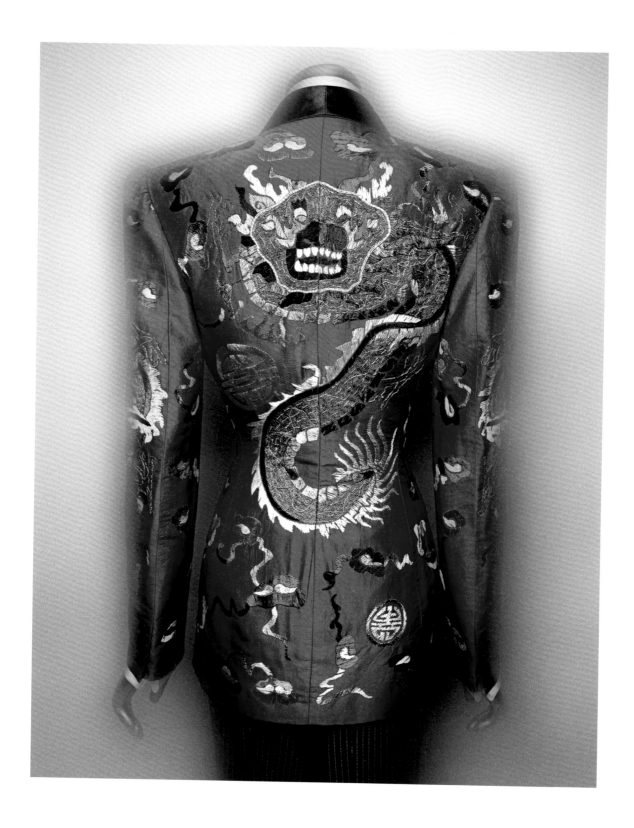

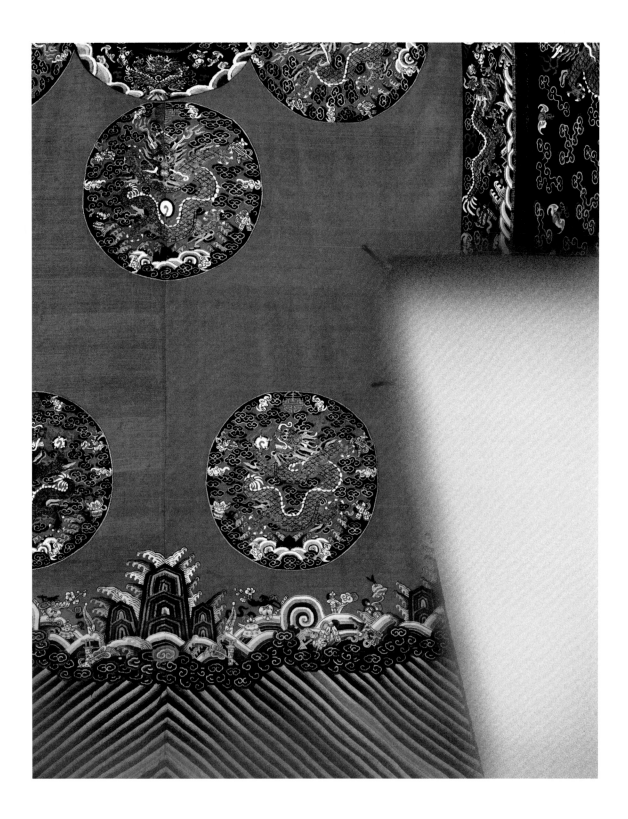

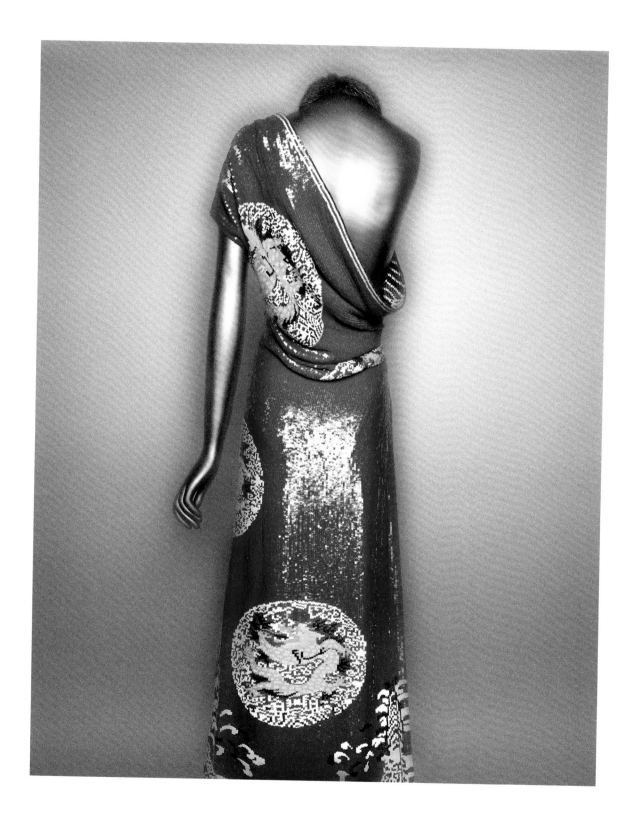

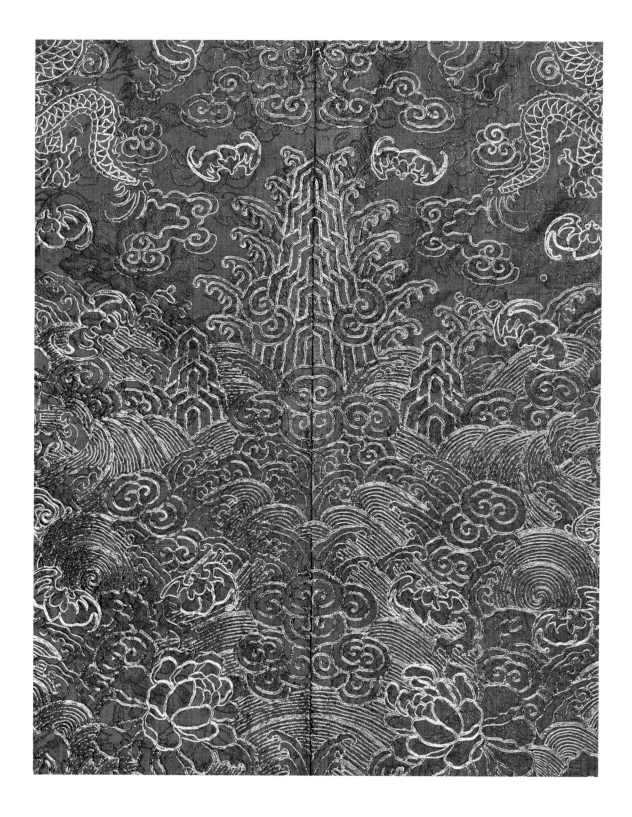

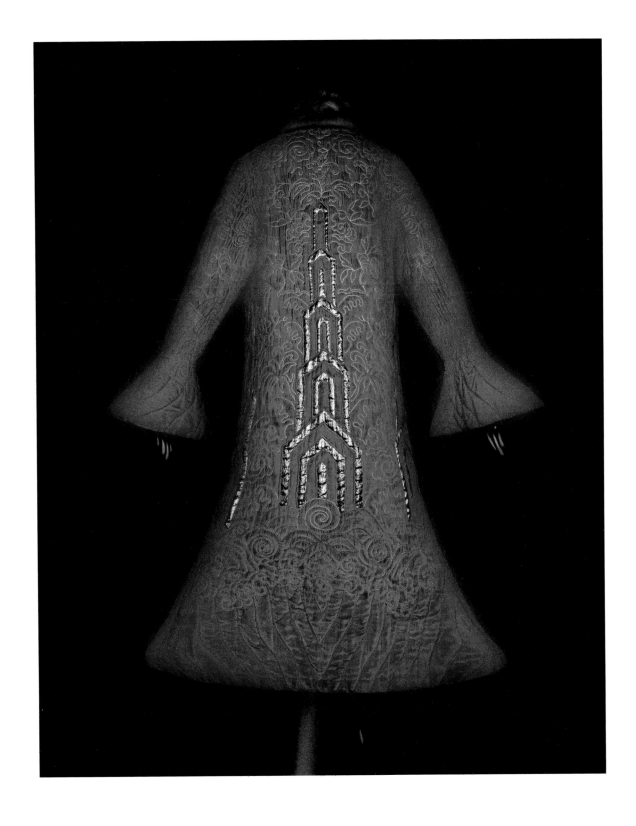

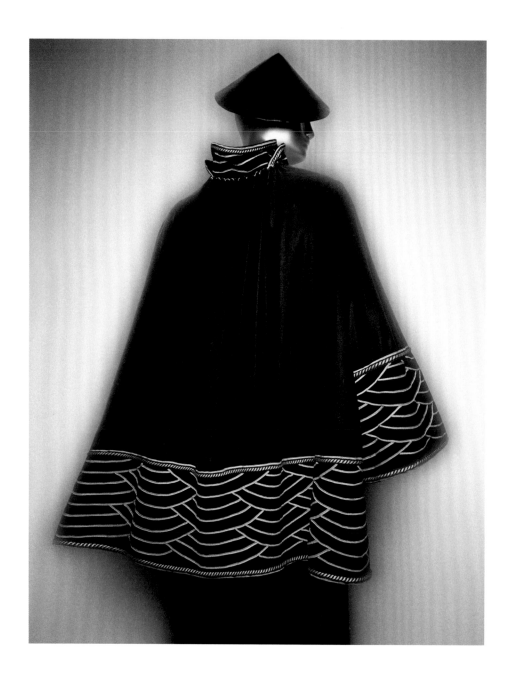

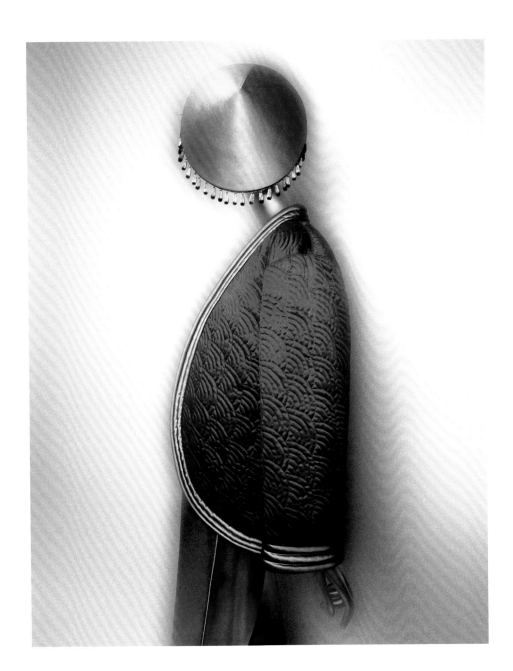

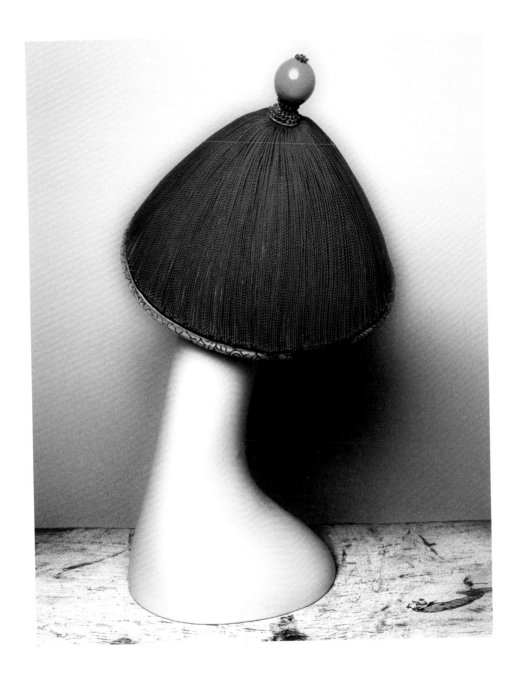

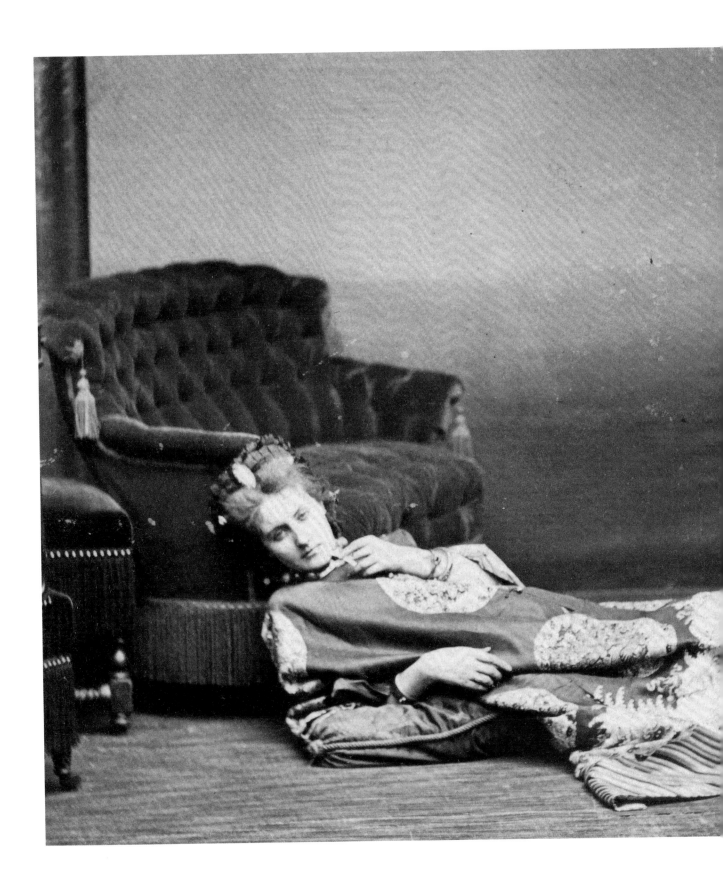

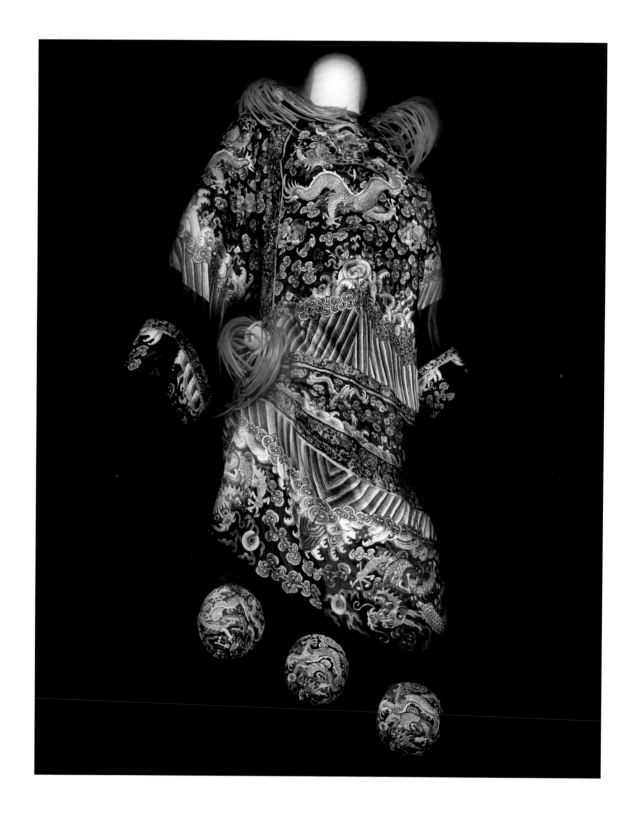

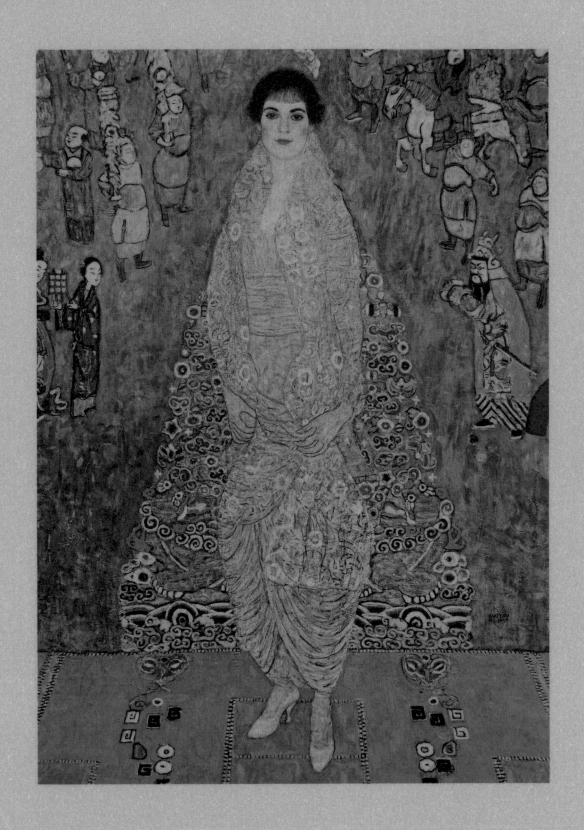

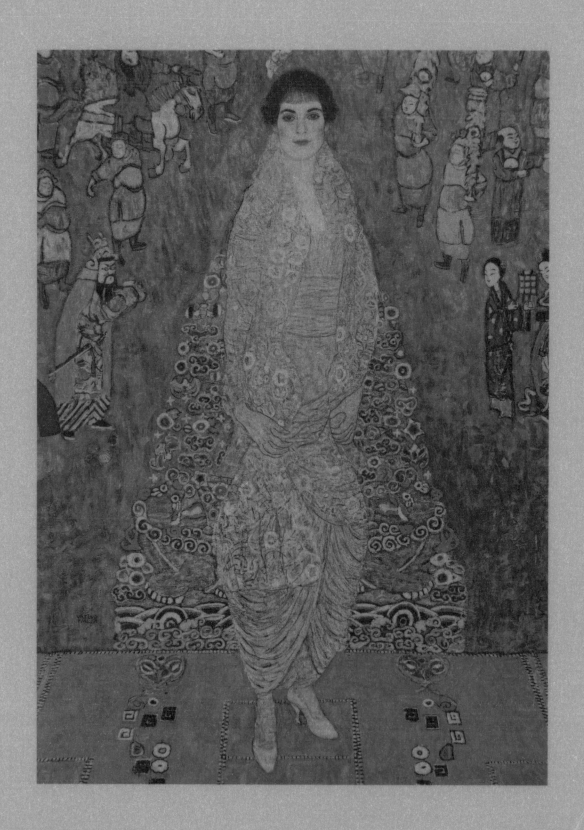

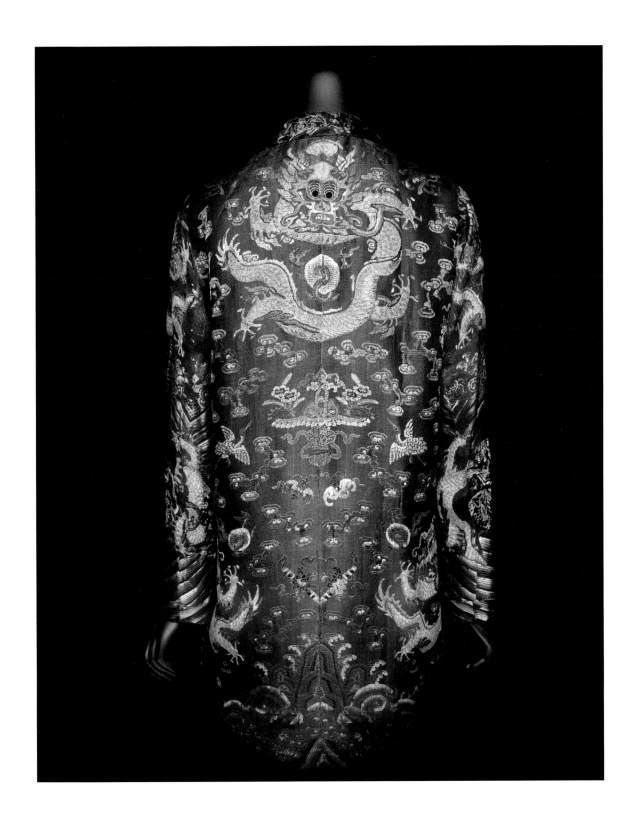

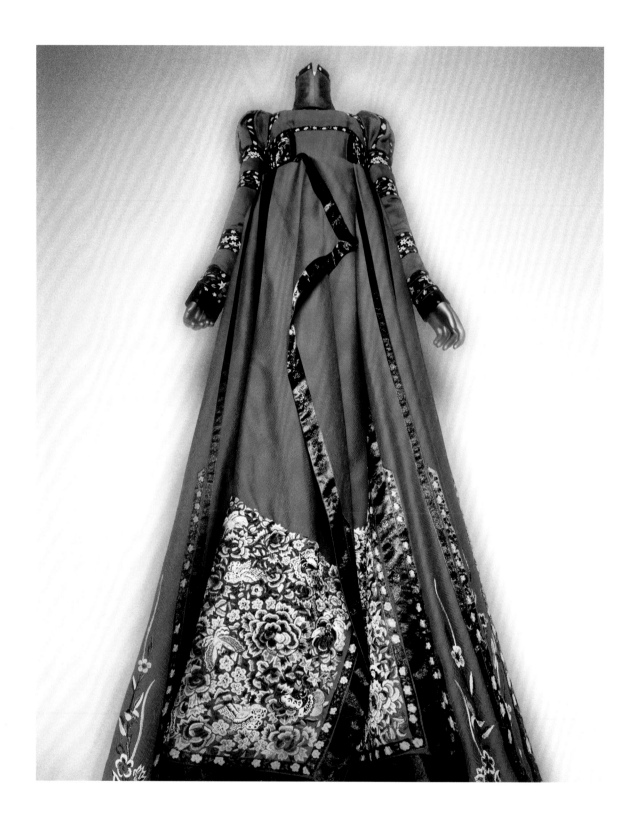

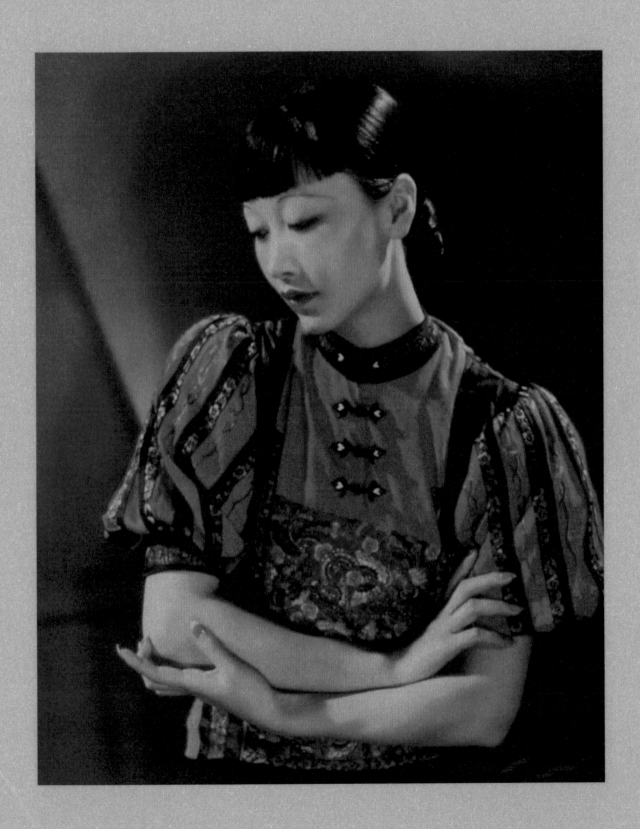

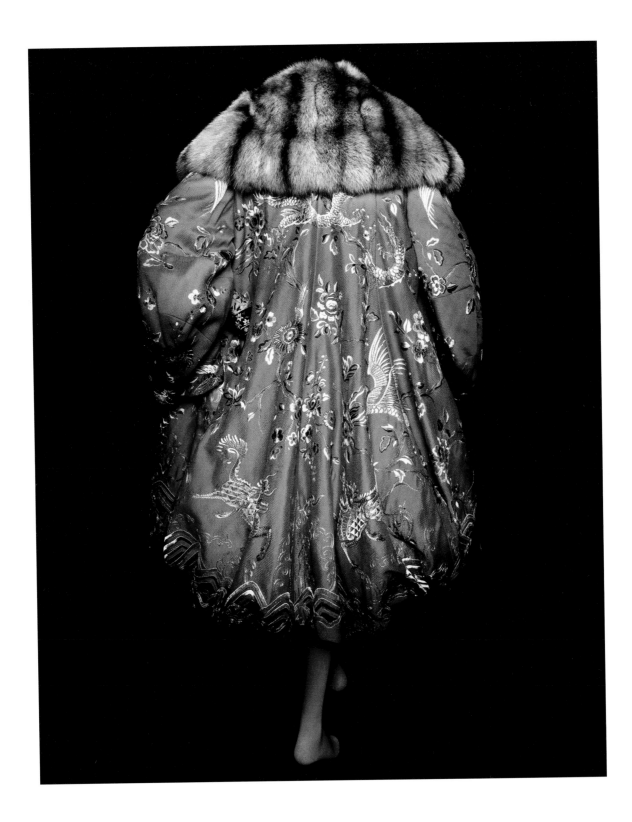

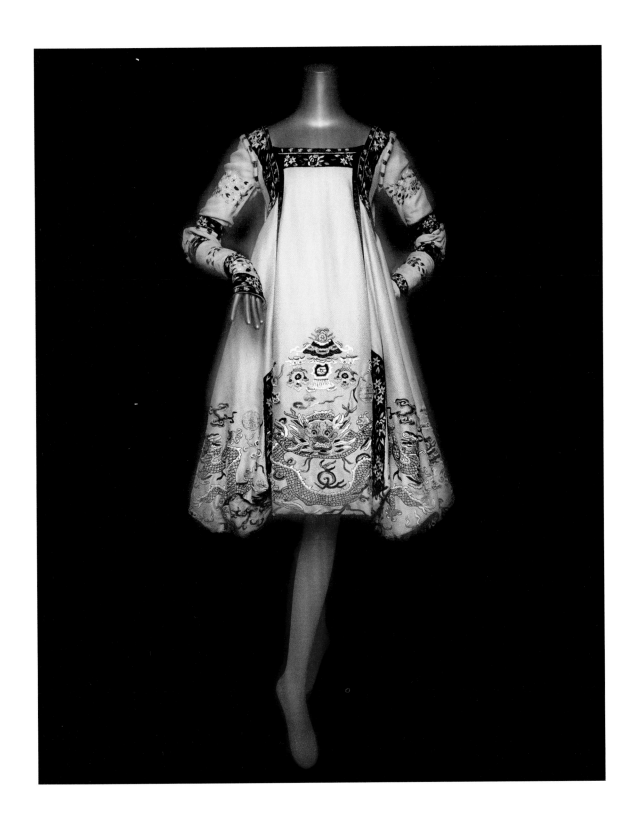

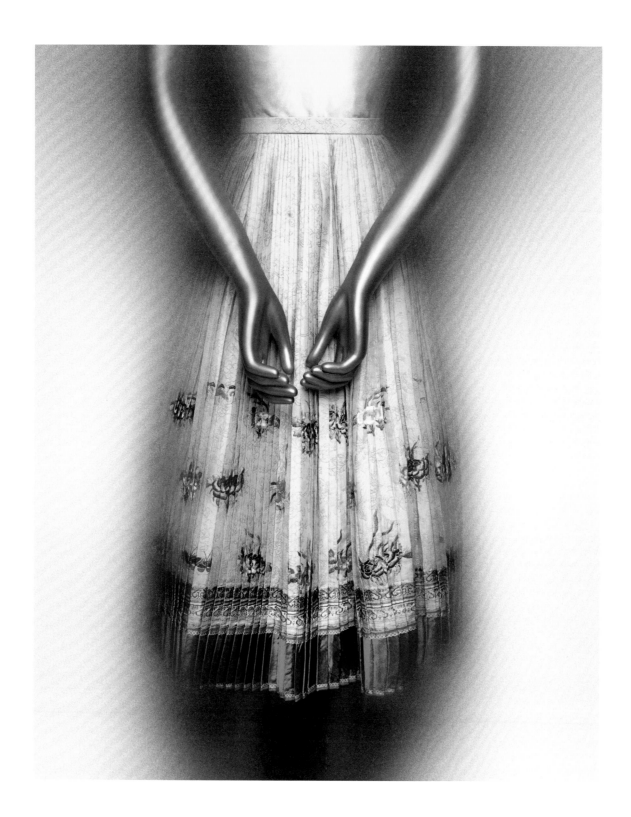

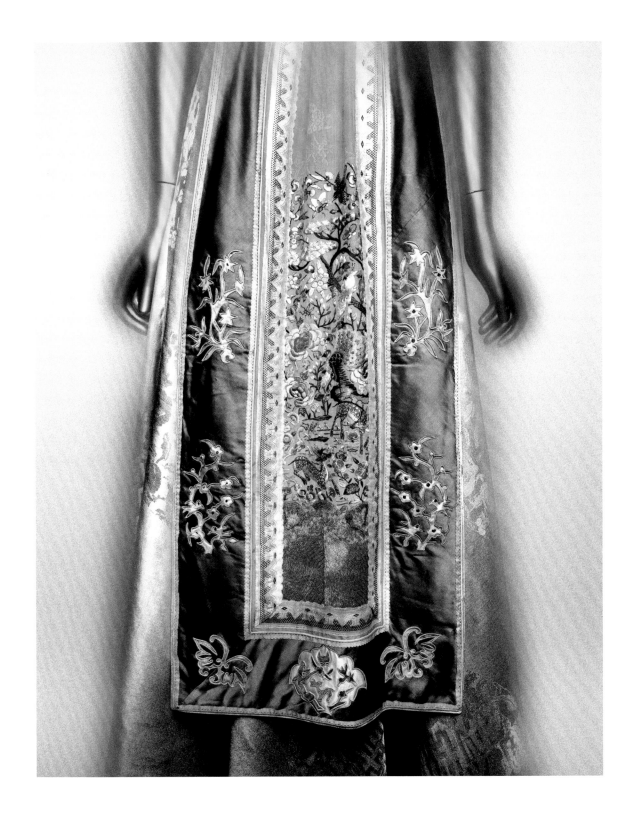

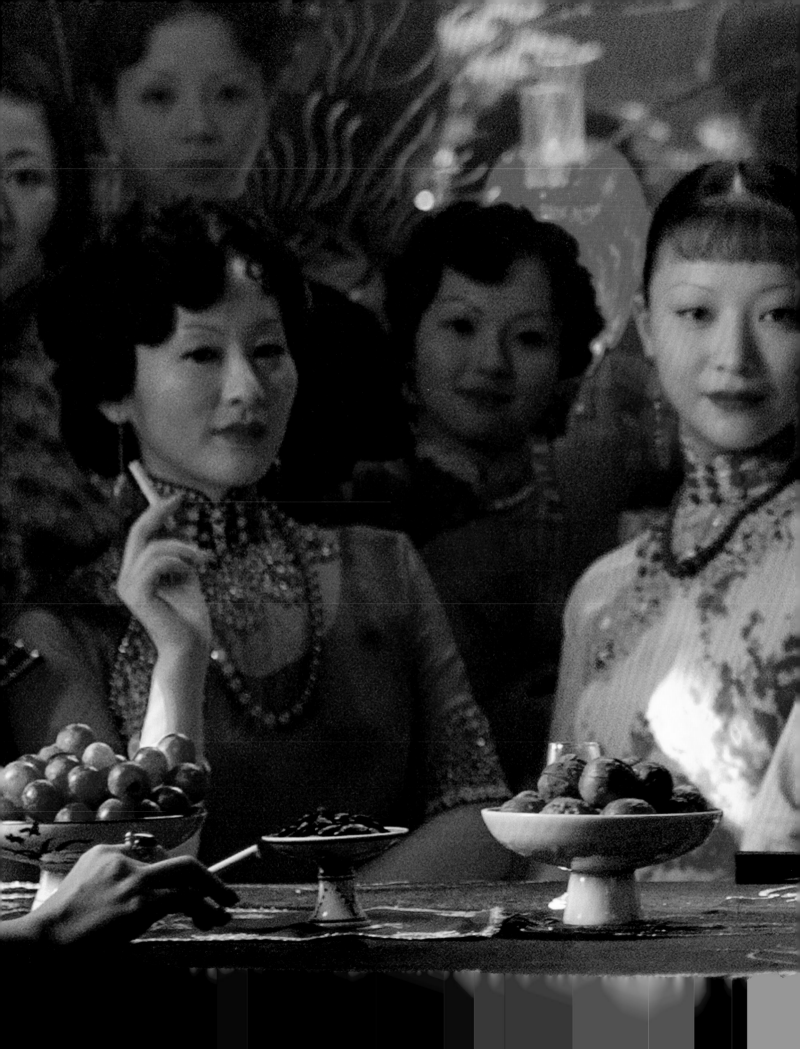

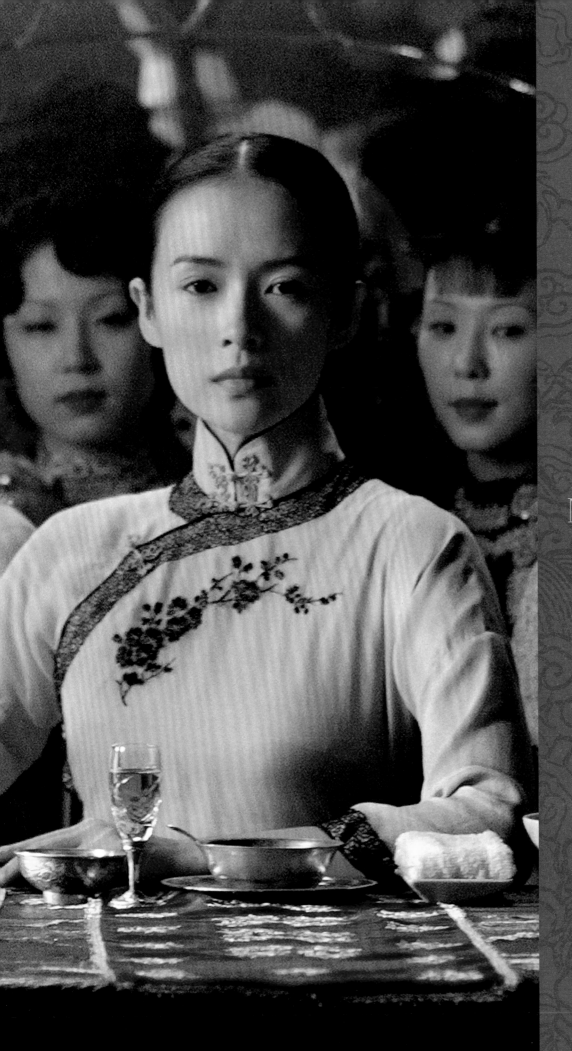

NATIONALIST
CHINA

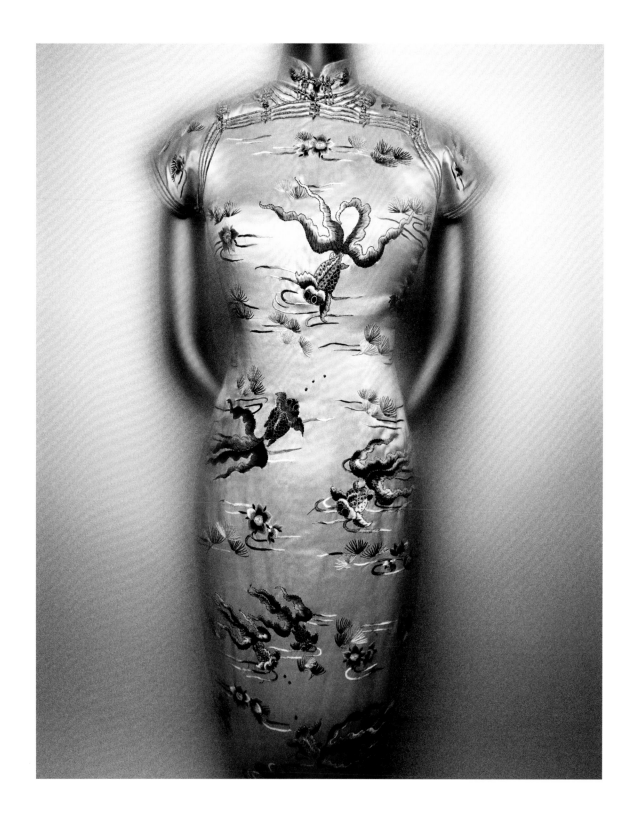

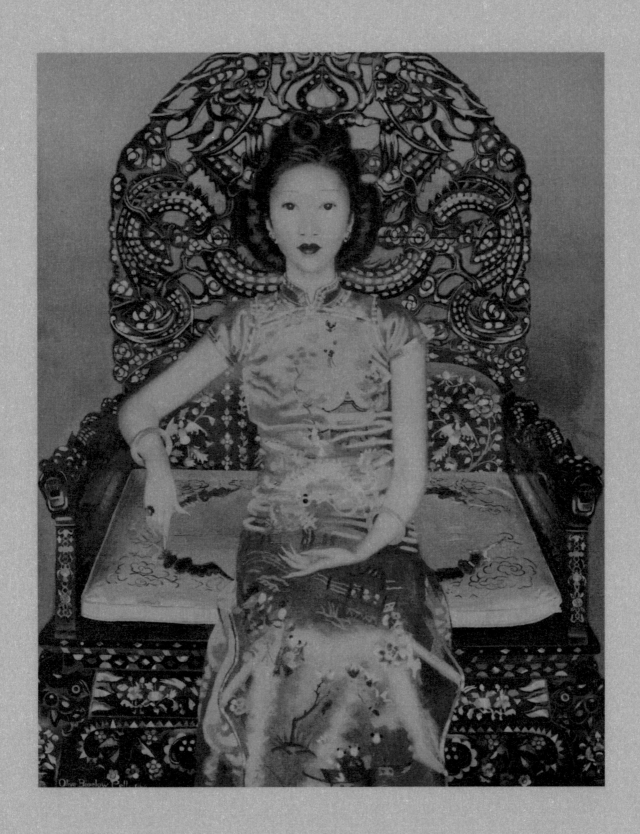

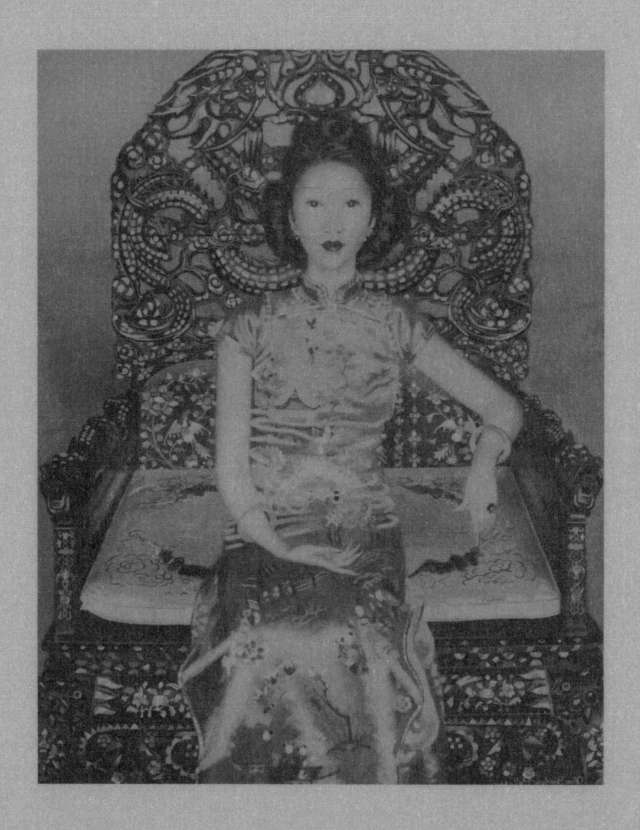

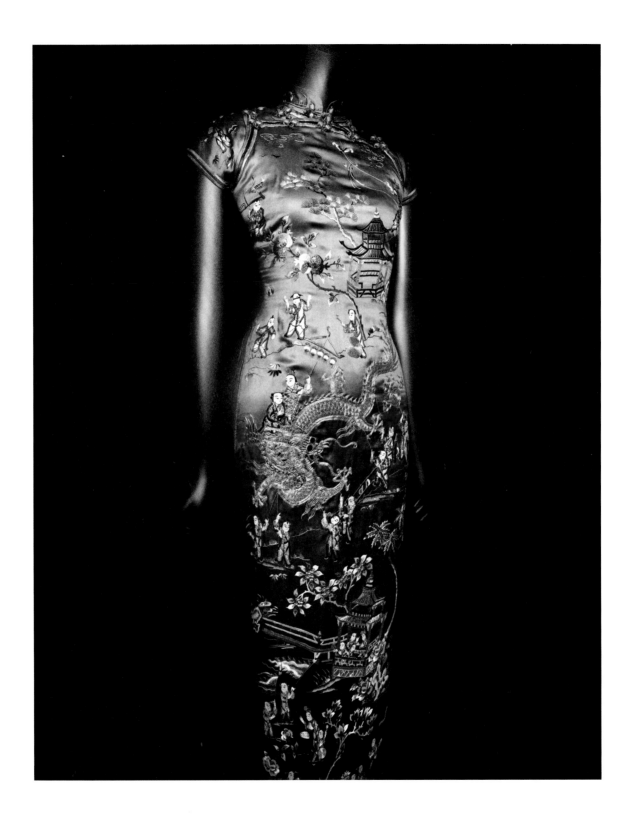

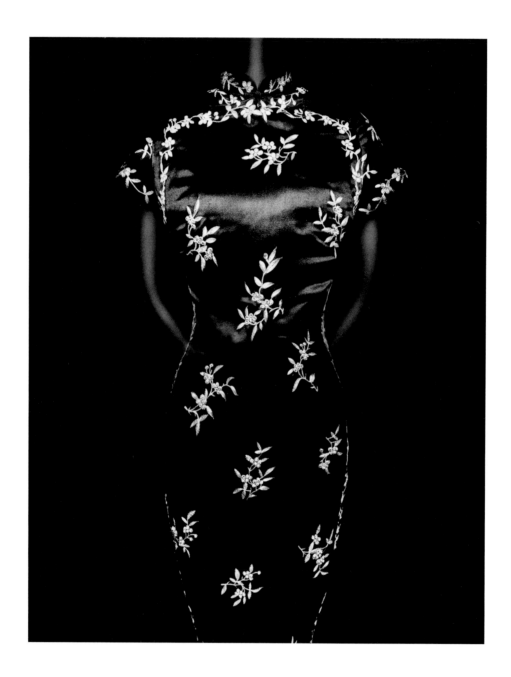

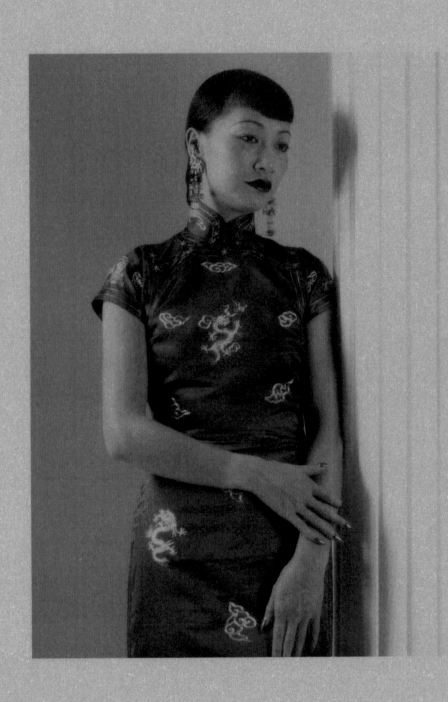

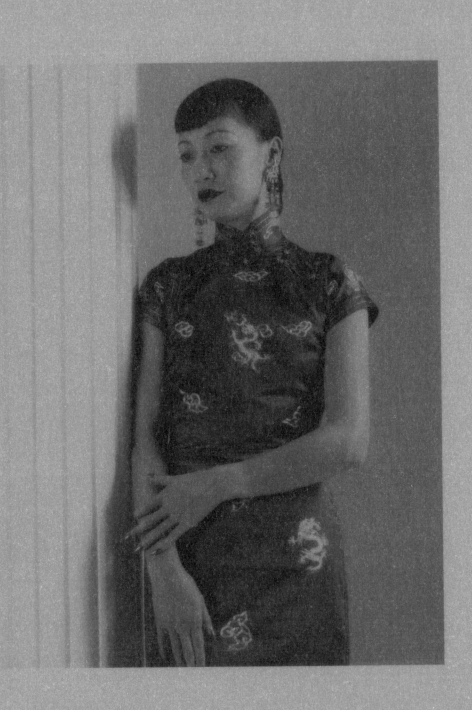

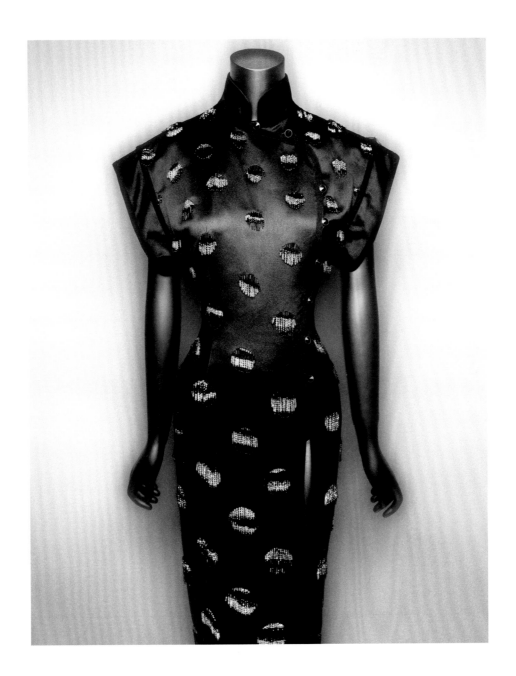

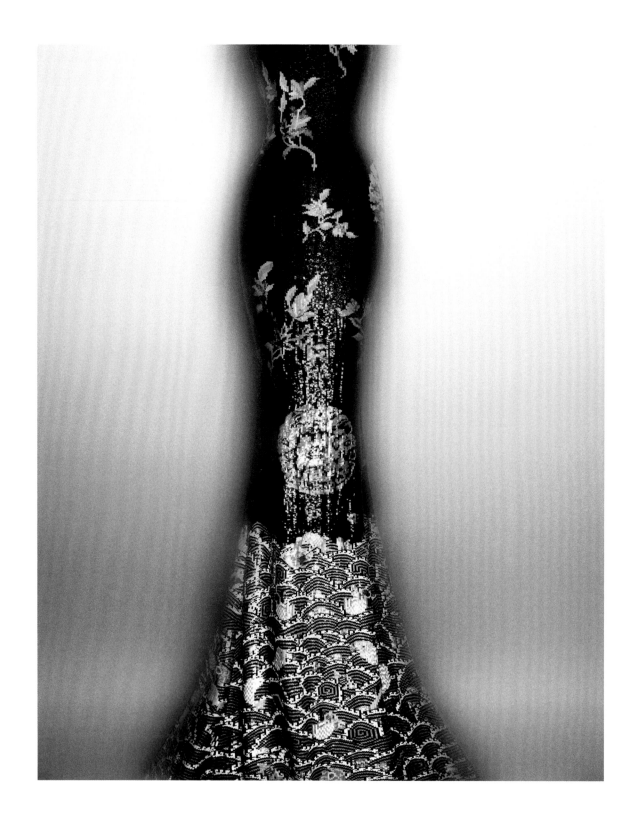

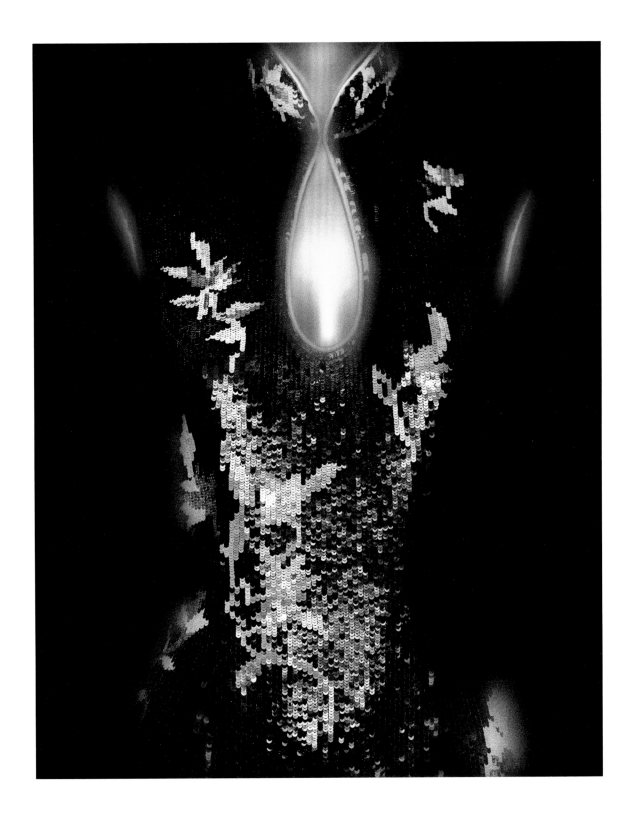

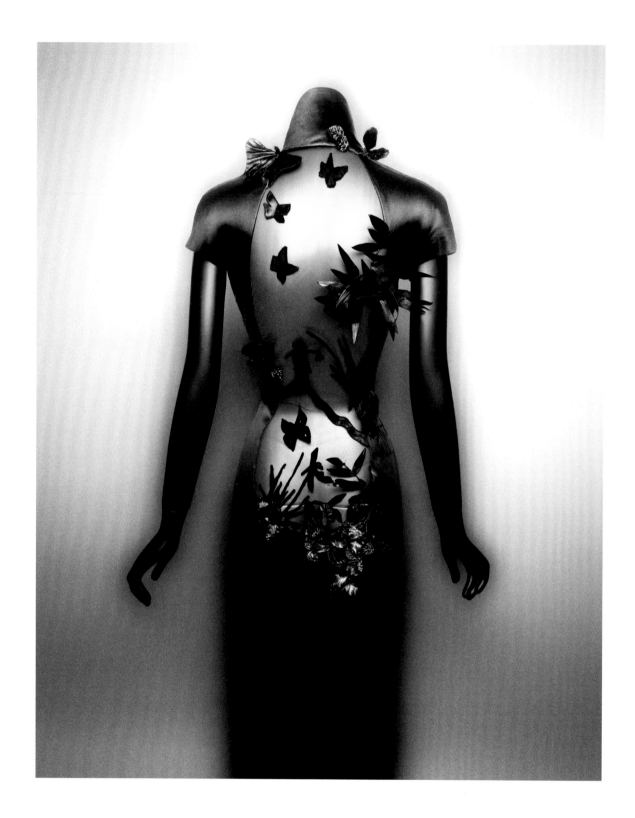

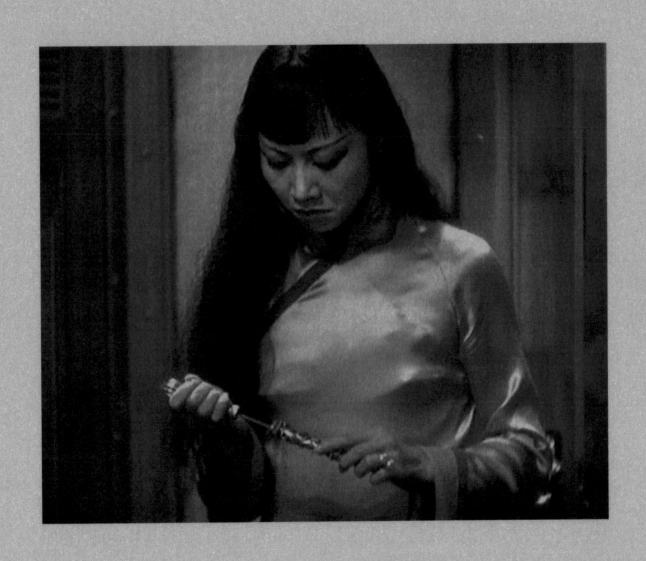

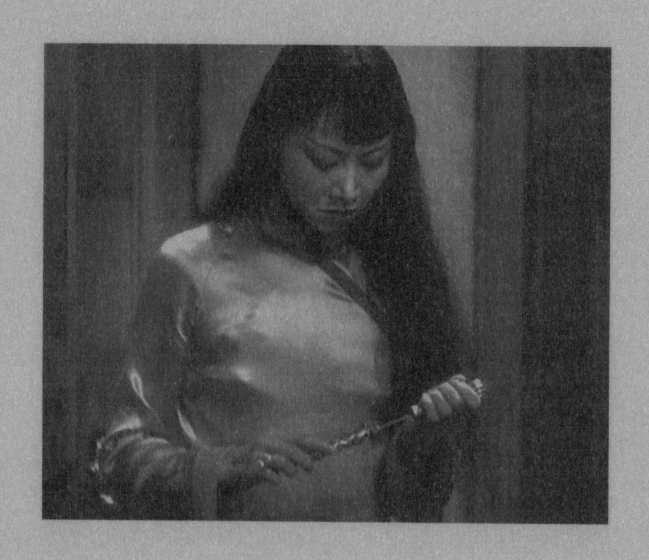

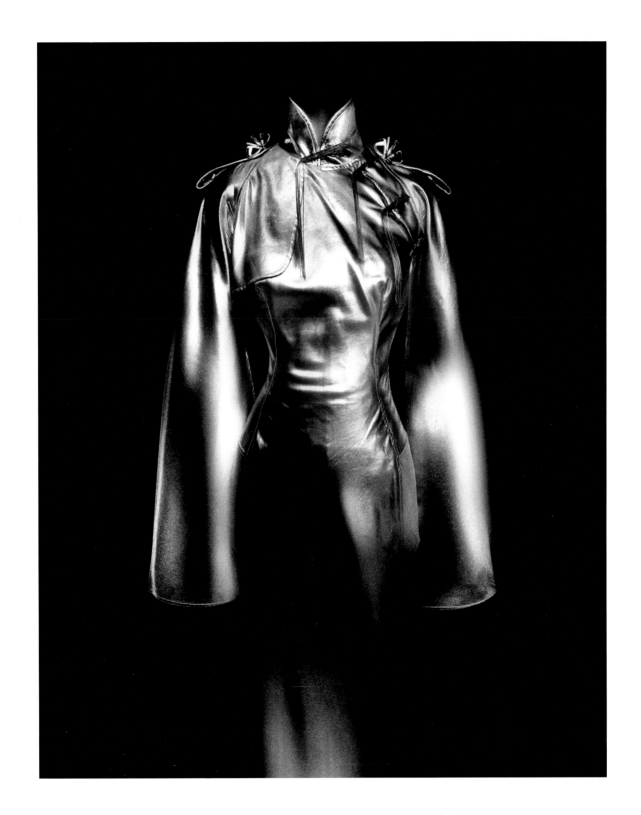

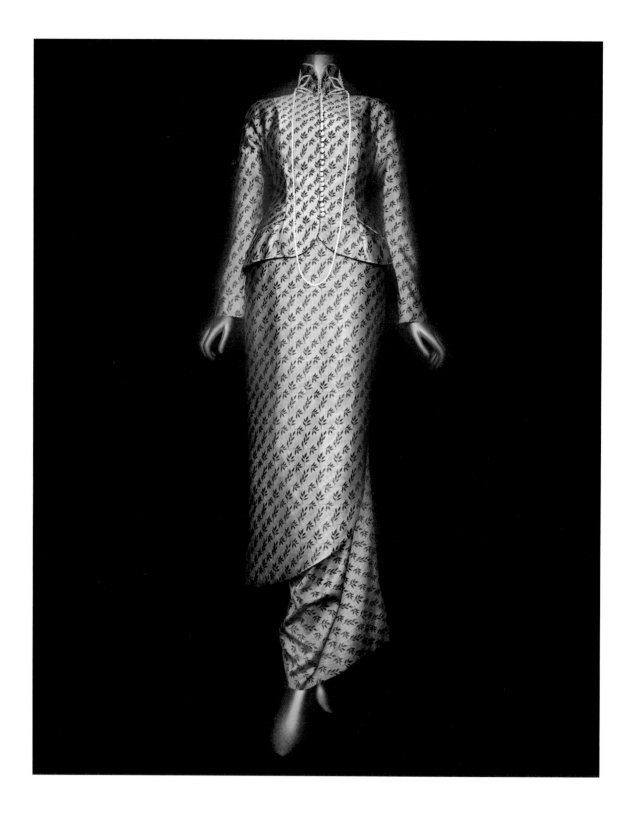

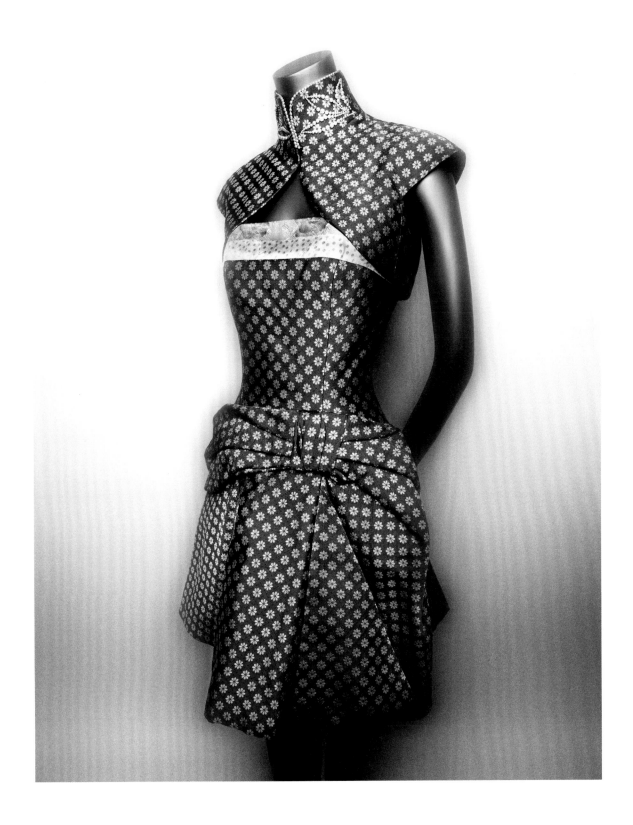

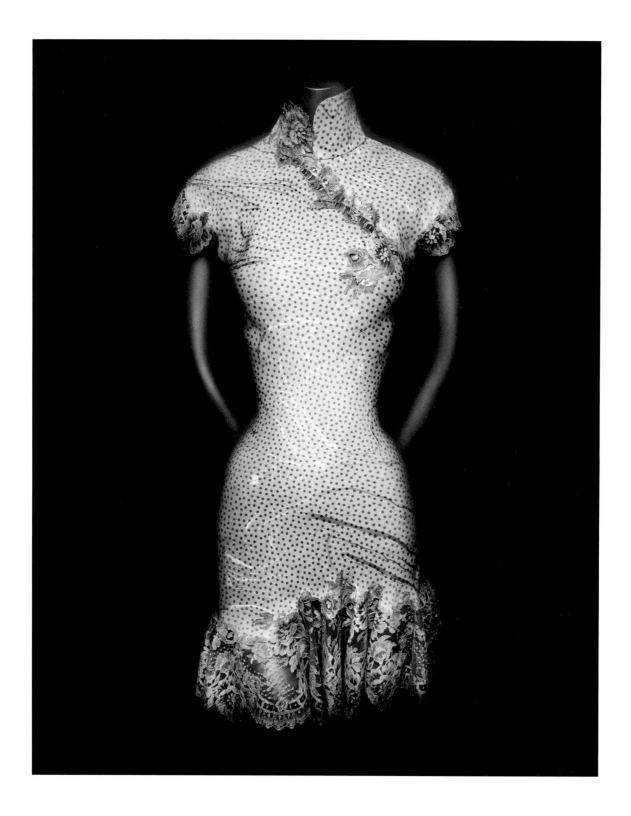

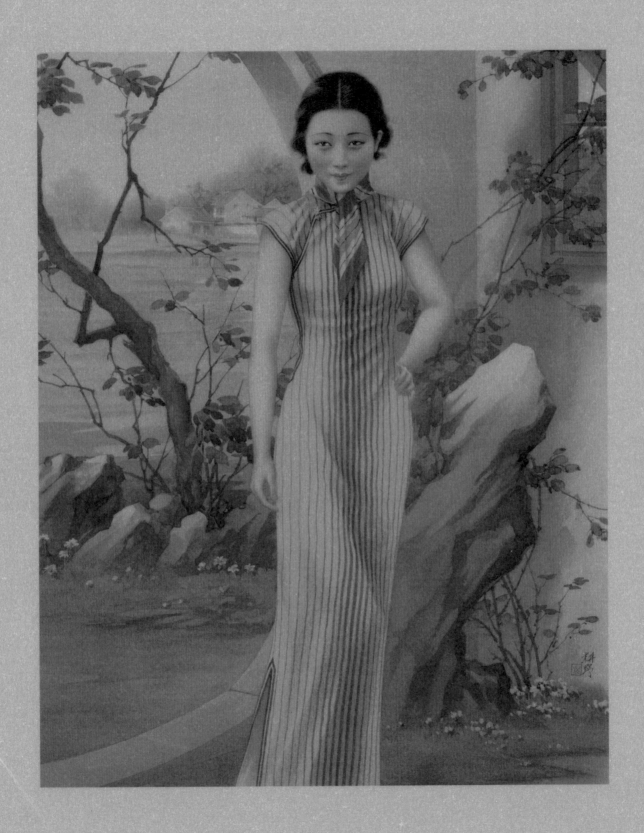

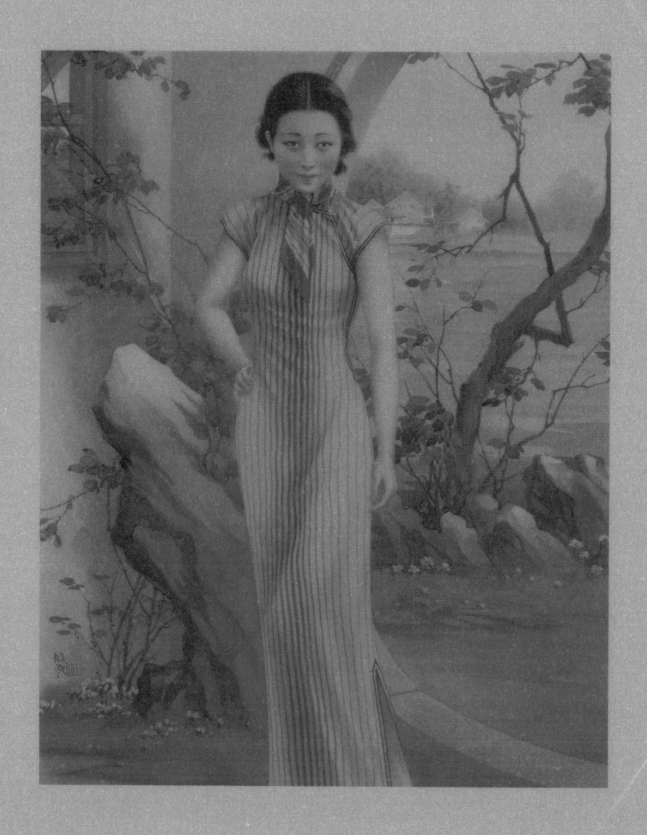

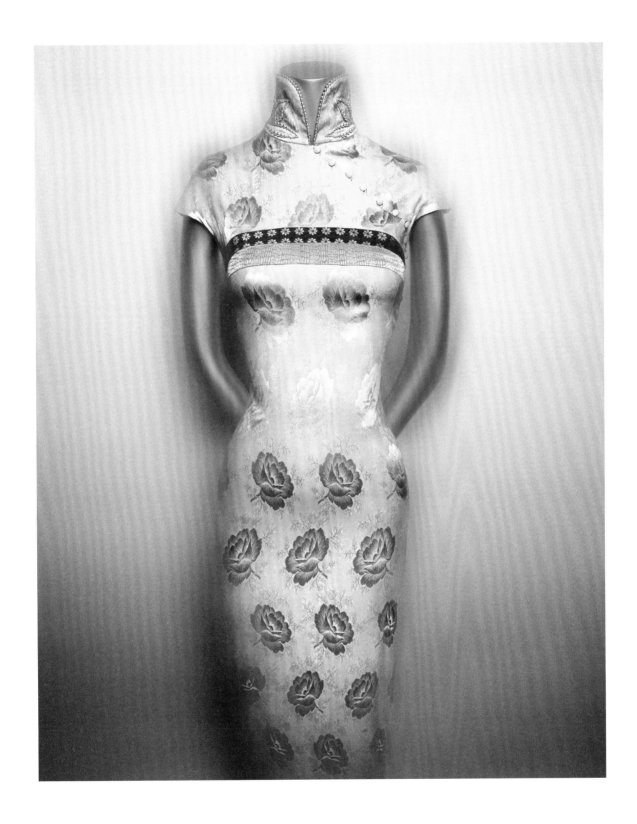

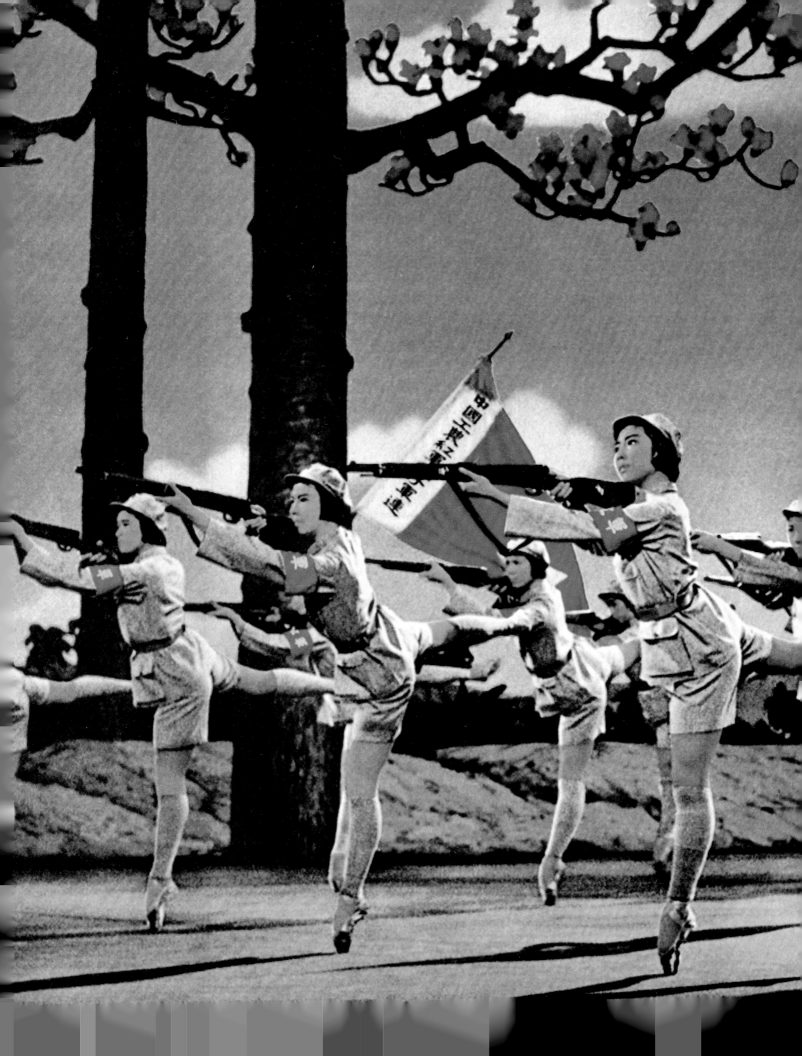

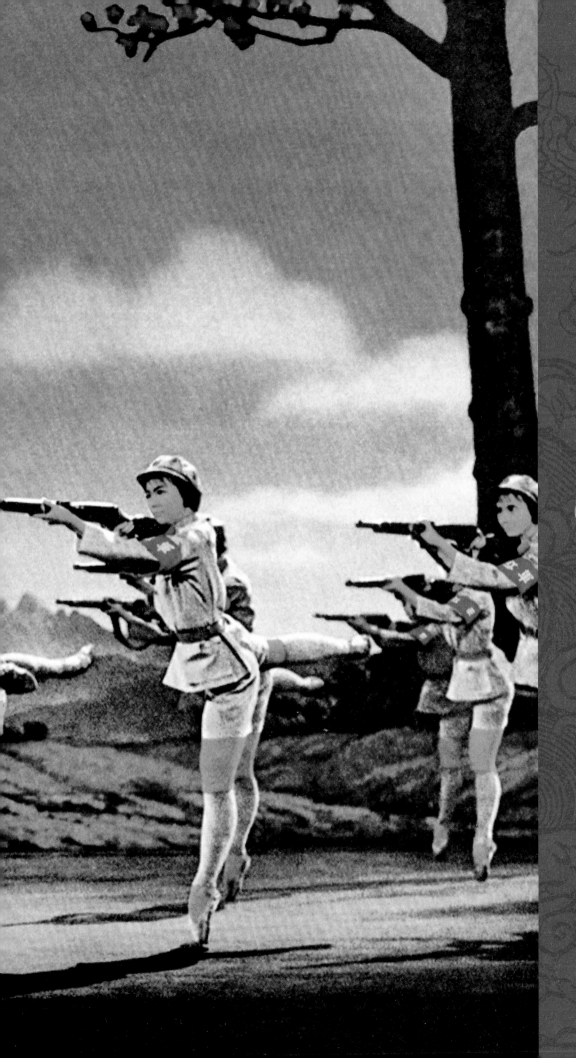

COMMUNIST
CHINA

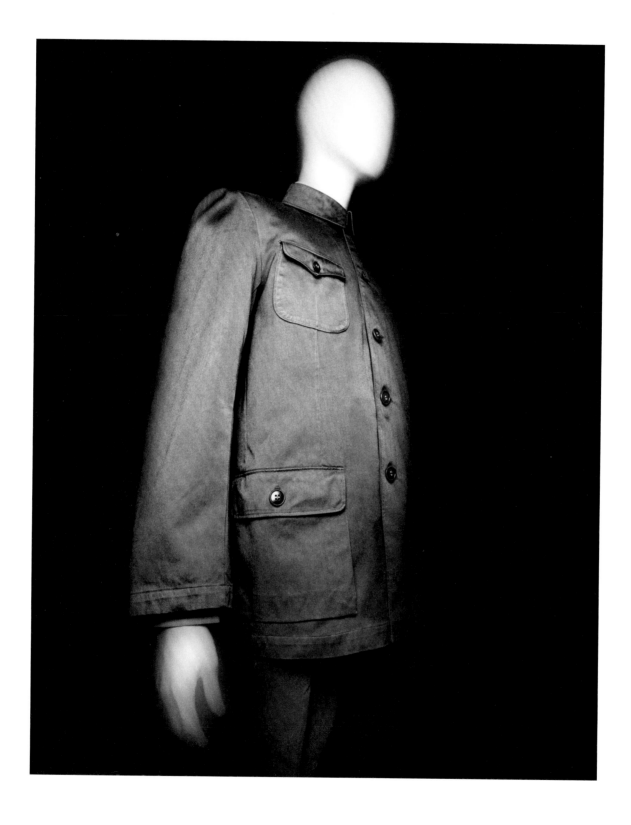

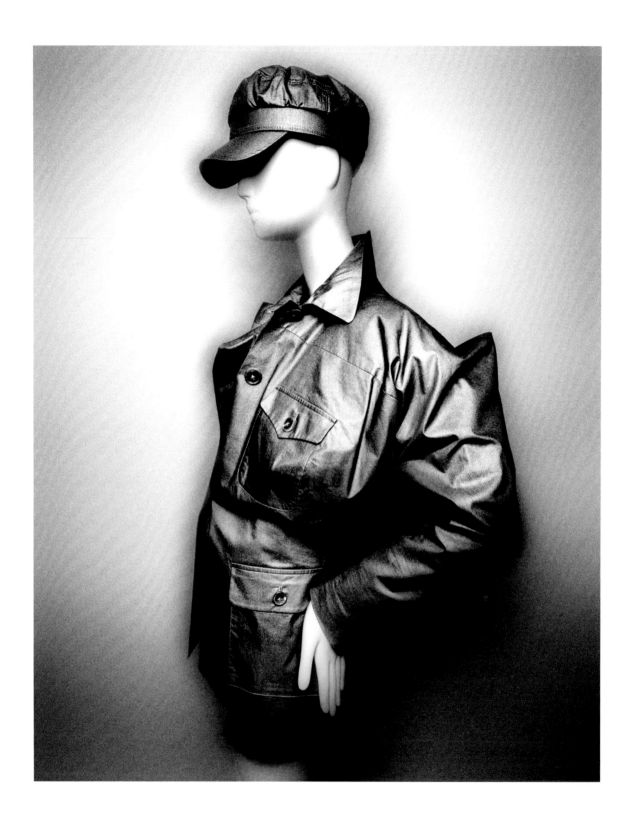

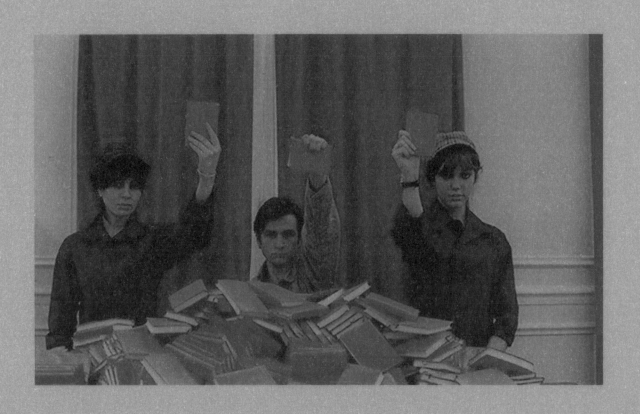

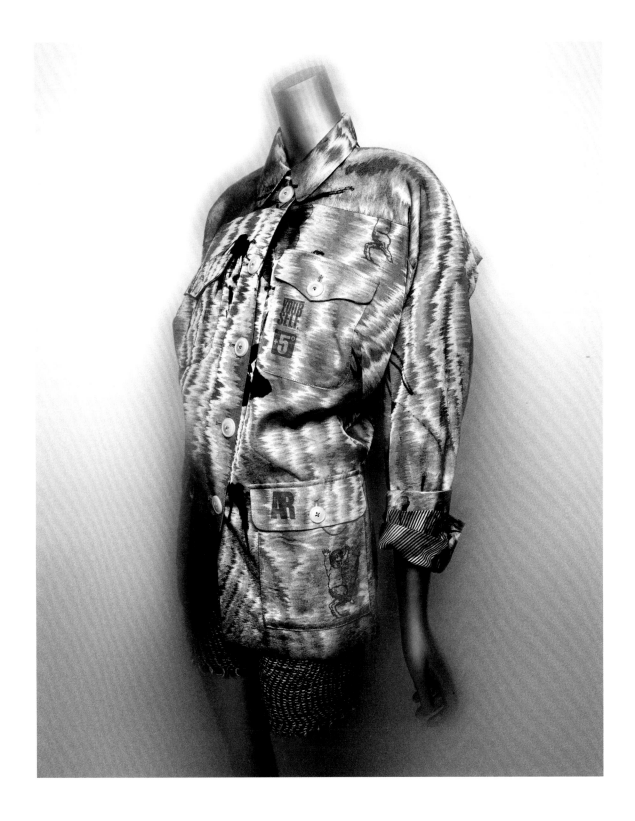

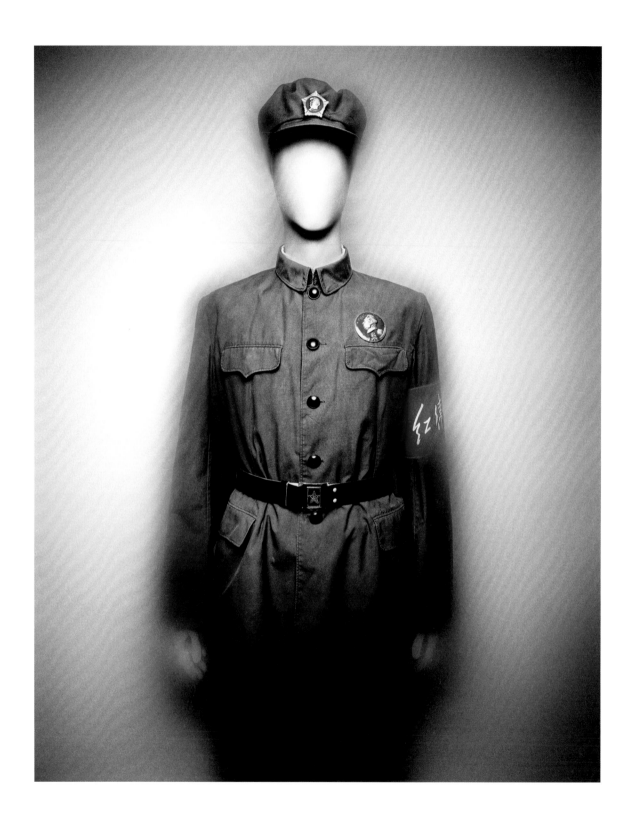

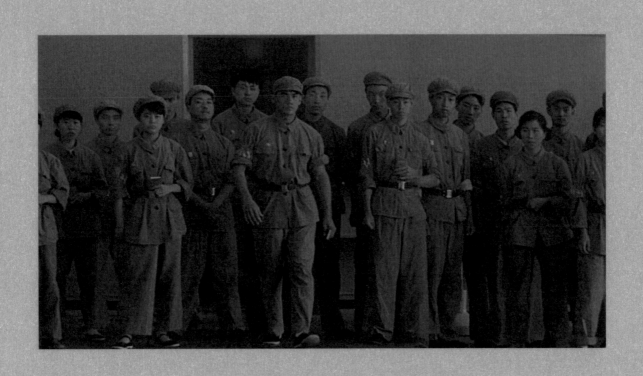

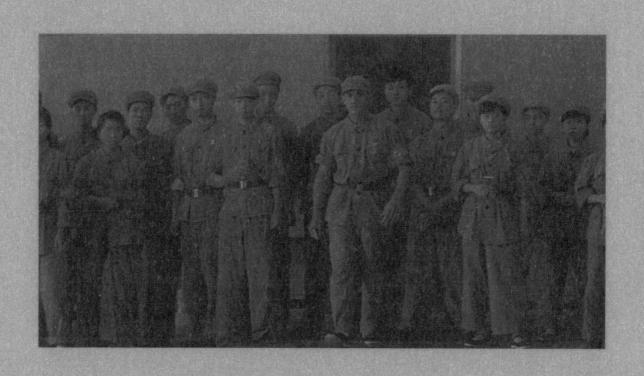

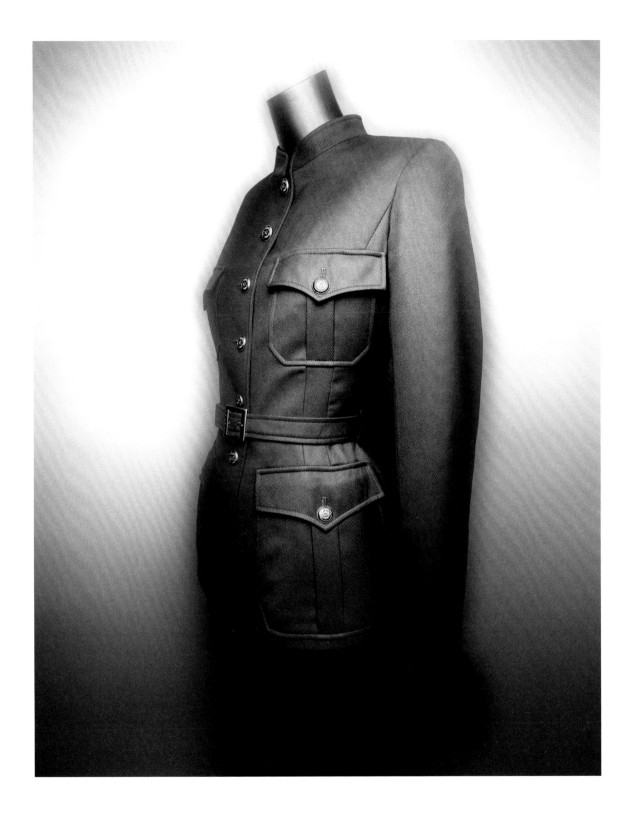

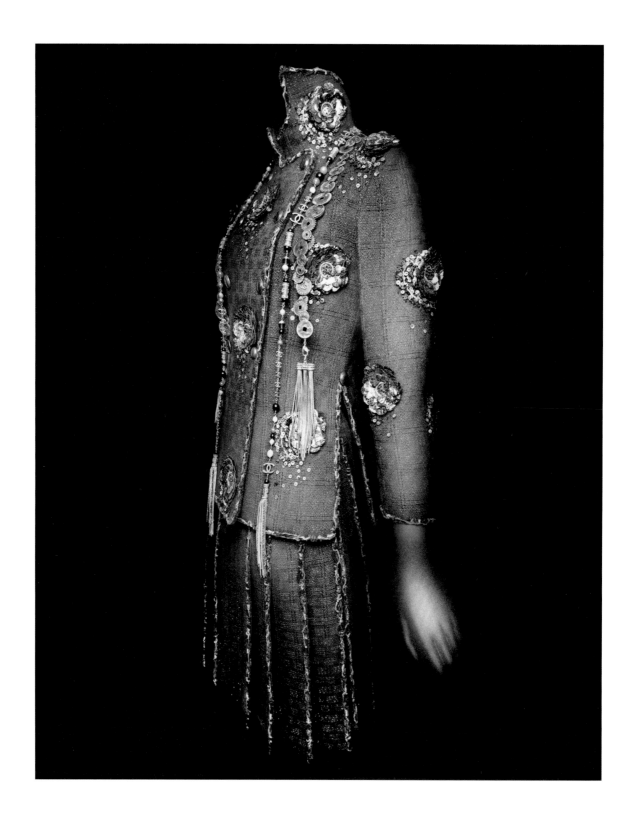

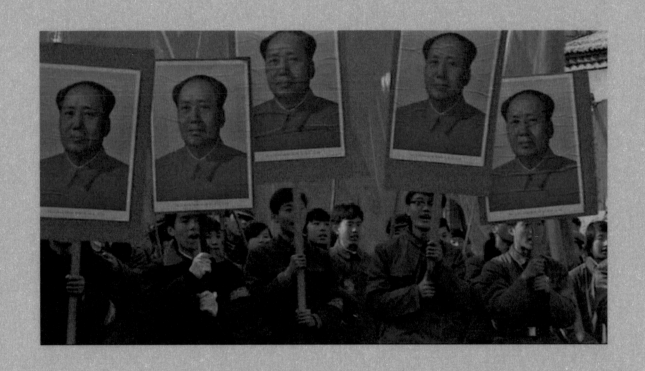

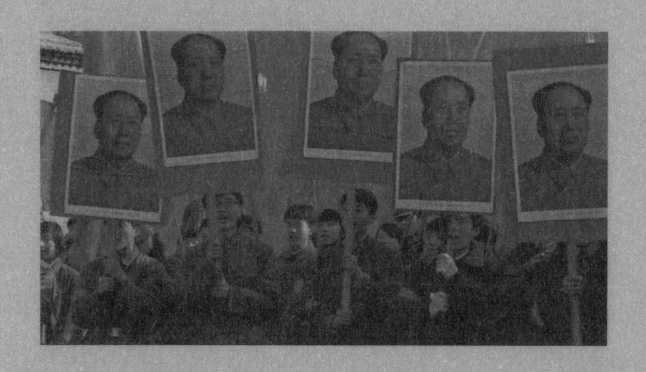

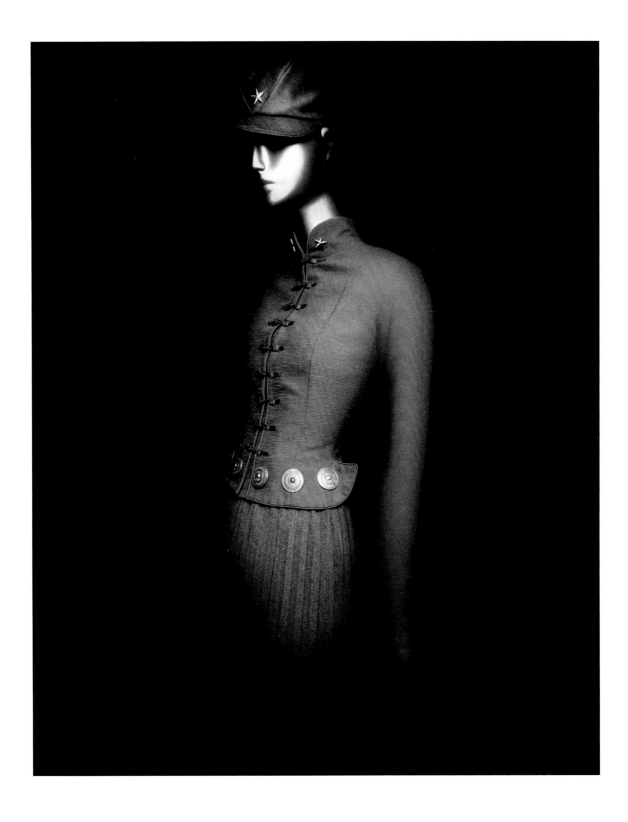

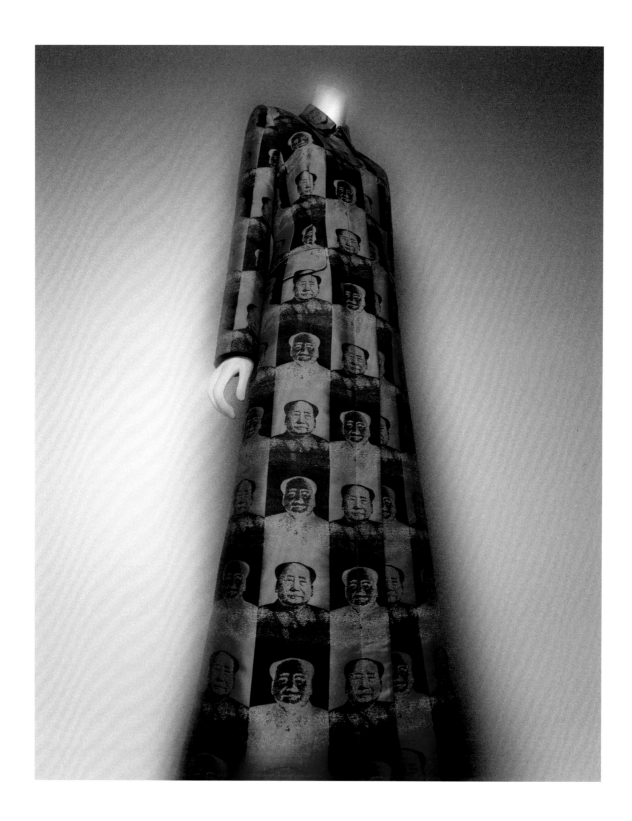

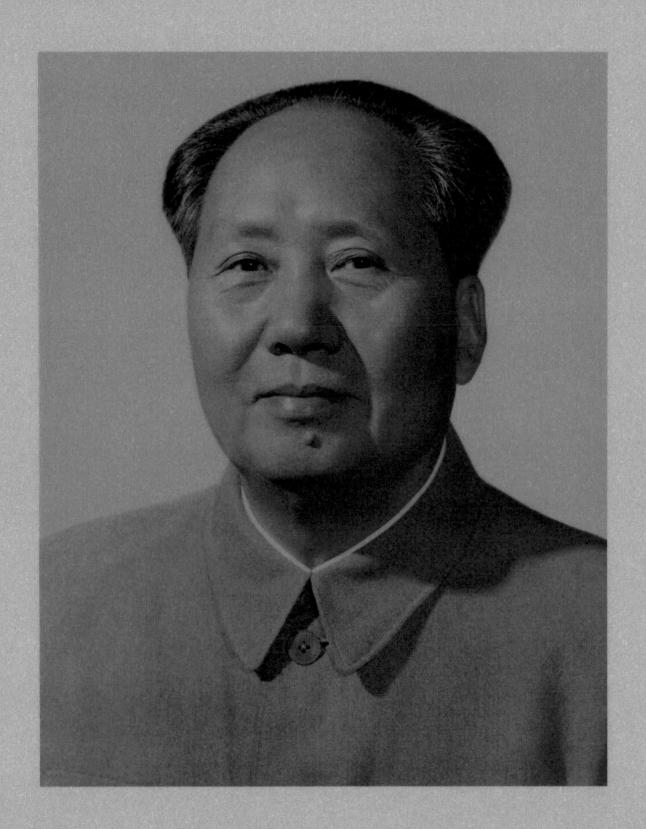

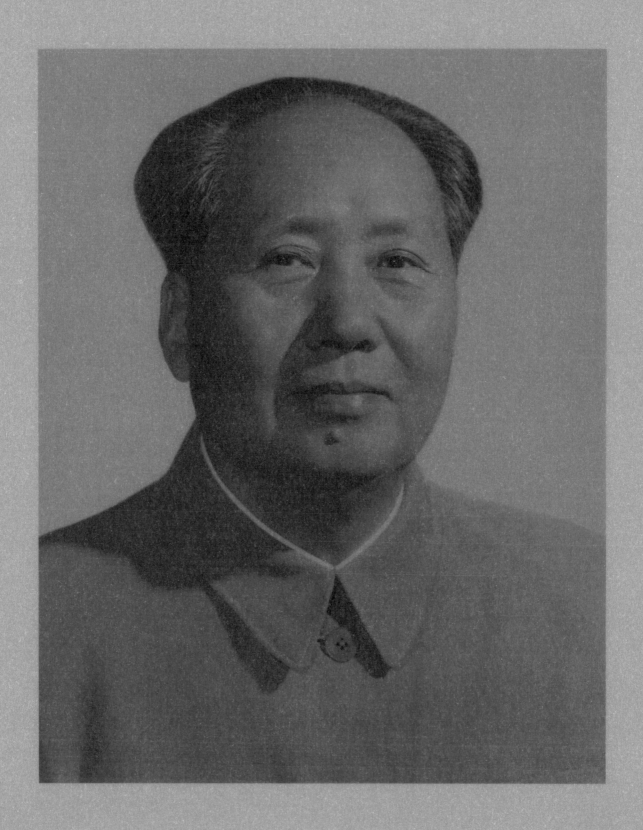

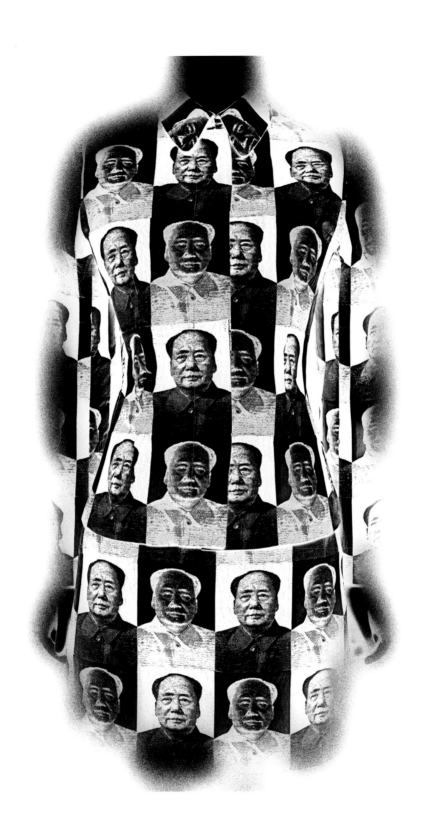

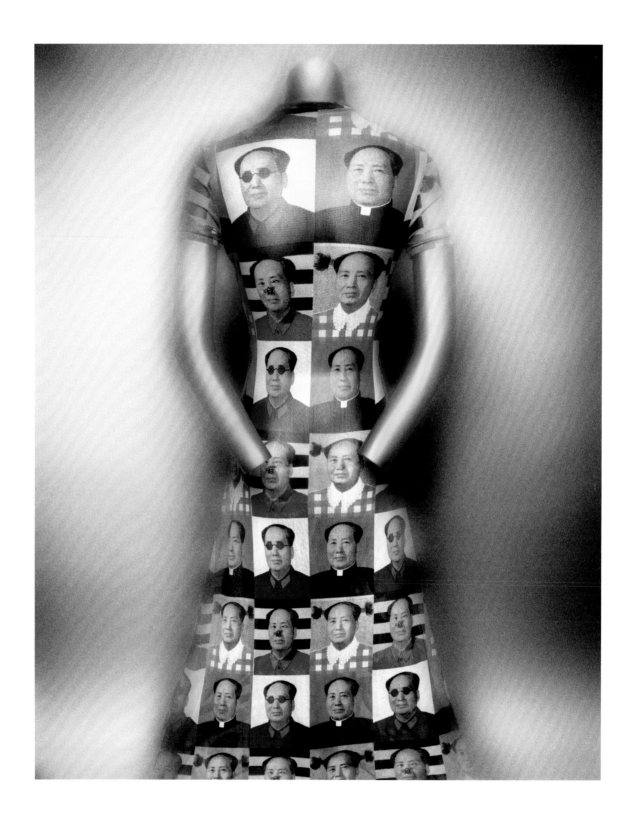

# EMPIRE
# OF
# SIGNS

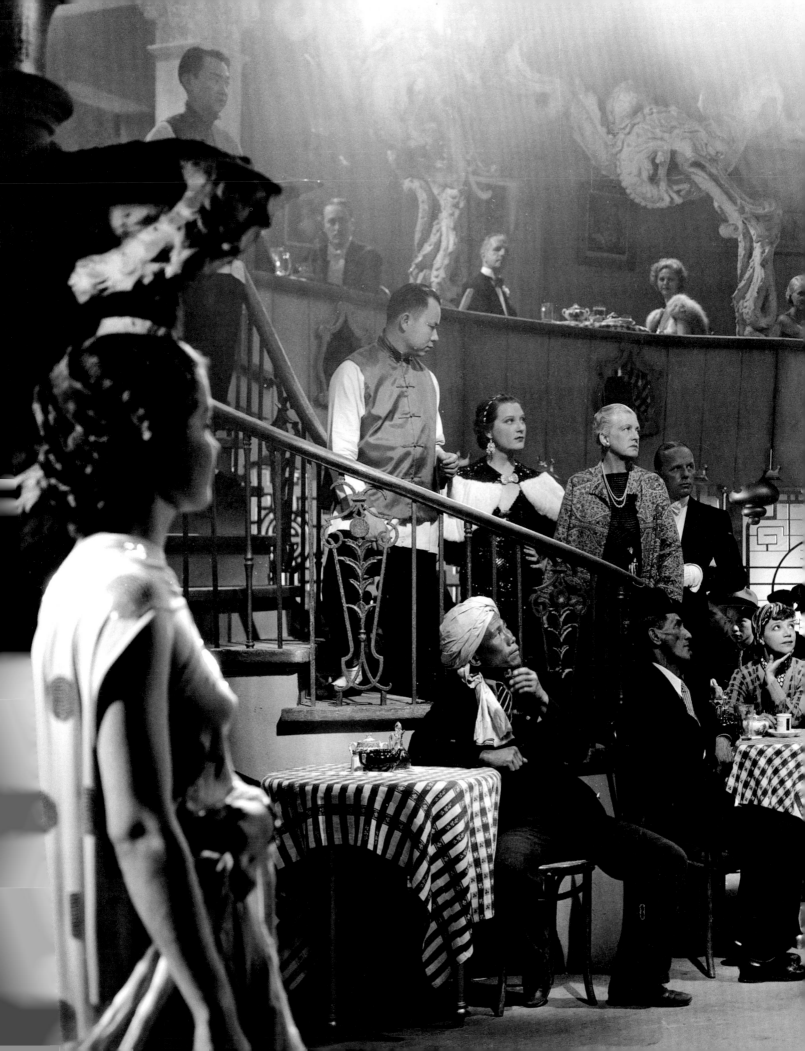

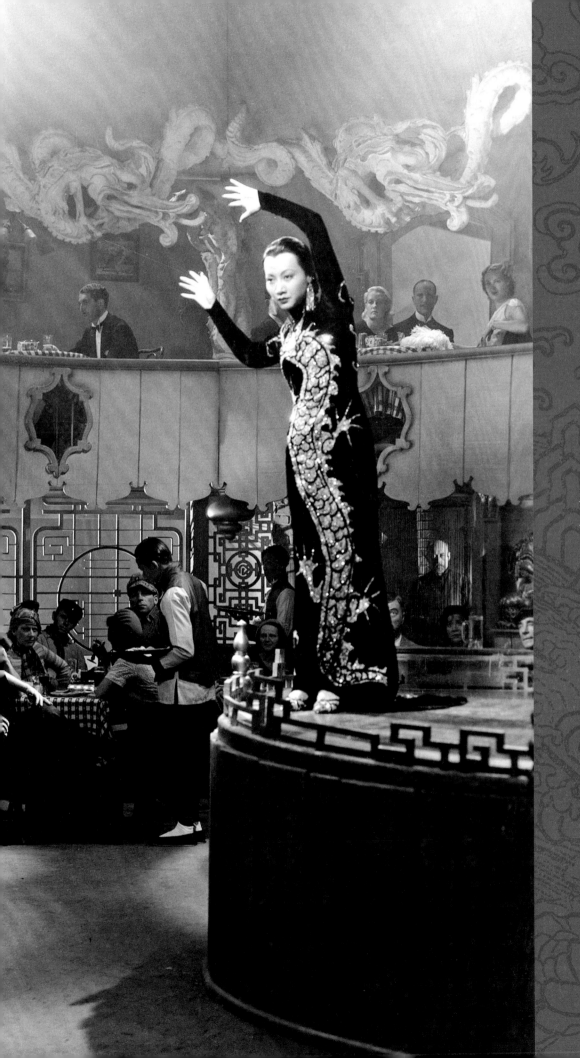

ENIGMATIC
BODIES

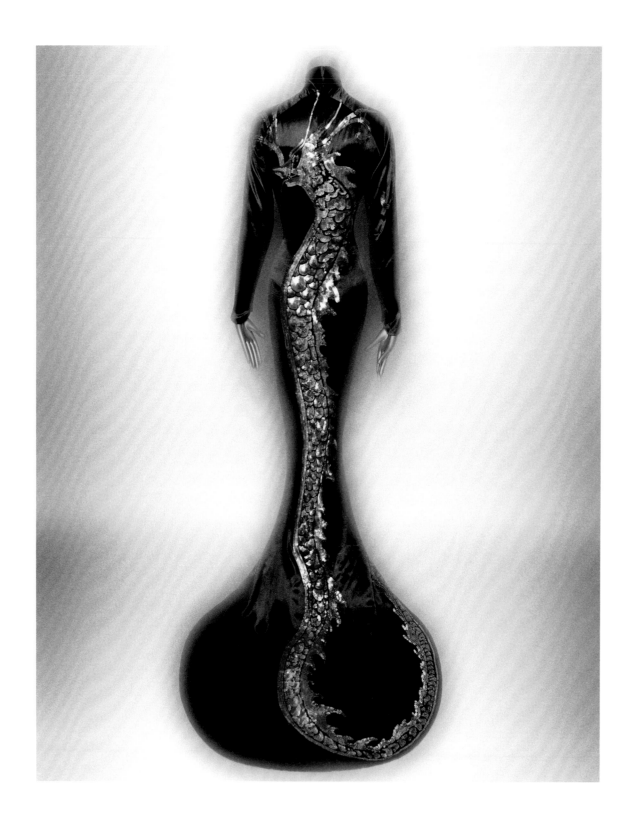

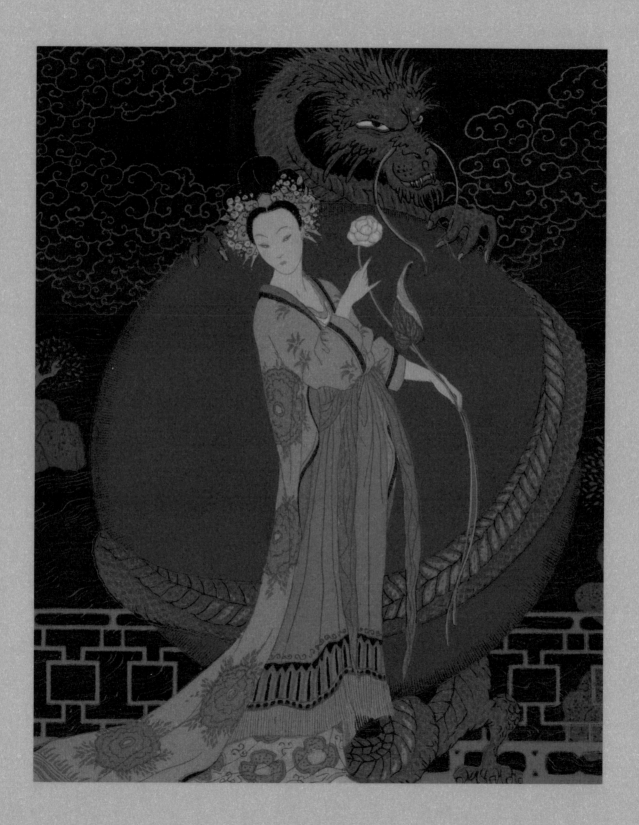

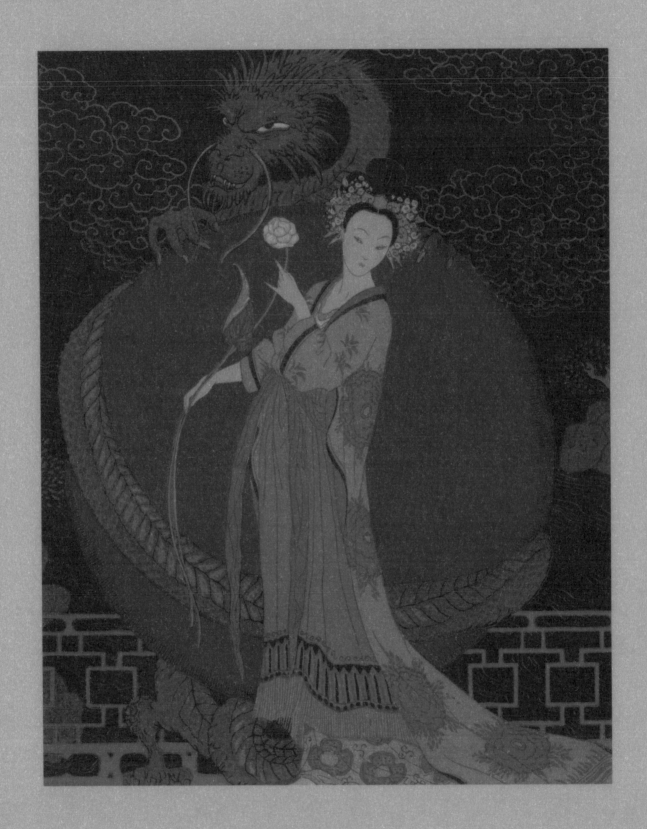

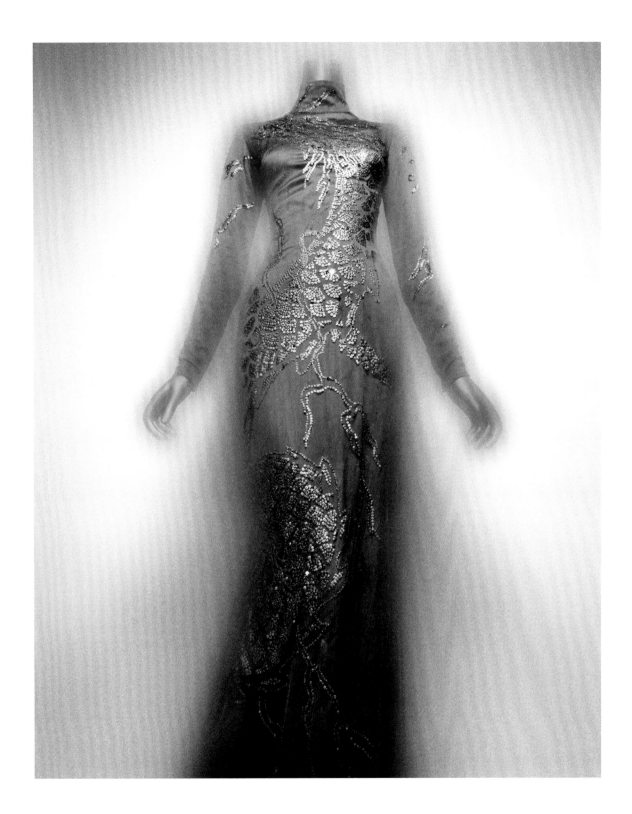

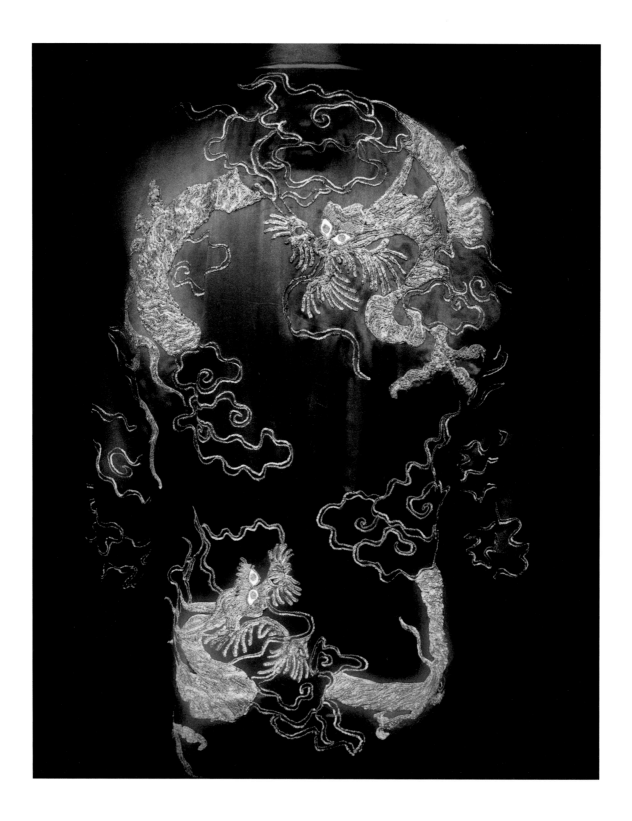

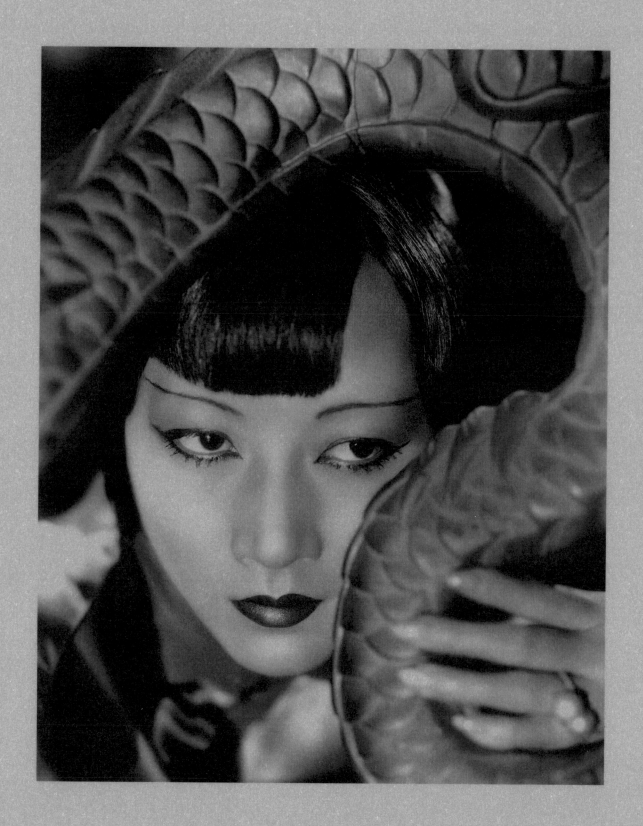

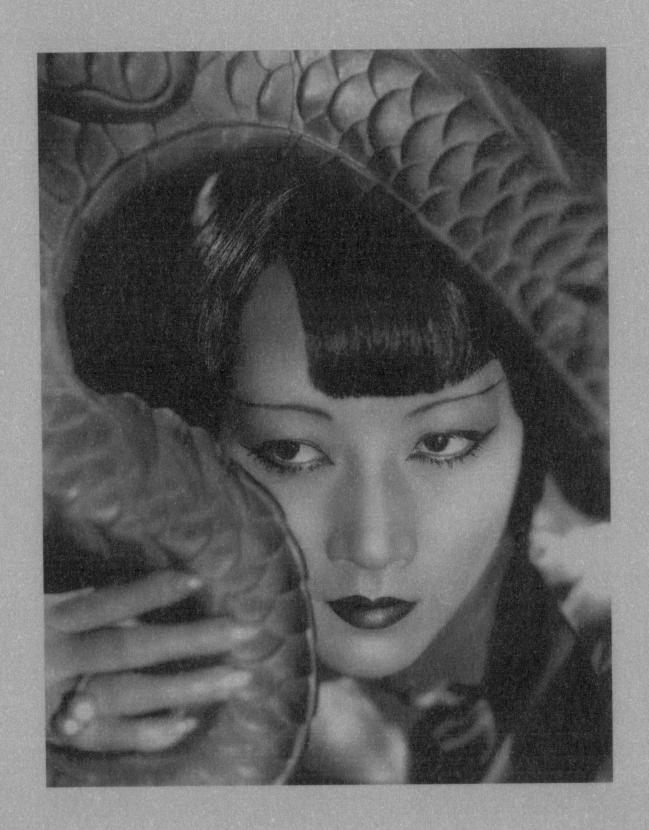

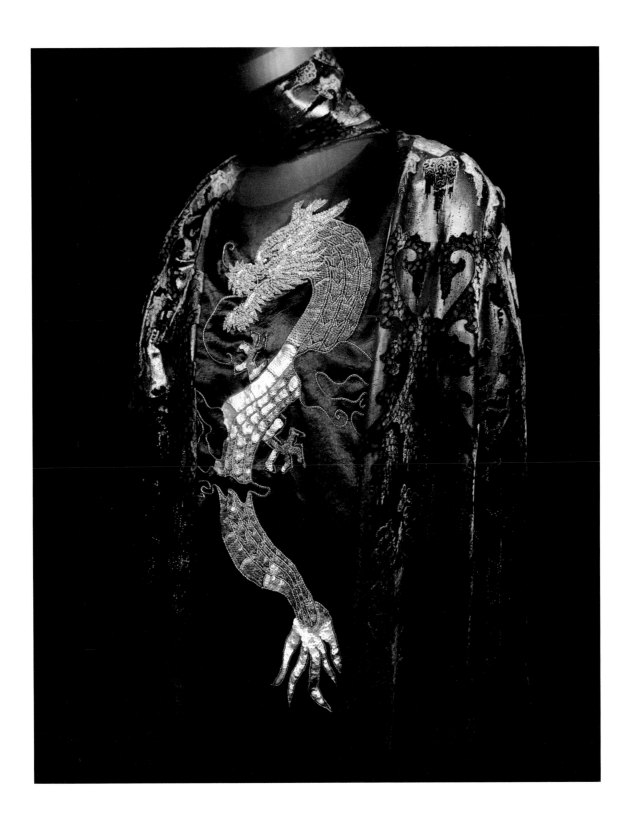

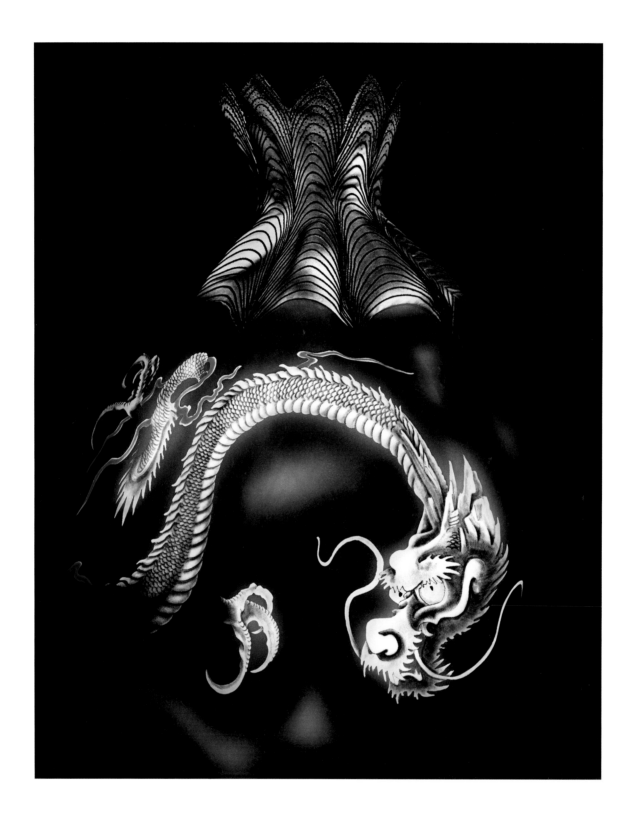

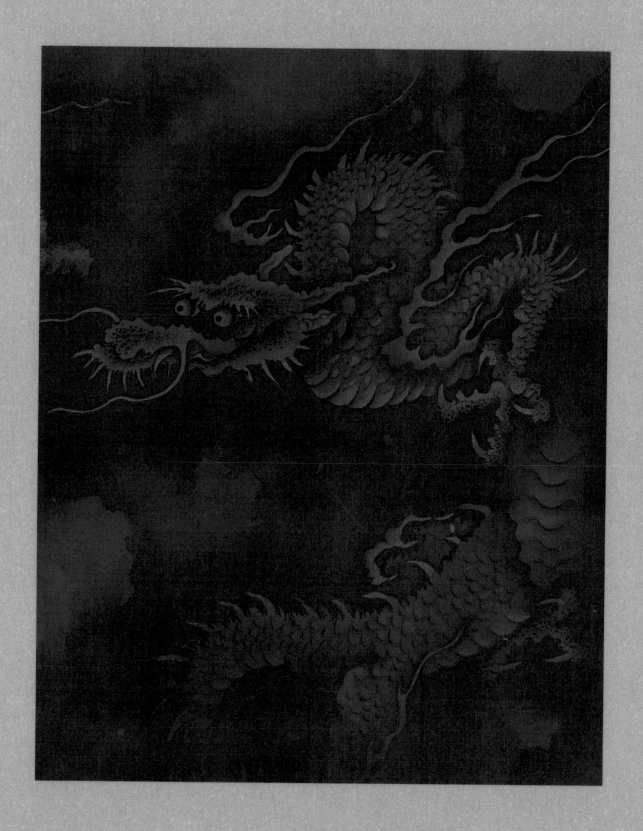

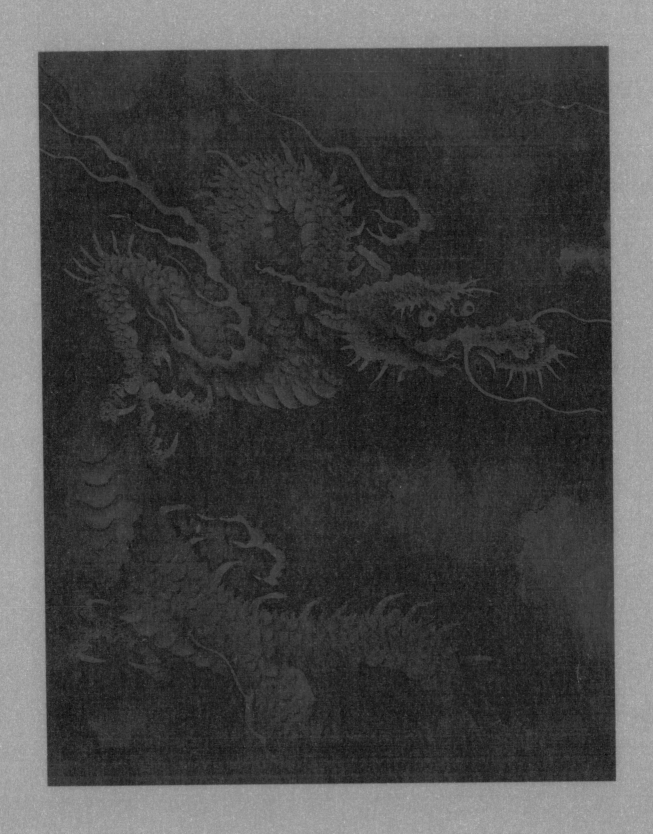

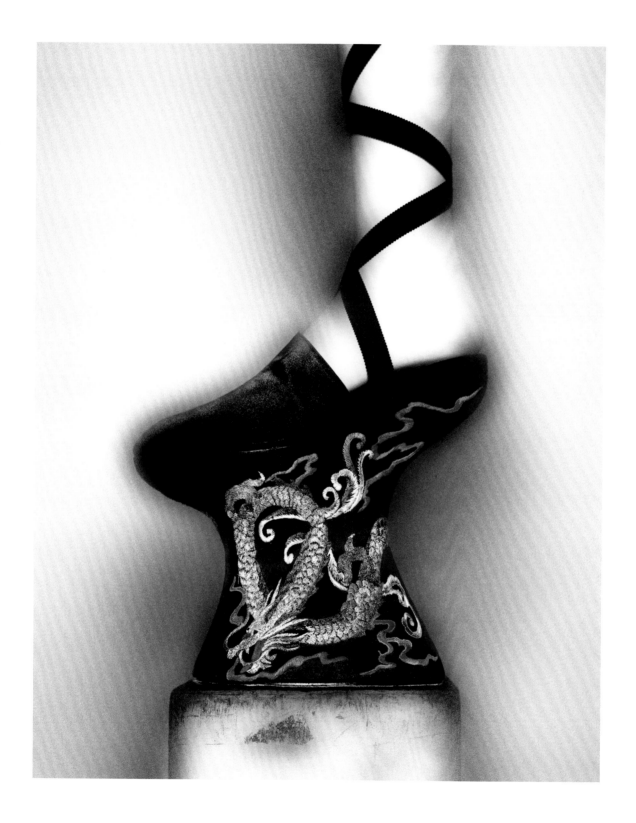

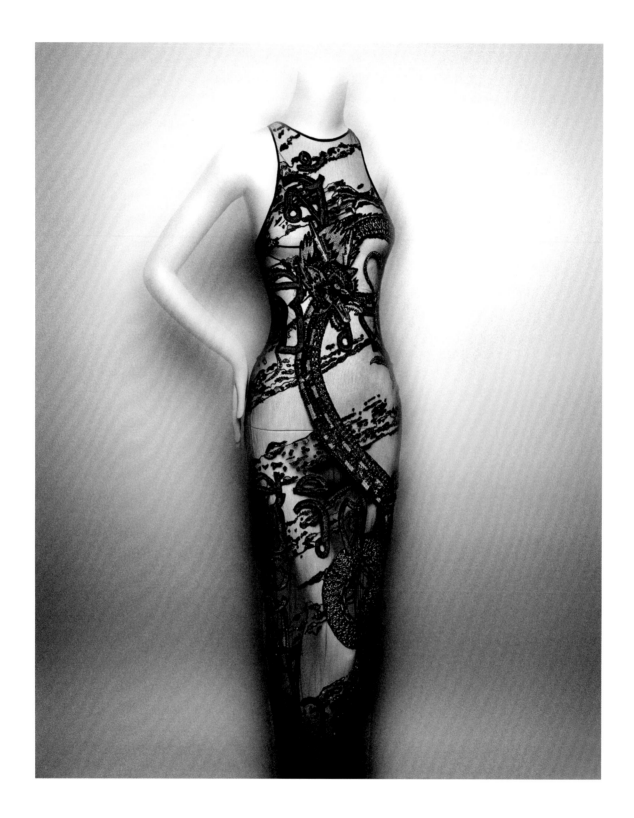

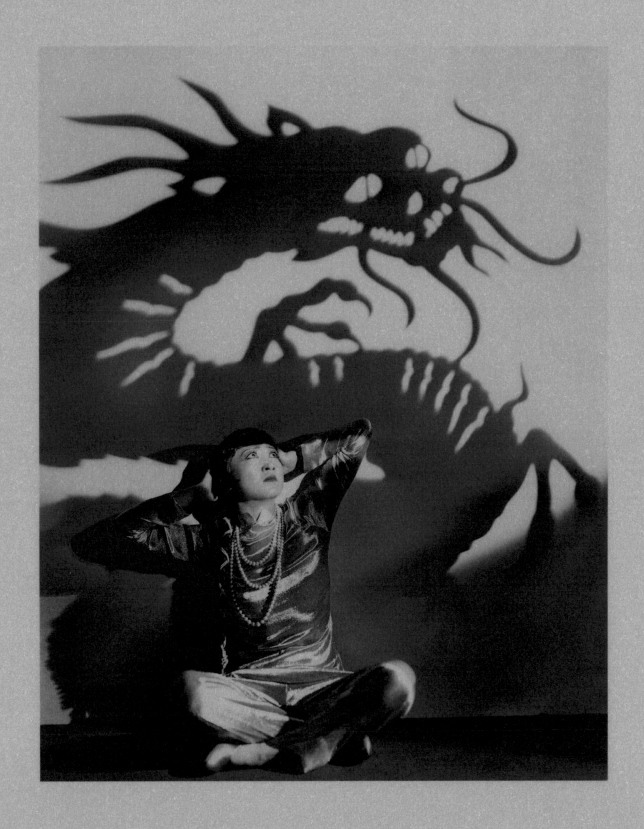

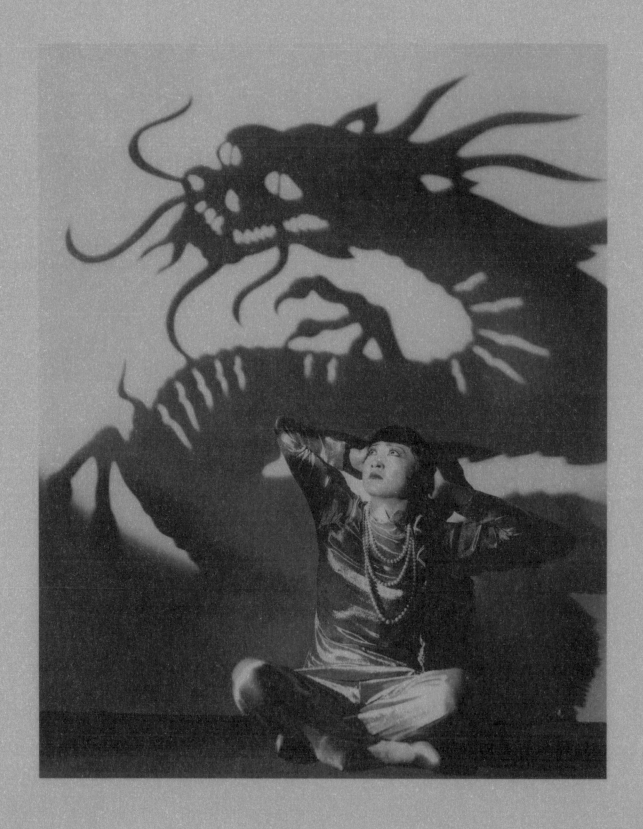

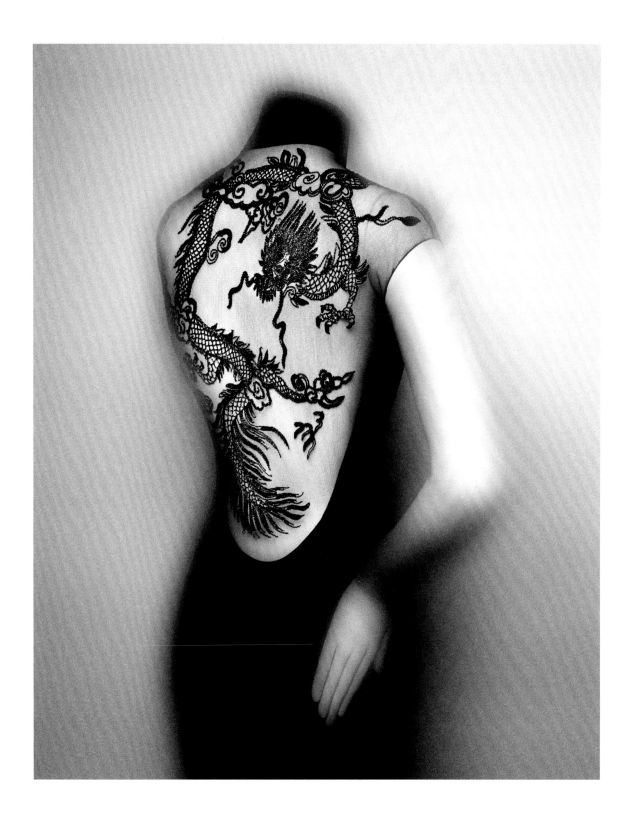

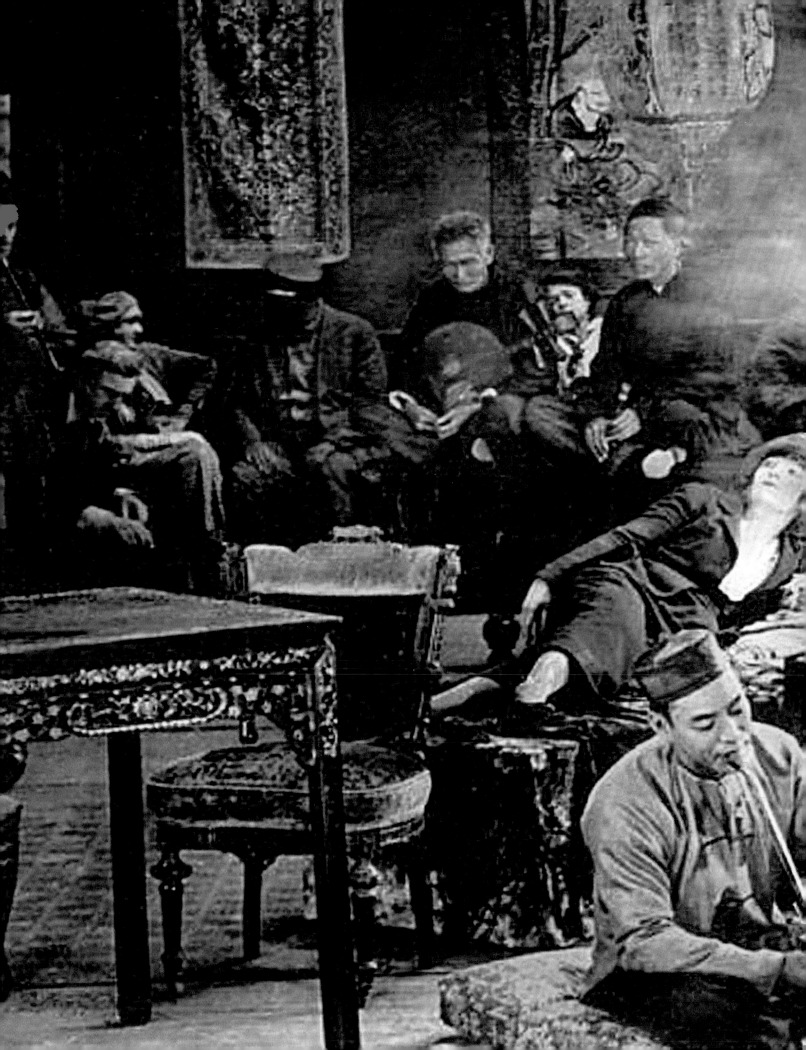

ENIGMATIC
SPACES

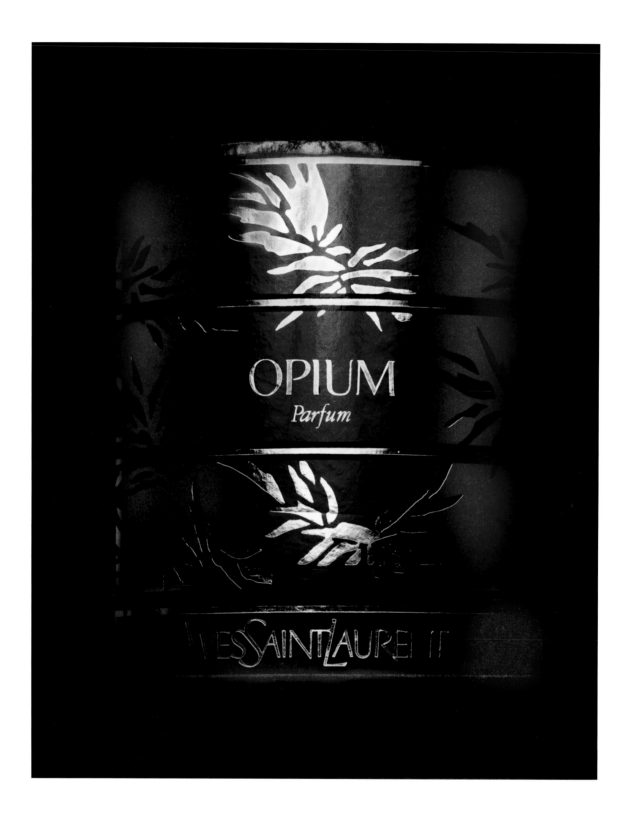

OPIUM,
pour celles qui s'adonnent à Yves Saint Laurent.

*Parfums*
Yves Saint Laurent

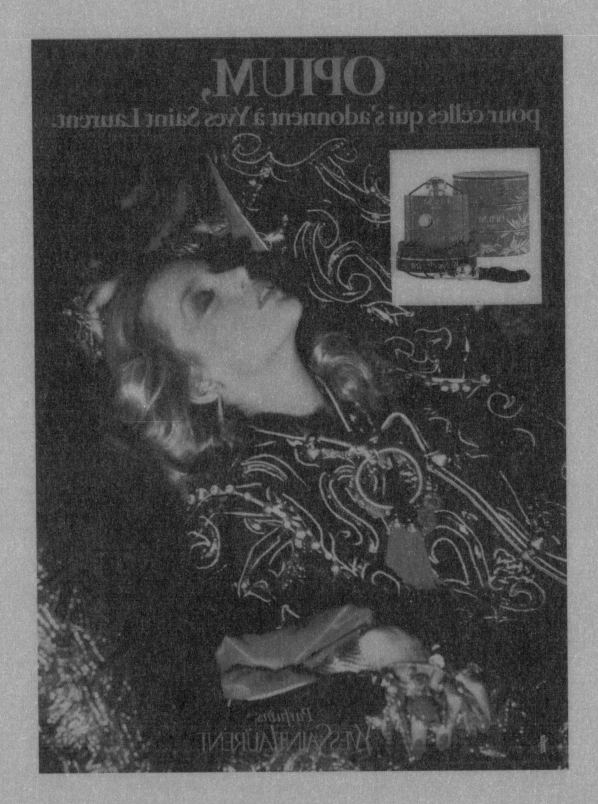

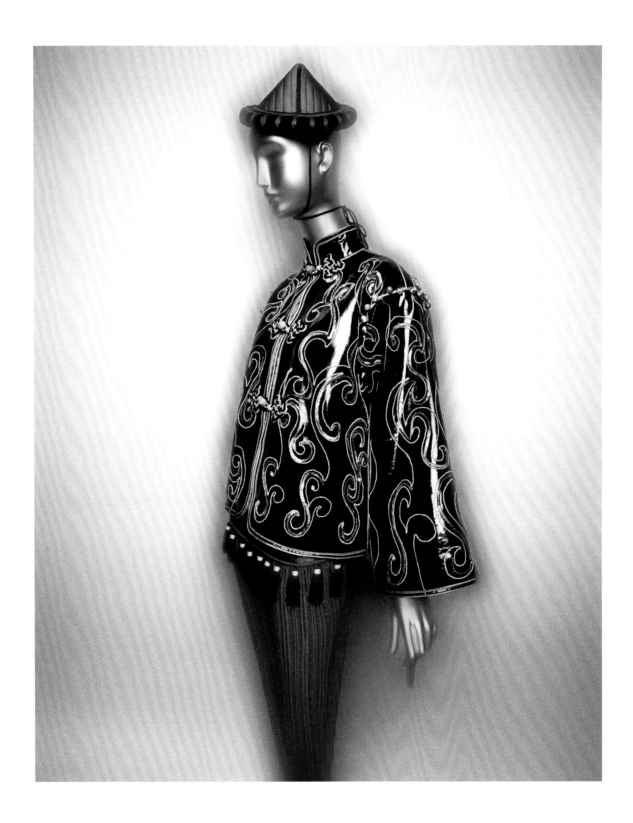

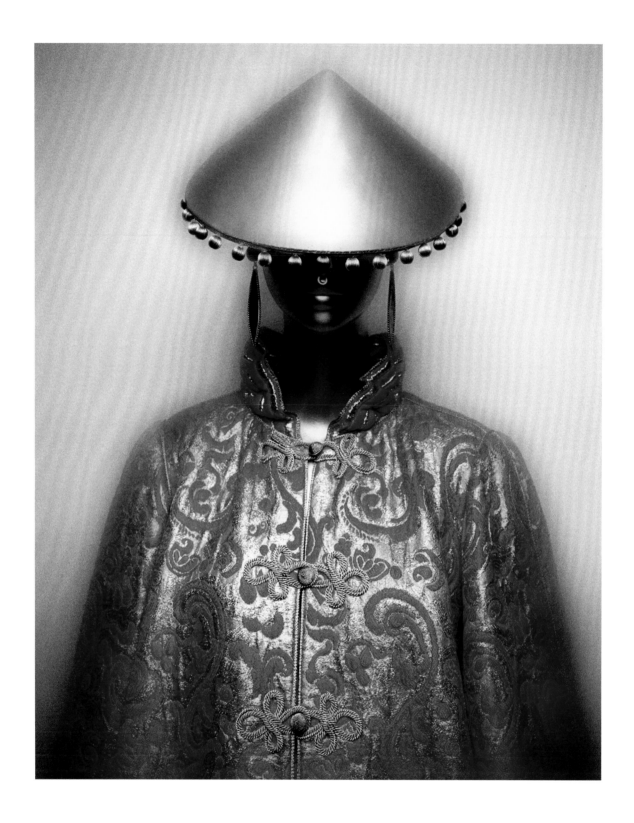

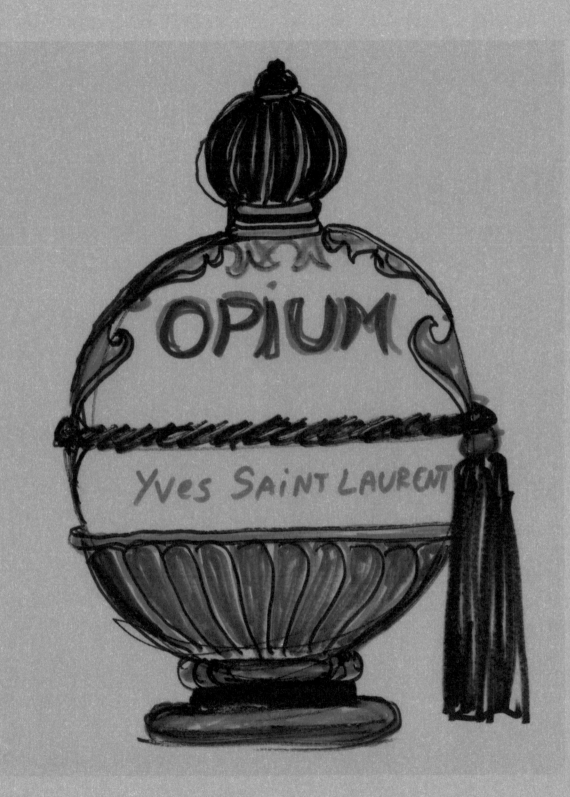

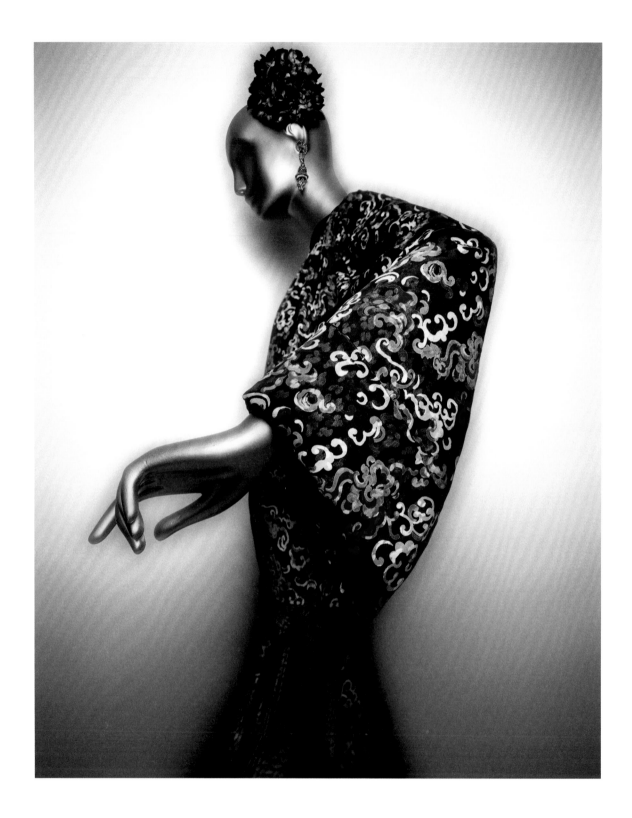

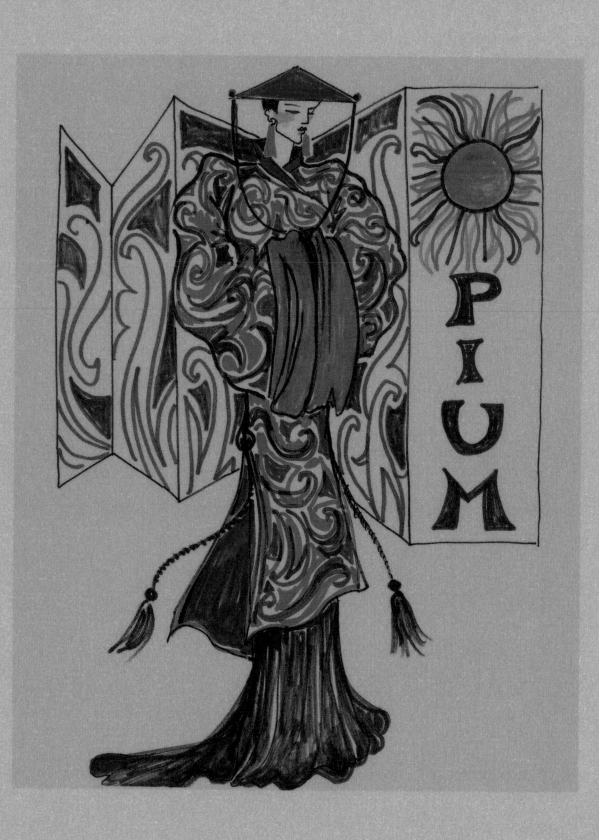

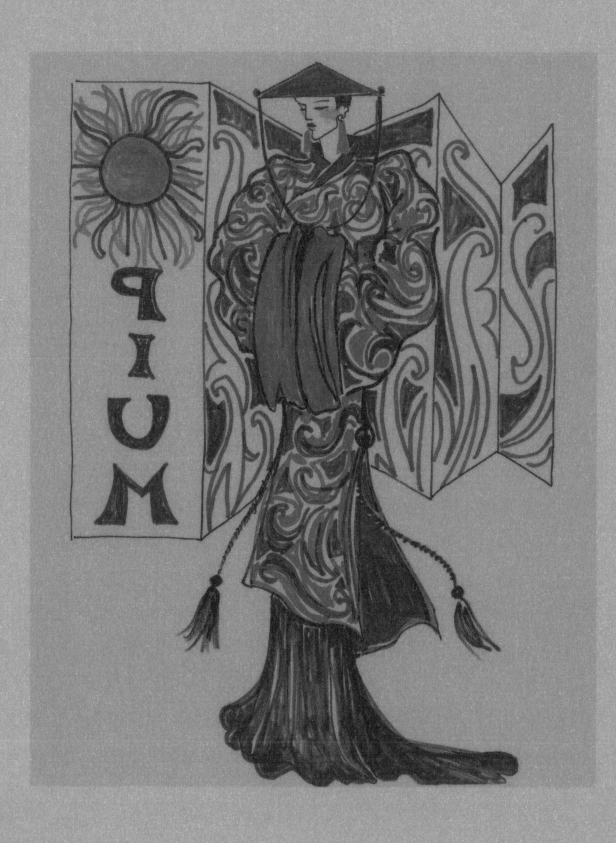

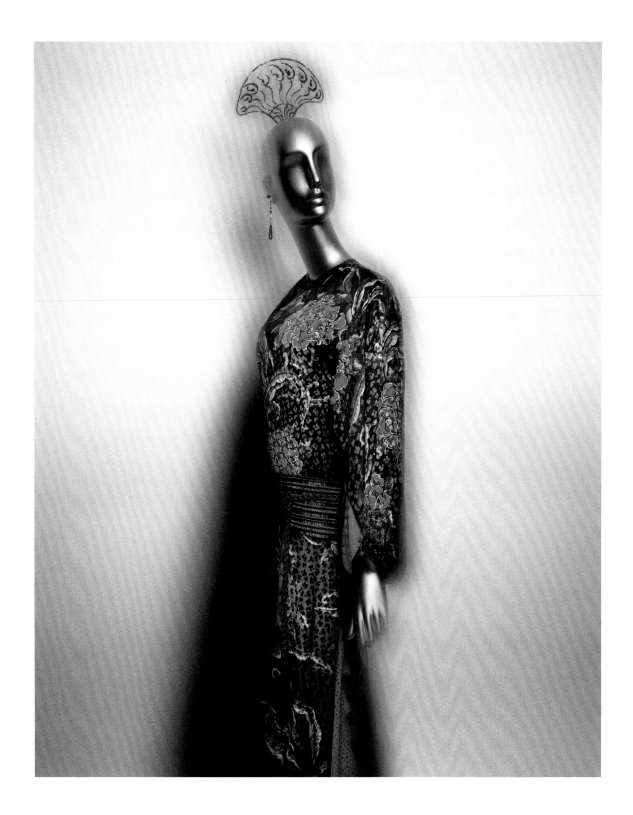

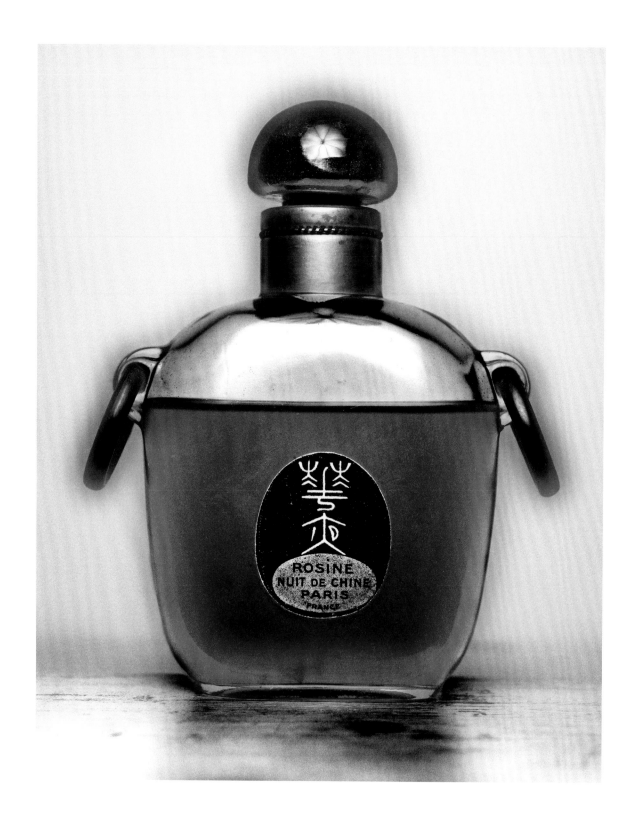

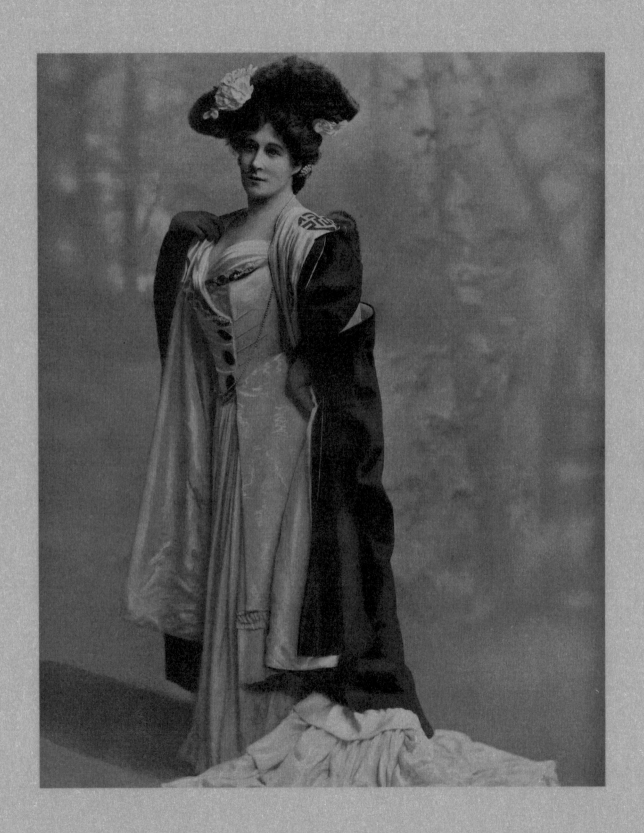

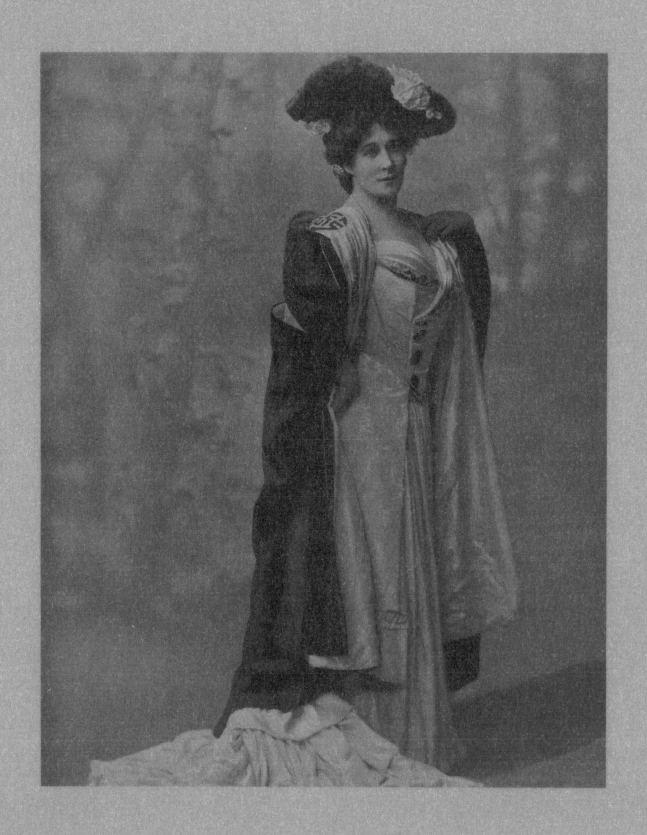

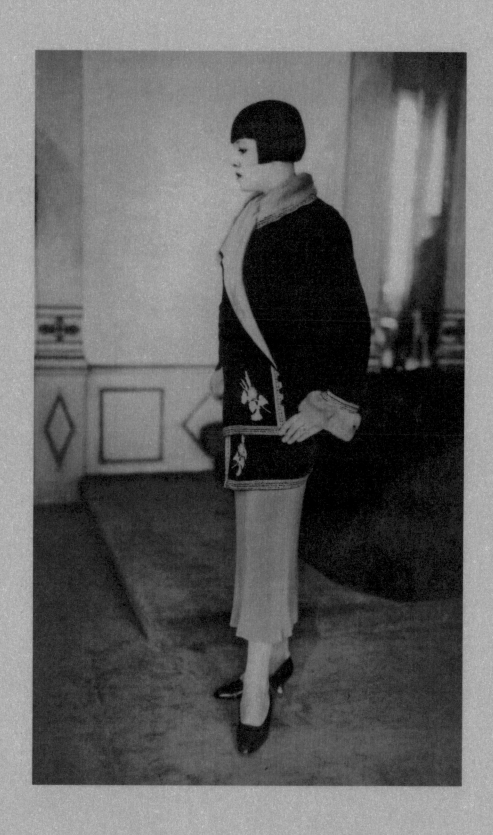

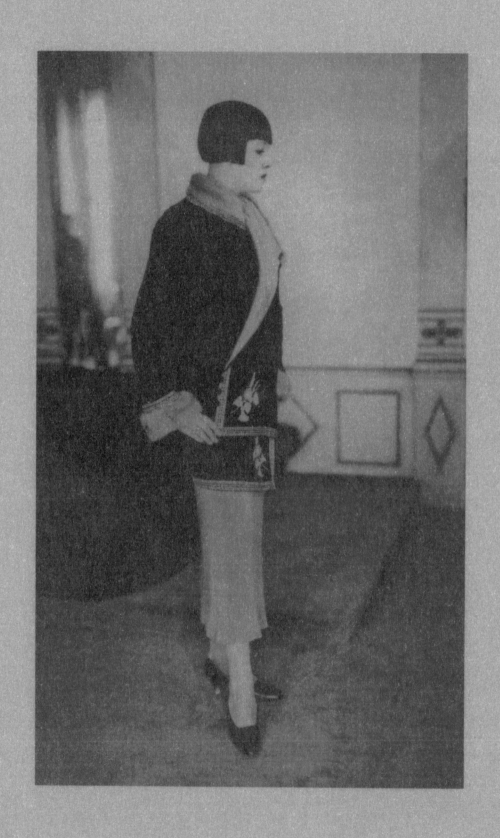

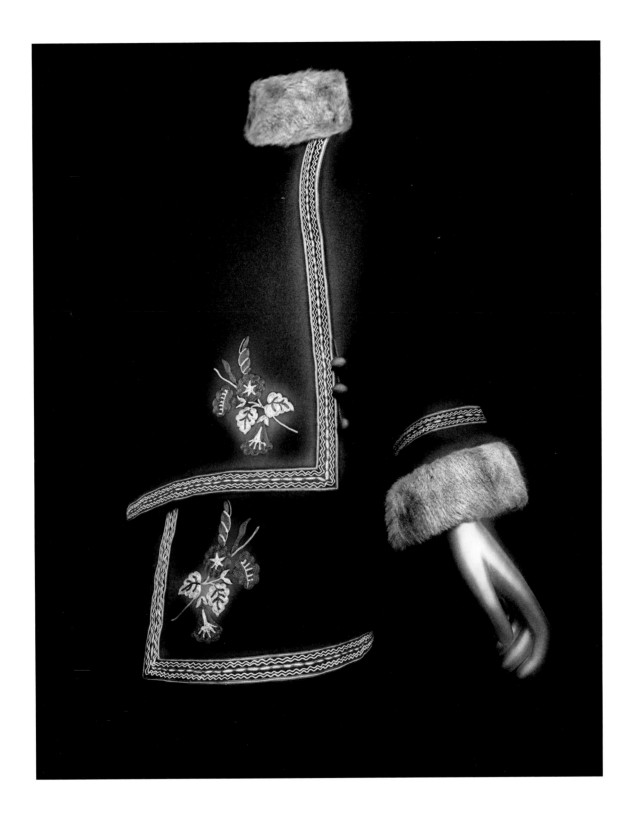

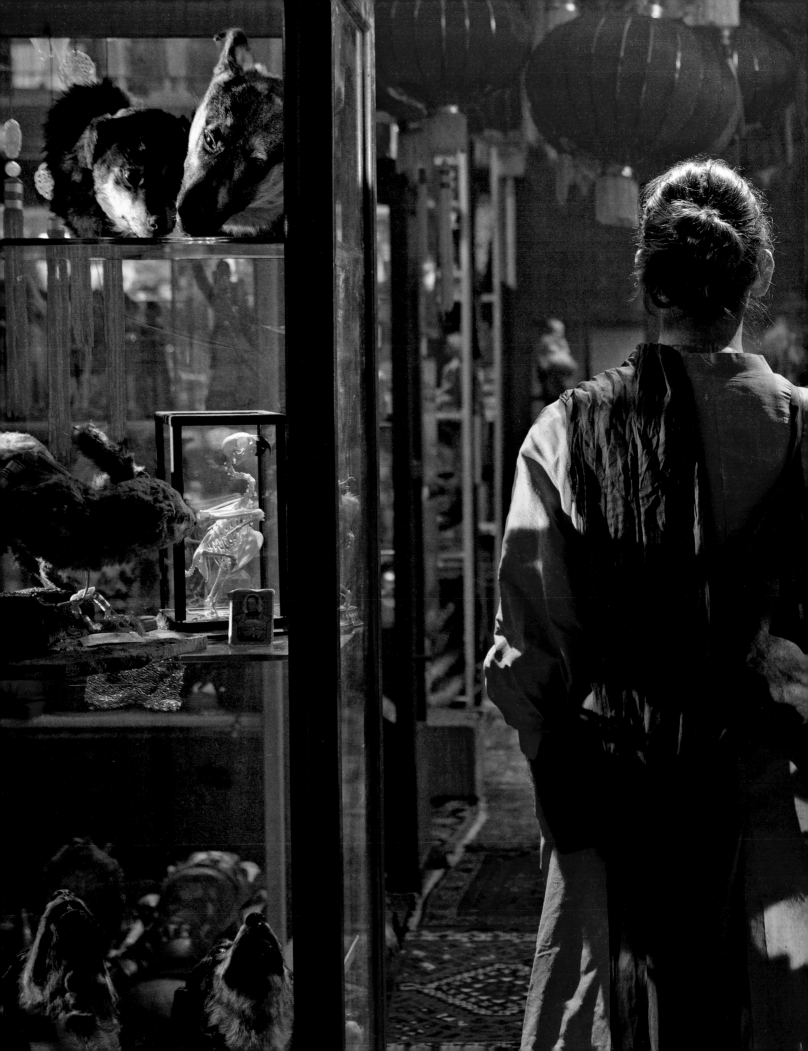

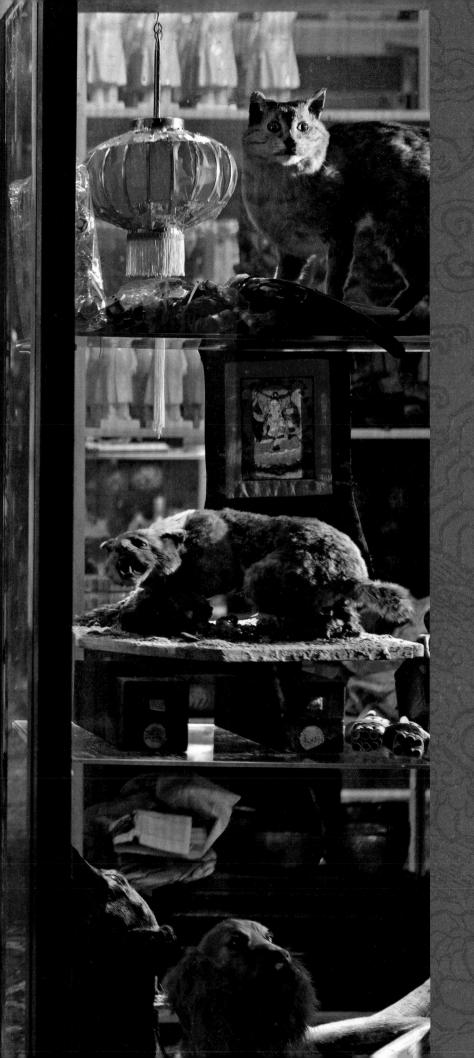

ENIGMATIC
OBJECTS

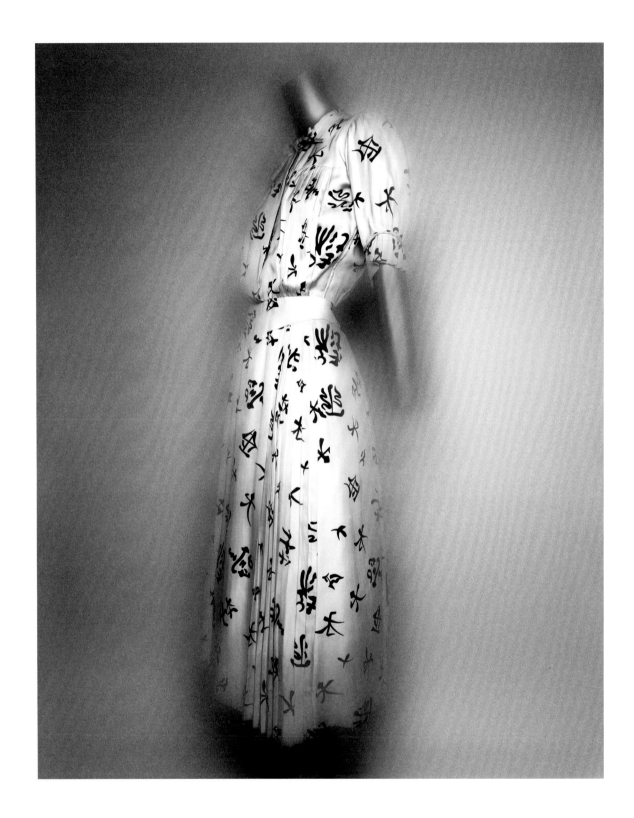

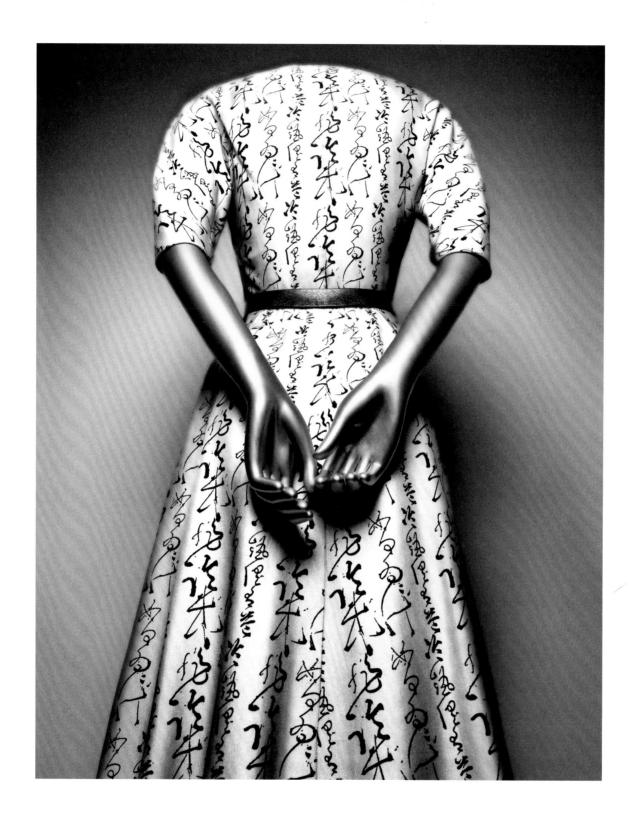

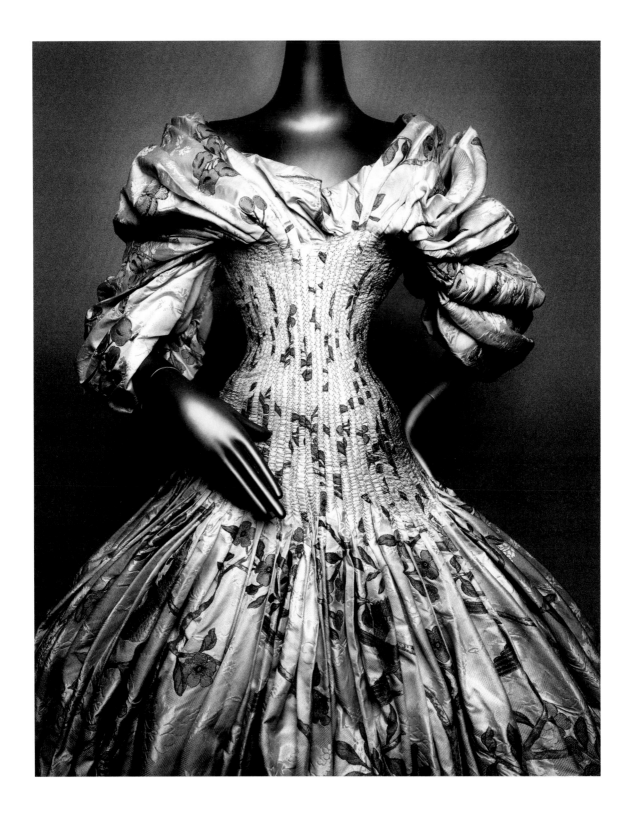

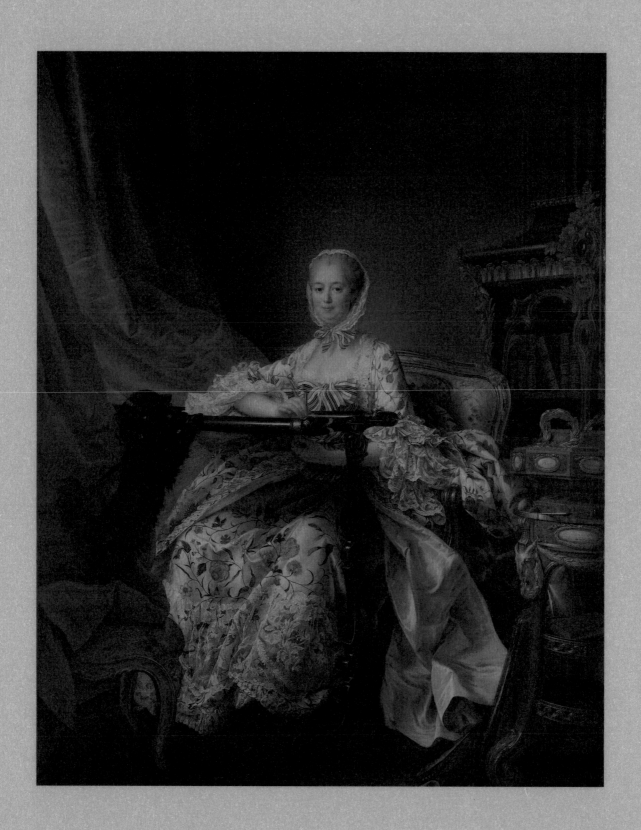

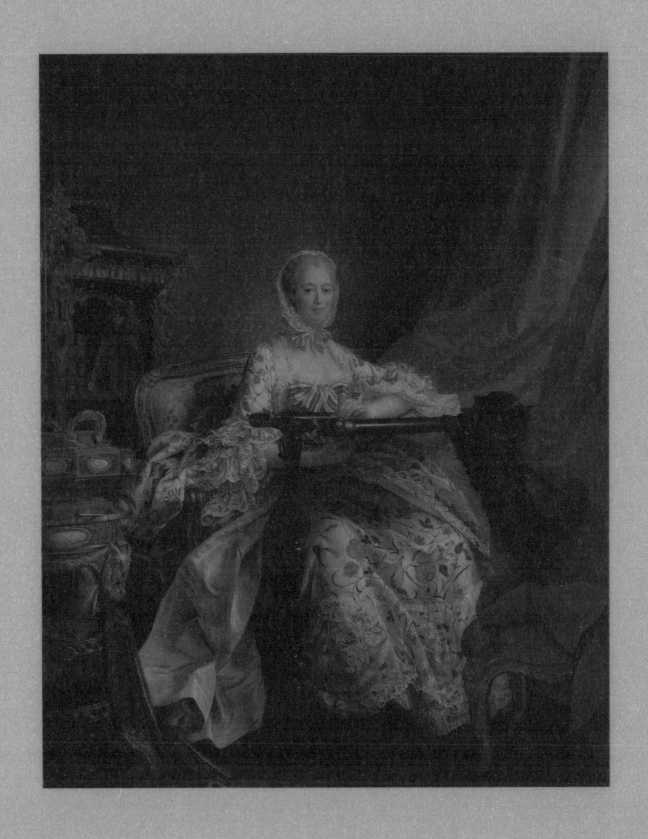

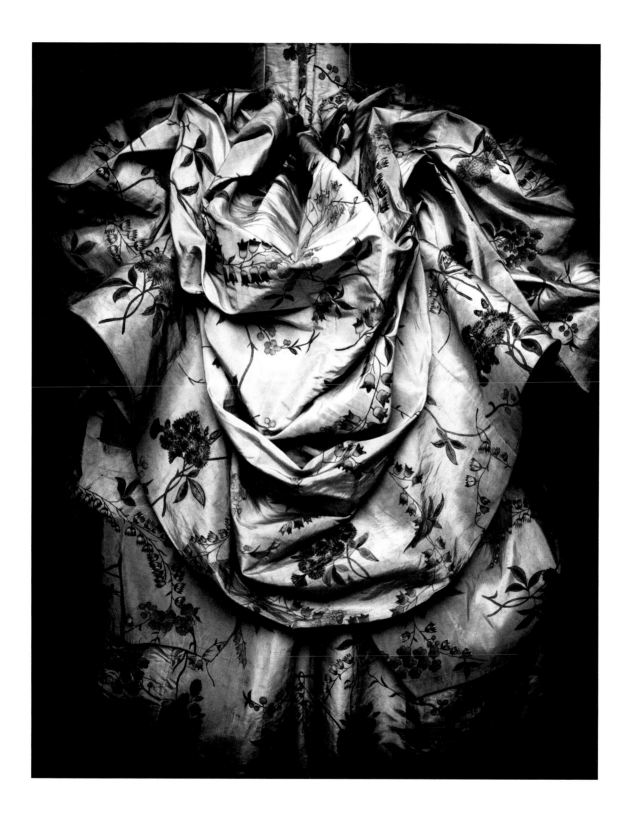

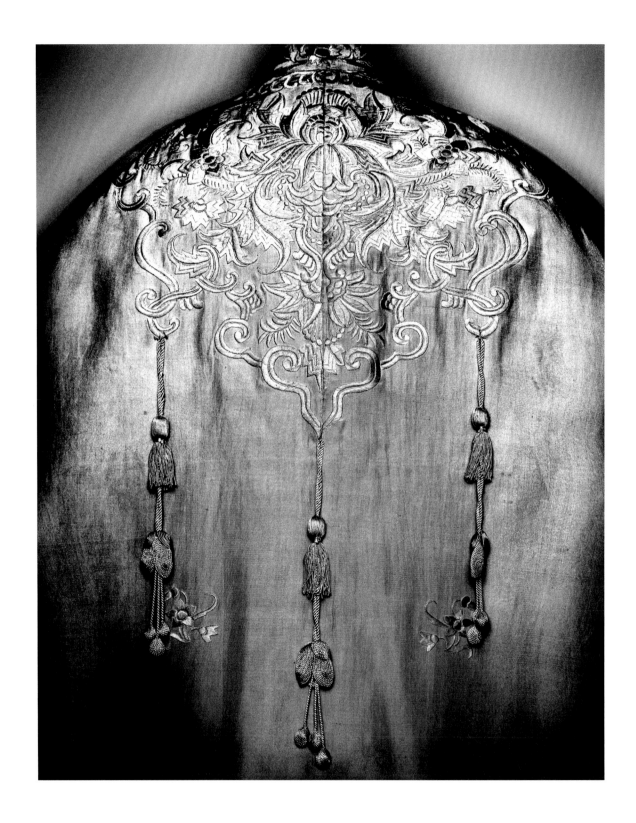

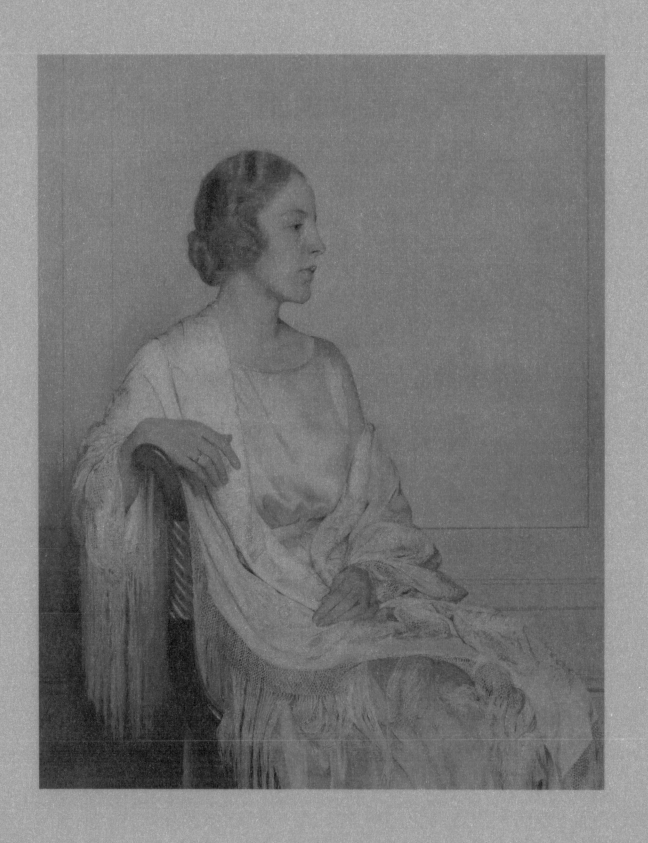

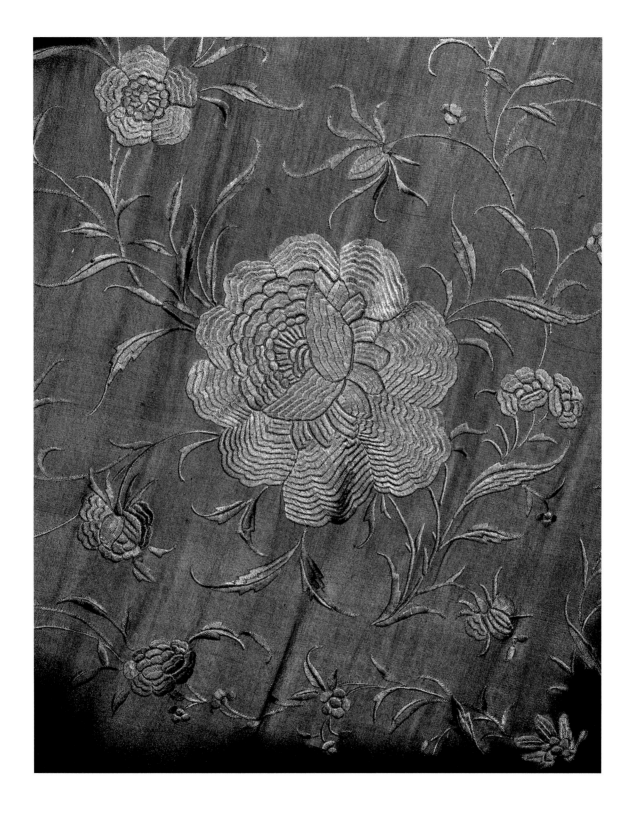

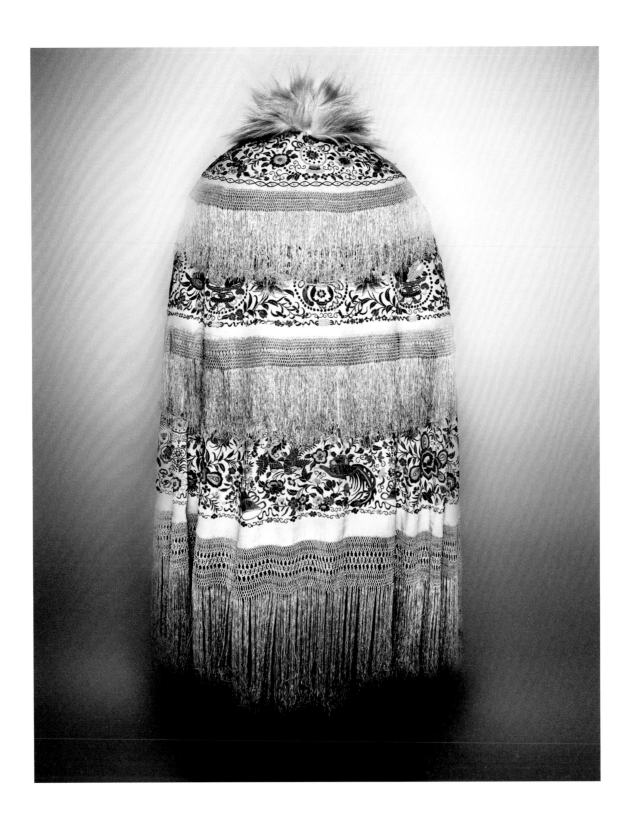

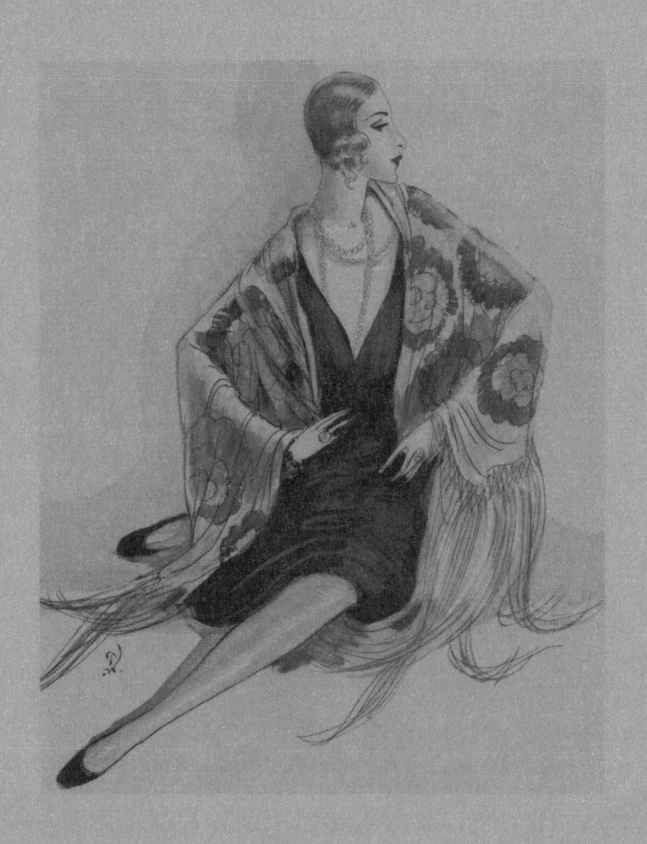

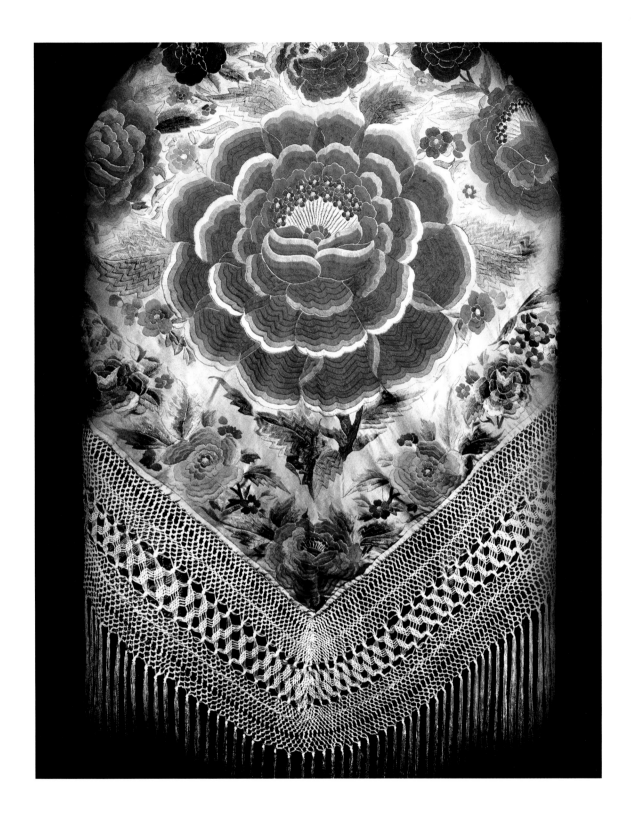

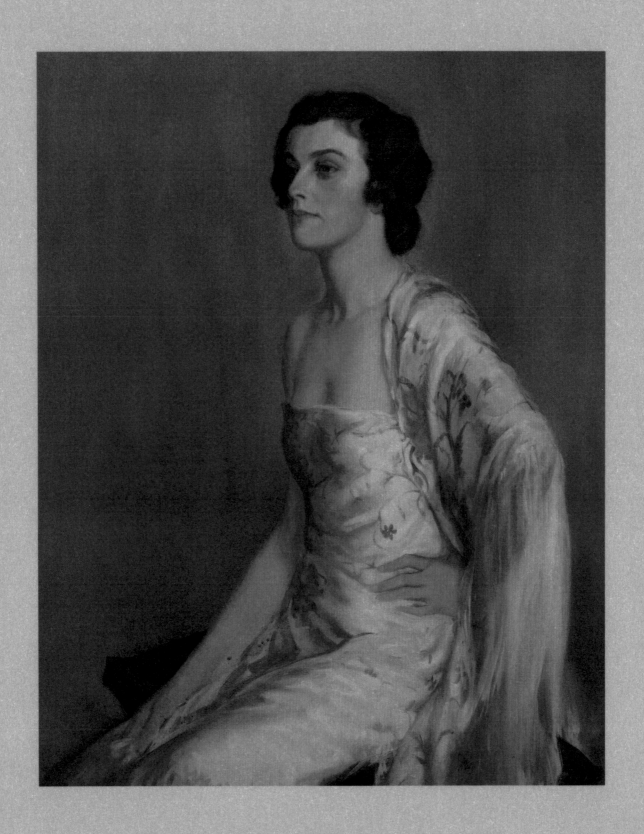

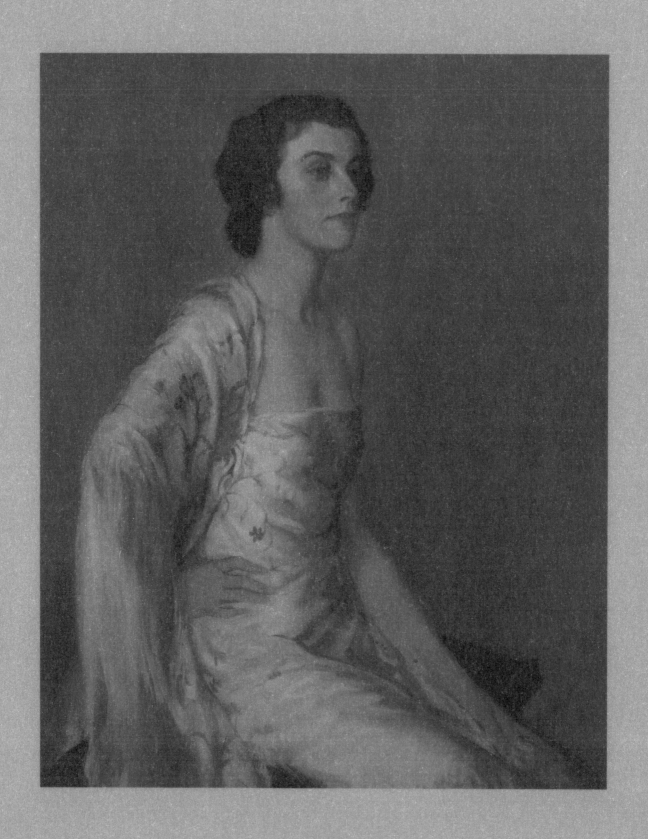

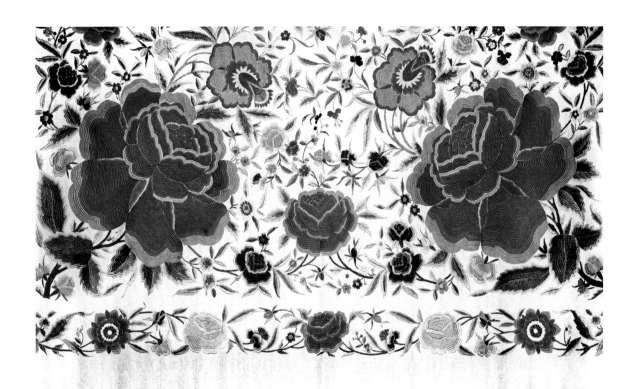

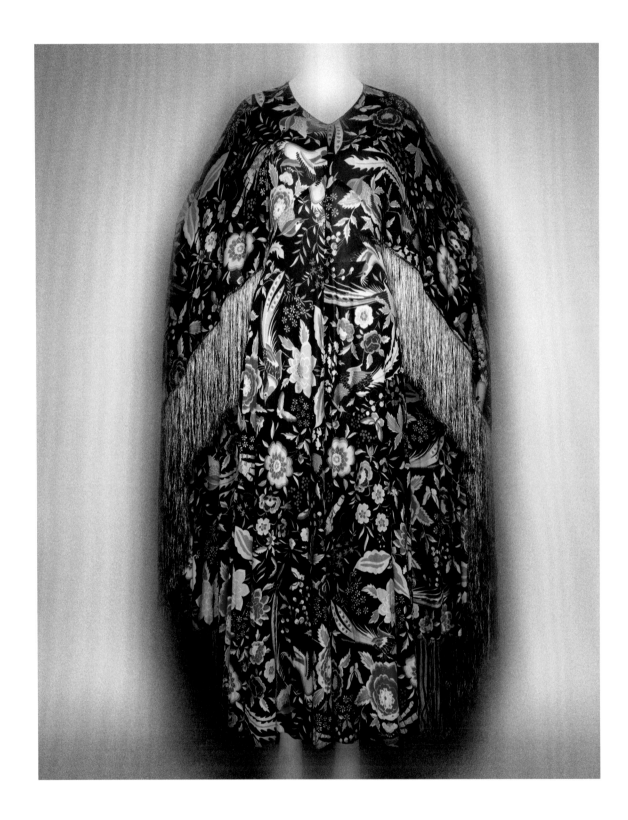

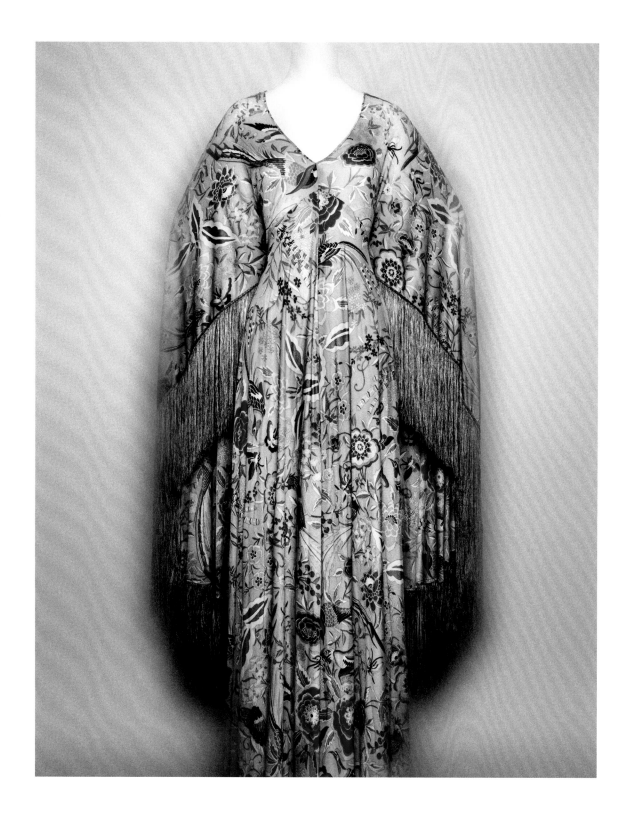

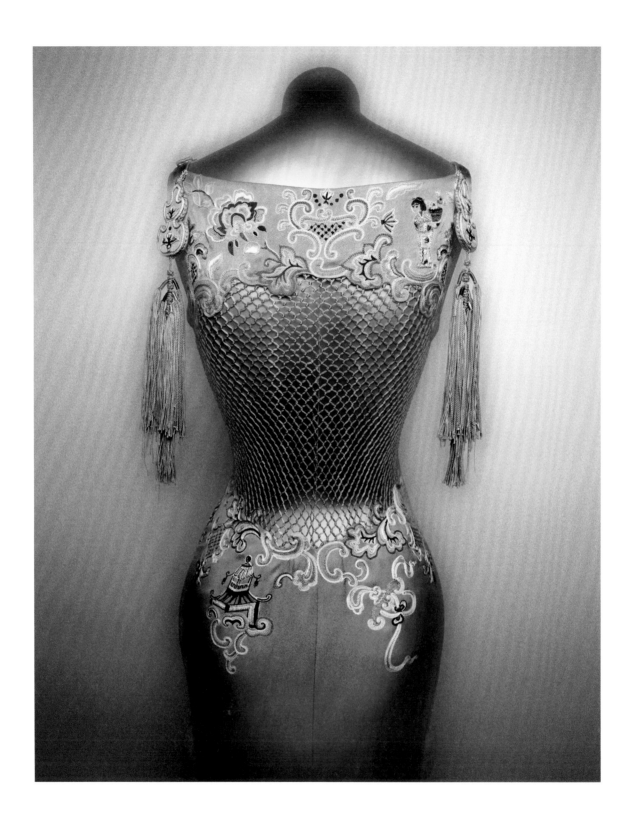

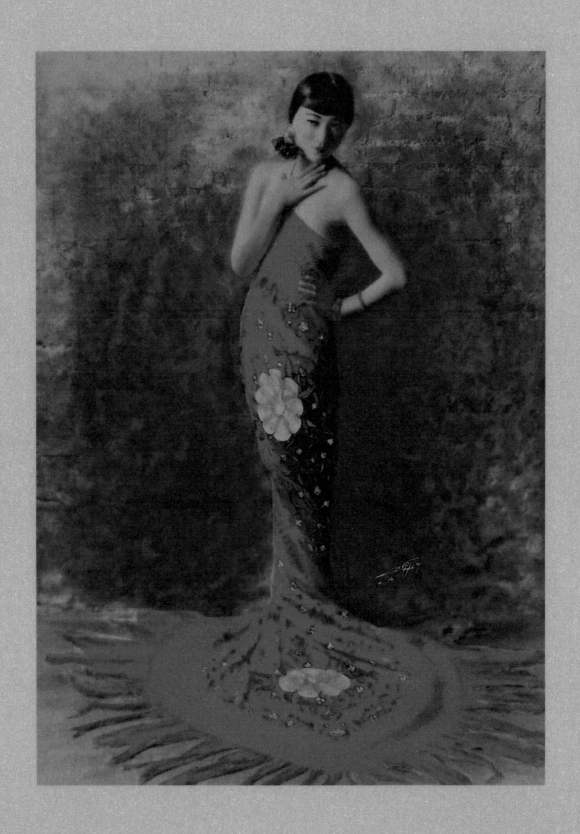

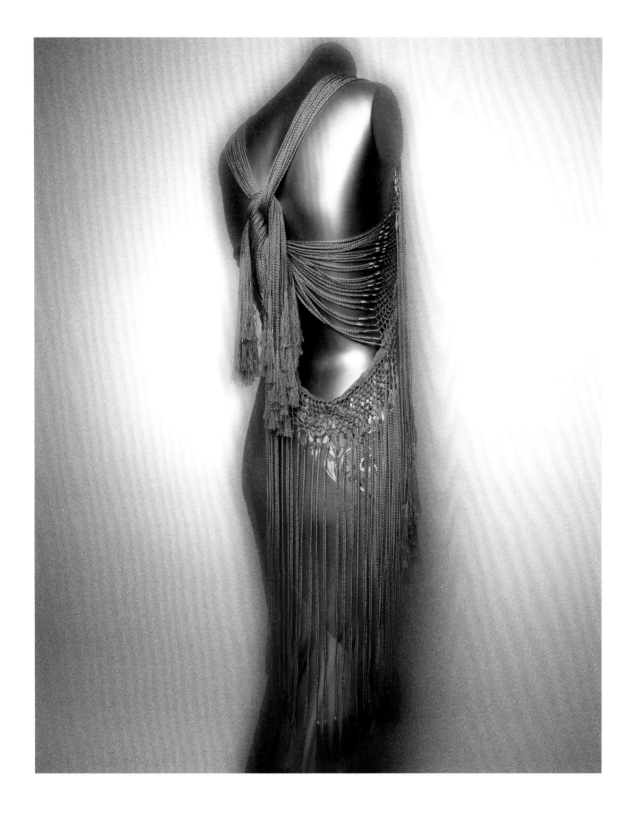

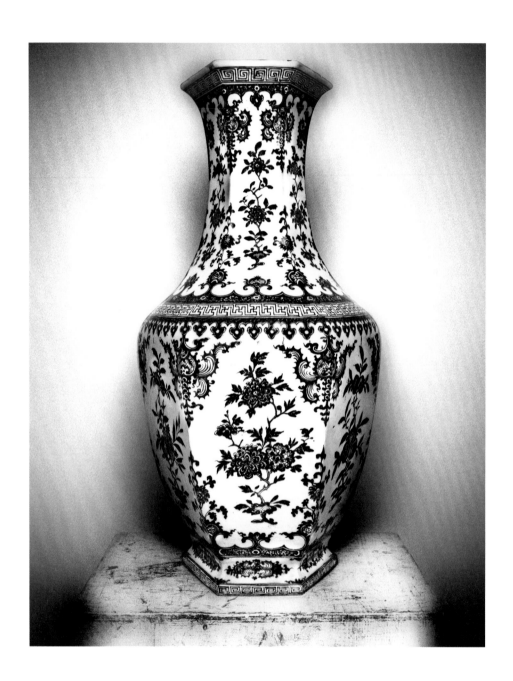

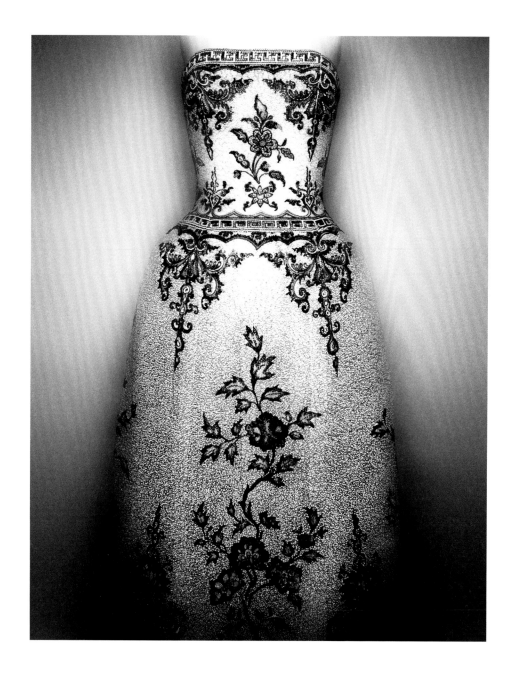

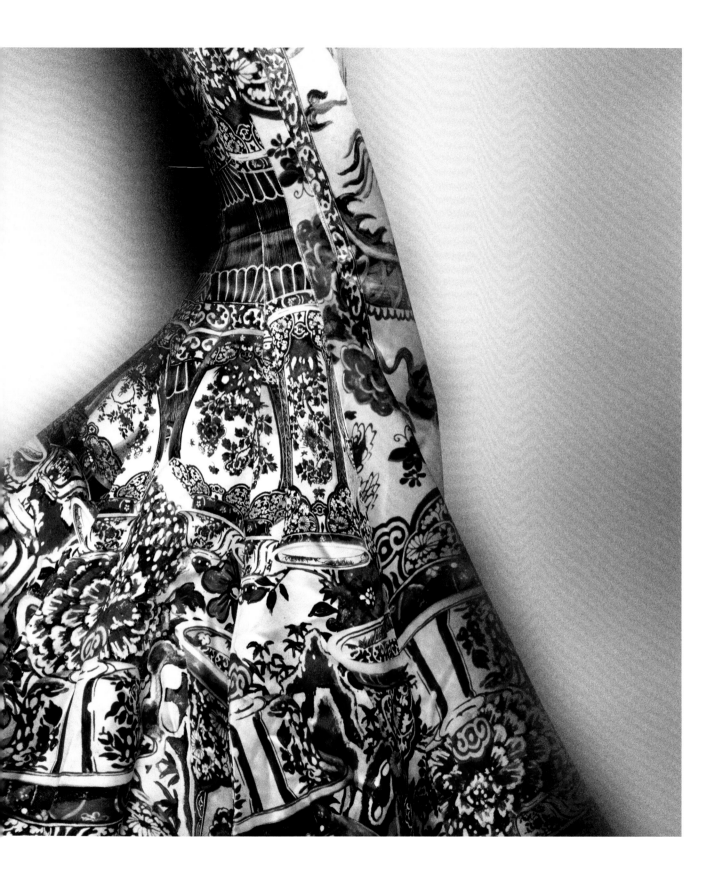

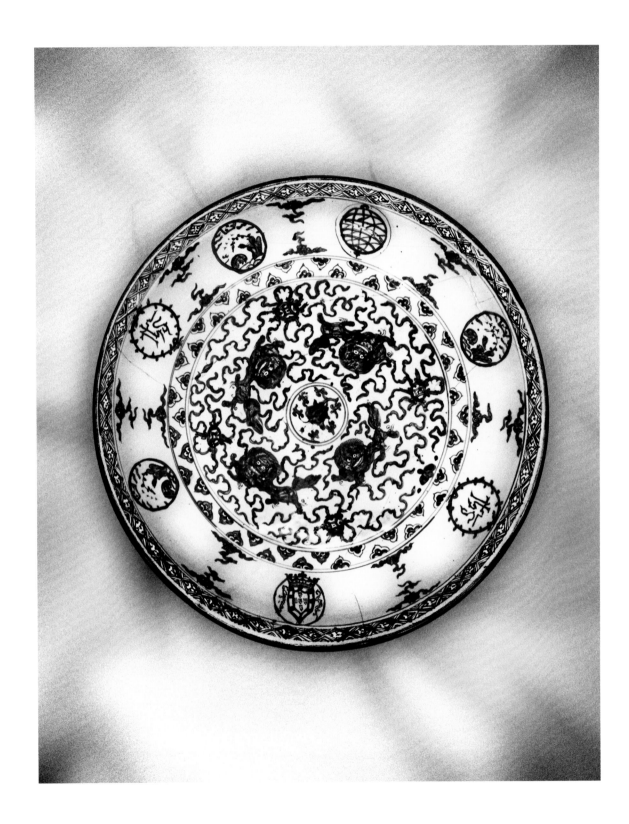

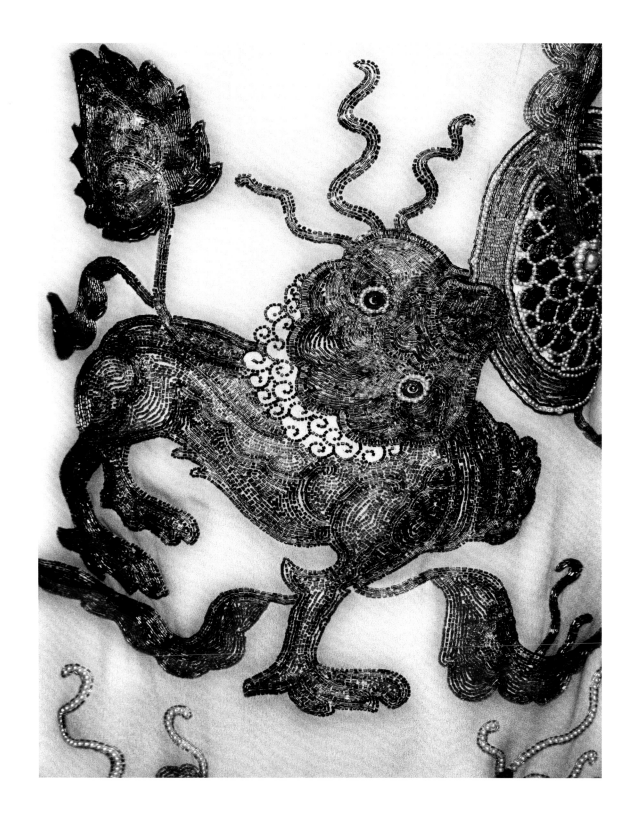

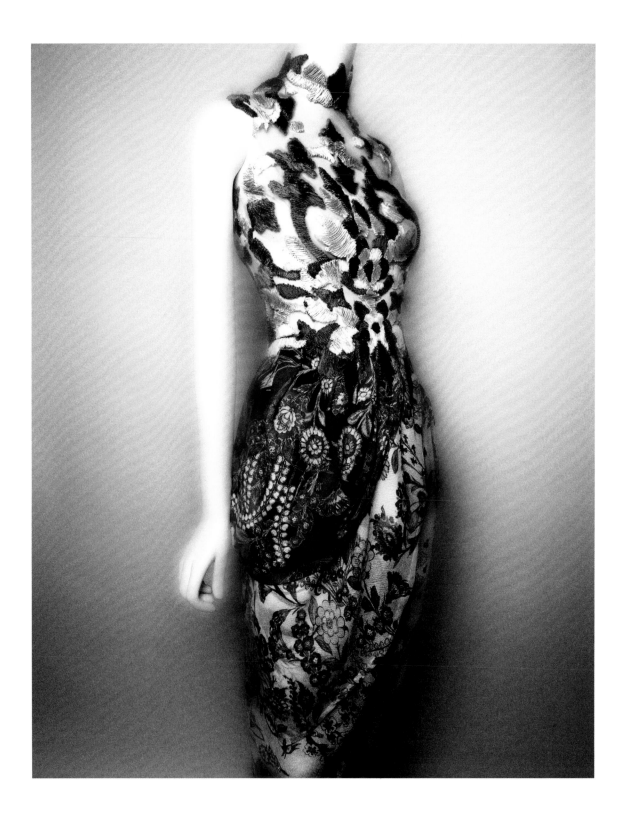

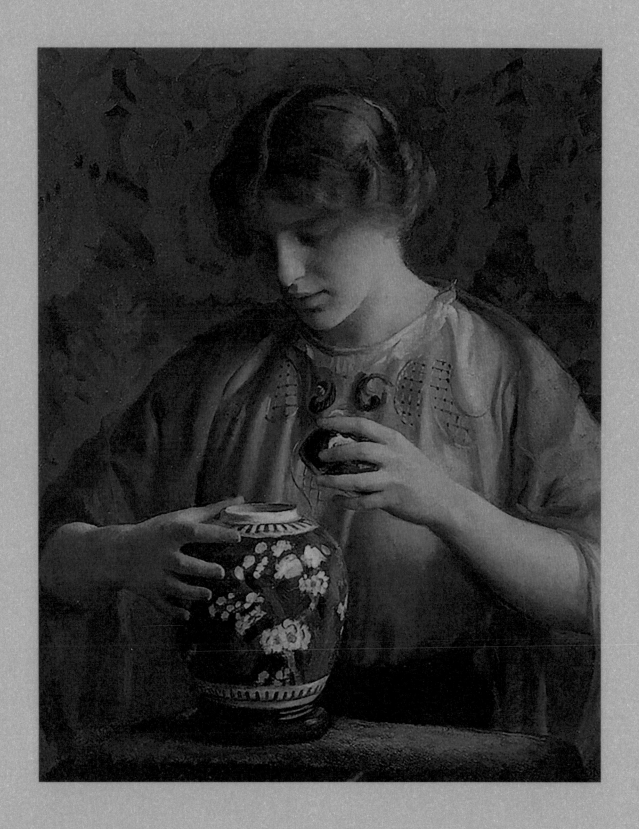

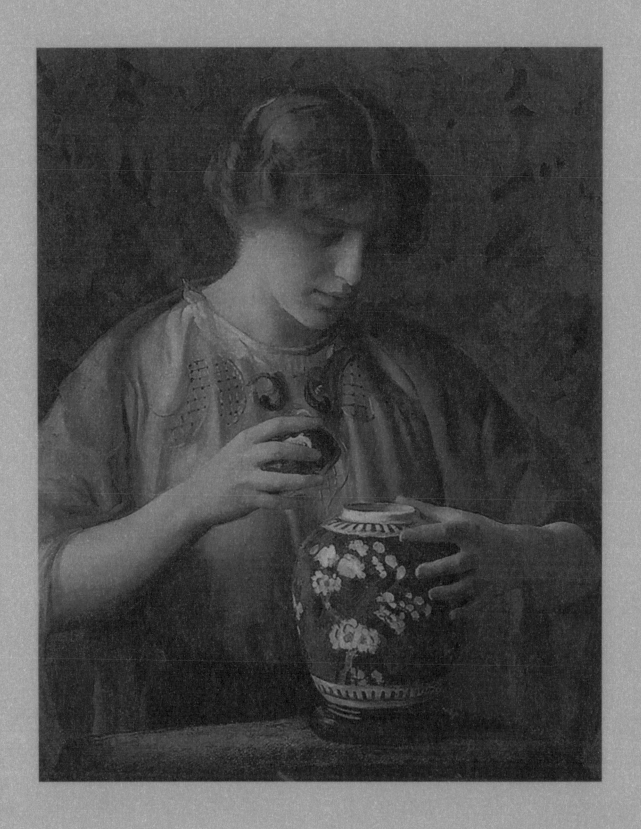

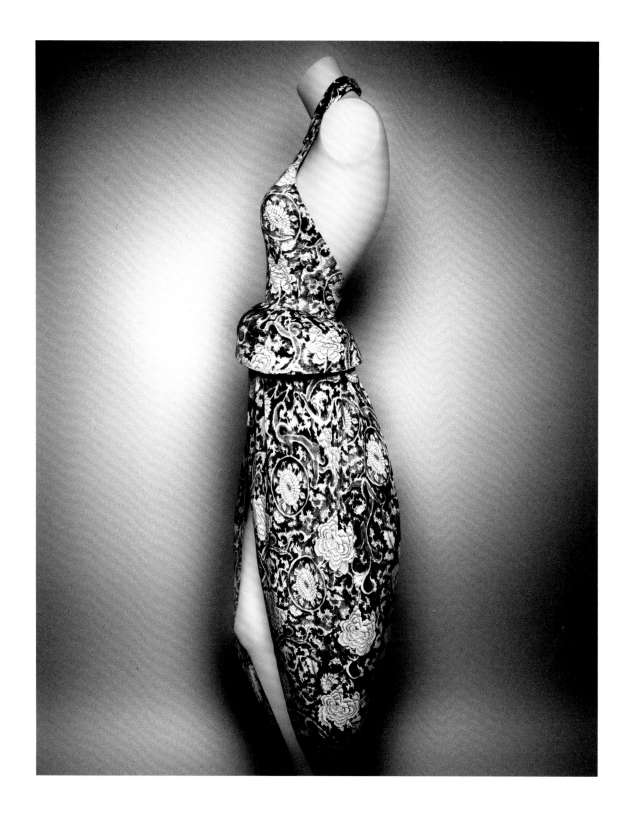

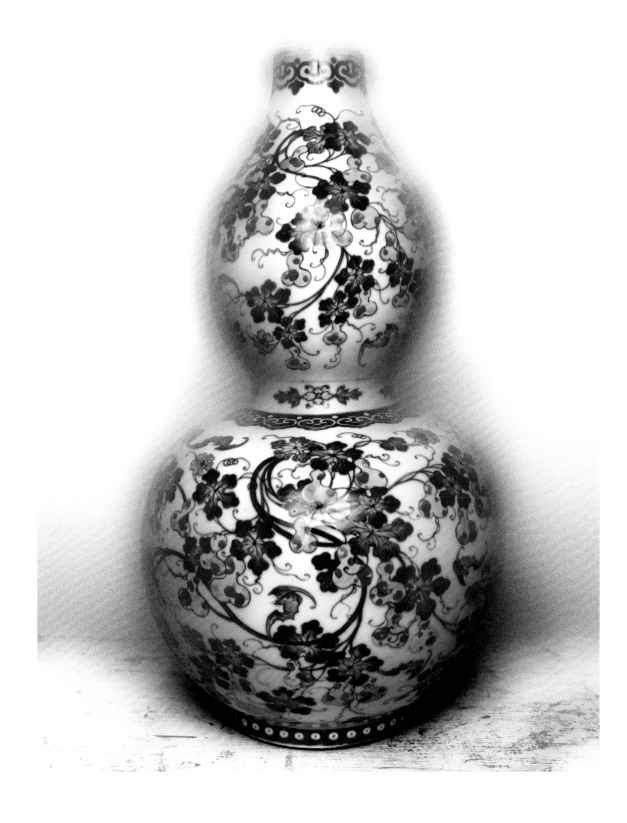

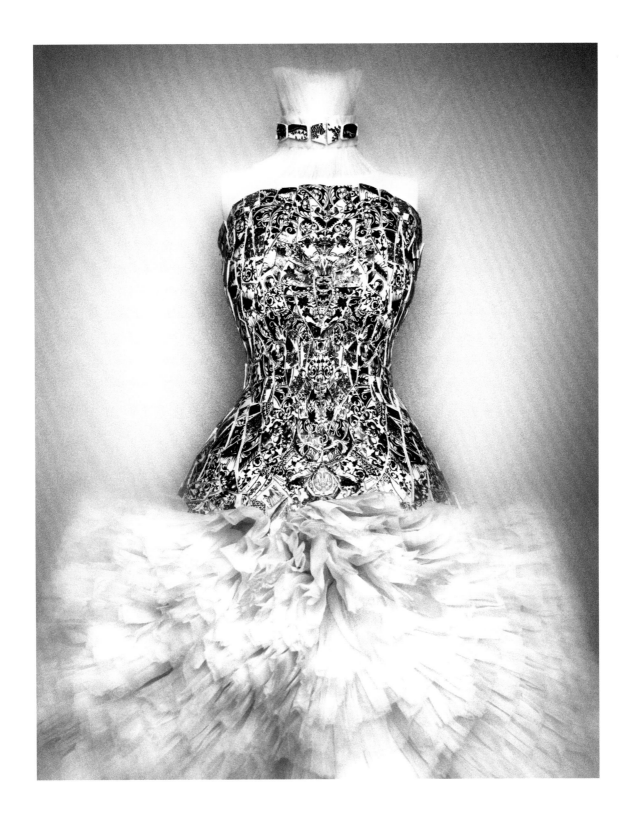

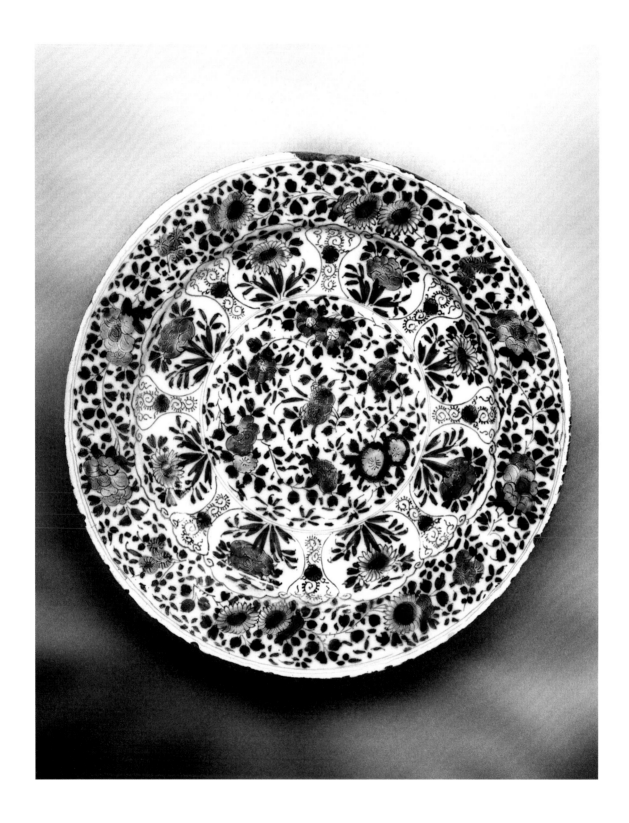

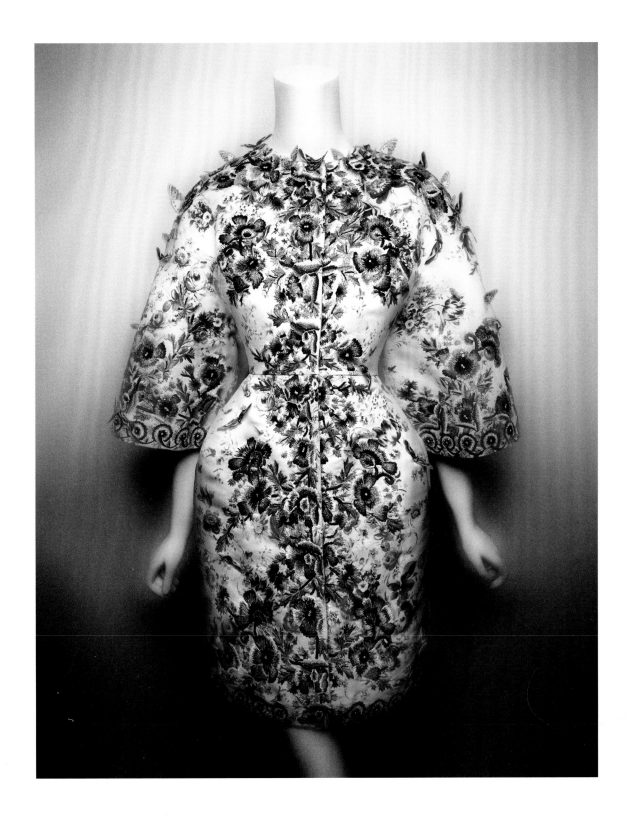

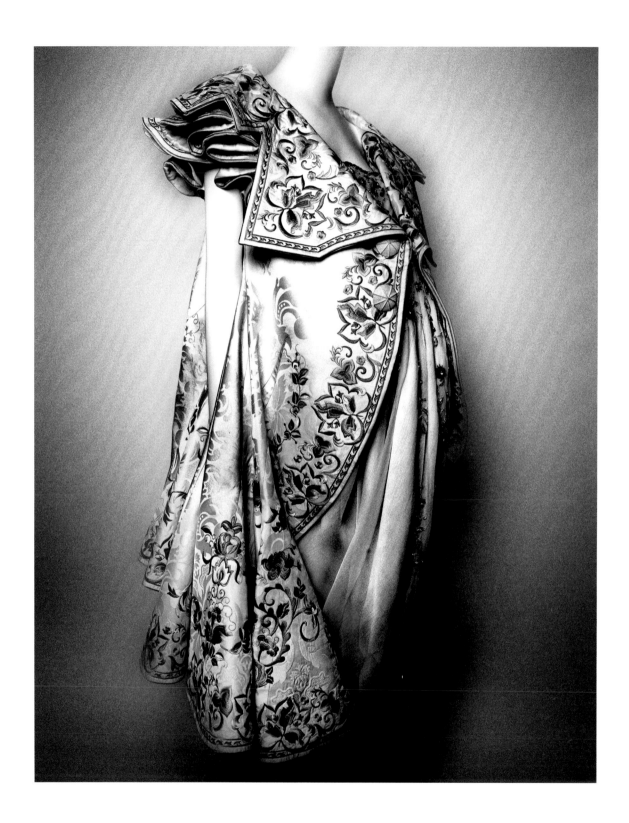

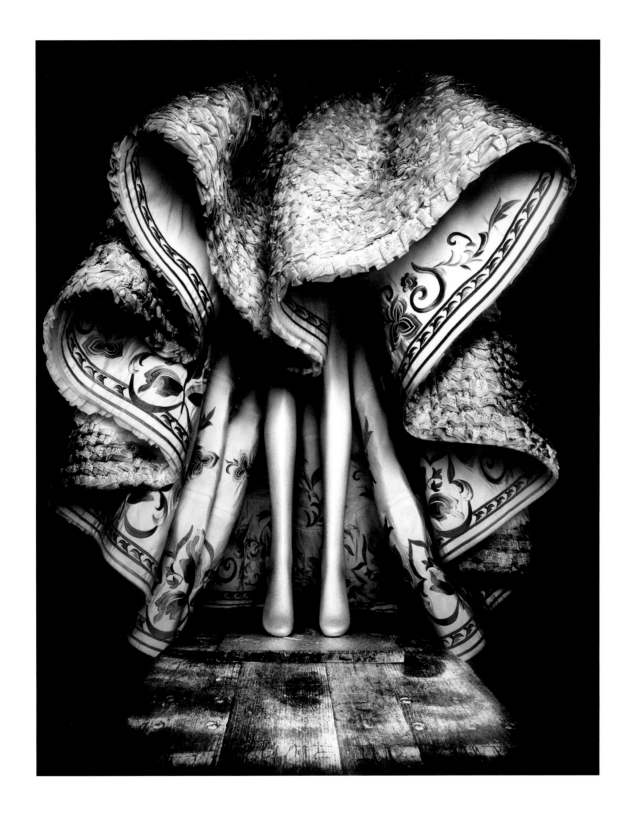

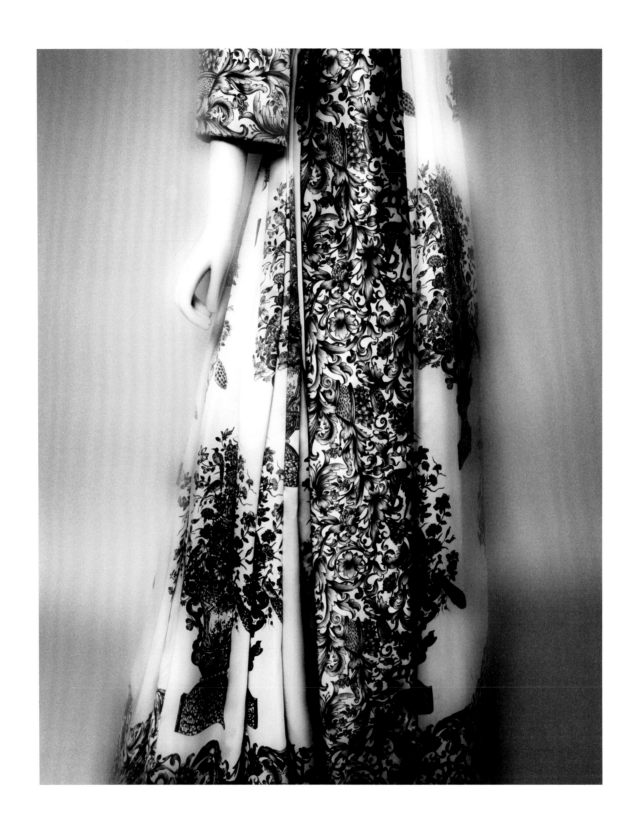

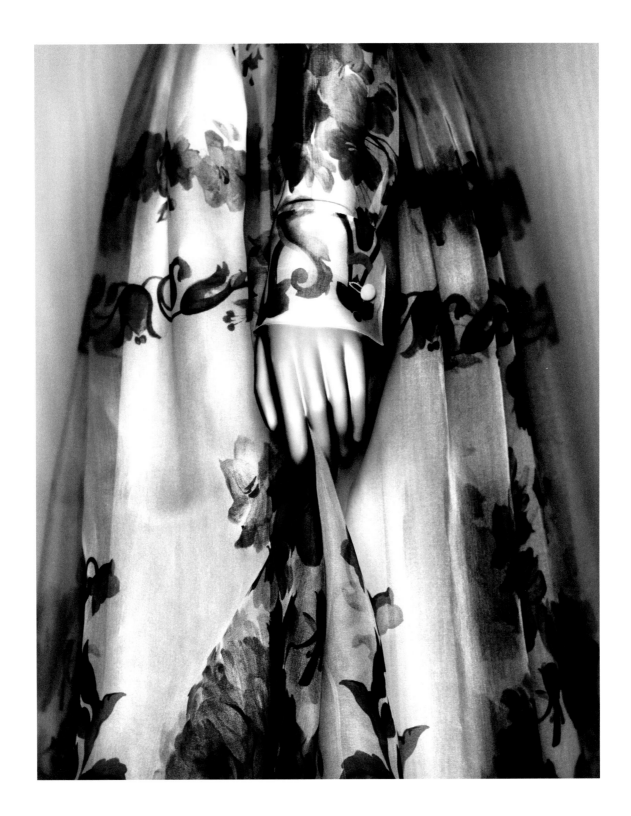

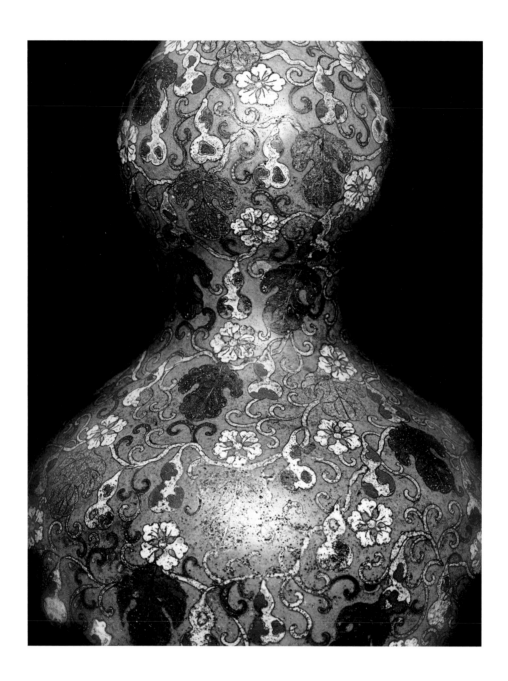

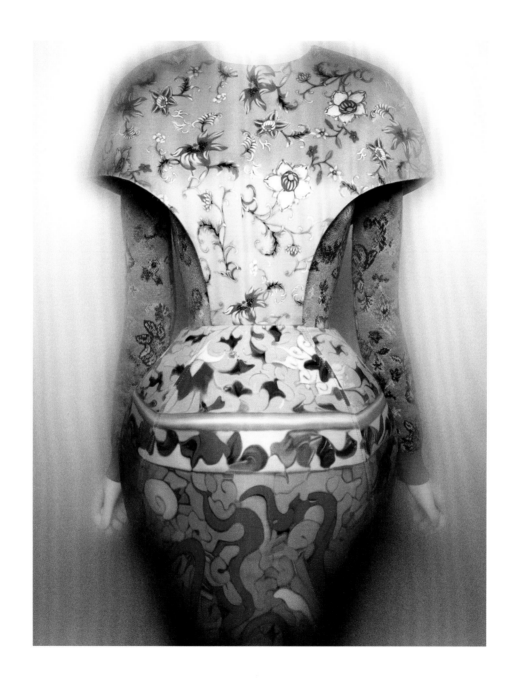

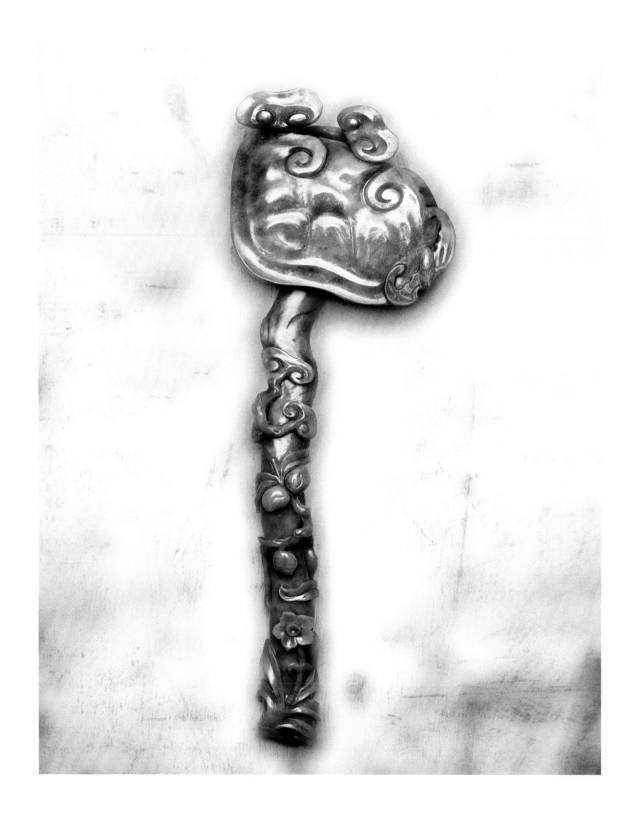

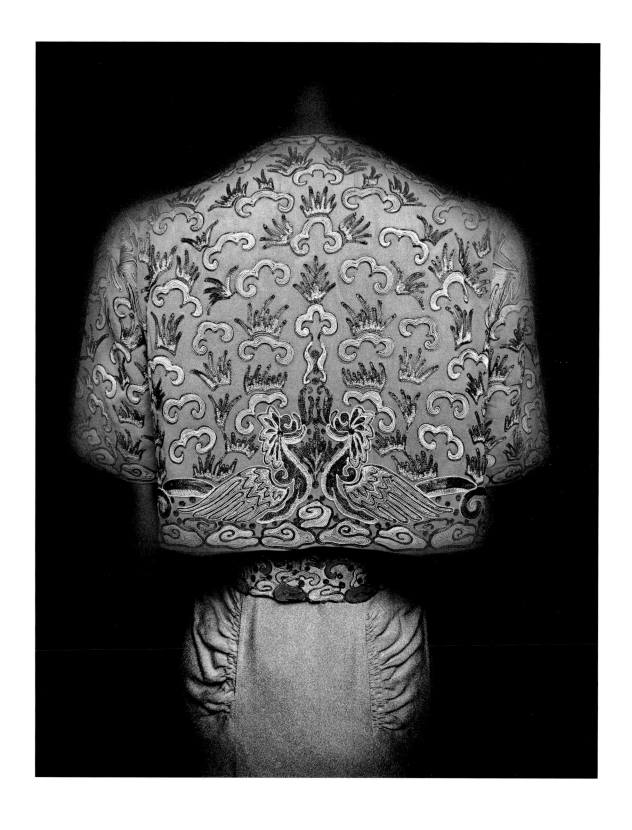

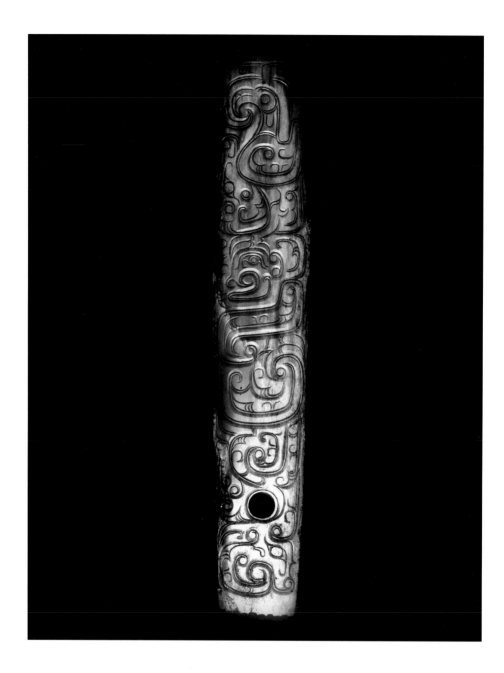

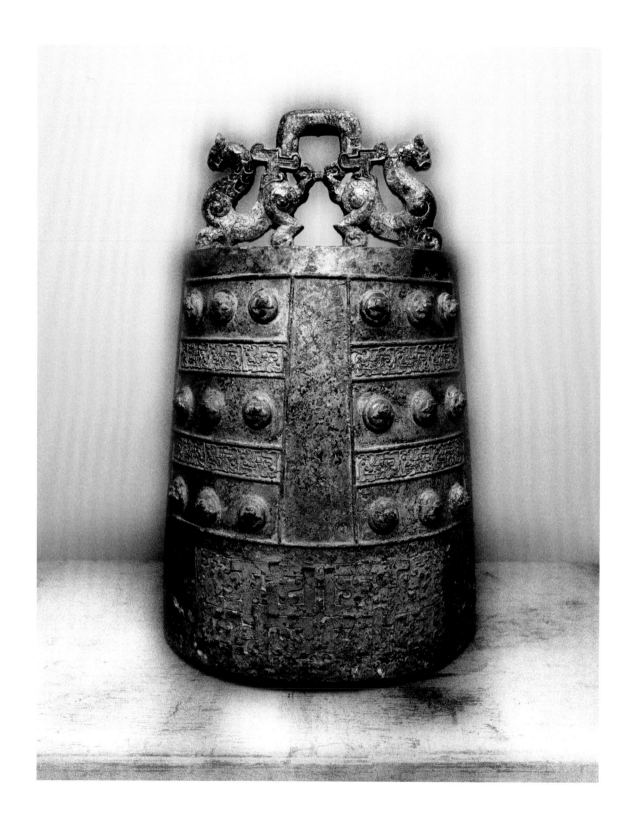

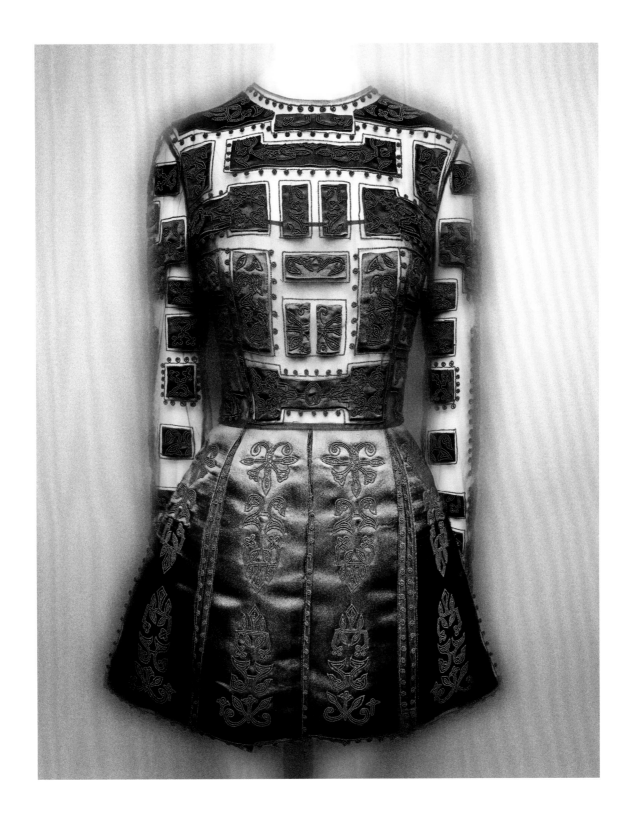

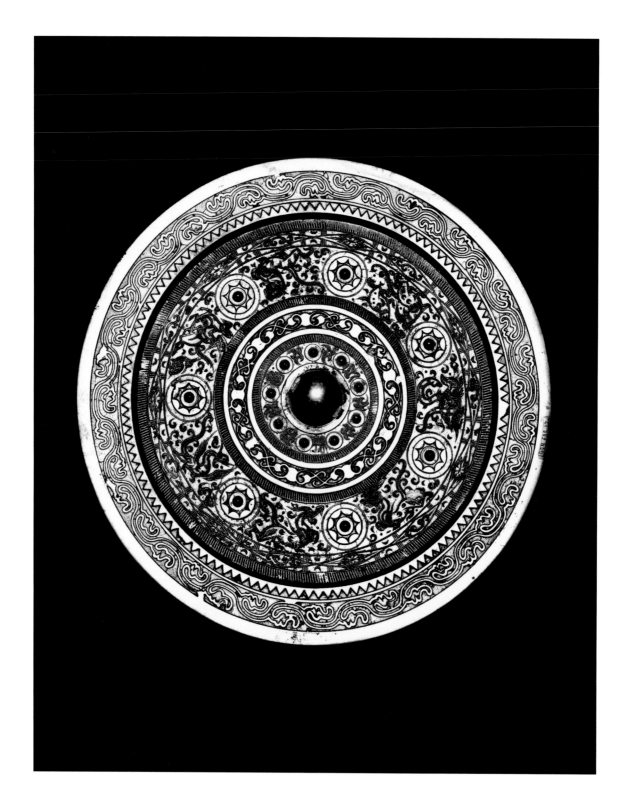

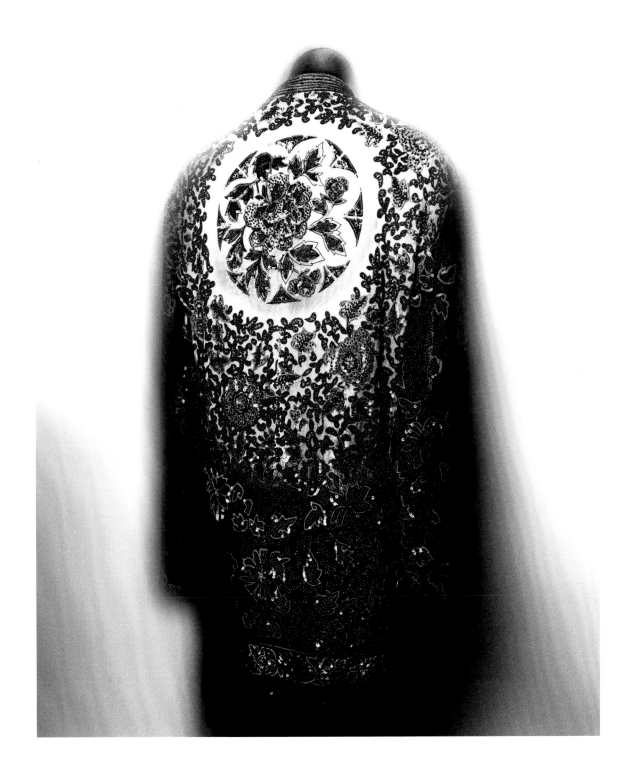

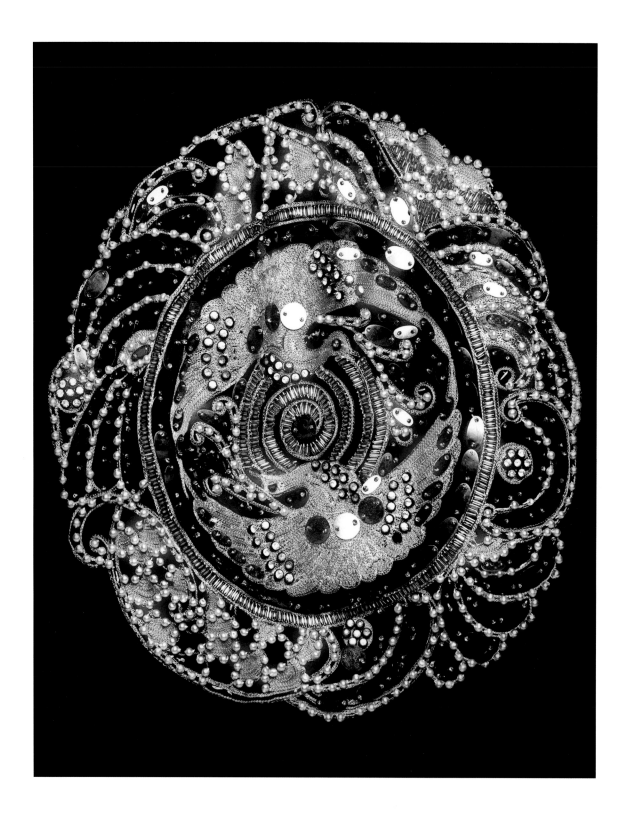

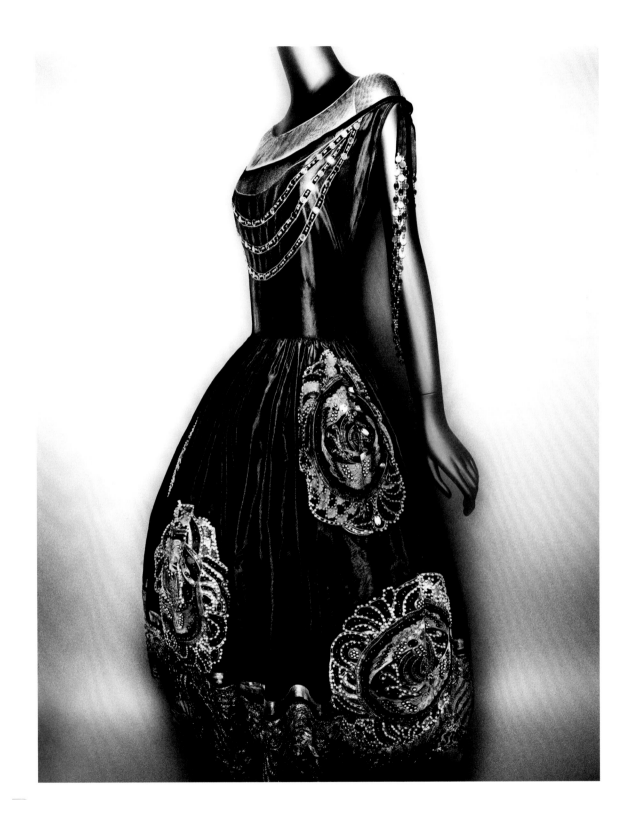

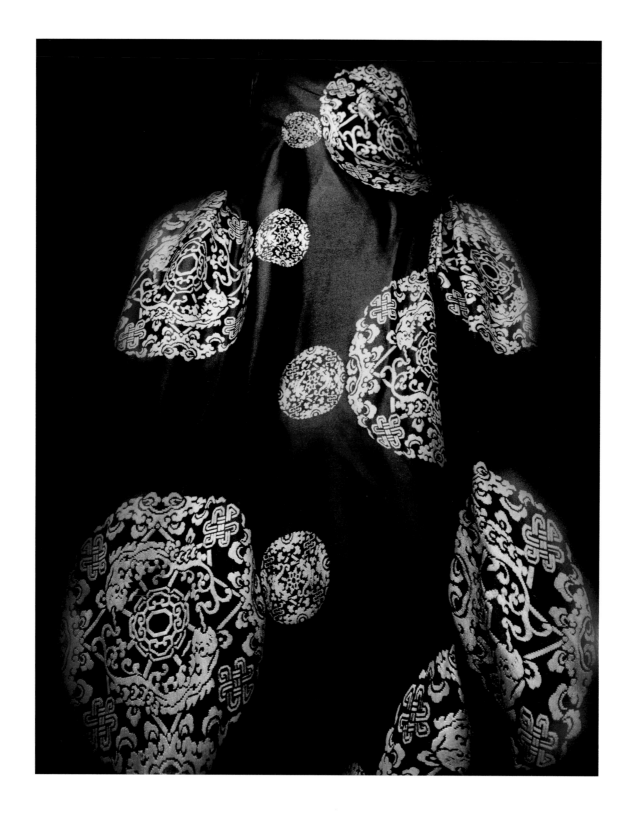

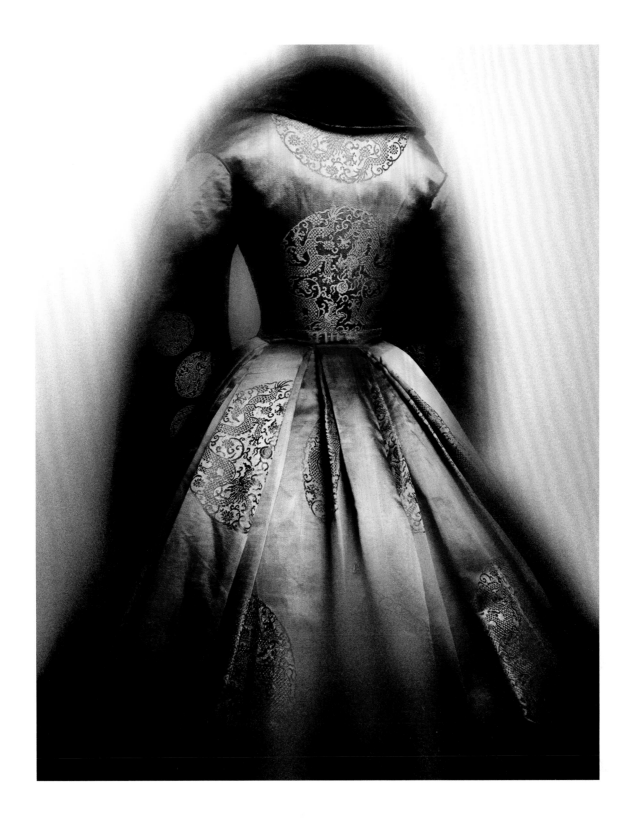

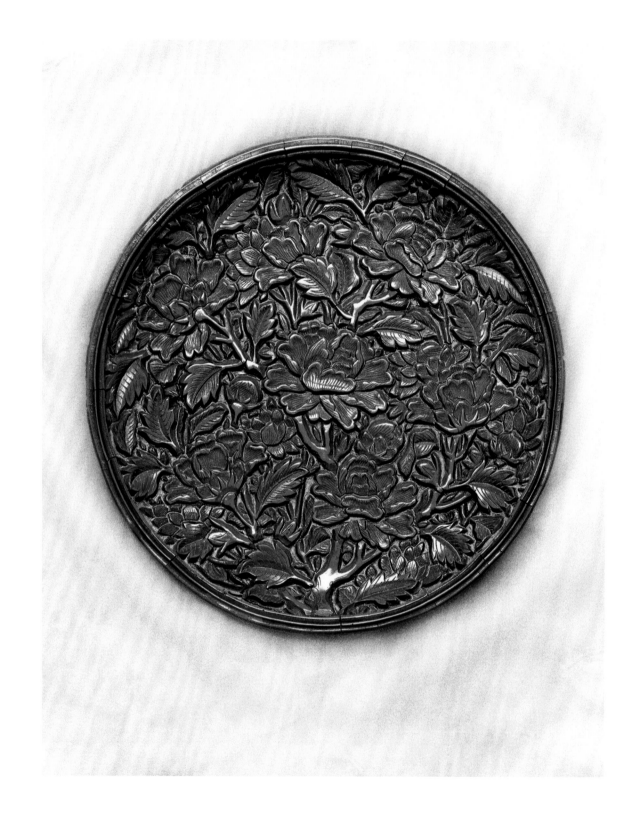

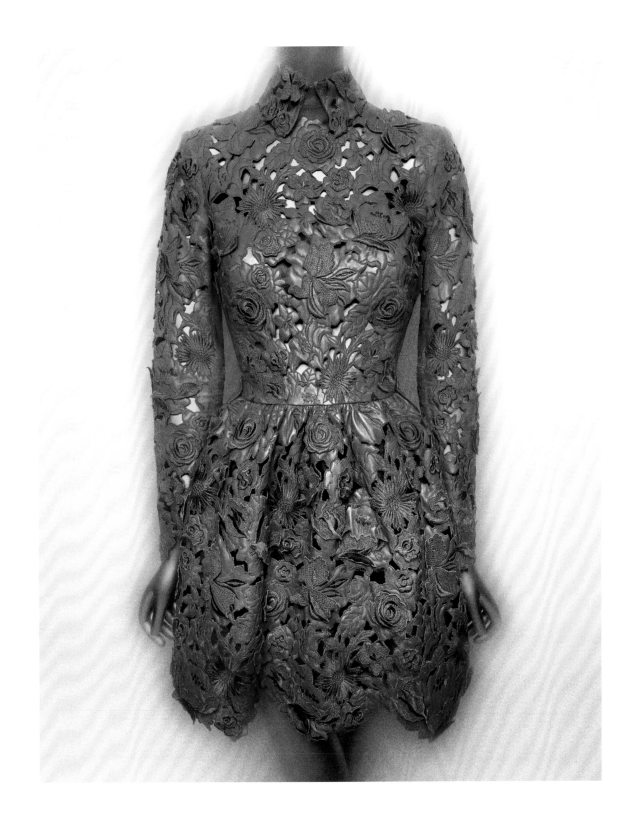

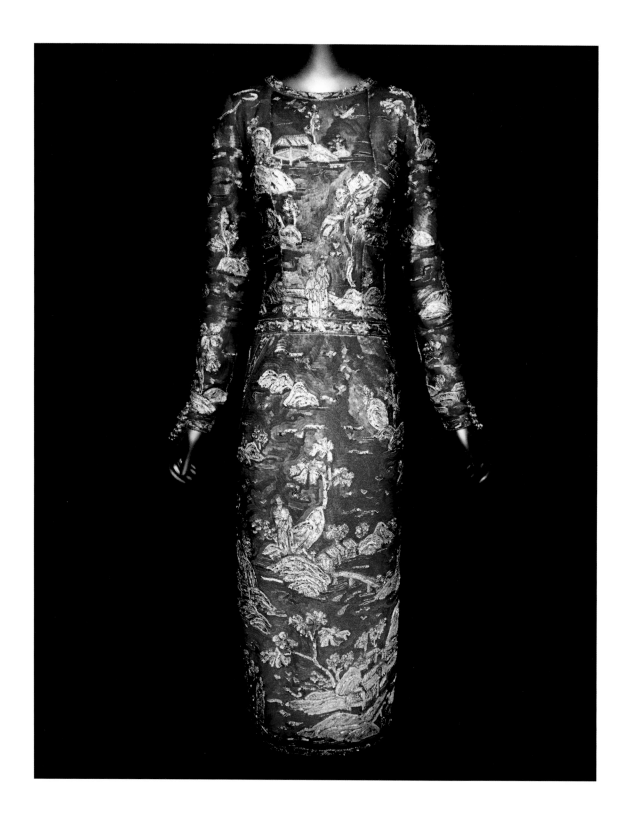

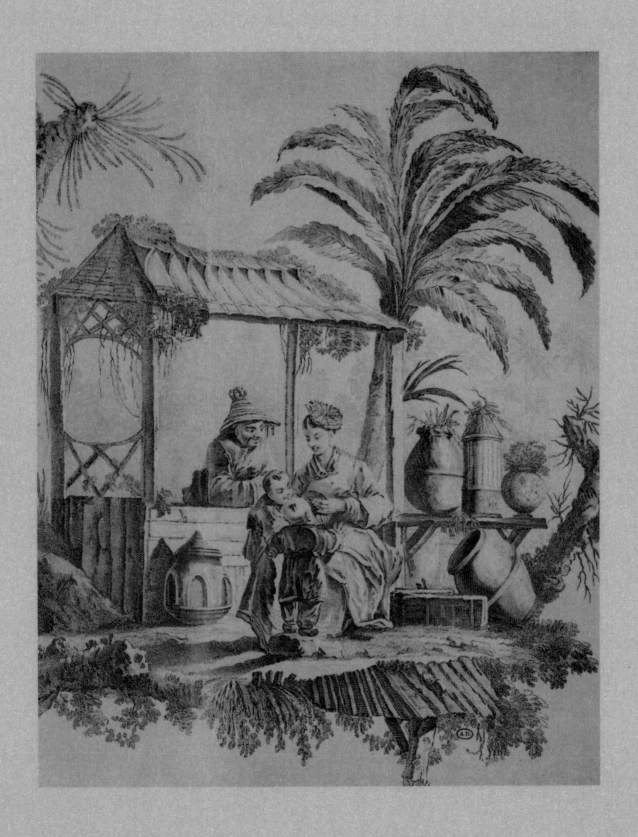

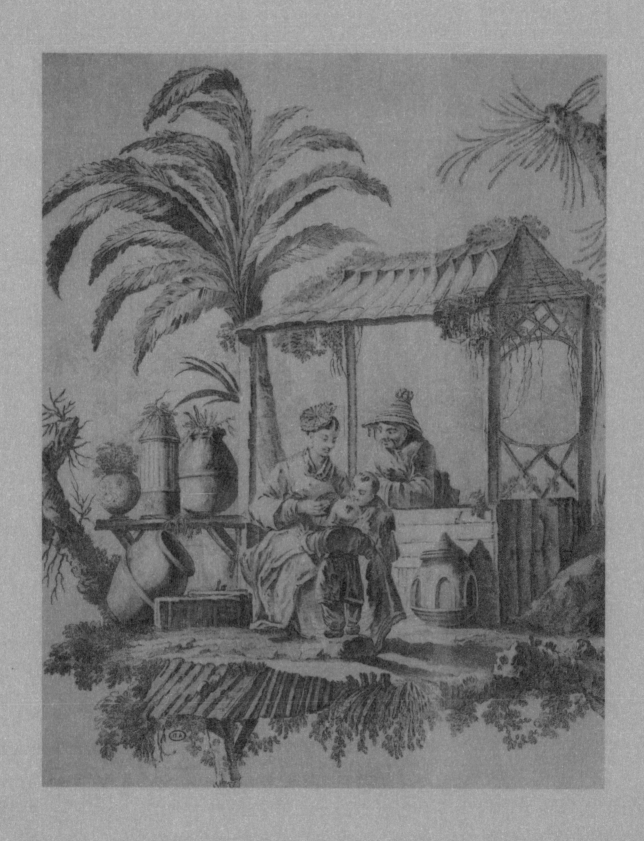

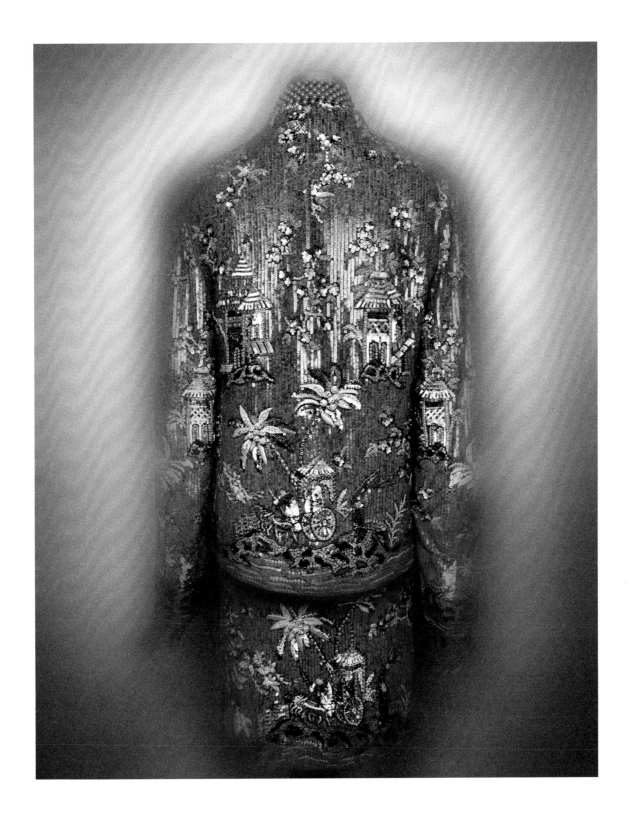

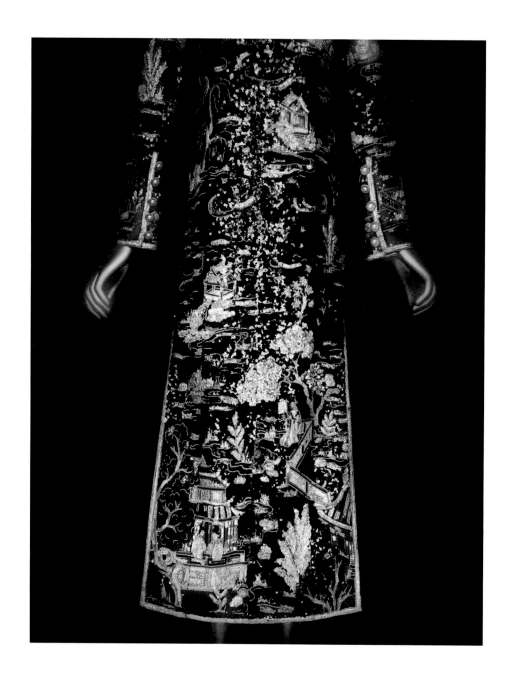

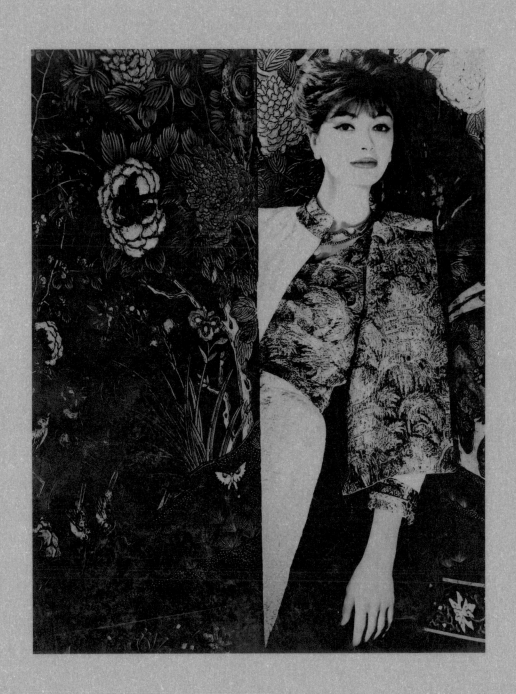

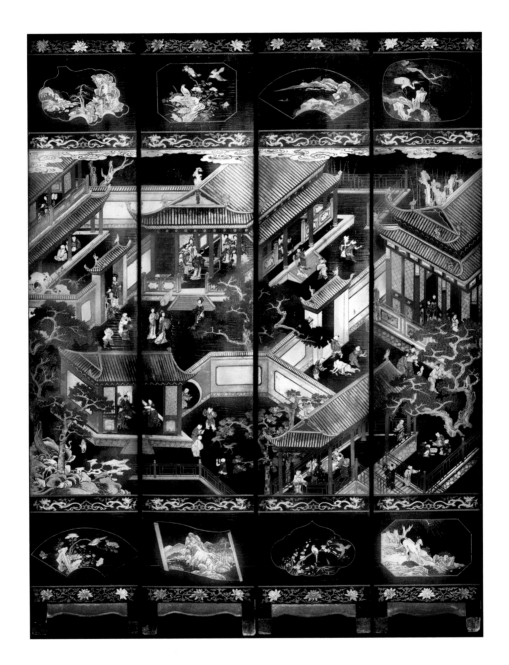

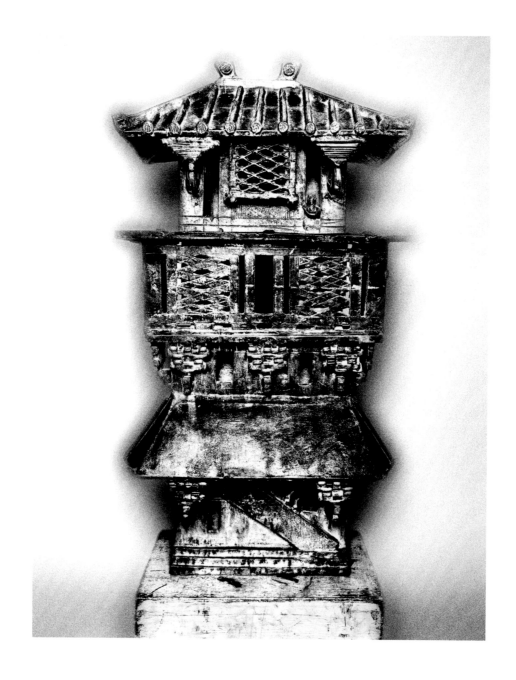

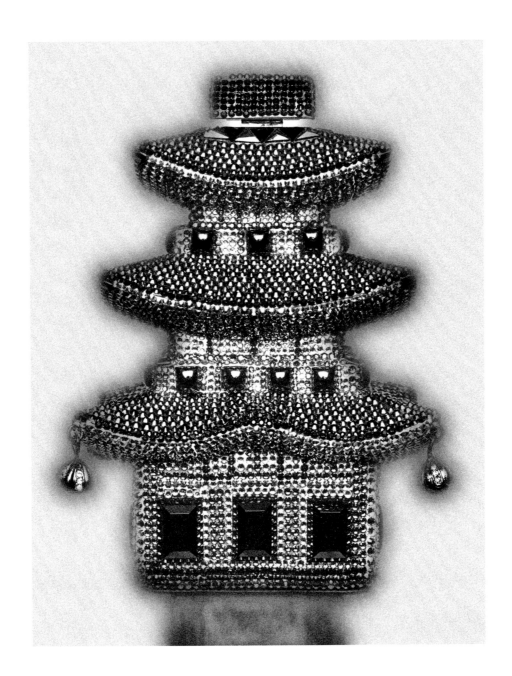

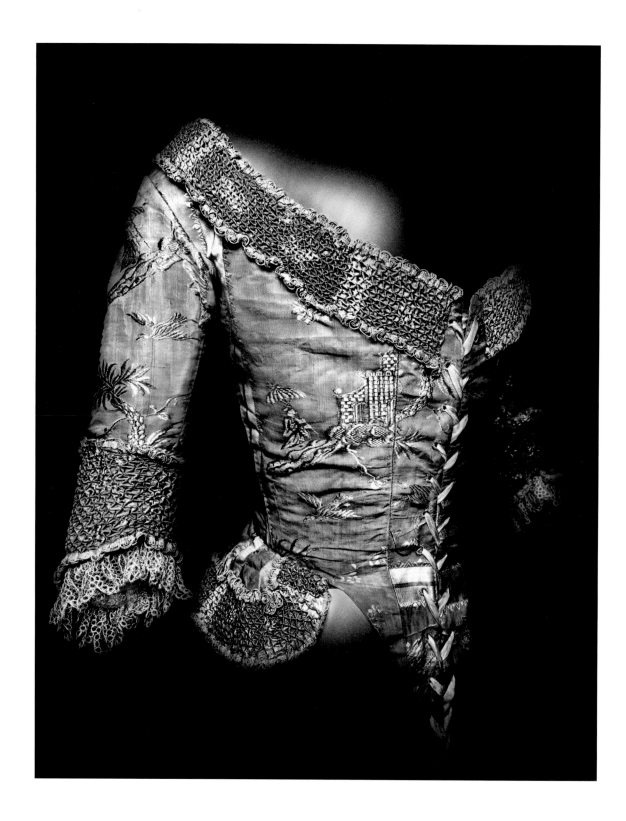

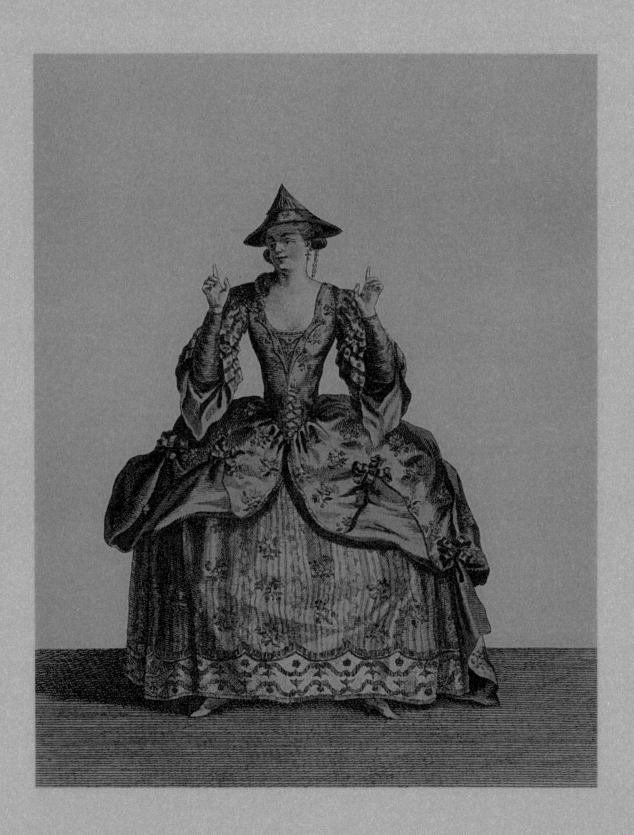

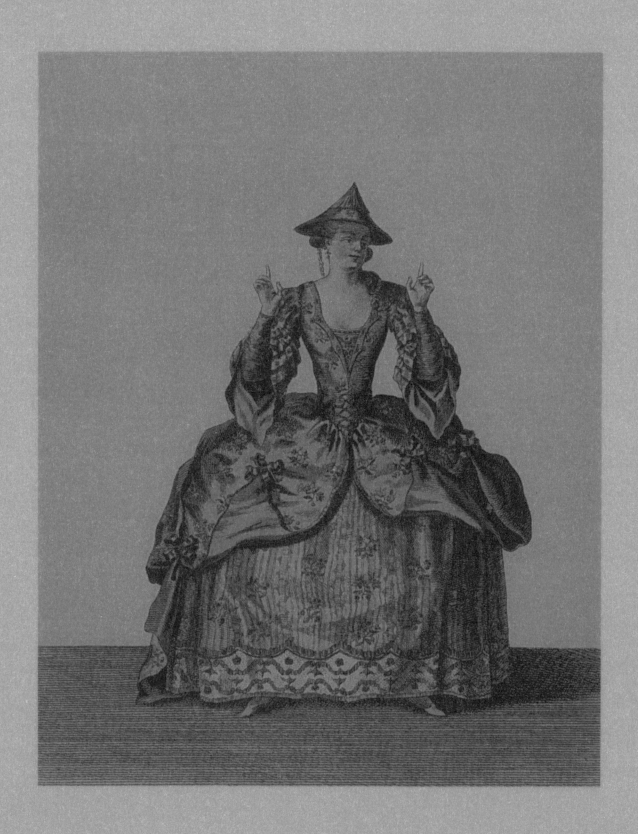

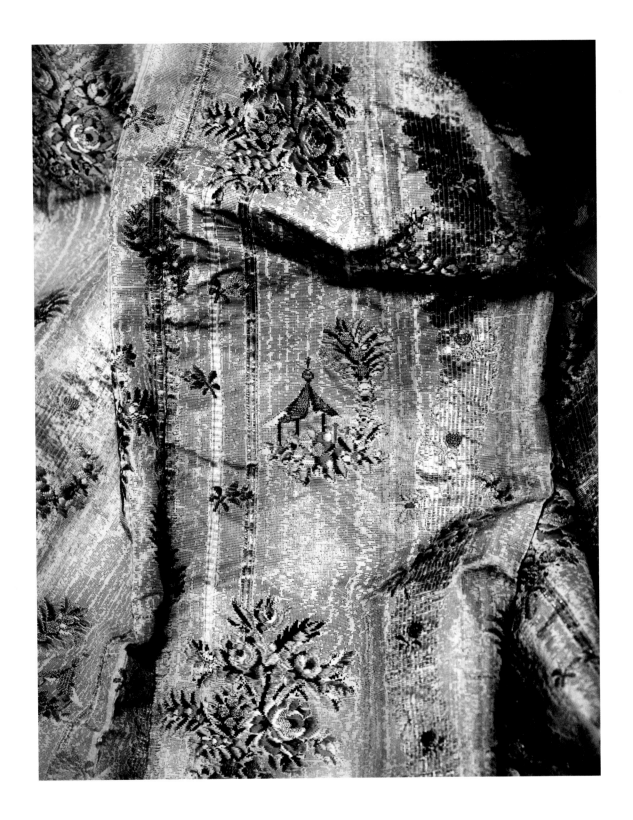

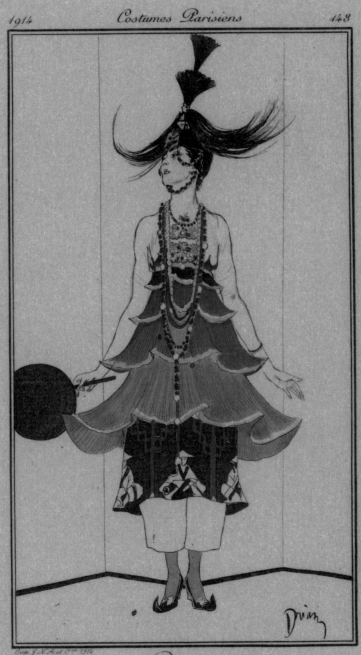

*Pagode*

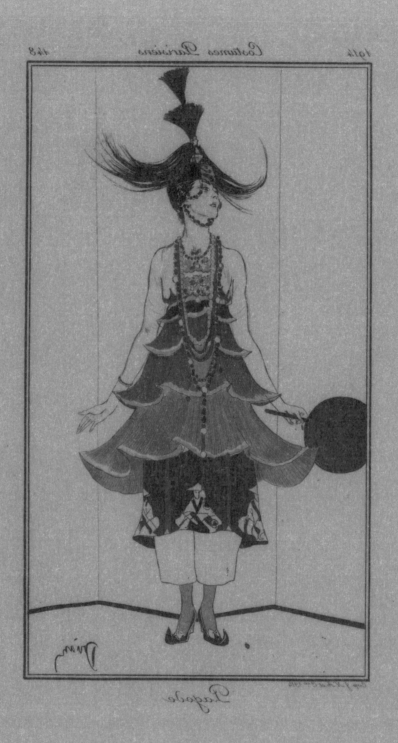

Pagode

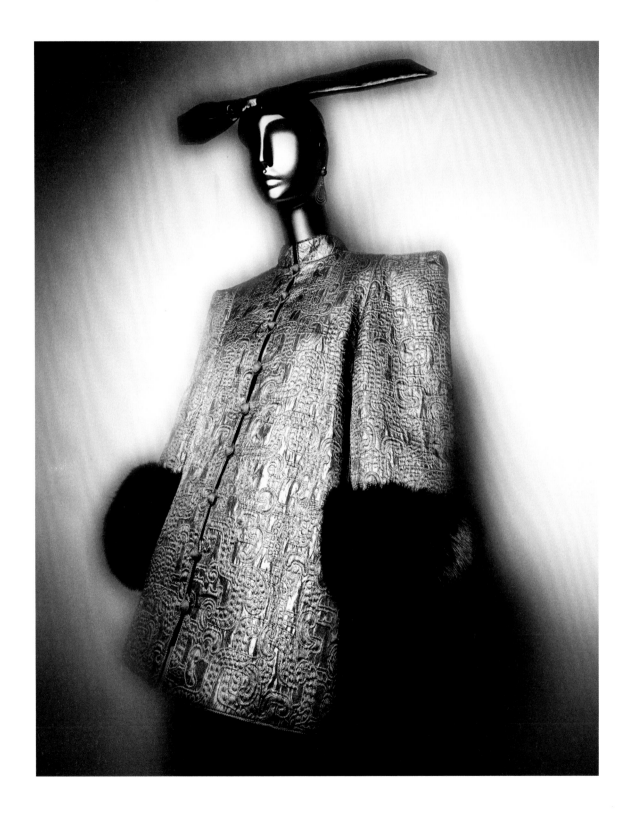

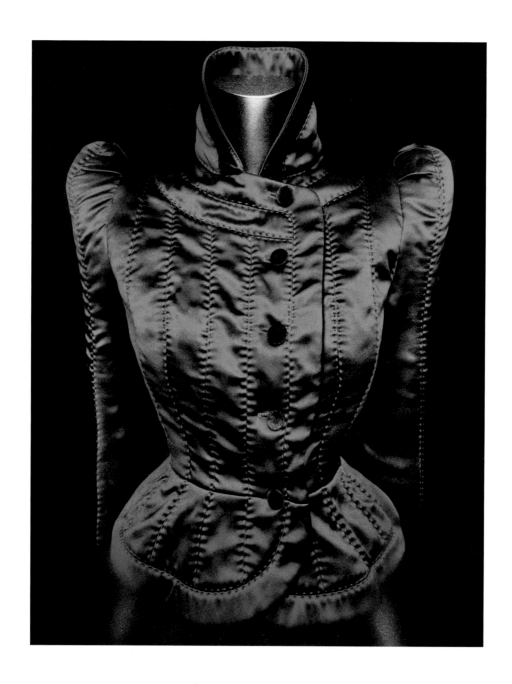

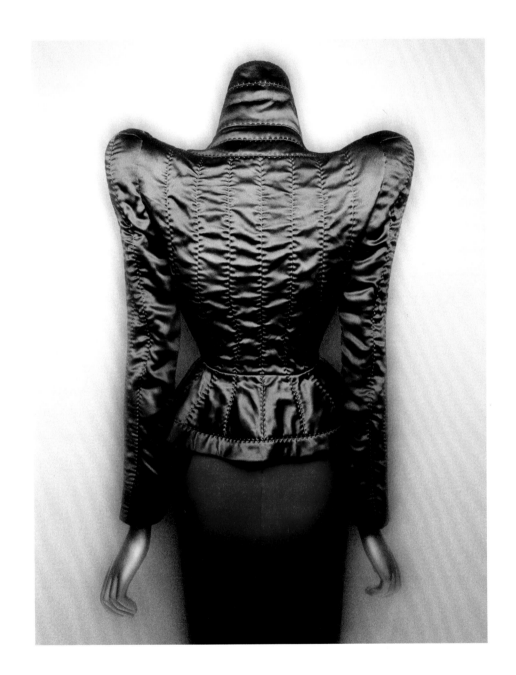

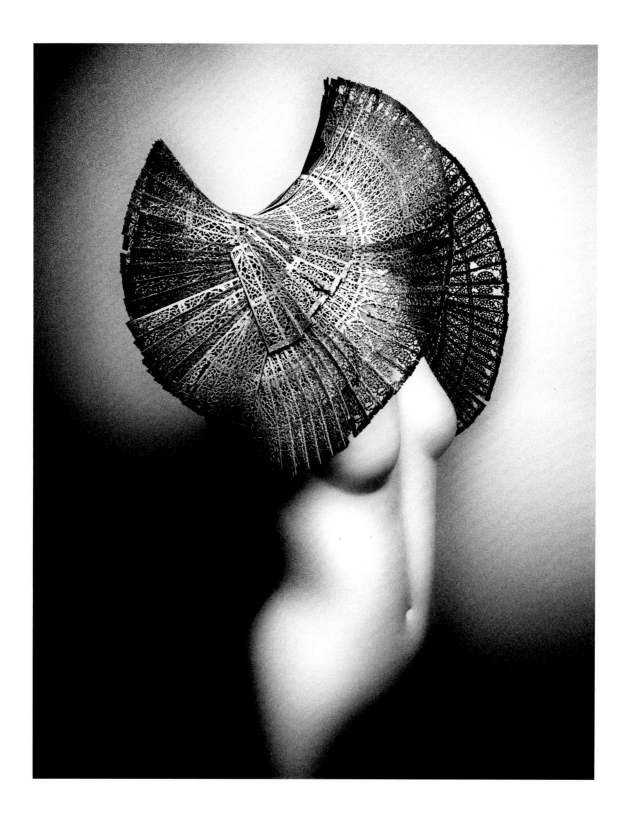

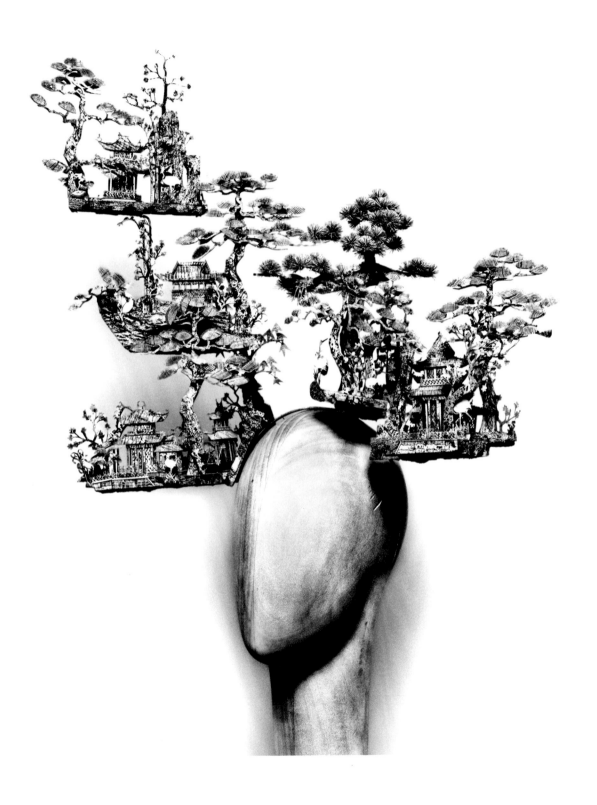

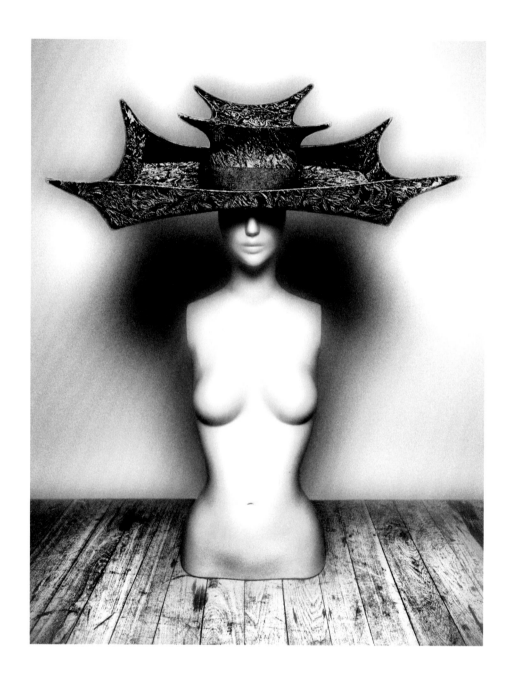

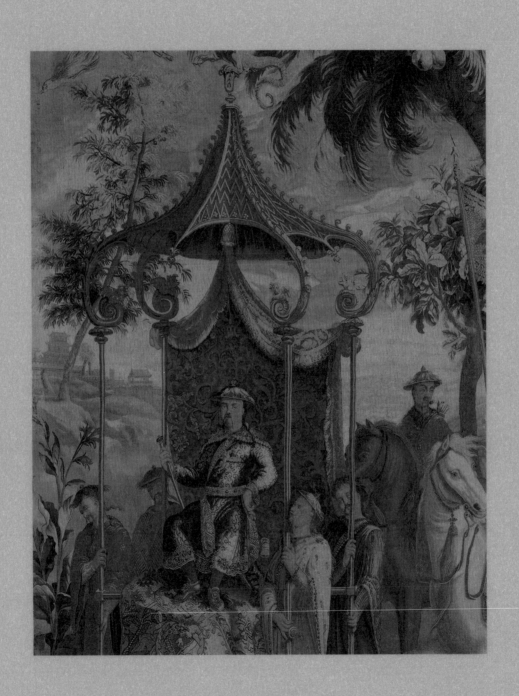

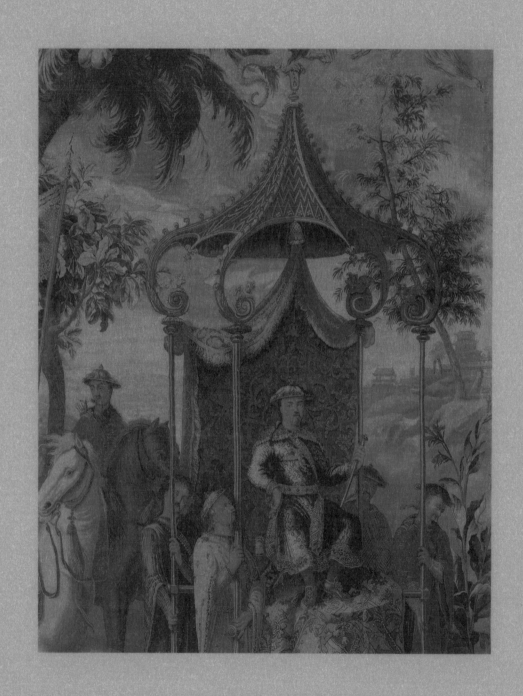

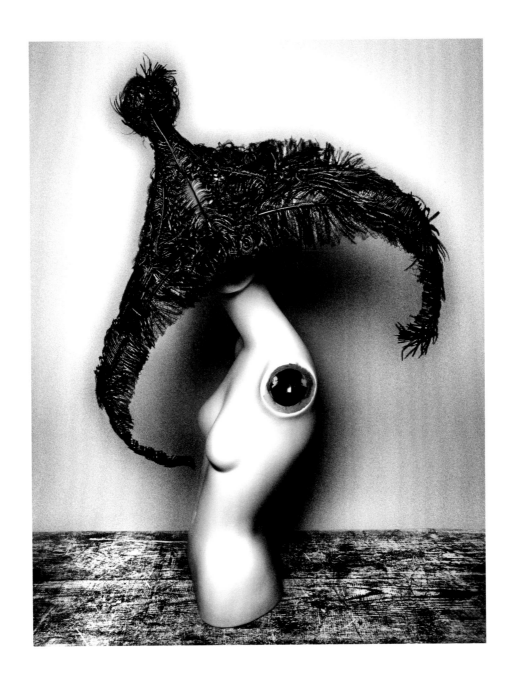

# INTERVIEW
# SOURCES & CREDITS

# John Galliano

## In Conversation with Andrew Bolton

The British fashion designer John Galliano is famous for his narrative-based approach to design. As creative director of Givenchy (1995–96), Christian Dior (1996–2011), and Maison Margiela (as of October 2014), as well as of his eponymous label (1988–2011), Galliano has enlivened the world of fashion through his seemingly paradoxical combinations of cultural and historical citations. His sources have ranged from ancient Egypt to the French Revolution and from Pocahontas to the Duchess of Windsor, but none has infused his work more consistently throughout his career than China.

**ANDREW BOLTON: More than any other designer featured in this catalogue and related exhibition, you have found China to be a recurrent source of inspiration in your work. What drew you to China initially?**

JOHN GALLIANO: I was fascinated with the culture. In retrospect, I think it was because I knew very little about it. Before I visited China, it was the fantasy that drew me to it, the sense of danger and mystery conveyed through Hollywood. Much later, I learned more about the real China through research—paintings, literature, architecture. My design process involves in-depth research, and I make a scrapbook for every collection with images that show my current thinking. But, yes, my initial interest in China was fueled by movies, by their fantasized and romanticized portrayals.

**B: Designers often view China through the lens of cinema; that's one of the main propositions of *China: Through the Looking Glass*. Hollywood movies of the 1930s and 1940s—especially those featuring Anna May Wong—have been a particular source of inspiration.**

G: Images of Anna May Wong have appeared frequently in my scrapbooks. The allure and mystique she projects are extremely powerful and seductive.

**B: She seems to have been a source for your spring/summer 1993 collection, which you titled "Olivia the Filibuster." It included several dresses based on the *qipao*. Some featured a spiraling dragon motif that reminded me of a dress Anna May Wong wore in *Limehouse Blues* [see page 140].**

G: Absolutely, she was the primary source of inspiration for those pieces. The fabric of the dresses was like licorice—black and super shiny. The dragon motif was a heat transfer with gold leaf. Some of the dresses were slashed strategically at the hip, so when the girls walked, the slash opened and closed, revealing the flesh beneath. It was like a wink.

**B: Your first haute couture collection for Christian Dior [spring/summer 1997] included two dresses inspired by Chinese export shawls,**

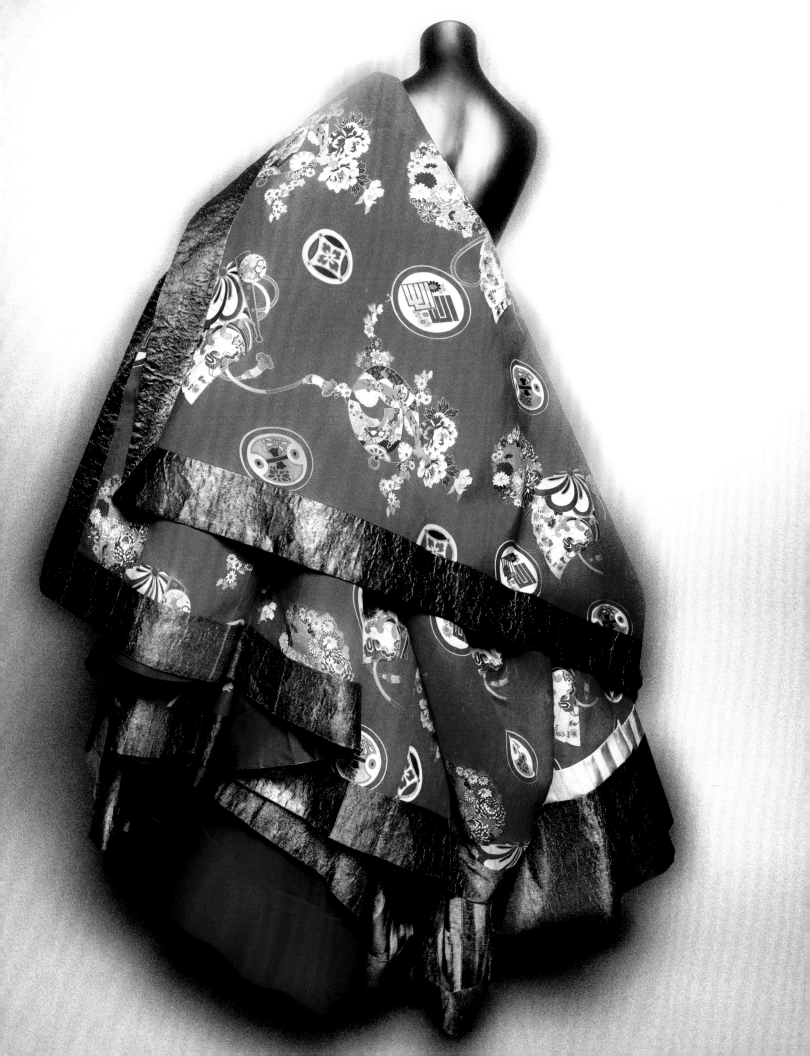

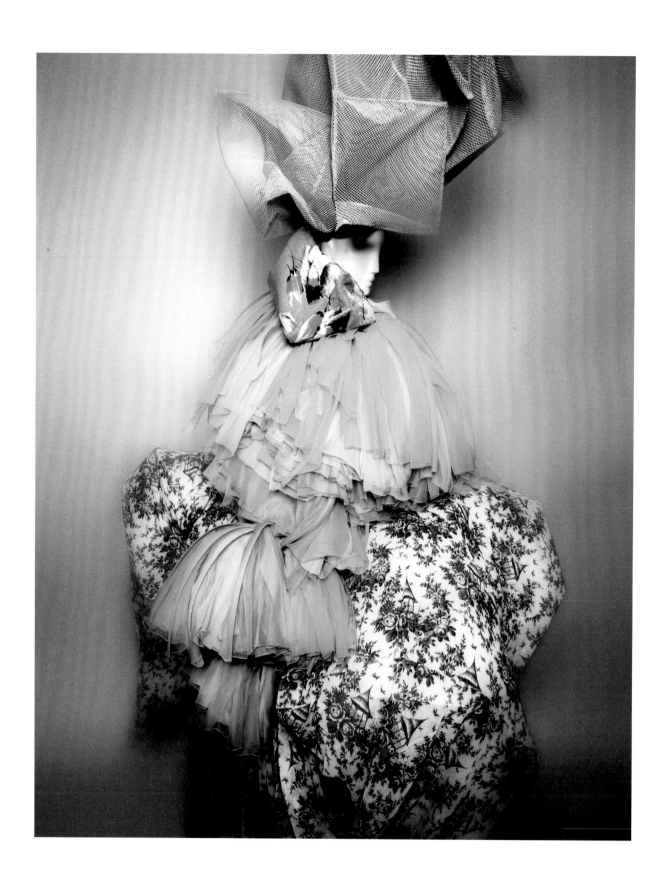

one pink and the other chartreuse [see pages 174–75]. The pink version reminds me of a dress Anna May Wong wears in a rare, hand-colored publicity photograph [see vellum facing page 174].

G: Yes, that photograph was one of my points of reference. I've always loved Chinese shawls—the deep fringe, the exquisite embroidery. Nicole Kidman wore the chartreuse version to the 1997 Academy Awards. It was the first time that an actress had worn a major dress to the Oscars. It was quite a brave statement, that chartreuse.

B: Your debut collection for Dior was partly inspired by China, and Mr. Dior himself drew heavily on Chinese references. He showed models titled "Chine," "Pékin," and "Shanghai" in 1948. Later he featured models called "Nuit de Chine," "Bleu de Chine," "Hong Kong," and "Chinoiseries." During your time at Dior, did any of those models serve as a catalyst for your Chinese-inspired collections?

G: My models at Dior frequently referenced Mr. Dior's, so yes, absolutely, they would have served as a catalyst. Probably not the main catalyst, though. They would just have been woven into my storyline.

B: You're like the Hans Christian Andersen of fashion. The characters in your autumn/winter 1997–98 ready-to-wear collection for Dior seemed to have time-traveled to Shanghai in the 1930s [see pages 120–21].

G: That collection was inspired by Chinese pinups, Shanghai calendar girls of the 1930s. I'd discovered these wonderful advertisements for cigarettes, toilet water, and other beauty products featuring beautiful women in tightly fitting *qipaos*. They were so inspiring.

B: It included several dresses inspired by the *qipao*. Traditionally, *qipaos* are cut on the straight grain, but yours were cut on the bias.

G: The *qipao* is already a very sensual garment, but I wanted to heighten its sensuality further by cutting it on the bias, which exaggerates the contours of a woman's body. It produced this natural drape at the knees, which I amplified in some of the *qipaos*. The fabrics I used were extremely beautiful: brocades, light silks with lace inserts, and heavier silks traditionally used for men's ties and cravats.

B: The collection was shown in the same year as the handover of Hong Kong to China. Was there a connection?

G: I was certainly conscious of the handover, yes.

B: I ask because the stories that unfold in your collections seem less motivated by politics than by personal interests. Take your autumn/winter 1998–99 haute couture collection for Dior, "A Voyage on the Diorient Express." It's an exercise in self-revelation. One of the dresses reminded me of a photograph of Anna May Wong wearing a blouse refashioned from a traditional Chinese skirt [see page 102 and the facing vellum].

G: That dress was actually inspired by portraits by the German Renaissance painter Lucas Cranach the Elder. Look at the silhouette and the placement of the embroideries. However, I did style it with jewelry inspired by the Miao people of China.

B: The collection merged historicist and Orientalist references seamlessly. But China was obviously only a minor source of inspiration, whereas it seems to have been the primary motivator in your spring/summer 1999 ready-to-wear collection for Dior [see page 131].

G: It was, at least for the first half of the collection. I was looking at Chinese military uniforms—the color, the gold accents. The touches of red, the small red beads and silk armbands, came from the uniforms of the Red Guards, Mao's young disciples.

**B: Those references are immediately recognizable, but what about the pleats?**

G: They came from Mariano Fortuny, and they were executed in the lightest of silks.

**B: I don't think Mao would have approved of your Red Guards. However, he might have approved of your Mongolian-inspired collection [spring/summer 2002 haute couture collection for Dior; see page 236].**

G: That was the result of a magical trip around Russia. We spent ten days doing research.

**B: Did you travel on the Trans-Siberian Railway?**

G: No, we were backpacking. We wanted to experience the real Russia. That trip really opened my eyes. We went to theaters, ballet schools, and ethnological museums. We saw some beautiful, beautiful costumes in their archives. The Mongolian costumes were extraordinary, heavily layered and embroidered. Some were made up of seven layers. They inspired several of the pieces in the collection.

**B: You approach your collections like an ethnographer. You've often said that travel is a critical aspect of your creative process. When did you first visit China, and what were your initial impressions?**

G: It was 2002. When I travel, I try to experience the culture firsthand, by soaking up the street life. That particular visit unfolded over three weeks, so I was able to submerge myself in the culture. I was blown away. Everything was so new and so inspiring that I wanted to know more and more. The colors, especially, made an impression on me. The streets of Shanghai at night were bathed in the light of red lanterns. And Beijing . . . the orange sun setting in a gray sky over red temples with green- and blue-tiled roofs, so unbelievably beautiful.

The contrast of old and new was startling, too. Shanghai is an incredibly modern metropolis, but in twenty minutes, you could be in the countryside. We'd all trundle off in my van, listening to pre-Communist music, driving through a landscape that didn't seem to have changed for hundreds of years. There were women plowing the fields wearing the most amazing costumes—it was both terribly real and terribly unreal at the same time. You get so electrified from one of those trips that you don't know what is going to surface when you get back home.

**B: What did surface?**

G: Well, in concrete terms, my spring/summer 2003 haute couture collection for Dior. In part, it stemmed from my meeting with Madame Song. Do you know Madame Song? She was Pierre Cardin's business associate. [Cardin bought Maxim's, the chic Paris bistro, in 1981, and Song opened its Beijing branch in 1983.] Madame Song looked after us on our trip. She introduced us to monks from the Shaolin monastery. Their discipline was so inspiring. I said to them, "I want to meditate. I've tried this and that, but I can't clear my mind." They asked about my creative process, and I explained everything. They responded, "Well, you don't need to look any further. You've been meditating since the age of thirteen." It dawned on me—my creative process is my meditation. The house could burn down and I'd not be aware of it, I'm so focused on my work.

**B: Creativity is absolutely a form of meditation. Your 2003 collection, however, is a little difficult to decipher. I see Japanese influences as much as Chinese influences [see pages 16, 21, 231, 232, 235].**

G: Well, my trip to China extended to Japan, so it's a conflation of both cultures. But, ultimately, it's just a fantasy. I never set out to re-create anything literally or religiously. Actually, visiting both countries in one trip was liberating. I think you can see this freedom in the collection—in the textures and in the shapes or volumes of the pieces.

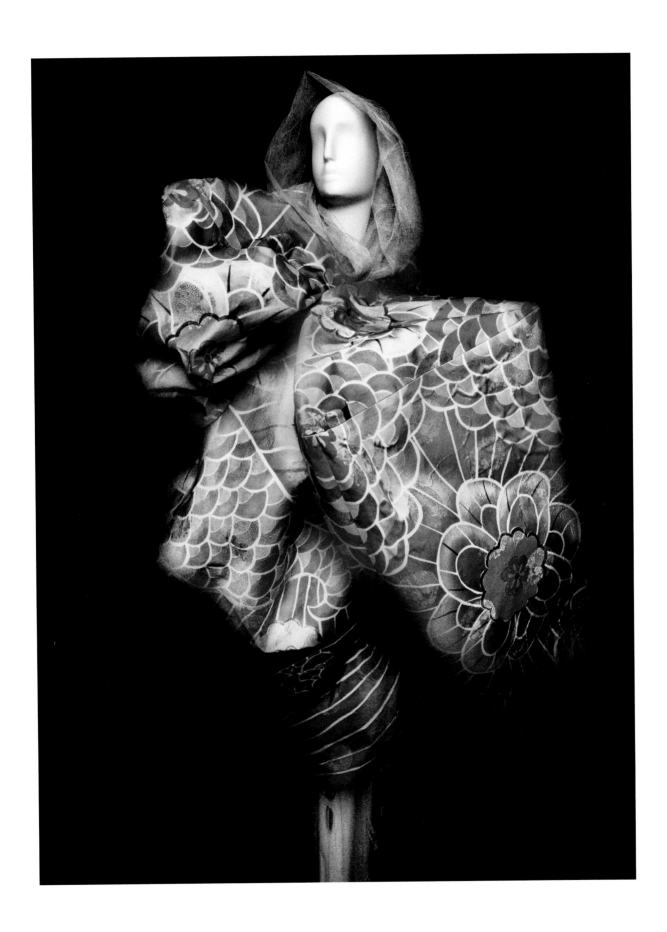

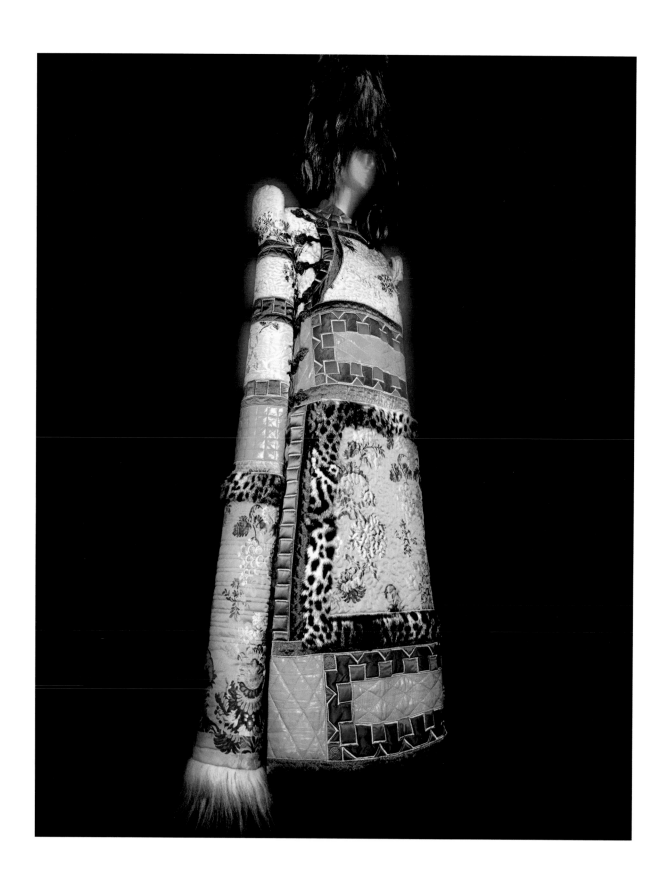

B: The textiles seem Japanese, while the shapes and volumes seem Chinese.

G: Yes, the shapes were inspired by Chinese opera costumes, as were the colors. I visited the Beijing Opera and was invited backstage, where I witnessed the preparations for the performance. It was incredible, the tradition, the ceremony, the layers of clothing wrapped and crisscrossed with string. We photographed everything. I didn't understand a word of the opera, but the visuals were mesmerizing.

B: Maison Martin Margiela's autumn/winter 2013-14 "Artisanal" collection featured two ensembles refashioned from Chinese opera costumes. And the atelier showed a repurposed nineteenth-century Chinese jacket in its spring/summer 2014 "Artisanal" collection.

G: Well, yes. Recycling, bricolage, deconstruction, decontextualization, whatever you want to call it, it's part of Margiela's DNA. It's part of my DNA. It was my oxygen. It's what pushed me creatively. It's how I arrived at certain cuts and certain ways of draping.

B: Your autumn/winter 2005-6 haute couture collection for Dior featured several models that at first looked like studies in extreme deconstruction. In fact, they were studies in the construction of haute couture—garments in the process of becoming.

G: What sets couture apart from ready-to-wear is the workmanship, the amazing attention to detail. Nothing is impossible, and imagination becomes even more beautiful. With those dresses, I wanted to show the magic of the draping on the form, how the block to the toile to the final gown is created, and all the stages in between. We did lots of "X-ray" fabrics, working with tulle so you could look through and see—and understand—all the layers of construction. The dresses reflected a kind of freeze-frame between the block and the belles of the ball. In hindsight, the collection was very Maison Martin Margiela.

B: Yes, you and Margiela share a similar approach to design. When it was announced that you had been named creative director at Maison Margiela, I saw it as a kind of homecoming. But one point of departure is that Margiela has always struck me as a nonnarrative designer. And you're the greatest storyteller fashion's ever seen.

G: There's definitely a narrative to Margiela's collections. It may not be a front-of-stage narrative that we can read easily, but it's definitely a backstage narrative. I've been going through his Polaroids of putting his collections together. There is a lot of emotion. His collections are written with emotion, they are conversations in emotion.

B: Fascinating. Margiela's often categorized as a purely intellectual designer.

G: Yes, but there is so much poetry in his work. Because a lot of his innovations have become part of the fashion landscape, of the fashion language, people forget how radical, how revolutionary, he was. Many of the ideas he introduced changed the trajectory of fashion—in some cases, forever.

B: What are your intentions for Maison Margiela going forward?

G: I'll continue looking to other cultures, like China, for inspiration, as well as to other historical periods. Bricolage defines my work, as it defined Margiela's. It's a new journey for me and a new journey for Maison Margiela. I see it as a process of renewal, of discovery, of returning to my roots. I think there will be a new honesty and authenticity to my work. A new emotionality.

# LIST OF ILLUSTRATIONS

Following is information about every image in this book in order of appearance, except for those in the essays on pages 30–71, where the images are accompanied by captions. A "v" in the page numbers below refers to the vellum leaf that follows the page indicated.

**p. 2**
Yves Saint Laurent (French, 1936–2008). Ensemble, autumn/winter 1977–78 haute couture. Coat of black and red silk ciré; pants of black silk velvet; hat of red silk ciré and black velvet with green feather. Courtesy of Fondation Pierre Bergé–Yves Saint Laurent, Paris

**p. 4**
Ralph Lauren (American, born 1939). Ensemble, autumn/winter 2011–12. Coat of black double-faced cashmere and shearling; jacket of red silk shantung and black silk satin embroidered with polychrome silk and gold metallic thread; shirt of white cotton broadcloth; pants of black and white pinstriped wool-synthetic twill. Courtesy of Ralph Lauren Collection

**p. 7**
Valentino S.p.A. (Italian, founded 1959). Evening dress, "Shanghai" collection 2013. Red and black silk and synthetic netting with appliqué of red silk chiffon embroidered with red seed beads. Courtesy of Valentino S.p.A.

**p. 9**
House of Balmain (French, founded 1945). Oscar de la Renta (American, born Dominican Republic, 1932–2014). Ensemble, autumn/winter 1999–2000. Orange silk damask embroidered with orange silk and gold and silver metallic thread. The Metropolitan Museum of Art, Gift of Mrs. Charles Wrightsman, 2001 (2001.712.2a–b)

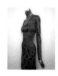
**p. 11**
House of Dior (French, founded 1947). John Galliano (British, born Gibraltar, 1960). Dress, autumn/winter 1997–98. Red silk jacquard embroidered with gold beads. Courtesy of Christian Dior Couture

**p. 12**
Jar with dragon. Chinese, early 15th century. Porcelain painted with cobalt blue under a transparent glaze, 19 x 19 in. (48.3 x 48.3 cm). The Metropolitan Museum of Art, Gift of Robert E. Tod, 1937 (37.191.1)

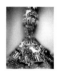
**p. 15**
Roberto Cavalli (Italian, born 1940). Evening dress, autumn/winter 2005–6. Blue and white silk satin. Courtesy of Roberto Cavalli

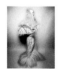
**p. 16**
House of Dior (French, founded 1947). John Galliano (British, born Gibraltar, 1960). Ensemble, spring/summer 2003 haute couture. Coat of pink silk jacquard embroidered with green and blue silk and gold metallic thread; dress of pink silk organza. Courtesy of Christian Dior Couture

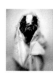
**p. 21**
House of Dior (French, founded 1947). John Galliano (British, born Gibraltar, 1960). Ensemble, spring/summer 2003 haute couture. Coat of pink silk taffeta embroidered with pink and green silk flowers; dress and ruff of black silk ciré. Courtesy of Christian Dior Couture

**p. 22**
Cristobal Balenciaga (Spanish, 1895–1972). Ensemble, 1955–56. White silk taffeta hand-painted with polychrome floral motifs. Courtesy of The Henry Ford, Dearborn, Michigan

**pp 74–75**
*The Last Emperor*, 1987

**p. 76**
Festival robe. Chinese, second half of the 18th century. Yellow silk satin embroidered with polychrome silk and metallic thread. The Metropolitan Museum of Art, Purchase, Joseph Pulitzer Bequest, 1935 (35.84.8)

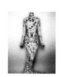
**p. 77**
Yves Saint Laurent (French, founded 1961). Tom Ford (American, born 1961). Evening dress, autumn/winter 2004–5. Yellow silk satin embroidered with polychrome plastic sequins. Courtesy of Yves Saint Laurent, Paris

**pp. 78–79**
Pieces for festival robe. Chinese, late 19th century. Yellow tapestry with polychrome silk and metallic thread. The Metropolitan Museum of Art, Gift of Mrs. Willis Wood, 1957 (57.28.2a–e)

**p. 78v**
Illustration of a court costume. Chinese, Qing dynasty (1644–1911). Work on paper, 15¾ x 18⅞ in. (40 x 48 cm). The Palace Museum, Beijing

**p. 80**
Dries Van Noten (Belgian, born 1958). Ensemble, autumn/winter 2012–13. Jacket of black wool-silk hammered satin printed with polychrome dragon motifs; pants of black wool twill. Courtesy of Dries Van Noten Archive

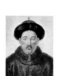
**p. 80v**
Sèvres Manufactory (French, founded 1740). *Portrait de l'empereur de Chine Qianlong* (detail), 1776. Porcelain plate, 9⅜ x 6⅞ x ¼ in. (23.7 x 17.4 x 0.5 cm) overall. Musée du Louvre, Paris

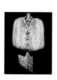
**p. 81**
Dries Van Noten (Belgian, born 1958). Ensemble, autumn/winter 2012–13. Coat of yellow fox fur; jacket of polychrome printed wool-silk hammered satin; shirt of polychrome printed silk satin; pants of black wool twill. Courtesy of Dries Van Noten Archive

p. 82
Woman's robe of state (detail). Chinese, 18th century. Red silk satin embroidered with polychrome silk and metallic thread. The Metropolitan Museum of Art, Purchase, Joseph Pulitzer Bequest, 1935 (35.84.4)

p. 83
Vivienne Tam (American, born Guangzhou). "Dragon Robe" dress, spring/summer 1998. Polychrome printed nylon mesh. The Metropolitan Museum of Art, Gift of Vivienne Tam, 2005 (2005.72.1)

p. 84
Attributed to Callot Soeurs (French, 1895–1937). Dress, 1922–24. Pink silk chiffon embroidered with pink and green silk and copper metallic thread. Courtesy of Hamish Bowles

p. 85
Callot Soeurs (French, 1895–1937). Dress (detail), 1920s. Pink silk chiffon embroidered with copper metallic thread and pearls; pink silk satin. Courtesy of Palais Galliera, Musée de la Mode de la Ville de Paris

p. 86
Yves Saint Laurent (French, founded 1961). Tom Ford (American, born 1961). Evening dress, autumn/winter 2004–5. Polychrome printed silk chiffon with silk chiffon appliqué; dark red silk velvet ribbon; brown mink fur. The Metropolitan Museum of Art, Purchase, Irene Lewisohn Trust Gift, 2013 (2013.900a, b)

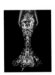

p. 87
Yves Saint Laurent (French, founded 1961). Tom Ford (American, born 1961). Evening dress, autumn/winter 2004–5. Polychrome printed black silk satin and chiffon. Courtesy of Tom Ford Archive

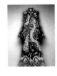

p. 88
Ralph Lauren (American, born 1939). Evening coat, autumn/winter 2011–12. Black triacetate crepe embroidered with polychrome silk and gold metallic thread. Courtesy of Ralph Lauren Collection

p. 88v
The Last Emperor, 1987

p. 89
Ralph Lauren (American, born 1939). Jacket, autumn/winter 2011–12. Red silk shantung and black silk satin embroidered with polychrome silk and gold metallic thread. Courtesy of Ralph Lauren Collection

p. 90
Woman's court robe. Chinese, 19th century. Silk and metallic thread tapestry with painted details. The Metropolitan Museum of Art, Gift of Ellen Peckham, 2011 (2011.433.2)

p. 91
Yves Saint Laurent (French, founded 1961). Tom Ford (American, born 1961). Evening dress, autumn/winter 2004–5. Red silk satin embroidered with polychrome plastic sequins; gray fox fur. The Metropolitan Museum of Art, Gift of Yves Saint Laurent, 2005 (2005.325.1)

p. 92
Festival robe (detail). Chinese, 19th century. Gold-wrapped metallic thread embroidery on red silk patterned gauze. The Metropolitan Museum of Art, Anonymous Gift, 1944 (44.122.2)

p. 93
Evening coat. French, ca. 1925. Double-sided pink and blue silk velvet, quilted and inset with gold lamé; brown mink fur. Brooklyn Museum Costume Collection at The Metropolitan Museum of Art, Gift of the Brooklyn Museum, 2009; Gift of Mrs. Robert S. Kilborne, 1958 (2009.300.259)

p. 94
Yves Saint Laurent (French, 1936–2008). Ensemble, autumn/winter 1977–78 haute couture. Evening jacket of black silk velvet embroidered with gold; pants of black silk velvet. Courtesy of Fondation Pierre Bergé—Yves Saint Laurent, Paris

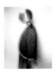

p. 95
Yves Saint Laurent (French, 1936–2008). Ensemble, autumn/winter 1977–78 haute couture. Evening jacket of quilted red and gold silk satin; pants of purple silk satin. Courtesy of Fondation Pierre Bergé—Yves Saint Laurent, Paris

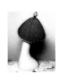

p. 96
Man's summer court hat with peacock feather. Chinese, late 19th–early 20th century. Red basketry; pink and green glass; peacock feather. The Metropolitan Museum of Art, Gift of Alice Boney, 1962 (62.30.3a, b)

p. 96v
The Last Emperor, 1987

p. 97
Jason Wu (American, born Taiwan, 1982). Hat, autumn/winter 2012–13. Black silk velvet with fringe of red silk and finial of gold metal and synthetic pearl bead. Courtesy of Jason Wu

pp. 98–99
Pierre-Louis Pierson (French, 1822–1913). Portrait of the Countess de Castiglione, 1860s. Albumen silver print from glass negative, 3 x 4¾ in. (7.6 x 12.1 cm). The Metropolitan Museum of Art, David Hunter McAlpin Fund, 1975 (1975.548.265)

p. 100
Mantle. Chinese, 1917–20. Black silk satin embroidered with polychrome silk and appliqué of red rooster feathers and pink silk flowers. Courtesy of Musée de la Mode et du Textile, UFAC collection, Les Arts Décoratifs, Paris

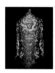

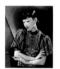

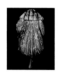
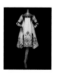

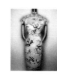
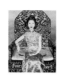
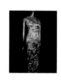
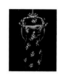
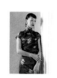

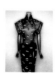

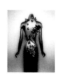

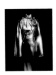
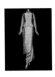
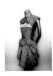

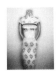

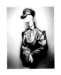

p. 132v
Unidentified artist (Chinese, active 1960s), retouched by Chen Shilin (Chinese, born 1930). *Chairman Mao*, 1964. Gelatin silver print, 12 x 9¼ in. (30.5 x 23.3 cm). The Metropolitan Museum of Art, Twentieth-Century Photography Fund, 2011 (2011.368)

p. 133
Vivienne Tam (American, born Guangzhou). "Mao Suit," spring/summer 1995. White and black silk jacquard. Courtesy of Vivienne Tam

p. 134
Vivienne Tam (American, born Guangzhou). Dress, spring/summer 1995. Polychrome printed nylon mesh. The Metropolitan Museum of Art, Gift of Vivienne Tam, 2004 (2004.521.1)

p. 134v
Andy Warhol (American, 1928–1987). *Mao*, 1973. Acrylic and silkscreen on canvas, 12 x 10 in. (30.5 x 25.4 cm). The Metropolitan Museum of Art, Gift of Halston, 1983 (1983.606.8)

p. 135
Vivienne Tam (American, born Guangzhou). Dress (detail), spring/summer 1995. Polychrome printed nylon mesh. The Metropolitan Museum of Art, Gift of Vivienne Tam, 2004 (2004.521.1)

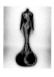

pp. 138–39
*Limehouse Blues*, 1934

p. 140
Travis Banton (American, 1894–1958). Evening dress, 1934. Black silk charmeuse embroidered with gold and silver sequins. Brooklyn Museum Costume Collection at The Metropolitan Museum of Art, Gift of the Brooklyn Museum, 2009; Gift of Anna May Wong, 1956 (2009.300.1507)

p. 140v
George Barbier (French, 1882–1932). *Lady with a Dragon*, ca. 1922. Color lithograph. Private Collection

p. 141
Alexander McQueen (British, 1969–2010). Dress, autumn/winter 2006–7. Blue-green silk charmeuse embroidered with copper sequins and clear crystals, overlaid with copper silk mesh. Courtesy of Alexander McQueen

p. 142
Vitaldi Babani (French, born Middle East, active 1895–1940). Pajamas, 1925–27. Dark blue silk satin embroidered with gold metal and orange silk thread. Courtesy of Palais Galliera, Musée de la Mode de la Ville de Paris

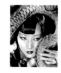

p. 142v
Otto Dyar (American, 1892–1988). Photograph of Anna May Wong, 1932

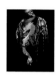

p. 143
Anna Sui (American, born 1955). Ensemble, autumn/winter 2014–15. Jacket of polychrome silk-synthetic velvet burnout with ombré silk fringe; shirt of black synthetic crinkle satin and velvet embroidered with crystals, gold sequins, and beads. Courtesy of Anna Sui

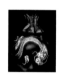

p. 144
House of Givenchy (French, founded 1952). Alexander McQueen (British, 1969–2010). Dress, autumn/winter 1997–98 haute couture. Black silk taffeta embroidered with black glass beads and crystals; black polychrome printed silk-cotton sateen; black synthetic lace. Courtesy of Givenchy

p. 144v
Zhang Yucai (Chinese, active 1295–1316). *Beneficent Rain* (detail), late 13th–early 14th century. Ink on silk, 10⅝ x 107 in. (26.8 x 271.8 cm) overall. The Metropolitan Museum of Art, Gift of Douglas Dillon, 1985 (1985.227.2)

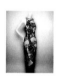

p. 145
House of Givenchy (French, founded 1952). Alexander McQueen (British, 1969–2010). Chopines, autumn/winter 1997 haute couture. Black silk satin embroidered with polychrome silk thread. Courtesy of Alexander McQueen

p. 146
Emilio Pucci (Italian, founded 1947). Peter Dundas (Norwegian, born 1969). Dress, spring/summer 2013. Slip of synthetic mesh embroidered with black and gray silk thread, black beads, and crystals; dress of black silk chiffon. Courtesy of Emilio Pucci

p. 146v
*Daughter of the Dragon*, 1931

p. 147
Ralph Lauren (American, born 1939). Evening dress, autumn/winter 2011–12. Black synthetic double georgette and net embroidered with black silk thread and beads. Courtesy of Ralph Lauren Collection

pp. 148–49
*Broken Blossoms*, 1919

p. 150
Yves Saint Laurent (French, founded 1961). "Opium" perfume packaging, 1980s. Red and gold embossed foil

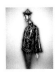
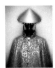
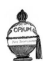
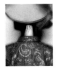
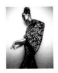

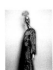

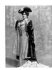

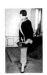

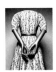
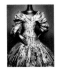

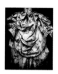

p. 165

*Robe à la polonaise.* French, ca. 1780. White silk taffeta hand-painted with polychrome floral motifs. The Metropolitan Museum of Art, Purchase, Mr. and Mrs. Alan S. Davis Gift, 1976 (1976.146a, b)

p. 166

Dolman. American or European, ca. 1880. Repurposed Chinese export shawl of white silk plain weave with embroidery of white silk thread. Courtesy of Kent State University Museum, Gift of the Martha McCaskey Selhorst Collection

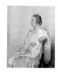

p. 166v

Gerald Kelly (British, 1879–1972). *Portrait of Jane with a White Shawl*, ca. 1927. Oil on canvas, 44½ × 34¼ in. (113 × 87 cm). Private Collection, Delaware; courtesy of Art Finance Partners LLC, New York

p. 167

Shawl (detail). Chinese, 1885–1910. White silk crepe embroidered with white silk. Brooklyn Museum Costume Collection at The Metropolitan Museum of Art, Gift of the Brooklyn Museum, 2009; Gift of Alastair Bradley Martin, 1965 (2009.300.7429)

p. 168

Paul Poiret (French, 1879–1944). "Flammes" ensemble, 1911. Shawl of white silk crepe embroidered with polychrome silk thread with gray and white goat fur; culotte jumpsuit of red silk velvet. Courtesy of Musée de la Mode et du Textile, Les Arts Décoratifs, Paris

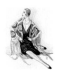

p. 168v

Illustration of Lady Abdy wearing Callot Soeurs shawl, 1926. *Vogue*, Sept. 1, 1926, p. 81

p. 169

Jean Paul Gaultier (French, born 1952). Shawl, autumn/winter 2010–11. Pale peach silk crepe embroidered with polychrome silk thread; mink and fox fur trim. Courtesy of Jean Paul Gaultier

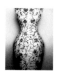

p. 170

Cristobal Balenciaga (Spanish, 1895–1972). Evening dress, 1962. White silk dupioni embroidered with polychrome silk floral motifs. Courtesy of Hamish Bowles

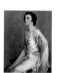

p. 170v

David Prophet Ramsay (British, 1888–1944). *A Lady with a Shawl (Miss Betty Cautley)* (detail), ca. 1937. Oil on canvas, 40¼ × 30⅛ in. (102 × 76.5 cm). Royal Scottish Academy, Edinburgh

p. 171

Shawl. Chinese, early 20th century. White silk crepe embroidered with polychrome silk thread. The Metropolitan Museum of Art, Gift of Mrs. Maxime L. Hermanos, 1968 (C.I.68.64.1)

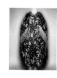

p. 172

Missoni (Italian, founded 1953). Dress, early 1970s. Polychrome printed dark blue synthetic knit. The Metropolitan Museum of Art, Gift of Evelyn D. Farland, 2008 (2008.173.2)

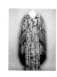

p. 173

Missoni (Italian, founded 1953). Dress, early 1970s. Polychrome printed light blue synthetic knit. The Metropolitan Museum of Art, Gift of Evelyn D. Farland, 2008 (2008.173.1)

p. 174

House of Dior (French, founded 1947). John Galliano (British, born Gibraltar, 1960). Dress, spring/summer 1997 haute couture. Yellow-green silk charmeuse with macramé and embroidery of polychrome silk thread; brown mink fur. Courtesy of Christian Dior Couture

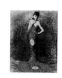

p. 174v

Edward Sheriff Curtis (American, 1868–1952). Publicity photo of Anna May Wong, 1925

p. 175

House of Dior (French, founded 1947). John Galliano (British, born Gibraltar, 1960). Dress, spring/summer 1997 haute couture. Pink silk satin embroidered with polychrome silk thread. Courtesy of Christian Dior Couture

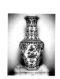

p. 176

Vase. Chinese, 19th century. Porcelain painted with cobalt blue under a transparent glaze, H. 27¼ in. (69.2 cm); Diam. 12¼ in. (31.1 cm). The Metropolitan Museum of Art, Gift of Paul E. Manheim, 1966 (66.156.1)

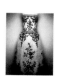

p. 177

House of CHANEL (French, founded 1913). Karl Lagerfeld (French, born Hamburg, 1938). House of Lesage (French, founded 1922). Evening dress, spring/summer 1984 haute couture. White silk organza, tulle, and taffeta embroidered with blue, white, and crystal beads. Courtesy of Collection CHANEL, Paris

pp. 178–79

Roberto Cavalli (Italian, born 1940). Evening dress, autumn/winter 2005–6. Blue and white silk satin. Courtesy of Roberto Cavalli

p. 180

Large dish. Chinese, ca. 1520–40. Porcelain with underglaze cobalt blue decoration, Diam. 20¾ in. (52.7 cm). The Metropolitan Museum of Art, Helena Woolworth McCann Collection, Purchase, Winfield Foundation Gift, 1967 (67.4)

p. 181

Edward Molyneux (French, born England, 1891–1974). Evening dress (detail), 1924. White silk crepe embroidered with silver and blue synthetic beads and pearls. The Metropolitan Museum of Art, Gift of Mrs. C. O. Kalman, 1979 (1979.569.8a)

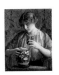
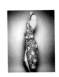

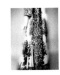
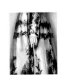

p. 200
Mirror. Chinese, 1st–3rd century. Bronze, Diam. 9¼ in. (23.5 cm). The Metropolitan Museum of Art, Charlotte C. and John C. Weber Collection, Gift of Charlotte C. and John C. Weber, 1994 (1994.605.12)

p. 201
Giorgio Armani (Italian, born 1934). Ensemble, spring/summer 1994. Gray, beige, and white printed silk chiffon embroidered with plastic sequins and beads. Courtesy of Giorgio Armani

p. 202
Jeanne Lanvin (French, 1867–1946). Robe de style (detail), spring/summer 1924. Black silk taffeta embroidered with green silk and silver metallic thread, and synthetic pearl, silver, black, and gold beads and paillettes; silver lamé and ivory silk tulle embroidered with metallic silver thread.The Metropolitan Museum of Art, Gift of Mrs. Albert Spalding, 1962 (C.I.62.58.1)

p. 202v
House of Lanvin advertisement. *Vogue*, June 15, 1924, p. 47

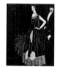

p. 203
Jeanne Lanvin (French, 1867–1946). Robe de style, spring/summer 1924. Black silk taffeta embroidered with green silk and silver metallic thread, and synthetic pearl, silver, black, and gold beads and paillettes; silver lamé and ivory silk tulle embroidered with metallic silver thread. The Metropolitan Museum of Art, Gift of Mrs. Albert Spalding, 1962 (C.I.62.58.1)

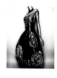

p. 204
Paul Poiret (French, 1879–1944). "Han Kéou" evening dress, ca. 1920. Brown and green silk satin figured liseré and brown silk velvet. Courtesy of Musée de la Mode et du Textile, UFAC collection, Les Arts Décoratifs, Paris

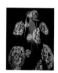

p. 205
Dress. British, ca. 1850. Red-brown silk velvet and damask. The Metropolitan Museum of Art, Purchase, Gifts in memory of Paul M. Ettesvold, and Judith and Gerson Leiber Fund, 1994 (1994.302.1)

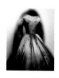

p. 206
Dish with flowers. Chinese, late 14th century–15th century. Carved red lacquer, Diam. 6 in. (15.2 cm). The Metropolitan Museum of Art, Lent by Florence and Herbert Irving (L.1996.47.13)

p. 207
Valentino S.p.A. (Italian, founded 1959). Dress, "Shanghai" collection 2013. Red leather cut-out with appliqué of red leather and embroidery of red silk thread. Courtesy of Valentino S.p.A.

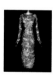

p. 208
House of CHANEL (French, founded 1913). Karl Lagerfeld (French, born Hamburg, 1938). House of Lesage (founded 1922). Evening dress, autumn/winter 1996–97 haute couture. Dress of red silk organza embroidered with red, gold, and silver plastic sequins, and gold beads. Courtesy of Collection CHANEL, Paris

p. 208v
Jean Pillement (French, 1728–1808). Chinoiserie scene (detail), 1758. Reproduced from *L'Oeuvre de Jean Pillement* (Paris: A. Guérinet, 1931), pl. 9

p. 209
Valentino Garavani (Italian, born 1932). Ensemble, autumn/winter 1990–91 haute couture. Jacket and skirt of beige silk satin and organza, embroidered with brown and gold silk yarn and metal thread, red-orange, gold, bronze, and silver plastic sequins, beads, and crystals. Courtesy of Valentino S.p.A.

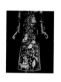

p. 210
House of CHANEL (French, founded 1913). Karl Lagerfeld (French, born Hamburg, 1938). House of Lesage (French, founded 1922). Evening coat, autumn/winter 1996–97 haute couture. Black silk organza and satin embroidered with black, gold, and coral plastic sequins, and gold beads. Courtesy of Collection CHANEL, Paris

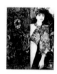

p. 210v
Max-Yves Brandily (probably French, active mid-20th century). Photo of model posing in front of Gabrielle "Coco" Chanel's Coromandel screen

p. 211
Feng Langgong (Chinese). *Summer Palace*, 1690. Folding screen of black lacquered wood, gilded and painted with polychrome designs, 9 ft. 8½ in. × 20 ft. 3 in. (295.9 × 617.2 cm). The Metropolitan Museum of Art, Gift of J. Pierpont Morgan, 1909 (09.6a–l)

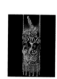

p. 212
Jean Patou (French, 1887–1936). Evening dress, 1925. Black silk satin embroidered with polychrome plastic sequins and beads. Courtesy of Palais Galliera, Musée de la Mode de la Ville de Paris

p. 213
Jean Patou (French, 1887–1936). Dress (detail), 1920s. Black silk chiffon embroidered with polychrome plastic beads. Courtesy of Didier Ludot

p. 214
Model of a watchtower. Chinese, 1st–early 3rd century. Green lead-glazed earthenware, 41 × 22⅝ × 11¾ in. (104.1 × 57.5 × 29.8 cm). The Metropolitan Museum of Art, Purchase, Dr. and Mrs. John C. Weber Gift, 1984 (1984.397a, b)

p. 215
Judith Leiber Couture Ltd. (American, founded 1963). Minaudière, ca. 2012. Silver metal and leather with gold, amber, and black crystals. Courtesy of Judith Leiber Couture

p. 216
Bodice. Probably French, 1775–85. Pink silk faille brocaded with white and pink silk thread. The Metropolitan Museum of Art, Purchase, Irene Lewisohn Bequest, 1978 (1978.298.1)

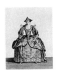

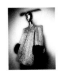
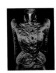

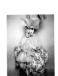
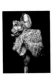

# SELECTED BIBLIOGRAPHY AND FILMOGRAPHY

## BIBLIOGRAPHY

Abbas, Ackbar. "The Erotics of Disappointment." In *Wong Kar-wai*, edited by Jean-Marc Lalanne, pp. 39–81. Paris: Editions Dis Voir, 1997.

Barthes, Roland. *Empire of Signs.* Translated by Richard Howard. 1970. New York: Hill and Wang, 1982.

Bell, James, ed. *Electric Shadows: A Century of Chinese Cinema.* London: British Film Institute, 2014.

Bernstein, Matthew, and Gaylyn Studlar, eds. *Visions of the East: Orientalism in Film.* New Brunswick: Rutgers University Press, 1997.

Chow, Rey. *Sentimental Fabulations, Contemporary Chinese Films: Attachment in the Age of Global Visibility.* New York: Columbia University Press, 2007.

Clunas, Craig, et al. *Chinese Export Art and Design.* London: Victoria and Albert Museum, 1987.

Finnane, Antonia. *Changing Clothes in China: Fashion, History, Nation.* New York: Columbia University Press, 2008.

Geczy, Adam. *Fashion and Orientalism: Dress, Textiles and Culture from the 17th to the 21st Century.* London and New York: Bloomsbury Academic, 2013.

Hearn, Maxwell K., and Wen Fong. "The Arts of Ancient China." *The Metropolitan Museum of Art Bulletin*, n.s., 32, no. 2 (1973–74), pp. 231–80.

Honour, Hugh. *Chinoiserie: The Vision of Cathay.* London: John Murray, 1961.

Jacobson, Dawn. *Chinoiserie.* London: Phaidon Press, 1993.

King, Homay. *Lost in Translation: Orientalism, Cinema, and the Enigmatic Signifier.* Durham, N.C.: Duke University Press, 2010.

Leidy, Denise P., Wai-fong Anita Siu, and James C. Y. Watt. "Chinese Decorative Arts." *The Metropolitan Museum of Art Bulletin*, n.s., 55, no. 1 (Summer 1997), pp. 1–3, 5–71.

Leong, Karen J. *The China Mystique: Pearl S. Buck, Anna May Wong, Mayling Soong, and the Transformation of American Orientalism.* Berkeley: University of California Press, 2005.

Ma, Jean. *Melancholy Drift: Marking Time in Chinese Cinema.* Hong Kong: Hong Kong University Press, 2010.

MacKenzie, John M. *Orientalism: History, Theory, and the Arts.* Manchester: Manchester University Press, 1995.

Martin, Richard, and Harold Koda. *Orientalism: Visions of the East in Western Dress.* Exh. cat., The Metropolitan Museum of Art, New York, 1994–95. New York, 1994.

Metzger, Sean. *Chinese Looks: Fashion, Performance, Race.* Bloomington: Indiana University Press, 2014.

Murck, Alfreda, and Wen Fong. "A Chinese Garden Court: The Astor Court at The Metropolitan Museum of Art." *The Metropolitan Museum of Art Bulletin*, n.s., 38, no. 3 (Winter 1980–81), pp. 2–64.

Qiong Zhang et al. *Qing dai gong ting fu shi/Costumes and Accessories of the Qing Court: The Complete Collection of Treasures of the Palace Museum.* Hong Kong: The Commercial Press, 2005.

The Palace Museum and the Hong Kong Museum of History. *Guo cai chao zhang: Qing dai gong ting fu shi/ The Splendours of Royal Costume: Qing Court Attire.* Exh. cat. and conference volume, Hong Kong Museum of History, 2013. 2 vols. Hong Kong, 2013.

Peck, Amelia, et al. *Interwoven Globe: The Worldwide Textile Trade, 1500–1800.* Exh. cat., The Metropolitan Museum of Art, New York, 2013–14. New York, 2013.

Pickowicz, Paul G. *China on Film: A Century of Exploration, Confrontation, and Controversy.* Lanham and Plymouth: Rowman & Littlefield Publishers, 2012.

Rado, Mei Mei. *Fashion at MOCA: Shanghai to New York.* Exh. cat., Museum of Chinese in America, New York, 2013. 2 vols. in 1. New York, 2013.

Roberts, Claire, ed. *Evolution & Revolution: Chinese Dress 1700s–1990s.* Sydney: Powerhouse Publishing; Museum of Applied Arts and Sciences, 1997.

Said, Edward W. *Orientalism.* New York: Pantheon Books, 1978.

Sklarew, Bruce H., et al. *Bertolucci's The Last Emperor: Multiple Takes.* Detroit: Wayne State University Press, 1998.

Steele, Valerie, and John S. Major. *China Chic: East Meets West.* New Haven and London: Yale University Press, 1999.

Valenstein, Suzanne G. "Highlights of Chinese Ceramics." *The Metropolitan Museum of Art Bulletin*, n.s., 33, no. 3 (Autumn 1975), pp. 115-64.

Watt, James C. Y. "The Arts of Ancient China." *The Metropolitan Museum of Art Bulletin*, n.s., 48, no. 1 (Summer 1990), pp. 1-2, 4-72.

Wilson, Verity. *Chinese Dress*. London: Victoria and Albert Museum, 1986.

Xiao Lijuan et al. *Li jiu chang xin: Qi pao de bian zou/ The Evergreen Classic: Transformation of the Qipao*. Exh. cat., Hong Kong Museum of History, 2010. Hong Kong, 2011.

Xue Yan. *Shi shang bai nian: 20 shi ji zhongguo fu zhuang/Fashions of the Last Century: Chinese Costume from Late Qing to Present*. Exh. cat., China National Silk Museum, Hangzhou, 2004. Hangzhou: China Academy of Art Publishing House, 2004.

Xue Yan et al. *Hua zhuang feng zi: Zhongguo bai nian qi pao/A Century of Cheongsam*. Exh. cat., China National Silk Museum, Hangzhou, 2012. Hangzhou, 2012.

Zhou Xun and Gao Chunming. *5000 Years of Chinese Costumes*. 1984. San Francisco: China Books & Periodicals, 1987.

FILMOGRAPHY

*Adynata*. Directed by Leslie Thornton. Leslie Thornton, 1983.

*The Big Sleep*. Directed by Howard Hawks. Warner Bros., 1946.

*The Bitter Tea of General Yen*. Directed by Frank Capra. Columbia Pictures Corporation, 1933.

*The Blue Kite*. Directed by Tian Zhuangzhuang. Beijing Film Studio/Chu Eyetos & Co./Longwick Film, 1993.

*Broken Blossoms or The Yellow Man and the Girl*. Directed by D. W. Griffith. D. W. Griffith Productions, 1919.

*A Chinese Ghost Story*. Directed by Ching Siu Tung. Cinema City Film Productions/Film Workshop, 1987.

*La Chinoise*. Directed by Jean-Luc Godard. Anouchka Films/Les Productions de la Guéville/Athos Films/Parc Film/Simar Films, 1967.

*Chungking Express*. Directed by Wong Kar Wai. Jet Tone Production, 1994.

*Chung Quo—Cina*. Directed by Michelangelo Antonioni. RAI Radiotelevisione Italiana, 1972.

*The Color of Pomegranates*. Directed by Sergei Parajanov. Armenfilm Studios, 1968.

*Crouching Tiger, Hidden Dragon*. Directed by Ang Lee. Asia Union Film & Entertainment Ltd./China Film Co-Production Corporation/Columbia Pictures Film Production Asia/EDKO Film/Good Machine/Sony Pictures Classics/United China Vision/Zoom Hunt International Productions Company Ltd., 2000.

*Curse of the Golden Flower*. Directed by Zhang Yimou. Beijing New Picture Film Co./EDKO Film/Elite Group Enterprises/Film Partner International, 2006.

*Daughter of the Dragon*. Directed by Lloyd Corrigan. Paramount Pictures, 1931.

*Disorient*. Directed by Fiona Tan. Video installation, Dutch Pavilion, 53rd Venice Biennale, 2009.

*Eros* ("The Hand" segment). Directed by Wong Kar Wai. Chan Wai Chung, Chan Ye Cheng, Jacky Pang Yee Wah, Wong Kar Wai, 2004.

*Farewell My Concubine*. Directed by Chen Kaige. Beijing Film Studio/China Film Co-Production Corporation/ Maverick Picture Company/Tomson Films, 1993.

*Flowers of Shanghai*. Directed by Hou Hsiao Hsien. 3H Productions/Shochiku Company, 1998.

*The Flowers of War*. Directed by Zhang Yimou. Beijing New Picture Film Co./EDKO Film/New Picture Company, 2011.

*The Goddess*. Directed by Yonggang Wu. Lianhua Film Company, 1934.

*The Grandmaster*. Directed by Wong Kar Wai. Block 2 Pictures/Jet Tone Films/Sil-Metropole Organisation/ Bona International Film Group, 2013.

*Green Snake*. Directed by Tsui Hark. Film Workshop/ Seasonal Film Corporation, 1993.

*Hero.* Directed by Zhang Yimou. Beijing New Picture Film Co./China Film Co-Production Corporation/Elite Group Enterprises, 2002.

*House of Flying Daggers.* Directed by Zhang Yimou. Beijing New Picture Film Co./China Film Co-Production Corporation/EDKO Film/Elite Group Enterprises/Zhang Yimou Studio, 2004.

*In the Heat of the Sun.* Directed by Wen Jiang. China Film Co-Production Corporation/Dragon Film, 1994.

*In the Mood for Love.* Directed by Wong Kar Wai. Block 2 Pictures/Jet Tone Production/Paradis Films, 2000.

*Johanna D'Arc of Mongolia.* Directed by Ulrike Ottinger. La Sept Cinéma/Popolar-Film/Zweites Deutsches Fernsehen (ZDF), 1989.

*The Last Emperor.* Directed by Bernardo Bertolucci. Recorded Picture Company (RPC)/Hemdale Film/Yanco Films Limited/TAO Film/Screenframe, 1987.

*Limehouse Blues.* Directed by Alexander Hall. Paramount Pictures, 1934.

*Love Is a Many-Splendored Thing.* Directed by Henry King and Otto Lang (uncredited). Twentieth Century Fox Film Corporation, 1955.

*Lust, Caution.* Directed by Ang Lee. Haishang Films/Focus Features/River Road Entertainment, 2007.

*M. Butterfly.* Directed by David Cronenberg. Geffen Pictures/Miranda Productions Inc., 1993.

*Once Upon a Time in America.* Directed by Sergio Leone. The Ladd Company/Embassy International Pictures/PSO International/Rafran Cinematografica (uncredited), 1984.

*Piccadilly.* Directed by Ewald André Dupont. British International Pictures (BIP), 1929.

*The Product Love (Die Ware Liebe).* Directed by Patty Chang. Video installation, first presented at Arratia, Beer Gallery, Berlin, and Mary Boone Gallery, New York, 2009.

*Raise the Red Lantern.* Directed by Zhang Yimou. ERA International/China Film Co-Production Corporation/Century Communications, 1991.

*The Red Detachment of Women.* Directed by Xie Jin. Tianma Film Studio, 1961.

*The Red Detachment of Women.* Directed by Fu Jie and Pan Wenzhan. Beijing Film Studio, 1970.

*Shanghai Express.* Directed by Josef von Sternberg. Paramount Pictures, 1932.

*The Shanghai Gesture.* Directed by Josef von Sternberg. Arnold Pressburger Films, 1941.

*Sorrows of the Forbidden City.* Directed by Zhu Shilin. Guangzhou Beauty Culture Communication Co. Ltd., 1948.

*The Thief of Baghdad.* Directed by Raoul Walsh. Douglas Fairbanks Pictures, 1924.

*Toll of the Sea.* Directed by Chester M. Franklin. Metro Pictures Corporation/Technicolor Motion Picture Corporation, 1922.

*A Touch of Sin.* Directed by Jia Zhangke. Xstream Pictures/Shanghai Film Group/Bandai Visual Company/Bitters End/MK2/Office Kitano/Shanxi Film & Television Group, 2013.

*A Touch of Zen.* Directed by King Hu (Hu Jinquan). International Film Company/Lian Bang/Union Film Company, 1971.

*2046.* Directed by Wong Kar Wai. Jet Tone Films/Shanghai Film Group Corporation/Orly Films, 2004.

*The Warlords.* Directed by Peter Chan and Yip Wai Man. Media Asia Films/Morgan & Chan Films/China Film Group/Applause Pictures (uncredited)/Beijing Jinyinma Movie & TV Culture Co. (uncredited)/Beijing Poly-bona Film Publishing Company (uncredited)/Chengtian Entertainment (uncredited)/Stellar Mega Film (uncredited)/Talent Aid International/Warner China Film HG Corporation (uncredited), 2007.

*The World of Suzie Wong.* Directed by Richard Quine. World Enterprises, 1960.

# ACKNOWLEDGMENTS

I am grateful to the many people who provided generous support for the exhibition "China: Through the Looking Glass" and this associated publication. In particular, I am fortunate to have had the advice and encouragement of Thomas P. Campbell, Director of The Metropolitan Museum of Art; Emily Kernan Rafferty, President; Jennifer Russell, Associate Director for Exhibitions; Carrie Rebora Barratt, Deputy Director for Collections and Administration; Harold Koda, Curator in Charge of The Costume Institute; Maxwell K. Hearn, Douglas Dillon Chairman, Department of Asian Art; Nina McN. Diefenbach, Vice President for Institutional Advancement; Anna Wintour, Artistic Director of Condé Nast and Editor in Chief of American *Vogue*; Jennifer Lawrence, Gong Li, Marissa Mayer, and Wendi Murdoch, Co-Chairs of The Costume Institute Benefit; Yahoo, which generously underwrote the exhibition and this publication; and Condé Nast, which provided additional support for both projects, along with several generous Chinese donors.

My sincerest appreciation goes to Wong Kar Wai and Nathan Crowley, respectively the Artistic Director and Production Designer of the exhibition. Special thanks, also, to Kristine Chan, William Chang, Winnie Lau, Stephen Jones, Jackie Pang, Norman Wang, and Charlotte Yu.

Sincerest appreciation also goes to the Met's Linda Sylling, Manager for Special Exhibitions and Gallery Installations; Taylor Miller, Associate Buildings Manager, Exhibitions; Susan Sellers, Head of Design; David Hollely, Daniel Kershaw, Daniel Koppich, Aubrey L. Knox, and Emile Molin of the Design Department; and Paul Caro, Christopher A. Noey, Lisa Rifkind, and Robin Schwalb of the Digital Media Department.

The Editorial Department of The Metropolitan Museum of Art, under the direction of Mark Polizzotti, Publisher and Editor in Chief, provided the expertise to realize this book. Special thanks go to Gwen Roginsky, who oversees all The Costume Institute's books, to our editor, Nancy E. Cohen, as well as to Crystal A. Dombrow, Kamilah Foreman, Marcie M. Muscat, Jane S. Tai,

Christopher Zichello, and Tony Mullin. I would also like to thank Homay King, Mei Mei Rado, and Adam Geczy for their erudite and insightful essays for the book, and John Galliano for his informative and enlightening interview. Special thanks to Natasha Jen and Belinda Chen for their beautiful book design. Sincere thanks, also, to Platon for his poetic and haunting photographs, to his team, Bob Serpe, Gabrielle Sirkin, and Cory VanderPloeg, and to his agent, Howard Bernstein.

My colleagues in The Costume Institute have been invaluable every step of the way. I extend my deepest gratitude to Elizabeth D. Arenaro, Rebecca Bacheller, Anna Barden, Tonya Blazio-Licorish, Elizabeth Q. Bryan, Michael Downer, Joyce Fung, Amanda B. Garfinkel, Cassandra Gero, Jessica L. Glasscock, Lauren Helliwell, Mellissa J. Huber, Tracy Jenkins, Mark Joseph, Emma Kadar-Penner, Julie Tran Lê, Emily McGoldrick, Megan Martinelli, Bethany L. Matia, Laura Mina, Marci K. Morimoto, Miriam G. Murphy, Rebecca Perry, Glenn O. Petersen, Jan Glier Reeder, Jessica Regan, Anne Reilly, Sarah Scaturro, Danielle Swanson, and Anna Yanofsky.

I would also like to express my sincere appreciation to the docents, interns, and volunteers of The Costume Institute: Marie Arnold, Kitty Benton, Patricia Corbin, Ronnie Grosbard, Ruth Henderson, Betsy Kahan, Susan Klein, Rena Lustberg, Ellen Needham, Wendy Nolan, Patricia Peterson, Eleanore Schloss, and Nancy Silbert; Alexandra Barlow, Sarah Jean Culbreth, Linden Hill, Christine Hopkins, Katie Kupferberg, and Laura Matina; and Mary Collymore-Bey, Rena Schklowsky, and Judith Sommer.

For the ongoing support of Friends of The Costume Institute, chaired by Lizzie Tisch, and the Visiting Committee of The Costume Institute, I am especially grateful.

My colleagues in the Department of Asian Art have been indispensable. I extend my deepest gratitude to Imtikar Ally, Alison Clark, JoAnn Kim, Denise Leidy, Pengliang Lu, Luis Nuñez, Joseph Scheier-Dolberg, Zhixin Jason Sun, Xin Wang, and Hwai-ling Yeh-Lewis.

I would also like to thank colleagues from various departments at The Metropolitan Museum of Art for their assistance, including John Barelli, Allison E. Barone, Pamela T. Barr, Mechthild Baumeister, Jessica S. Bell, Warren L. Bennett, Barbara J. Bridgers, Joel Chatfield, Maanik Chauhan, Kimberly Chey, Nancy Chilton, Jennie Choi, Aileen Chuk, Meryl Cohen, Clint Ross Coller, Willa Cox, Matthew Cumbie, Eva H. DeAngelis-Glasser, Martha Deese, Cristina Del Valle, Michael D. Dominick, Maria E. Fillas, Giovanna P. Fiorino-Iannace, Elizabeth Katherine Fitzgerald, Patricia Gilkison, Vanessa Hagerbaumer, Michelle M. Hagewood, Doug Harrison, Sarah Higby, Harold Holzer, Min Sun Hwang, Tom A. Javits, Kristine Kamiya, Bronwyn Keenan, Isabel Kim, Daniëlle O. Kisluk-Grosheide, Eva L. Labson, Amy Desmond Lamberti, Richard Lichte, Joseph Loh, Kristin MacDonald, Melanie Malkin, Shaaron Marrero, Ann Matson, Kieran D. McCulloch, Rebecca McGinnis, Missy McHugh, Jennifer Mock, Susan Mouncey, Kathy Mucciolo Savas, Jeffrey Munger, Joanna M. Prosser, Shayda Rahgozar, Luisa Ricardo-Herrera, Yael Rosenfield, Samantha Safer, Frederick J. Sager, Eugenia Santaella, Tom Scally, Catherine Scrivo, Jessica M. Sewell, Soo Hee H. Song, Juan Stacey, Denny Stone, Elizabeth Stoneman, Jacqueline Terrassa, Erin Thompson, Limor Tomer, Elyse Topalian, Donna Williams, Eileen M. Willis, Karin L. Willis, Stephanie R. Wuertz, and Florica Zaharia.

I am extremely grateful to lenders Giorgio Armani (Paula Decato, Laetitia Loffredo, Rod Manley, Alessandra Paini); Art Finance Partners LLC (Andrew C. Rose); Art Gallery of Western Australia, Perth (Tanja Coleman); Hamish Bowles (Jennifer Park, Lilah Ramzi, Molly Sorkin); Cartier (Gregory Bishop, Pierre Rainero, Vivian Thatos); Susan Casden; Roberto Cavalli (Cristiano Mancini); Chanel (Emmanuel Coquery, Marie Hamelin, Odile Premel); China National Silk Museum, Hangzhou; China Chow; Christie's South Kensington (Pat Frost); Cincinnati Art Museum (Cynthia Amnéus, Carola Bell); Kendra Daniel; Dominique Deroche; Christian Dior (Olivier Bialobos, Justine Lasgi, Soïzic Pfaff); Dolce & Gabbana (Valerio D'Ambrosio); Fashion Institute of Design & Merchandising, Los Angeles (Kevin Jones); Winnie and Michael Feng; Fondation Pierre Bergé–Yves Saint Laurent, Paris (Olivier Flaviano, Philippe Mugnier, Laurence Neveu, Joséphine Théry, Sandrine Tinturier, Leslie Veyrat, Catherine Zeitoun); Tom Ford (Cliff Fleiser, Jarrett Olivo, Julie Ann Orsini); Fundación Cristóbal Balenciaga, Getaria, Spain (Igor Uria); Fundación Museo de la Moda, Santiago, Chile (Jorge Yarur Bascuñán, Acacia Echazarreta, Jessica Meza); Diane von Furstenberg (Romy Chan, Franca Dantes, Brenda Greving); Galerie St. Etienne, New York (Elizabeth Marcus); Jean Paul Gaultier (Jelka Music, Morgane Raterron); Cora Ginsberg (Titi Halle); Givenchy (Laure Aillagon, Guillemette Duzan, Sofia Alexandra Nebiolo); Craig Green (Sarah Barnes, Becky Child, Justin Padgett, Helen Price, Francesca Shuck, Angelos Tsourapas); Ground-Zero (Frankie Yung); Daphne Guinness (Isobel Gorst, Emma Prideaux); Guo Pei (Jack Cao, Serenity Hu); Adrian Hailwood; Hanart 1918 (Zhou Zhuguang); The Henry Ford, Dearborn, Mich. (Fran Faile, Jeanine Head Miller, Leslie Mio); Hong Kong Museum of History (Osmond S. H. Chan, Carol S. W. Lau, Susanna L. K. Siu); Zhang Hongtu; Mary Katrantzou (Emma Clayton, Sandra Siljestedt); Niris Katusa; Kent State University Museum, Kent, Ohio (Joanne Fenn, Sara Hume); Marianna Klaiman; Patricia Koo Tsien (Elizabeth Clark, Richard Koo, Patty Pei Tang, Catherine Shih Ying-Ying Yuan); Lacoste (Austin Smedstad); Ralph Lauren (Alyson Carluccio, Bette-Ann Gwathmey, Allison Johnson); Judith Leiber (Karen Handley); Didier Ludot (François Hurteau-Flamand, Sarah Wolfe); Maison Margiela (Axel Arrès, Emilie Boireaux, Giada Bufalini, Marianne Vandenbroucque); Christie Mayer Lefkowith; Ma Ke; Alexander McQueen (Hongyi Huang, Justine Wilkie); Mei Lanfang Memorial Museum, Beijing (Liu Zhen, Qin Huasheng); Musée Christian Dior (Barbara Jeauffroy-Mairet, Marie-Pierre Osmont); Musée de la Mode et du Textile, Musées des Arts Décoratifs, Palais du Louvre, Paris (Marie-Sophie

Carron de la Carrière, Olivier Gabet, Marie-Pierre Ribère, Myriam Teissier, Jennifer Walheim); Museum at the Fashion Institute of Technology, New York (Sonia Dingilian, Valerie Steele); Museum of Fine Arts, Boston (Pamela A. Parmal); National Gallery, London (Sarah Hardy); National Gallery of Art, Washington, D.C. (Lisa MacDougall, Melissa Stegeman); National Museum of Singapore (Chloe Ang, Sarah Jane Benson, May Khuen Chung, Angelita Teo); National Gallery of Victoria (Tony Ellwood, Ted Gott, Sarah Nixon); Palace Museum, Beijing (Li Shaoyi, Liu Yufeng, Dora Yuan); Palais Galliera, Musée de la Mode de la Ville de Paris (Sophie Grossiord, Charlotte Piot, Olivier Saillard, Alexandre Samson); Peabody Essex Museum, Salem, Mass. (Christine Bertoni); Philadelphia Museum of Art (Dilys Blum, Kristina Haugland); Powerhouse Museum, Ultimo, Australia (Katrina Hogan); Emilio Pucci (Cinzia Bernasconi, Chelsea Lake, Christina Newman); Red Gate Gallery, Beijing (Brian Wallace); Robischon Gallery, Denver; Alexis Roche; Rodarte (Kate Mulleavy, Laura Mulleavy); Royal Scottish Academy, Edinburgh (Sandy Wood); Arthur M. Sackler Gallery, Smithsonian Institution, Washington, D.C. (Rebecca Gregson, David Hogge); Sandy Schreier; Saint Laurent (Lilian Bard, Brant Cryder, Barbara Nguyen, Stephanie Tran); Paul Smith (Paul Rousseas, Cindy Vieira); Anna Sui (Sara Bezler, Allie Lynch, Thomas Miller, Kristina Niolu, Anita Pandian); Vivienne Tam (Wendi Li, Alan Wang); Isabel and Ruben Toledo; Muna Tseng; Valentino (Giancarlo Giammetti, Mona Sharf Swanson, Violante Valdettaro); Giambattista Valli (Matthew Gebbert); Dries Van Noten (Jan Vanhoof); Victoria and Albert Museum, London (Oriole Cullen, Hannah Kauffman); Louis Vuitton (Maggie Jenks-Daly, Tania Metti); Jason Wu (Gina Pepe); Vivienne Westwood (Murray Blewett, Sharon Donnelly, Frances Knight-Jacobs); and Laurence Xu (Yiyi Jing).

I would also like to thank the following individuals and agencies for providing photographs for this publication: Bloomsbury Publishing (Emily Ardizzone); Condé Nast (Leigh Montville); Fondation Pierre Bergé (Pierre Bergé, Olivier Flaviano, Philippe Mugnier); de Gournay (Anneke Gilkes); Hearst Magazines (Wendy Israel); Kobal Collection (Jamie Vuignier); Museum at the Fashion Institute of Technology (Melissa Marra); and Studio Peter Lindbergh (Benjamin Lindbergh, Peter Lindbergh).

Special thanks to Raul Àvila, Dr. Bao Mingxin (Donghua University, Shanghai), Lauren Bellamy, Dr. Bian Xiangyang (Donghua University, Shanghai), Hamish Bowles, Juliana Cairone, Veronica Chou, Melvin Chua, Grace Coddington, Andrew Coffman, Grazia D'Annunzio, Fiona DaRin, Sylvana Ward Durrett, Anne Feng (University of Chicago), Baroness Jacqueline von Hammerstein-Loxten (Pagoda Paris), Lizzy Harris, Thomas P. Kelly (University of Chicago), Eaddy Kiernan, Hildy Kuryk, Jade Lau, Dr. Li Meng (Donghua University, Shanghai), Shannon Price, Qin Cai (China National Silk Museum, Hangzhou), Neal Rosenberg, Andrew Rossi, Bryan Sarkinen, Dr. Shan Jixiang (Palace Museum, Beijing), Schuyler Weiss, Dr. Xu Zhen (Mei Lanfang Memorial Museum, Beijing), Dr. Xu Zheng (China National Silk Museum, Hangzhou), Xue Yan (China National Silk Museum, Hangzhou), Dr. Yan Yong (Palace Museum, Beijing), Yixin Zhang (Grinnell College, Iowa), Dr. Zhao Feng (China National Silk Museum, Hangzhou), and Zhou Zhuguang (Han-Art 1918).

For their ongoing support, I would like to extend my heartfelt thanks to Paul Austin, Alex Barlow, Harry and Marion Bolton, Ben and Miranda Carr, Christine Coulson, Brooke Cundiff, Alice Fleet, Michael Hainey, Kim Kassel, Dodie Kazanjian, Teresa W. Lai, Alex Lewis, Calvin Tomkins, Trino Verkade, Rebecca Ward, Sarah Jane Wilde, and especially Thom Browne.

Andrew Bolton

## PHOTOGRAPH CREDITS

## CONTRIBUTORS

Andrew Bolton is Curator in The Costume Institute at The Metropolitan Museum of Art, New York.

John Galliano is a fashion designer.

Adam Geczy is Senior Lecturer at Sydney College of the Arts, a faculty of the University of Sydney, Australia.

Maxwell K. Hearn is Douglas Dillon Chairman of the Department of Asian Art at The Metropolitan Museum of Art, New York.

Homay King is Associate Professor of Art History at Bryn Mawr College, Bryn Mawr, Pennsylvania.

Harold Koda is Curator in Charge of The Costume Institute at The Metropolitan Museum of Art, New York.

Platon is a photographer and human rights activist.

Mei Mei Rado is a doctoral candidate in art history, Bard Graduate Center, New York.

Wong Kar Wai is a filmmaker.

This catalogue is published in conjunction with "China: Through the Looking Glass," on view at The Metropolitan Museum of Art, New York, from May 7 through August 16, 2015.

The exhibition is made possible by

YAHOO!

Additional support is provided by

CONDÉ NAST

and several generous Chinese donors.

Published by The Metropolitan Museum of Art, New York

Mark Polizzotti, Publisher and Editor in Chief

Gwen Roginsky, Associate Publisher and General Manager of Publications

Peter Antony, Chief Production Manager

Michael Sittenfeld, Managing Editor

Robert Weisberg, Senior Project Manager

Edited by Nancy E. Cohen

Designed by Pentagram: Natasha Jen and Belinda Chen

Production by Christopher Zichello

Bibliography, filmography, and notes edited by Penny Jones

Image acquisitions and permissions by Jessica L. Glasscock and Crystal A. Dombrow

Typeset in GT Sectra Display, Suisse Works, and Futura

Printed on 90 gsm Perigord

Separations by Professional Graphics, Inc., Rockford, Illinois

Printed and bound by Conti Tipocolor S.p.A., Florence, Italy

Cover image for flexibound edition adapted by Platon from a nineteenth-century festival robe; see page 92

Photograph credits appear on page 254.

The Metropolitan Museum of Art
1000 Fifth Avenue
New York, New York 10028
metmuseum.org

Distributed by
Yale University Press, New Haven and London
yalebooks.com/art
yalebooks.co.uk

Cataloging-in-Publication Data is available from the Library of Congress.

ISBN 978–1–58839–563–4 (flexi: The Metropolitan Museum of Art)

ISBN 978–1–58839–577–1 (deluxe edition: The Metropolitan Museum of Art)

ISBN 978–0–300–21112–2 (flexi: Yale University Press)

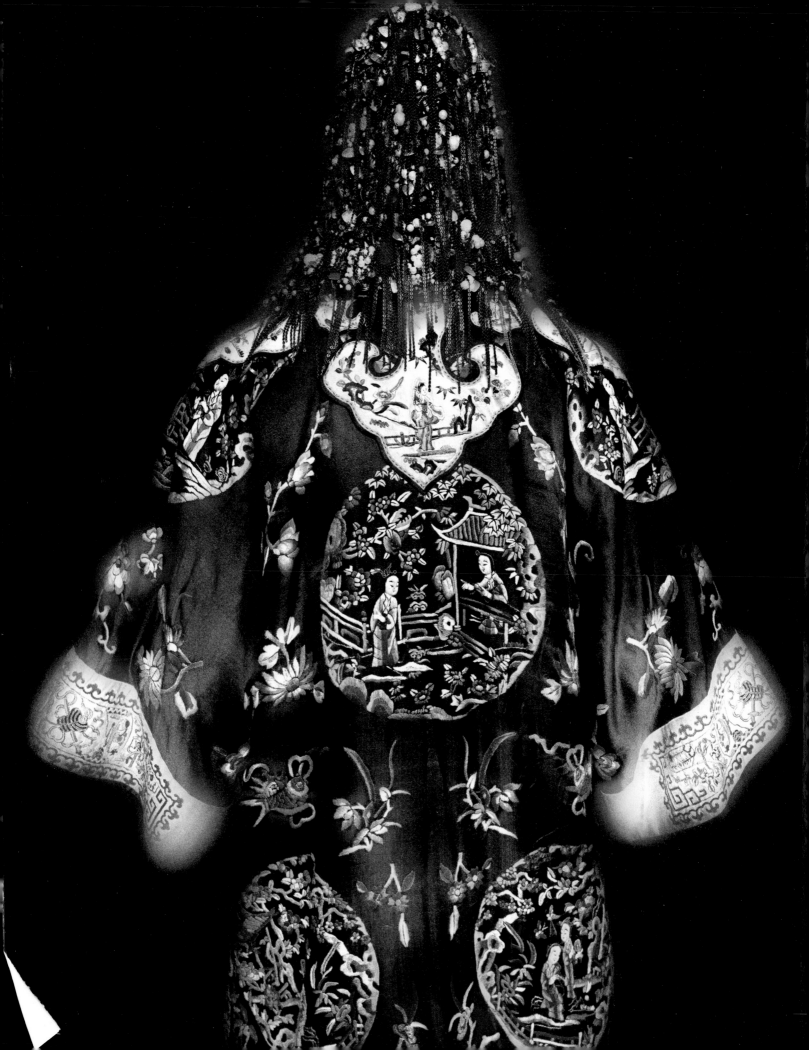